FV

WITHDRAWN

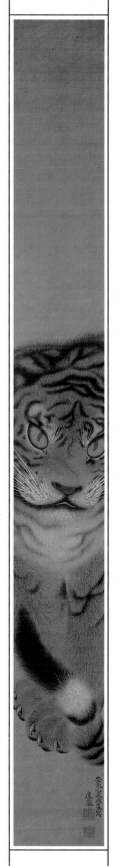

JAPANESE ART
MASTERPIECES IN THE BRITISH MUSEUM

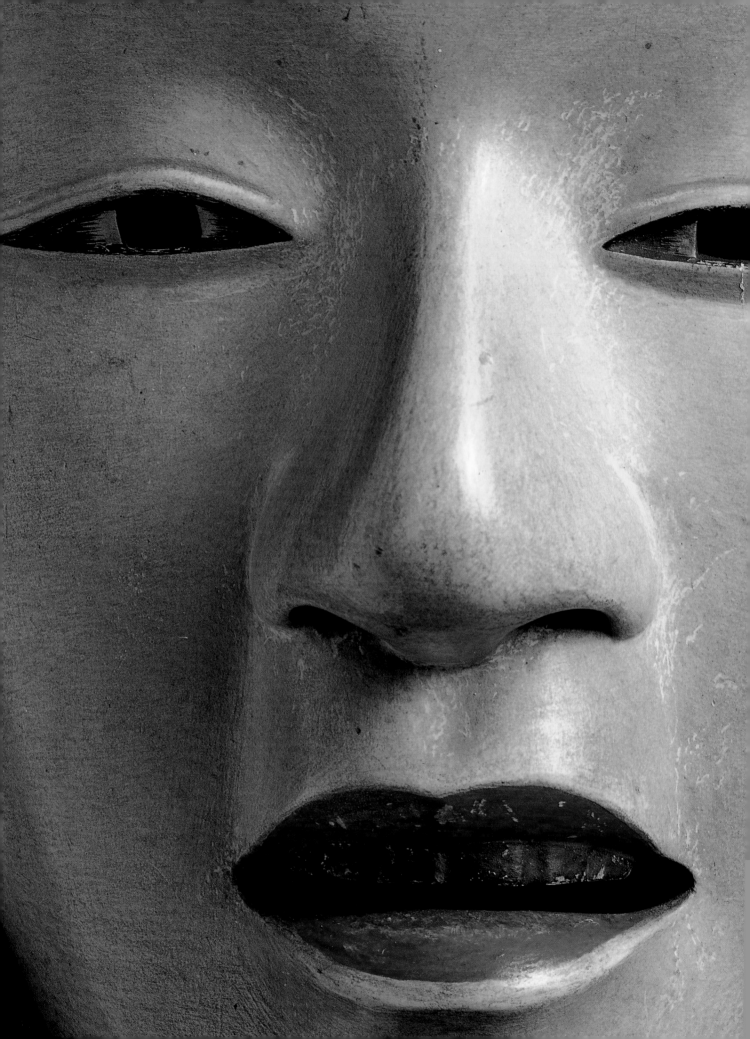

LAWRENCE SMITH, VICTOR HARRIS AND TIMOTHY CLARK

JAPANESE ART

MASTERPIECES IN THE BRITISH MUSEUM

OXFORD UNIVERSITY PRESS · NEW YORK · 1990

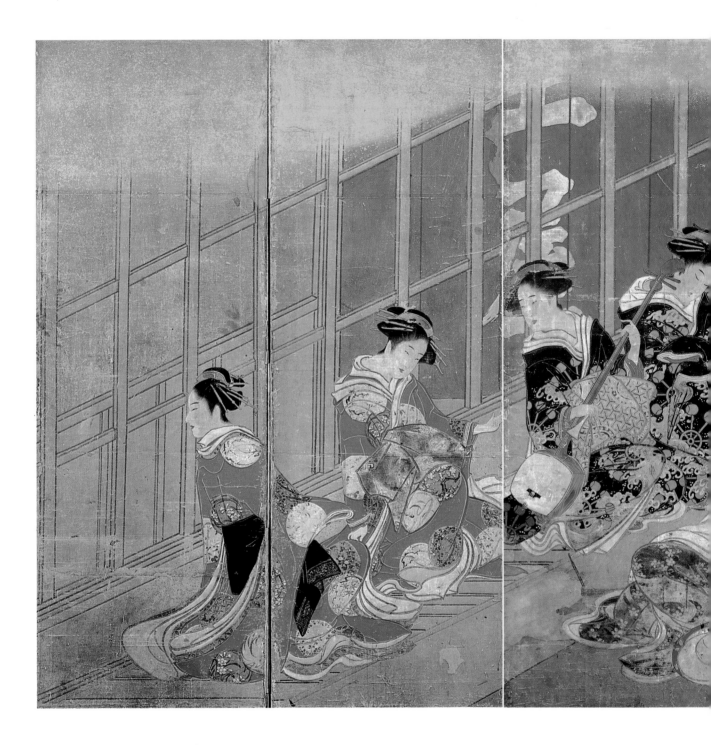

Published in North America by Oxford University Press, Inc.,
200 Madison Avenue, New York, NY 10016

Oxford is a registered trademark of Oxford University Press

A record of the Library of Congress Cataloging-in-Publication
Data is available from the United States Library of Congress

ISBN 0-19-520834-X

Designed by Harry Green

Set in Palatino and Gill by
Rowland Phototypesetting Ltd,
Bury St Edmunds, Suffolk,
and printed in Italy by
Arnoldo Mondadori Editore,
Verona

Page 1 'Tiger' (no. 179) by Maruyama Ōkyo,
hanging scroll, 1775

Pages 2–3 Detail of Nō mask (no. 138),
painted wood, 18th–19th century

Pages 4–5 Detail of *Courtesans of the Tamaya house
of pleasure* (no. 194), six-fold screen

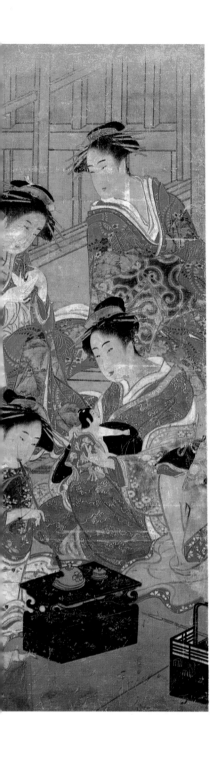

CONTENTS

This book has been supported by
a generous donation from the
Pilkington Anglo-Japanese Cultural Foundation

DONORS

The following have enabled the building of the new Japanese galleries in the British Museum through their generous contributions. In this list surnames are given second, in international style.

Received in Japan

Konica Corporation
Asahi Shimbun
Dr Sōshitsu Sen and the Urasenke Foundation
Federation of Electric Power Companies
Tokyo Bankers' Association Inc.
Japan Automobile Manufacturers' Association Inc.
Japan Electrical Manufacturers' Association
Five Cities Art Dealers' Union
Japan Foreign Trade Council Inc.
Japan Iron & Steel Federation
Petroleum Association of Japan
Federation of Construction Contractors' Association
Association of Tokyo Stock Exchange Regular Members
Federation of Pharmaceutical Manufacturers' Association in Japan
Japan Gas Association
Kōdansha Ltd
Life Insurance Association of Japan
Electronic Industries' Association of Japan
Communication Industry Association of Japan
Marine & Fire Insurance Association of Japan Inc.
Government of Japan
Kampō Harada
Hiroshi Irumano
Japan non-Government Railway Association
Regional Banks' Association of Japan Inc.
Mitsubishi Heavy Industries Ltd
Trust Company Association of Japan
Real Estate Companies' Association in Japan
Robert Vergez
Brewers' Association of Japan
Japan Department Stores Association
Kōichi Kishimoto
Japan Chemical Fibre Association
National Association of Sōgō Banks
Cement Association of Japan
Cornes & Co. Ltd
Dai Nippon Printing Co. Ltd
Toppan Printing Co. Ltd
Anonymous donor
Flat Glass Association of Japan
Japan Paper Association
Kokusai Denshin Denwa Co. Ltd
Nippon Express Co. Ltd
Yamato Transport Co. Ltd
Fuji Xerox Co. Ltd
Suntory Ltd
Kao Corporation
Asahi Shimbun readers
Ajinomoto Co. Inc.
Dentsū Inc.
Drico Ltd
Japan Tobacco Inc.
Komatsu Ltd
Mitsubishi Kasei Corporation
Sumitomo Chemical Co. Ltd
Ichibankan Tailor Co. Ltd
Japanese Shipowners' Association
Mitsubishi Petrochemical Co. Ltd
NGK Insulators Ltd
Nippon Meat Packers Inc.
Daikin Industries Ltd
Nisshin Food Products Co. Ltd
Hakuhōdō Inc.
House Food Industrial Co. Ltd
Makio Itoh
Ryōichi Kawai
Junkichi Mayuyama
Mitsui Tōatsu Chemical Inc.
Nisshin Flour Milling Co. Ltd
Ube Industries Ltd
Sato Bundō
Mitsui Petrochemical Industries Ltd

Toshirō Masuda
Bunzō Torikoshi
Matsuhira Yasuda
Kenji Yumino
Yasuda Matsuhira
and many small donations

Received in the United Kingdom

Brian and Esther Pilkington
Nissan UK Ltd
Japan Airlines
Gordon Bowyer & Partners
S. G. Warburg & Co.
Wolfson Foundation
British Museum visitors
Baring Foundation
HTS Management Holdings Ltd
British Museum Society
British Telecom plc
County NatWest Ltd
Eskenazi Ltd
Ocean Transport & Trading plc
Rio Tinto Zinc Ltd
Robert Sawers
John Swire & Sons
Josiah Wedgwood & Sons Ltd
Ohbayashi-Gumi
Robert Fleming Holdings Ltd
Esmée Fairbairn Charitable Trust
Anonymous donor
Dr W. S. Barry
Cable & Wireless plc
Christie's
Klaus Naumann
Arthur Young Charitable Foundation
Hambros plc
Kōdō Okuda
John Taylor Pool, jun.
Guardian Royal Exchange Charitable Trust
Lazard Brothers & Co. Ltd Charity Trust
Barclays Bank plc
Keiko Hasegawa
Lawrence Smith
David King
Evelyn de Rothschild
Lloyds Bank plc
John and Sandy Milne Henderson
National Westminster Bank plc
Oscar Faber Consulting Engineers
Sotheby's
Fred and Joan Baekeland
Setsuko Okonogi
Lord Moyne
David and Paula Newman
Jack Hillier
Dennis Wiseman
Chōzō Yamanouchi
Sir David Wilson
Oranges & Lemons
Manami Wada
Eikoku Magazine
Israel Goldman
R. A. Lamb
Spink & Son Ltd
and many small donations

PREFACE

NOTE
Japanese
personal names
are given with
the surname first.
Macrons over the
letters 'o' and 'u' are
omitted in the
universally used
city names of Tokyo,
Osaka and Kyoto,
and in words such as
'shogun', which are
judged to have
entered the English
language.

The occasion of the opening of a completely new suite of Japanese galleries in the British Museum is a good time to review the collections, which are probably the most comprehensive in their scope in Europe. The choice of illustrations for this book has resulted from that review and also contributed to it. The objectives are twofold: to describe succinctly the history of Japanese art and culture through a series of chapters based on the strengths of the British Museum's holdings; and at the same time to provide an accurate account of their range and to illustrate many of the finest pieces.

There is one exception which deserves explanation. The chapter on 'The Arts of the Tea Ceremony' includes seven items lent for the opening exhibition by the Urasenke Foundation of Kyoto, who are among the biggest benefactors of the new galleries. In recognition of their donation of a complete *chashitsu* (Tea Ceremony room) as a permanent exhibit in the British Museum, it was thought suitable to improve the quality of this section by borrowing from their unequalled collection of Tea wares. One of these items is in fact Chinese (no. 109), but it is of a type so closely copied in Japan that it is not always possible to distinguish one from the other. It should be noted that certain classes of art are omitted either because they do not form part of the British Museum's collections, or because they lie outside its brief. Among them are costume, the folk crafts, and paintings in Western or international techniques and formats of the last 120 years.

Otherwise the choice covers Japanese items held in the Department of Japanese Antiquities, separated from the Department of Oriental Antiquities in 1987, with coins from the Department of Coins and Medals and clocks from the Clock Room of the Department of Medieval and Later Antiquities. The texts on coins have been kindly provided by Joe Cribb of the former, and the catalogue entries on clocks by Dr John Leopold of the latter, whom I cordially thank. The bulk of the text is by my colleagues Victor Harris (Chapters 1, 4, 5, 7, 8, 9), Timothy Clark (Chapters 10, 11), and myself (Introduction and Chapters 2, 3, 6, 12). We have all benefited from the advice or scholarly work of Japanese colleagues, who in the last two decades have increasingly directed their attention to foreign

collections. It is impossible to mention them all, but the most notable include Arakawa Hirokazu, Harada Ichibin, Komatsu Taishū, Ogasawara Nobuo and Yabe Yoshiaki of the Department of Applied Arts in the Tokyo National Museum; Murashige Yasushi and Takamizawa Akio of the Department of Fine Arts in the same institution; Professors Chino Kaori and Kobayashi Tadashi of Gakushūin University; Professor Sasaki Jōhei of Kyoto University; Professor Narazaki Muneshige, formerly of Risshō University; Asano Shūgō of Chiba City Museum; and Tsutsui Hiroichi of the Urasenke Foundation. Outside Japan Roger Keyes has advised on some aspects of Ukiyo-e prints, Jack Hillier on Ukiyo-e painting, Scott Johnson on Shijō painting, and Michael Birch on the Tea Ceremony.

The gradual disappearance of the distinction between Japanese and foreign scholarship, and the ever-growing literature from all sources on Japanese art and culture, have led us to include in both the catalogue entries and Bibliography a number of crucial books in Japanese. Although they are obviously not accessible to the general reader, they can no longer be omitted.

I wish to acknowledge the hard work of a number of my colleagues in the British Museum, without whom this book would not have been possible. Greg Irvine, Sarah Jones and Sally Morton have diligently looked after the collections, their records and their photographs. Francesca Harvey has helped with bibliographical work, and Catherine Edwards has patiently typed and retyped much of the text. The photographs, except those for the seven items from the Urasenke Foundation, were taken by Paul Gardner and David Agar of the British Museum Photographic Service. Deborah Wakeling has been, as so often in the past, a punctilious editor of a complex book.

Brian Pilkington of the Pilkington Anglo-Japanese Cultural Foundation has made possible the publication of this full-colour book at a reasonable price. He is also one of the many benefactors of the new Japanese galleries, all listed on p. 6, which will for the first time do proper justice to these splendid collections.

LAWRENCE SMITH
Keeper of Japanese Antiquities, British Museum
7 December 1989

AN APPROACH TO JAPANESE ART AND CULTURE

INTRODUCTION

Any attempt to make rational sense of the cultural history of an ancient, populous and energetic nation is certain to mislead by over-simplification. This is even more likely when a Westerner with one set of built-in intellectual attitudes and cultural assumptions tries to interpret a civilisation like Japan's which is constructed on the basis of quite different ideas. In these circumstances the word 'contradiction' may soon be introduced.

Westerners are apt to see contradictions in the existence side by side of emotions or styles or ways of life which through wish or habit or convenience they might themselves keep separate. Thus the combination of violence with artistic sensibility in some members of the military class in the sixteenth century (such as the Regent Hideyoshi) might be interpreted as a contradiction, whereas it might be readily accepted in, for example, the warlord and musician Frederick the Great of Prussia. On a more directly artistic level some Westerners find it notoriously difficult to reconcile the more extreme aesthetics of Tea Ceremony pottery with the refinements of Kyoto courtly culture, though both might be practised by the same people, especially in the sixteenth and seventeenth centuries. And there are those outside Japan who would find it hard to believe that the paintings nos 179 and 178 could be by the same artist, the one detailed, conventional, yet more than a little tongue in cheek, the other austere, cool and sophisticated.

Instead of seeing contradictions, it would be more illuminating to think of a gradual accumulation of lasting cultural effects, all of them continuing to exist side by side, just as in an experienced human being the gradual additions of experience are remembered, and some retained and some abandoned, though not necessarily for ever. So in Japanese history various changes have taken place which have left a permanent mark in culture – buildings, gardens, art, literature, theatrical and

musical traditions, religion, philosophy, cuisine, clothing, and the whole body of folk belief and practice.

All of these (and many others) together are what make a culture distinctive, and Japan is no exception. But in Japan the very high level of self-consciousness, or self-examination of the nation's characteristics, has led to an unusually high rate of survival of the skills and attitudes of the past, and their constant revival and reuse by later generations. The three most recently produced items illustrated in this book vividly support this tendency (nos 58, 124 and 250), the first maintaining an art from the Heian period, the second a craft from the sixteenth century, and the third a tradition from the eighteenth century. They incidentally also illustrate three of the greatest continuing influences on Japanese cultural life – calligraphy, the Tea Ceremony and the theatre.

This brief survey therefore records significant and enduring additions to Japanese cultural and artistic consciousness. Usually these have been linked to social and political changes, but they do not always coincide at all exactly with the historical periods which are listed on p. 248 and which are used in the conventional way in the thematic chapters of this book. Japanese art historians themselves recognise the fact that the same dominant social and cultural tendencies may both precede and follow major historical or political events. In this way, for example, they may extend the Momoyama period as a cultural phenomenon from the usual 1600 or 1614 (the fall of Osaka Castle) or 1639 (the beginning of the Isolation), or even allow it to drift on into the late seventeenth century, when a genuinely different artistic spirit began to emerge.

The longest of all these periods was the Jōmon, a hunting and gathering culture lasting some 10,000 years, and ending in central Japan only *c.* 300 BC. Through all of this extended late stone age the inhabitants of Japan lived in the forests and mountains or by the seas or rivers. To this day the preference for fish, especially raw fish and shellfish, and for mountain herbs and roots is a marked feature of Japanese food culture. Theirs was a nomadic way of life; what villages there were do not seem to have been long-lived. This prolonged and distinctive civilisation, comparatively suddenly replaced by a more settled way of life, left Japan a legacy of inherent attitudes which have endured. These include a sense of impermanence in architecture, a preference for living in a way which blurs the distinction between outside and inside, and an awareness of the changes brought by the

seasons which remains to the present day one of the strongest characteristics of Japanese life.

At a deeper level it has been observed that the Japanese unconscious mind adopts neither the sea nor the sky as its symbol but rather the dark, mysterious forested mountains which still cover eighty per cent of the country. Most folklore traditions come from these forests, priests and hermits in successive ages retreated to them, and the timber which is the basis of traditional architecture is grown in them. On a more practical level archaeological evidence shows that lacquer, after wood the most characteristic of Japanese materials, was already being tapped on the mountains in the late Jōmon period. Without doubt, however, its greatest physical legacy is the vast body of Jōmon ('cord-marked') pottery which has given its name to the era. Its immense skill and invention and wide geographical distribution point to a people with a special feeling for ceramics. This remains true even in modern Japan, where art-pottery thrives.

The introduction of rice agriculture from the continent in the third century BC was the biggest change in Japanese cultural history. The Japanese now took up residence on the limited flat country between the mountains and the sea, where they have lived ever since. In this situation land became vital and Japan began to be crowded. From this was born of necessity the traditional economy in the use of space that has shaped the Japanese way of life, especially in architecture and garden design. Rice became the overwhelming staple, and the need to ensure nature would be kind resulted in the formal organisation of the native Shintō religion. It is known that the basic style of Shintō architecture came to its early maturity in the Yayoi period. With rice the traditional Japanese cuisine became virtually settled, and saké, the national drink, was first brewed. Saké still has strong links with Shintō worship.

The introduction of bronze and iron (virtually at the same time) naturally made easier the growth of warlike states, which in turn were a direct result of settled agriculture. It has been suggested by Japanese anthropologists that this relatively sudden change from the untrammelled to the very restricted is at the heart of the Japanese tendency to swing between the very controlled and the very wild. Examples of the latter are the numerous uninhibited folk festivals and the strong tradition of celebration of the grotesquely demonic (as in Genki's handscroll, no. 180, which combines both).

The Yayoi and Kofun ('great tombs') periods witnessed

more and more contacts between Japan and the mainland of East Asia, and an increasing recognition of and respect for the cultural dominance of China. It is now known that silk was used by the aristocracy during the later Yayoi, and Japanese production steadily increased thereafter to become one of the bases of their culture – used not only for clothes but also by the eighth century for linings and wrappings, for paintings and their mounts, for the braded cords which appear in so many ceremonial areas of life, and of course for writing on.

The second most important cultural change in Japanese life was the conscious absorption of East Asian, particularly Chinese civilisation, from the mid-sixth up to the end of the eighth centuries (approximating to the Asuka and Nara periods). By far the most significant elements in this process were the adoption of the Chinese system of writing and the establishment of Buddhism. Although the Japanese language was not suitable to be expressed in the complex Chinese characters, it was the only model available. The prestige of the written word itself was carried over from China, and indeed calligraphy in brush and ink has been the most prestigious of the arts in Japan ever since. Study of the Buddhist scriptures led the way to the acquisition of Chinese learning as well as writing, so that during this period Daoist and Confucian religious ideas also became familiar to scholars, historians and administrators. The mixture of ideas derived from Buddhism, Shintō, Daoism and Confucianism was to create a typically complex web of thought in Japanese life which still remains in the background of modern attitudes. The art of writing necessitated the greater use of the Chinese inventions of silk, paper (first made in Japan in the seventh century) and printing (first used in Japan in the eighth century).

The Chinese versions of Buddhism, transmitted partly through Korea, brought a much more advanced architectural style (sixth century onwards), using pillars, complex bracketing systems for roofs, and roof tiles. Palaces for the ruling families very soon followed. The advanced applied decorative arts of China and Korea were learned with remarkable speed – including architectural carving, moulded tiles, gilt-bronze fittings, decorated lacquerwork, inlaid metalwork, the various formats of paintings (wall-paintings, folding screens, fans, hanging scrolls, handscrolls); the practices and techniques of sculpture in wood and lacquer; and the use and manufacture of musical instruments. This period of intense learning formed the solid basis of most

subsequent Japanese culture, which from then on can be seen as a distinctive province of the wider East Asian civilisation dominated by China. The position of England in European civilisation is to some extent parallel.

Having absorbed what it needed of continental civilisation, Japan now paused to develop its own distinctive ways. The most significant expression of this was moving the capital to Heian-kyō (modern Kyoto), where the Imperial family and court were to remain until 1868. A new style of architecture called Shinden was pioneered there in the new palace, much more adapted to native taste. It used woven mats on raised wooden floors, and the Japanese began to sit, eat and sleep on them. With the virtual disappearance of chairs, and hence of other large furniture, the characteristic Japanese domestic way of life became settled, gradually spreading downwards to all classes. Shinden style also made use of small artificial gardens designed to recall the natural world, and open corridors connecting separate buildings. People could live half indoors and half outdoors, absorbing to the full the effects of the changing seasons.

In such settings culture was from the ninth to the eleventh centuries dominated by an axis of the courtly classes (from whom the administrators were drawn also) and the Buddhist priesthood, who were in those days sometimes the same people and certainly from the same class. Buddhism tended, therefore, like courtly life, to be remote, mysterious and beautiful. The restrained, rich elegance which became characteristic of the court nobility has remained one ideal to this day. It was dominated by the sense of the passing sadness of things, the transience of life as reflected in the seasons, which in Japanese is called *aware*. It could be claimed to be the dominant mode of Japanese culture. The great literary classics of the courtly classes, especially *Ise Monogatari* ('Tales of Ise', tenth century), *Genji Monogatari* ('The Tale of Genji', c. 1000) and the great poetic anthologies (notably the thirteenth-century 'One Hundred Poets' Anthology') became eventually known by all educated Japanese, and they were and still are constantly illustrated or referred to in art and decoration. These classics were written mainly in the native syllabary called *hiragana*, which became the distinctive Japanese calligraphic style. It could be called feminine in character, and indeed many of the great figures of courtly literature were women. The Kyoto courtly ideals were constantly revived or copied by other classes, notably by rich merchants in the whole period from the mid-fifteenth to the mid-nineteenth centuries.

From the early twelfth century onwards another major change of consciousness took place, spurred by reaction against the courtly and priestly dominance. The samurai class of warriors, who originated in the provinces, became the real rulers of the country, and their internal struggles for power over the increasingly helpless emperors placed Japan on a military footing which was to last substantially until 1945. With the appointment of Yoritomo as the first Shogun (Generalissimo) in 1192, it became accepted that Japan was in effect ruled by its top soldier, and all his military retainers (samurai) thus became the dominant class. The prestige of the military arts and their later derivatives dates from this period. The greatest swords, made in the thirteenth century, set a standard for the future.

The vigour of earlier samurai culture was reflected in the rise of much more accessible forms of Buddhism, especially the popular 'Pure Land' sects and the inherently nationalistic Nichiren movement. The number of temples increased considerably. All this resulted in a more humane and direct attitude to art – Japan's first naturalistic portraits date from this era – but above all it saw the flowering of the pictorial narrative handscroll, which has remained one of the glories of Japanese painting. The subjects of these often extended works included narratives of warfare, the histories of temples or of great Buddhist saints and founders, and the courtly romances of the Heian period.

The period from approximately 1300 to 1550 continued to be marked by internal samurai warfare, but it saw also the emergence and eventual cultural dominance of Zen Buddhism. Although Zen was Chinese in origin, it was adopted in Japan with great enthusiasm among the educated classes and especially the samurai. By the late fourteenth century it had been embraced by the shoguns of the Ashikaga family, and its cultural activities had come almost to replace the more traditional artistic styles of the court. The importance of Zen's contribution to subsequent Japanese life cannot be exaggerated: under its auspices and using its inspiration there came to maturity the Tea Ceremony and all its arts (pp. 116–18); ink-painting and character-calligraphy in the Chinese style; flower arrangement (ikebana); the Incense Ceremony (kōdō); the Nō drama. All of these remain important traditional activities in modern Japan. The austere gravel and rock garden, now considered quintessentially Japanese, is also of Zen origin. To the concept of elegant aware were added the aesthetic ideals of wabi (austerity) and sabi ('rust', the effect of natural age) which through the Tea Ceremony have permeated the whole of Japanese thinking. The modern concept of shibui (astringent taste) is a descendant of these ideals.

Another far-reaching effect was the style of architecture called shoin-zukuri, originating in the late fifteenth century in the private apartments of Zen temples. It was a further Japanisation of the Shinden style, austere, simple, elegant and flexible. Floors were now entirely covered with the woven tatami mats, which are universally pale green when new and age to a buff colour. This became perhaps the dominant colour of Japanese culture, a natural and implied background to arts and artefacts alike, and a potent unifying force. Shoin-zukuri also introduced the tokonoma (or display alcove, see p. 118) and thereafter made the hanging scroll the received, classic format for painting and calligraphy. This was to have lasting effects on pictorial composition. Shōji (paper-covered sliding wall-sections) were also introduced, and when painted (fusuma-e) became one of Japan's most splendid art-forms. Sets of fusuma-e (for example, no. 46), especially with gold backgrounds, were used in the castles which sprang up in the second half of the sixteenth century as a response to the advent of firearms; together with folding screens they became the vehicle for the dazzling school of Momoyama screen painting, the glories of which continued to be revived by various schools well into the twentieth century.

In all of these periods, and indeed until 1868, power lay in the hands of self-appointed ruling élites. But from the second half of the fifteenth century a quite different sort of power began to develop and has continued to grow up to its present almost total dominance – the power of commerce. In Kyoto, Osaka and Sakai the increase in foreign trade, and the needs of the shoguns and other warlords for finance and stability of supplies during their apparently endless wars, led to the rapid growth of a financially skilled merchant class. People of this class soon became patrons of the arts, especially of the Tea Ceremony, and their dislike of their samurai masters inclined them to support the court aristocracy and to imitate its cultural activities. This alliance led to the great school of painting and decoration begun by Sōtatsu (p. 52) and carried on by the Rimpa school (p. 180). Rimpa in turn became probably the most important element in the twentieth-century native painting style called Nihonga (see p. 181).

This merchant culture was confident, optimistic and

open-minded, sucking up the many influences from abroad which poured in during the period from *c*. 1450 up to the policy of Isolation in 1639. They included new waves of Chinese arts, especialy painting, porcelain, textiles and lacquer; textiles from India and South-East Asia; pictorial styles and new shapes of vessels from the Europeans, who first arrived in 1543; and the arts of Korea. Immigrants and prisoners from Korea revitalised Japan's pottery styles in Kyūshū and western Japan and made the first porcelain there. The porcelain industry, until *c*. 1600 almost non-existent, gradually grew until by the nineteenth century it was habitually used by most urban Japanese; it became and remains a major export to the West. The expansive Momoyama way of life, worldly, fashion-conscious and relatively free, endured as an ideal, even after the Isolation began, of exciting hedonism and brilliantly powerful design. The simple and practical kimono, which reached virtually its present form in the late sixteenth century, became the most versatile vehicle for innovative design, a position it has held ever since.

When the Tokugawa family moved their government headquarters to Edo (modern Tokyo) in the early seventeenth century, it rapidly grew to be Japan's largest city, dominated as no other, in spite of their political powerlessness, by the merchant classes. The stage was set for the rise of big-city bourgeois culture here and in Osaka, and to some extent in Kyoto and Nagoya, and when the government imposed its policy of *sakoku* (isolation from the rest of the world), it in fact only hastened the growth of this new way of life based on money and entertainment. The period of Isolation (1639–1853) saw the explosive development of specifically city phenomena – the popular Kabuki theatre and the Bunraku puppet theatre, the reign of the great courtesans in their palace-like houses, the Ukiyo-e art movement and especially the popular woodblock print, sumo wrestling, the racy novels of Ihara Saikaku (1642–93), and the design of fashionable textiles and personal accoutrements such as *inrō* and netsuke (p. 148). To the concepts of *aware*, *wabi* and *sabi* were added the very urban *iki* (stylishness) and *sui* (chic). Drawing on the existing traditions of the past, bourgeois culture flourished in isolation until it had run out of inspiration.

The ending of Isolation led by 1868 to the fall of the shogunal style of government, the restoration of constitutional power to the emperors, who now moved to Edo (renamed Tokyo), a civilian administration and a flood of Western influence. Before that, however, the merchants and traders of Japan were using their expertise to move into world markets, and the skills of the Edo period in ceramics, lacquer, carving and metalwork, in particular, were being adapted to Western taste. The later nineteenth century is in some respects the high point of Japanese craftsmanship but a period of very confused taste (no. 152). Japan's new-found role as a producing and trading nation has continued ever since, interrupted only by the generation of the Pacific War, its preambles and immediate after-effects.

The internal culture of the Imperialist era (1868–1945) was once more one of intense learning and absorption. In the fine arts old styles and methods seemed by the late 1870s to be in danger of extinction, as students rushed to learn Western painting and sculpture from invited European teachers. But by 1880 it had been realised that Japanese culture was in real peril, and the rate of change began to be more controlled. One typical movement was Nihonga, a school of painting designed to combine various native styles into a unity which would have the strength to survive against Yōga ('Western painting'). This was so successful that the period 1900–40 can now be seen as a great age of native-style painting. The processes by which graphic art absorbed and benefited from Western influences are described in Chapter 12. A further stabilising force on cultural change (though not ultimately to Japan's benefit) was the Shintō nationalism which led to militarism but encouraged the survival of native cultural attitudes. Possibly the most important force, and indeed one which gave a new and revived sense of artistic identity, was the *mingei* ('folk crafts') movement, first formally identified in 1926 by Yanagi Sōetsu.

Mingei had particularly far-reaching effects in paper-making, ceramics, lacquer, textiles and graphic art. Since 1945 it is possible to see that studio craftsmen and artists preserving old skills and styles have become the carriers of Japanese artistic tradition, yet in some sense standing aloof from the political, commercial and social developments of which they often disapprove. For Japan since the end of the Occupation in 1952 has become for the first time in its history a truly international country, and for the first time its own native cultural forms are being studied, appreciated and cultivated throughout the world. It is difficult to guess what will develop next from this unprecedented state of affairs.

JAPAN BEFORE BUDDHISM

(nos 1–19)

The long period before historical records begin seems at first to have little in common with what followed, but it must be recognised that many important aspects of Japanese culture were fixed before the advent of Buddhism in the sixth century. They include the Shintō religion, a whole set of folk beliefs and practices, a natural building style in wood, inherent skill in pottery, a very individual preference for eating the products of the sea, the rivers and the mountains, and a preoccupation with masks.

Recent archeological studies have shown the possible existence in Japan of a stone culture at about the same time as the Upper Paleolithic of Europe. Although opinions differ over an early chronology, reliable dating has been possible with material excavated at the sites of some later settlements. From one such site, a cave-dwelling at Fukui near Nagasaki, fragments of what is believed to be the oldest pottery in the world yet identified were discovered. Levels in the cave showed consecutive occupation by a paleolithic followed by a microlithic culture, then microliths together with pottery fragments, and finally pottery with polished stone implements. The pottery was shown by carbon dating to date to *c.* 10,000 BC. It was evidently an early example of the 'Jōmon' ware known since its excavation at a site known as the Ōmori Shell Mound near Tokyo in 1877 by the American, Edward S. Morse.

Jōmon period

Morse named the pottery Jōmon, meaning 'cord pattern', after the characteristic patterns on its surface made by the impression of twisted cord. The Jōmon culture persisted throughout most of Japan from *c.* 10,000 BC to just a few centuries BC, and was for most of that long period an economy of hunters, fishers and gatherers with little settled agriculture and people living in small groups.

Their larger social organisation is a matter for speculation, but the ever-increasing elaboration and skill of their pottery suggest cultural stability and continuity. The pottery remains are found together with chipped stone arrowheads and other tools including skinners and stones for opening nuts and shellfish (no. 12).

The types of Jōmon pottery are all unglazed low-fired wares which fall into six main chronological divisions ranging from an Incipient Jōmon, through Initial, Early, Middle and Late, to a Neo-Jōmon. The Incipient phase describes the very earliest pottery thought to date from *c.* 10,000 BC until the emergence of the first pottery with cord patterns *c.* 7500 BC (the Initial phase). However, even approximate dates for these and the following four phases cannot be set, since there is much regional variation in types of pottery and a wealth of data yet to be analysed. Incipient Jōmon pots were deep, first with flat bottoms and later conical in a shape convenient for setting in the earth. The pots were formed from coils of clay pressed on each other and then smoothed into a continuous surface. The earliest decoration was made with fingernail marks, and the true cord pattern marks the transition from the Incipient into the Initial phase. These surface patterns on the pottery were made with twisted cords wrapped round sticks; shells were also impressed into the clay for decoration. The rims of the pots tend to have four large peaks, which remained a common feature of much Jōmon ware in later periods.

'Early' period ware shows increased variation in pot type and the use of well-polished stone tools. Excavated bone needles and thimbles prove the existence of textiles, possibly made of mulberry bark which abounded in mountain valleys.

The Middle period, which first emerged in the mountain region of central Japan, saw an even greater variety of shapes of pot, culminating in the most extraordinary highly ornamented jars with raised, pierced and convoluted rims and vigorous patterns in high relief on the sides. These are impractical ceramics of great presence and must have had religious or ceremonial significance. This is further suggested by later Middle-period pieces decorated with human masks set in roundels. The Japanese fondness for masks (see pp. 147–8) seems to have run continuously from that time at least. Excavations of the typical square Jōmon pit houses of this period have also produced female pottery figurines and stone phalli buried by the walls, indicating a communal religious awareness of fertility.

The Late Jōmon (*c.* 2500–1000 BC) saw much migration from the higher regions to the coast due to cooling climatic conditions. Spouted vessels with incised decoration make their appearance, together with simple pots charmingly covered with incised zones separated by raised bands (no. 1). Huge mounds of discarded sea shells found next to Jōmon settlements, like the Omori Shell Mound described by Morse, attest to the principal diet of the Late Jōmon. Bones of animals hunted for food and sea creatures were put to use to make implements and ornaments. Bones made needles, harpoons and fish-hooks, and shells were cut and ground to make bracelets and earrings, or pierced with holes for eyes and nose to make ritual masks.

The Final Jōmon (*c.* 1000–300 BC) saw the beginnings of an as yet rather undeveloped agriculture. New varieties of pottery found include shallow bowls of great practicality and larger ritual figurines.

Increasing contact between Japan and the continent in this period culminated in import skills and perhaps an actual immigration which transformed Jōmon society *c.* 300 BC into a very different type. Nevertheless, Jōmon culture did not die out entirely, for the typical pottery continued to be made well into historic times in the northern island of Hokkaidō. Philipp Franz von Seibold, a German national who obtained a post at the Dutch trading station in Nagasaki in 1823, acquired pieces of this Neo-Jōmon pottery and brought it to Europe. He understood it to be pottery of the Ainu people, a very few of whose descendants inhabit Hokkaidō today and who were originally spread over Japan (no. 2).

Yayoi period

Among the technological innovations imported from the continent *c.* 300 BC was an improved pottery technique, the metallurgy of bronze and iron, and, most important of all, the cultivation of millet and rice in paddy fields. The new era is known as Yayoi from the name of the site near Tokyo where its characteristic pottery was first discovered. Stable farming communities gradually replaced the hunters and foragers, and these formed the basis of the agricultural system which still exists.

Yayoi pottery is made of the same coarse clay as Jōmon and is also often decorated with incised lines and cord patterns. But there are important differences: whereas Jōmon pots are generally deep and narrow reflecting their principal use for boiling, Yayoi pots are of many different shapes indicating a wider range of uses in the

agricultural community, such as storage of grain, and are consequently simpler in design (no. 4).

The pottery is higher-fired than Jōmon ware and is built up with rolls of clay, the sides finished smooth by cutting and burnishing. Decoration on the pots is simpler, consisting of straight, curved and zigzagged incised lines, and also wave patterns produced with a comb (no. 3). The use of polished stone tools continued, and various ritual and ornamental stone objects were made to very high technical standards.

Iron and bronze were introduced during this era. Iron was quickly recognised as the better material for tools and weapons, but bronze appears to have been used solely for ritual objects. Thus there was never a Bronze Age in Japan in the usually accepted sense. The ritual bronzes are, however, the most striking surviving artefacts of the period and include mirrors, daggers, spears and halberds (no. 16) copied from Chinese originals, and tall, straight-walled bells which are called *dōtaku*.

The origin of the *dōtaku* is thought to have been in the Chinese cattle-bell, but as there was in Japan no concept of cattle farming they must have been imported and then developed as solely ritual objects. They are found buried in isolated positions, often on hillsides. Evidence that they may have been repeatedly unearthed and reburied suggests their use in agricultural ritual. The *dōtaku* were cast in moulds built up from pieces of stone, carved with the patterns found on the finished castings, some of which have been excavated. The earliest *dōtaku* have robust suspension rings on top and clappers, but the suspension rings gradually became larger and wholly decorative. They must have been singularly ineffective as bells and produced only a muffled tone. Initially small and decorated with bands of whorls, triangles and hatching, similar to those found on contemporary Chinese mirrors, in the later Yayoi period the *dōtaku* increased in size and are often decorated with scenes of animals or humans engaged in hunting and agriculture (no. 15).

Bronze mirrors were directly copied from Chinese originals and were, as in China, symbols of authority. They have been found buried both in graves and also together with *dōtaku*. Designs on later mirrors and *dōtaku* show rice warehouses on stilts in a form which became standard architecture for Shintō shrines. This fusion of ancient animistic practices with rituals to promote the now-vital rice crop seems to have produced the earliest identifiable form of the Shintō religion. Chinese sources describe a Japan during the first centuries AD consisting of many separate kingdoms. They tell that in AD 57 an envoy from the Japanese kingdom of Na to the Chinese capital Loyang was entrusted with a gold seal confirming the recognition of the King of Na by the Han Emperor. This seal was accidently discovered in a field in 1784. Later sources describe the activities of a Queen Himiko of the state of Yamatai, who tried to enlist the aid of China against another Japanese state in the third century. Yamatai has been tentatively identified with the powerful state of Yamato which was firmly established in central Japan in the fourth century and whose rulers were the ancestors of the present Imperial family.

Kofun period

By the late fourth century the Yamato state had moved far towards a dominance over a federation of the other Japanese kingdoms, and their rulers are now clearly identifiable as the ancestors of the Imperial line. There are conflicting views concerning the historical facts of Yamato's relations with the Korean kingdoms at this time; some historians suggest Japanese invasion of parts of Korea, some invasion of Japan by a Korean military class. Whatever the truth, there can be no doubt of very close links between the two countries, resulting in a similarity of culture, and especially in the use of mounted warriors in armour who enabled the unification of Japan under the dominant state to progress more quickly.

The power of the ruling class during this period can be well envisaged from the size and splendour of the tombs of their rulers, the huge mounds, or *kofun*, which gave their name to the Kofun period. They vary from about ten metres across to some hundreds of metres in length, developing over time from simple round mounds to 'keyhole'-shaped, with a central square or round burial chamber, a projecting oblong approach corridor and huge moats. The most impressive of these, and the largest earthwork tomb known to man, is that of the Emperor Nintoku, whose keyhole-shaped *kofun* is 486 metres long, set in a moat with a circumference of four kilometres.

The first plain round tombs were built on high ground with entry for the wooden coffin from above. A stone roof and earth covering completed the grave. The mound might be marked by a number of low-fired pottery cylinders or representations of animals, objects or people set into the ground in protective circles or groups. These

are called *haniwa*, and are thought to reflect the ancient Chinese practice of burying servants and goods with a dead ruler (no.6).

Many of the later keyhole tombs are those of past Yamato rulers, including ancestors of the present Imperial line, and may never be investigated. But the many other tombs which have been excavated show a wealth of funerary goods, including iron weapons, armour, gilt horse accoutrements, gilt shoes, crowns, jewellery, bronze mirrors and quantities of pottery. Much of this material is very close to Korean material of the same period, and some was possibly brought from Korea. Since there was so much cultural exchange with Korea during this period, it is not hard to imagine that some of the craftsmen came from the continent, and even that some of the occupants of the tombs were Korean immigrants closely related to the Japanese nobility (no. 10).

The Kofun period saw much technological advance, particularly in furnaces and kilns. Robust, straight steel swords were made using heat treatment to harden them. The mercury amalgam method was used to gild copper plate used on horse trappings and ritual accoutrements. A new kind of pottery using fine grey clay was fired at higher temperatures (over 1,000 degrees C) in ground kilns. This pottery, turned on the wheel towards the end of its historic development, is called Sue ware. Due to the high temperature, some Sue ware has an ash glaze resulting from the glassification of material from the kiln walls. Ritual pedestalled vessels, *tazze*, covered containers, bottles, vases and dishes were made specially for funerary use. Some of the finest are decorated with moulded figures of animals and people. These wares are extremely close to contemporary Korean Silla pottery (nos 7, 9, 10, 11).

Kofun burial became more widespread during the sixth century suggesting the increasing affluence and stability of the nation. Many smaller mounds of this period contained just sufficient goods for the use of the occupant in the afterlife. They usually contain a sword, bronze mirror and a jewel, all objects of powerful ritual significance and symbols of authority. To this day the three together make up the official Imperial regalia.

In addition to Sue ware the later tombs often contained a soft red practical domestic pottery known as Haji ware. This Haji ware continued in ordinary use from the Kofun period into the Heian period. Haji kilns and cooking vessels similar to those excavated from the tombs have been found also in excavations at the sites of a number of dwelling-houses (no. 5).

Much of the British Museum's collection of Kofun material came from the British metallurgist Professor William Gowland, who during his stay in Japan between 1872 and 1889 investigated 406 tombs and surveyed 140. Gowland collected material from many sites which had been burgled in earlier times and which were almost bereft of goods save for the occasional sherd or other trifle. He records, for example, on carefully cleaning out an exposed stone sarcophagus which had been filled with rubble '. . . a small glass bead, and a quantity of vermilion'. However, he obtained significant material from two important tombs – the one he called the Shiba, or Shibayama dolmen, on the east slope of the Ikoma Mountain south of Osaka, and that at Rokuya, Tamba Province. The Rokuya dolmen yielded two splendid gilt horse-bits, fragments of other horse-trappings, an iron sword, beads and pottery (nos 17, 18).

The Shibayama dolmen was closed by a wall of stone one and half metres thick, and Gowland was the first to enter it since it was sealed in the sixth century. From among the remains of a pine-wood coffin he recovered personal ornaments of metal and beads of glass and jasper. The tomb also yielded a sword, another in fragments, a dagger, iron arrowheads, horse-trappings and a large number of beads. There were spherical beads of blue glass and stone, tubular ones of green stone which had once been strung together with the comma-shaped *magatama* stone jewels on a necklace, and three *magatama* made of chalcedony, rock-crystal and steatite. Sixteen fine specimens of Sue ware in the tomb included one of the largest found. Other even more accomplished examples of stone polishing and carving are found in Kofun tombs (no. 14).

Since there are no contemporary Japanese written documents of the Kofun period, the contents of the tombs are by far our greatest clues to the Japanese culture of that time, which can be seen to have been of complexity and high technical skill. It was, however, a pre-literate culture, and it was the introduction of writing with all the other trappings of the higher civilisation of East Asia, introduced with Buddhism from the mid-sixth century, that ended the Kofun period, and brought Japan into the light of known history.

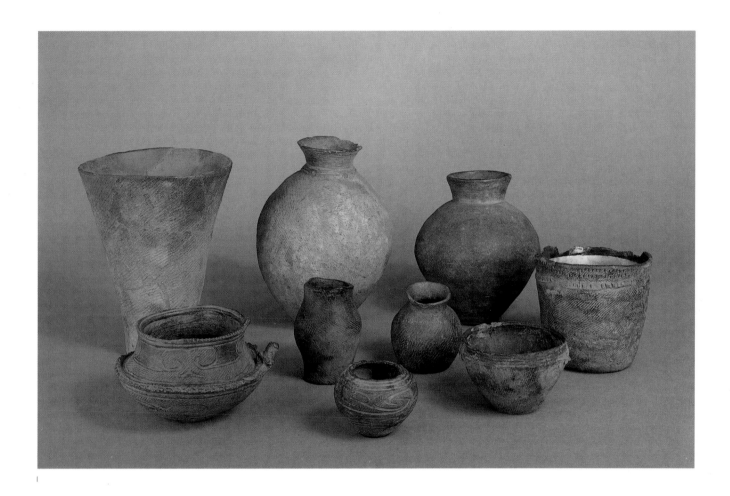

1

1 Jōmon pottery

Late–Middle and Late periods
Low-fired pottery; max. H. 26.8 cm; min H. 7.5 cm
OA + 20, 632, 633, 654, 668, 670, 775, 1929.4-13.1,
 1956.7-16.1

OA + 632, 654, 668 and 775 are from the
Japanese collection made by Philipp Franz
von Siebold during his stay in Nagasaki
(1823–9). The interior of OA + 20, a Middle
Jōmon piece, has been lacquered, probably
in the early nineteenth century by a
connoisseur of antiquities.

2 Neo-Jōmon pottery

Neo-Jōmon period; Otaru, Hokkaidō
Low-fired pottery; max. H. 24.4 cm
Provenance: Dr J. Anderson Collection
OA + 639, 653, 681

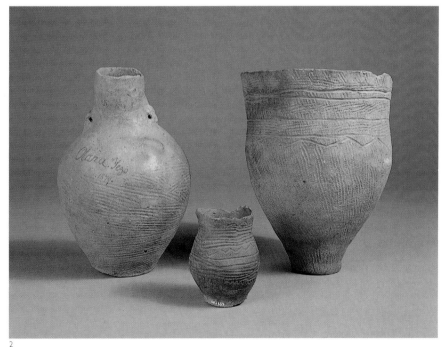

2

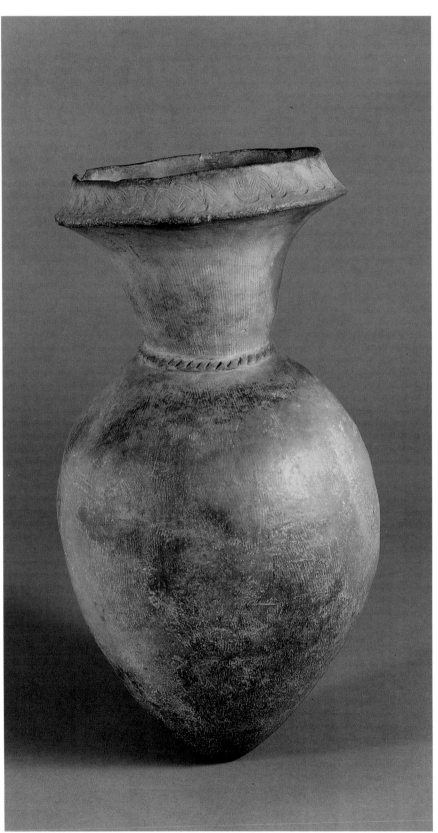

3

3 Trumpet-necked storage jar

Yayoi period
Red pottery; H. 44 cm
Provenance: William Gowland Collection
F2238

The jar is decorated with a cord-pattern
relief moulding at the join of the neck and
combed wave patterns around the outside
of the neck.

4 Two Yayoi vessels

Red pottery

a) Late Yayoi period
H. 19.0 cm
F2200

b) Middle Yayoi period
H. 12.3 cm
1961.2-15.4. Given by Professor S. Umehara

5 Group of Haji pottery

Late Kofun period
Low-fired red pottery; max. H. 15.1 cm;
 min H. 8.8 cm
F2201, 2203, 2203a, 2203b, 2204, 2205

Nos F2204 and 2205 bear ink inscriptions
reading 'Yamato Abe Monjuin', probably
indicating a findspot in Yamato Province.
The remaining pieces are from a tomb near
Yasui in Izumo Province.
 These vessels are all connected with food
and drink and must have ritual significance
as tomb goods. The vessel on the far right is
possibly a rice steamer.

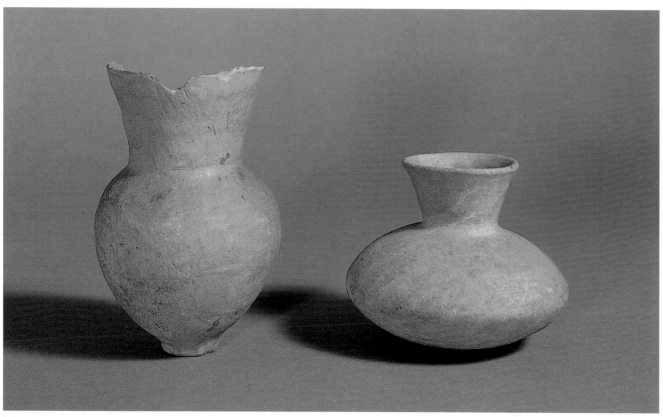

4a, b

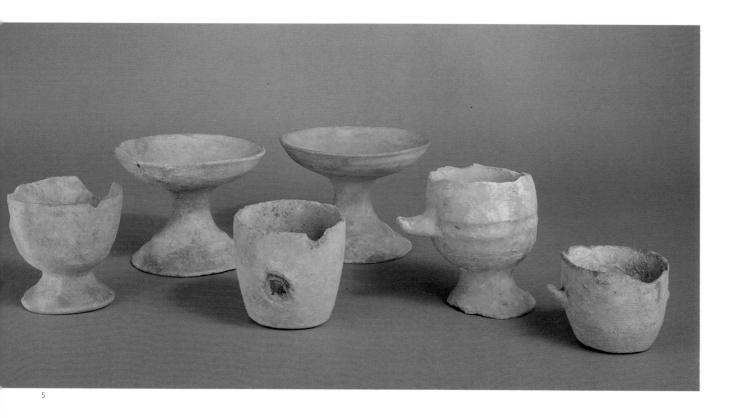

5

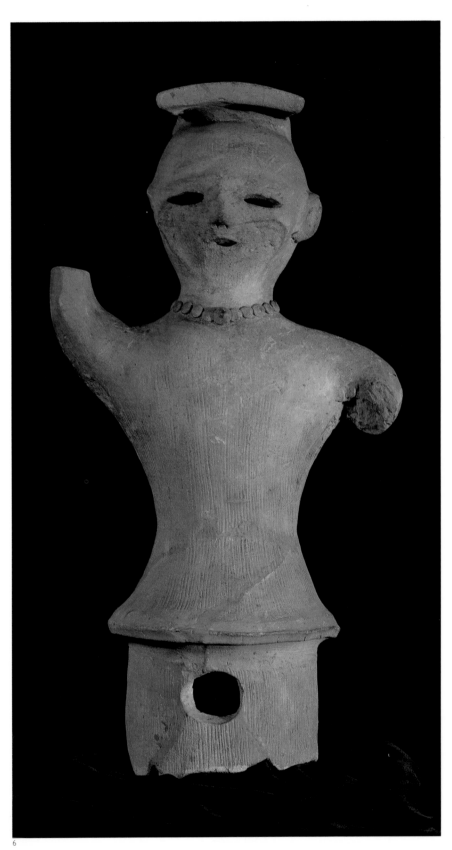

6

6 *Haniwa*

Kofun period, 6th century
Low-fired red pottery; H. 55 cm
Provenance: William Gowland Collection
F2210. Given by Sir A. W. Franks

The figure has her hair tied up into an
elaborate coiffure and wears a necklace of
beads. The object was excavated in the
neighbourhood of the village of Motomachi
near the port town of Konjō in Musashi
Province.

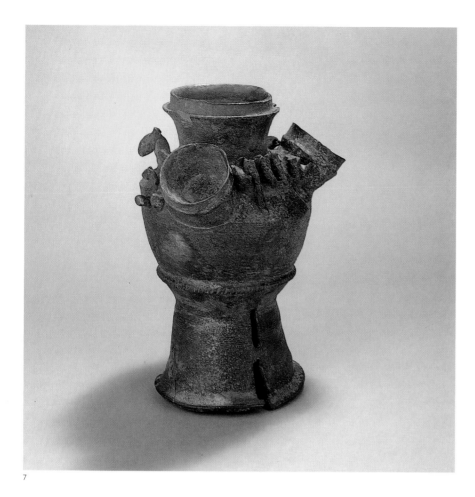

7

7 Sue jar

Kofun period, 6th century
High-fired pottery with ash glaze; H. 33 cm
F2227

The jar has several traditional features of
Sue tomb wares. The base is pierced like a
ceremonial stand, and additional vessels
have been fused to the sides; most notably
simple models of boatmen and animals have
been attached to the shoulder.

8 Sue coffin

Kofun period
High-fired pottery; L. 145 cm
F2212

The coffin is supported on eighteen short
cylindrical feet. There is a circular aperture
at each end of the lid, once fitted with a
stopper, and six small holes pierced on each
side. This is an extraordinary example of the
technical capabilities of Sue pottery. It was
excavated from a stone chambered dolmen
by William Gowland in 1884 at Sakuraidani,
about ten kilometres south of Osaka.

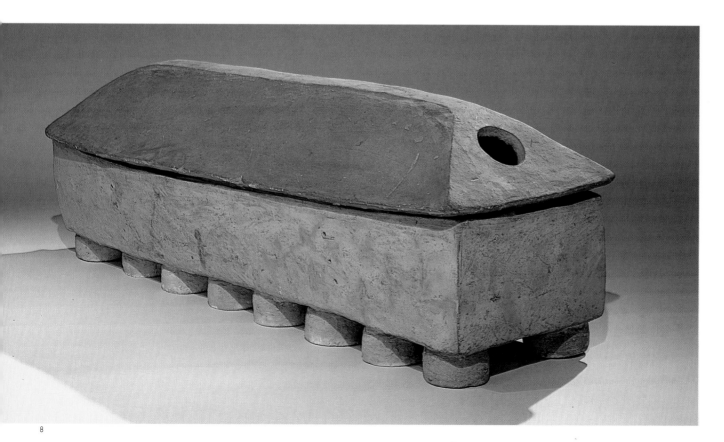

8

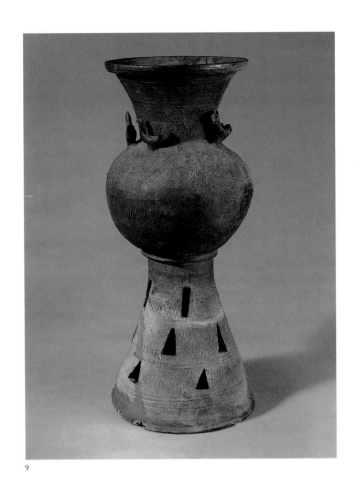

9

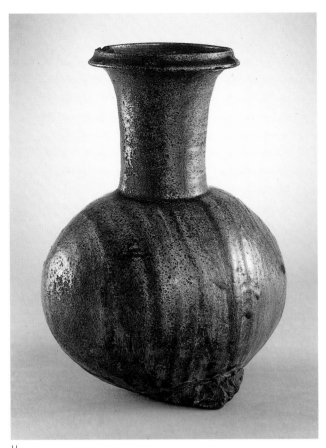

11

10

9 Sue funerary jar

Kofun period, 6th century
High-fired pottery with ash glaze; H. 52.5 cm
F2228

Models of birds, deer and a dog or boar
have been applied around the shoulder. The
whole piece is covered with a cord pattern
and incised bands. The enormously high
stand is pierced in a style which became
traditional and is attached to the jar itself.
The jar was excavated at Kotani village in
Kōzuke Province.

10 Group of Sue ware

High-fired pottery, mostly with ash glaze;
 max. H. 52.6 cm; min H. 6.6 cm
F2213a, 2213d, 2213e, 2214, 2219, 2219a, 2222,
 2224g, 2225, 2226, 2231, 2234b, 2242, 2248,
 2267a, OA + 665

These pieces have been photographed
together to show the impressive range of
Sue tomb pottery in both shape and
decoration. They were all excavated by
pioneer Western archaeologists and come
from a wide range of sites in central Honshū
and Shikoku.

11 Long-necked Sue jar

Kofun period, 7th century
High-fired pottery with applied ash glaze;
 H. 25.5 cm
Published: Tokyo National Museum 1987, no. 50
Provenance: Acquired by William Gowland from
 the late 19th-century Japanese pottery
 specialist Noritani Ninagawa
F2268

This vessel shows potter's wheel marks on
the base. The lump on the base is fused
material from the floor of the kiln.

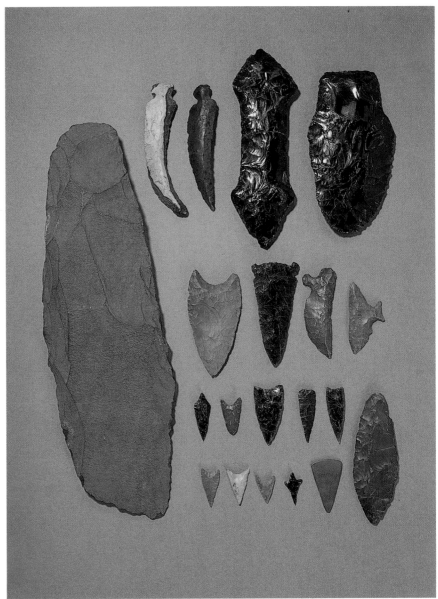

9

12

12 Group of arrowheads and cutting tools

Late Jōmon period
Flint, stone and obsidian; max. L. 29.8 cm
OA + 1149, 1150, 1151, 1152, 1153, 1155, 1157, 1159,
 1169, 1170, 1171, 1172, 1175, 1176, 1181, 1185,
 1186, 1187, 1193, 1946.10-14.1

The range of implements from sites in
Hokkaidō in this illustration shows the
transition from an ancient flint-knapping
tradition to a much more sophisticated
stone-cutting and -polishing technique
inspired by continental models.

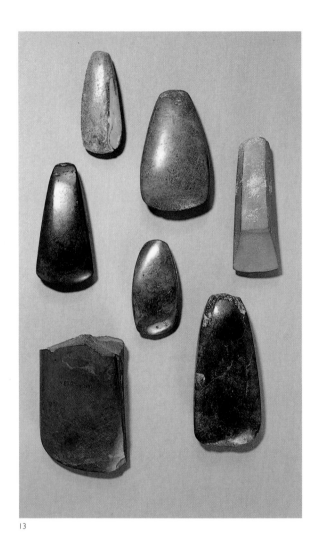

13

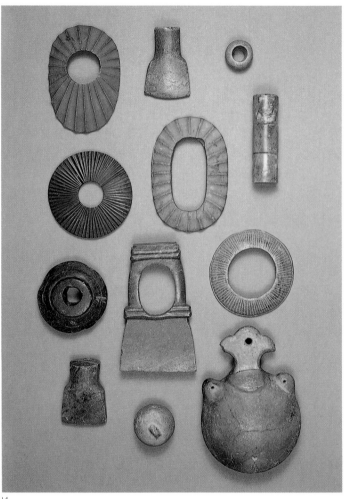

14

13 Group of ritual axe-heads and chisels

Yayoi and Neo-Jōmon periods
Carved and polished stone; max. L. 13 cm
OA + 1188, 1191, 1192, 1195, 1196, 1198, 2597

These pieces are all from the Gowland
Collection except OA + 1198; OA + 1191, 1196
and 1198 are from Hokkaidō, and OA + 1192
is from Iwami Province. The considerable
skills of this period in stone cutting and
polishing are well demonstrated in the
elegant shapes and fine finishes of these
implements.

14 Ritual objects

Kofun period
Carved and polished stone, pottery;
 max. L. 14.1 cm
OA + 1204, 1205, 1211, 1217, 1220, 1222, 2686, 2687,
 1928.10-6.39, 1947.7-28.8, 9, 10

This illustration demonstrates the high level
of technical skill achieved in stone work in
the Kofun period, mostly for objects to be
placed in tombs. They include bracelets and
rings, cutting tools and a ritual 'hoe'. At
bottom right are a pottery bell and a rattle of
similar technical finesse.

15 Two *dōtaku*

a) Middle Yayoi period
H. 59.7 cm
Published: Tokyo National Museum 1987, no. 26
1897.11-21.11. Given by Sir A. W. Franks

In the publication *Dōtaku Kozu* (1822) it is
recorded that this piece was discovered in
Wakayama Prefecture. At that time it was in
the collection of Kishi Seiichi.

b) Yayoi period
H. 1.1015 m
Provenance: William Gowland Collection
OA + 535. Given by Sir A. W. Franks

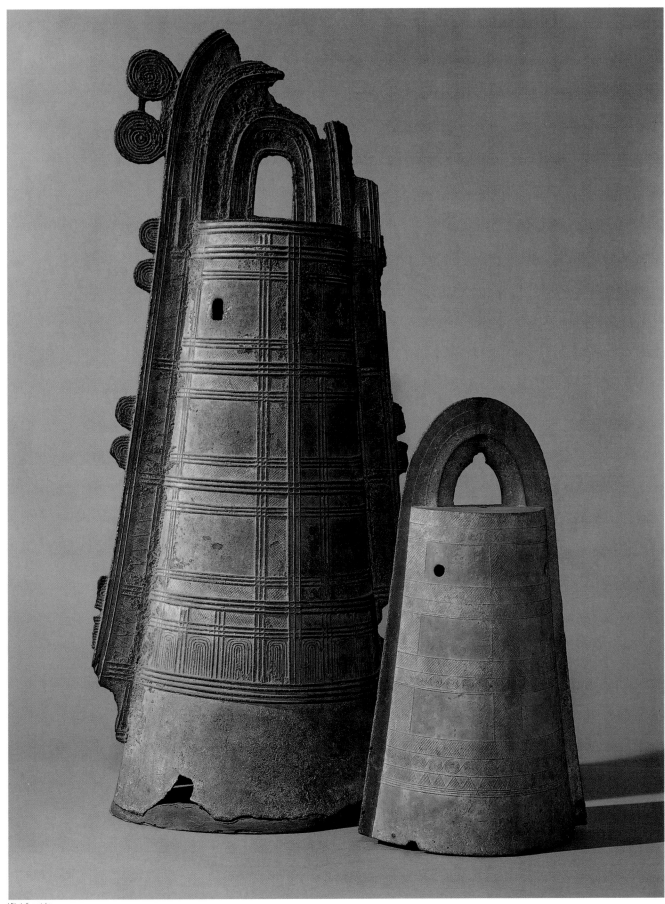

15b *left; a right*

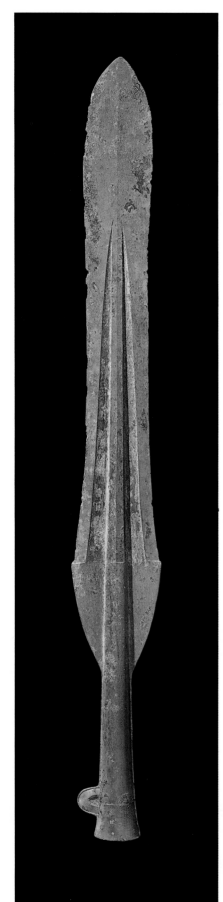

16

17

16 Ritual spear blade (*dōhoko*)

Yayoi period
Bronze; L. 80.6 cm
Published: Tokyo National Museum 1987, no. 27
1965.2-23.3. Given by Professor S. Umehara

The spear blade is said to have been
excavated at Okamoto-chō, Kasuga City,
modern Fukuoka Prefecture.

17 Decorative horse-trappings

Late Kofun period, 6th century
Gilt copper or gilt copper over iron;
 max. L. 21.3 cm
OA + 1250, 1251, 1253, 1254, 3007, 3013, 3014, 3031,
 3032

The origins of the skill of the Japanese in
decorative metalwork, so noticeable in the
sword-fittings of later periods, go back to
work of this sort from the Kofun period. It is
known from *haniwa* models that such pieces
were attached by leather or textile
strapping. OA + 1250 and 1253 were
excavated by William Gowland from
different tombs.

18 Two horse-bits

Late Kofun period
Forged iron with gilt-copper plate;
 (a) max. L. 19.9 cm; (b) max. DIAM. 10.0 cm
(a) OA + 1157; (b) OA + 1255

The heads of the iron rivets are dressed with
sheet-silver overlay. Both bits were
excavated by William Gowland from the
tomb at Rokuya in Tamba Province.

18a, b

19 Two mirrors in Chinese style

Bronze

a) Middle Kofun period, *c.* 5th century
DIAM. (excl. jingles) 12.9 cm
OA + 544

b) Kofun period, 6th century
DIAM. 21.1 cm
1965.2-23.2. Given by Professor S. Umehara

The very formalised patterns on
contemporary Chinese mirrors were at first
copied by the Japanese, but by the ninth
century a more naturalistic native style
developed. The Kofun period Japanese had
a strong taste for jingles and rattles, but this
too was to disappear very quickly.
 No. 19b was excavated from a tomb near
Miyachidake, Chikuzen Province.

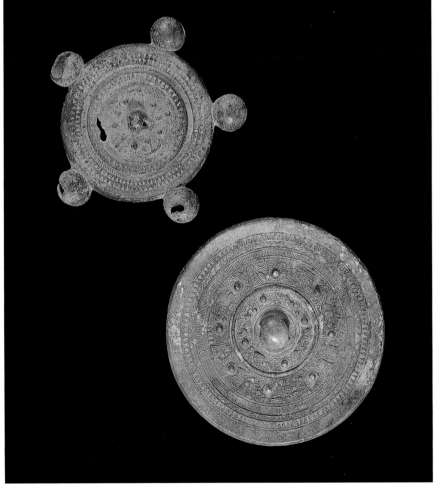

19a *top*; b *bottom*

27

2

THE ARTS OF BUDDHISM

(nos 20–40)

The arts of sculpture, painting, calligraphy and architecture (with all its attendant crafts) all developed steadily from the mid-sixth century onwards in the service of the Buddhist religion, and until the tenth century this was the dominant influence in all the arts. Until that time by far the main patronage of Buddhist institutions came from the Imperial family, so the courtly and the religious aesthetic tended to develop together. Buddhism remained the mainstream of Japanese sculpture until virtually the mid-nineteenth century, except for some smaller forms which flourished mainly in the Edo period (see Chapter 8). During the long Heian period, Buddhist painting separated from courtly painting into its own tradition, but in that era Buddhist art was produced for large numbers of temples over a wide geographical area and hence also survives from that period in greater quantity. A more limited production of sculpture and painting gradually grew up in the service of the Shintō religion, but its models were nearly all Buddhist since it had, until the advent of the foreign religion, no imagery of its own. Its pre-Buddhist architectural style remained distinctive but was influenced by Buddhist practice in the organisation and scale of buildings (no. 36).

The arts of Buddhism had frequent revivals of energy with the advent of new sects, but by the fifteenth century only Zen continued to produce new styles and ideas. After the fifteenth century Buddhist institutions certainly continued to generate arts and crafts on a large scale, but fervour had diminished, or rather moved to the individual believer and towards a more recognisably human scale and increasingly secular styles, often practised by independent artists and sculptors. Sometimes these had no apparent religious meaning at all, as in the seventeenth-century set of sliding doors from a Shintō shrine (no. 46) which adorned a priest's or guest's room.

The setting for these traditional arts was invariably the Buddhist temple or more rarely the Shintō shrine. Sculptures and paintings for contemplation, reverence, worship or instruction had to be clearly visible in dark interiors lit by dim lamps, and internal architectural features and religious equipment had similarly to make their presence felt. In sculpture a sense of mystery thus became both desirable and necessary. Images were normally on a dais, raised above the people, and hence were designed to look their best when seen and lit from below. This tradition continues even in small, late pieces such as no. 142. In the earliest periods (sixth to ninth centuries) there was some preference for bronzes without gilding and unpainted wooden images, which reflects an Asian continental tradition based on stone or bronze, but as more native tendencies developed, pigmented or gilt wood became the norm. Stone carving was never important in Japanese Buddhist sculpture, partly because of the lack of a suitable native material. Where it does exist, it is usually in remote shrines in wooded or mountainous areas, or in the form of somewhat folky wayside images, or as pairs of lion-dogs at the gateways to Shintō shrines. Stone carving was, nevertheless, an important tradition in the making of large lanterns for gardens or to place along temple steps or approaches.

The need to stand out in the gloom made bright colours and gold the dominant surface finishes from the time a true native style emerged in the tenth century, and this applies to both painting and sculpture. Wooden images would be covered in a white gesso, then lacquered, and finally painted or gilded. Early and long-revered pieces have almost always lost their original coatings, though they are sometimes regilded (no. 32). Where there are remains of the original coloration, they give little idea of the pristine brilliance of the piece. The canopy for hanging over an image (no. 25) is here perhaps the best-preserved example. It is also another type of object susceptible to the carver's art.

Hanging paintings, a traditional format derived from religious banners in India, were normally on silk. It was considered a richer and hence more suitable material, and had the advantage of being better able to hold thicker pigments and gold leaf. It could also be painted or gilded on the back to provide a richer ground for the colours, or be backed with coloured papers (no. 30). To match these splendid images silk and gold brocades became the normal mountings and these were extremely expensive; gilt-bronze roller-ends and corner-pieces engraved with symbolic motifs were also often added (no. 40). These all provided the required sense of splendour and made the painting more compelling in the subdued light.

These were variations on the silk-painting techniques of Tang China, using carbon-black for outline and water-based mineral pigments such as malachite, azurite and ground shell-white. In the very long term some of these pigments have in fact eaten away the silk altogether (no. 33), especially the copper-based greens. The method of filling in black outline with bright, clear colours is basically the same as that of the secular Yamato-e style (see p. 50). It should be noted that these rolled paintings would be brought out for particular occasions only, a practice which reflected Japanese secular preference, especially from the fifteenth century; but paintings on fixed wall panels or on plaster walls were quite commonly used from the seventh to the eleventh centuries. Only a few of these have survived in isolated temples, such as the Daigoji near Kyoto. Fires or damp have destroyed the rest.

Sculptural techniques, in the same way as painting, showed at first a strong desire for the solid and permanent-seeming images which spoke of continental tradition. The biggest of these was the great bronze Buddha of the Tōdaiji Temple (eighth century) which was over fifteen metres high. By the ninth century these were beginning to be replaced more and more by sculpture in wood, which finally became the normal material. Bronzes did continue to be made, however, mostly on a smaller scale.

Bronzes were made by the lost-wax process. The image was modelled in a wax coating over a rough core made of wood, clay or other expendable material, and a mould of clay formed over it. When the clay set hard, the wax was melted away leaving a space into which the molten bronze could be poured. The surface of the resulting hollow sculpture thus reproduced the fine detail of the original wax model on the outside, and the inside surface followed the shape of the core. The core itself was removed, although often pieces of it remained inside (these have proved valuable in dating sculptures by the carbon 14 or thermoluminescence methods). The surface of the bronze was usually gilded using the gold-mercury amalgam method, except sometimes in the earliest periods. Wooden images until the eleventh century were made by the *ichiboku zukuri* method, carving from single solid blocks of camphor, cypress or other woods. Sculpture in solid wood is liable to split with time, even

though the use of quadrant sections of the tree reduces this tendency, so the main body of the sculpture was often hollowed from the back to relieve any stresses which occurred because of ageing or environmental change.

During the eleventh century the refined *yosegi zukuri* method of constructing wooden images gradually replaced *ichiboku zukuri*, to become standard from the Kamakura period up to the mid-nineteenth century. Its perfection is attributed to the sculptor Jōchō in the mid-eleventh century. By this method the image was built up from many sections of carved wood glued together to form a hollow figure. The advantages were several: the overall weight was reduced; and the risks of splitting were eliminated. Since each piece was separate, different pieces of wood could be chosen to put together more complex shapes than before. It was also possible to mass-produce pieces in this way to supply the considerable demand throughout Japan. Another advantage was that damaged areas could be easily replaced. The school of the sculptor Unkei, who produced vigorous and naturalistic sculptures, and his contemporary Kaikei flourished during the early Kamakura period, exploiting this technique to its full, often in very large pieces such as the majestic Guardian Kings of the Hōryūji Temple gateway. A Kamakura period figure of the Buddha Amida (no. 23) has a naturally humane expression of gentle serenity appropriate to the Amidist concept of Buddha as saviour (see below) and a plasticity which is due to the *yosegi* method.

The figure of the Bodhisattva Kannon (no. 24) is in the complex *yosegi* technique of the Kamakura period. It has crystal eyes inserted from behind, and fine strips of gold leaf are applied to the surface in intricate patterns to represent brocaded garments, a method which was also used effectively on paintings of the period.

Sculpture (and painting) continued to be the preserve of workshops called *bussho* in the great urban temples, like Tōdaiji and Kōfukuji in Nara, which supplied as much of the demand as they could. Later provincial pieces are thus generally obvious from their comparative simplicity or out-of-date style.

A sense of restrained but rather remote splendour may be seen as the mainstream of Buddhist art in Japan all through its history up to the mid-nineteenth century, when it declined catastrophically as a result of the nationalist resurgence of Shintō. The sects which became

established in Japan in the seventh century were all in the Mahayana or 'Great Vehicle' tradition then prevailing in East Asia; these were already well supplied with a highly developed pantheon of deities to engage the faith of the people, in contrast to the earlier Hinayana ('Small Vehicle') branch of Buddhism which concentrated its imagery mainly on the life of the historical Buddha (Japanese Shaka), his death and entry into *nirvana* (no. 31), and his splendour when transformed into his true identity as the eternal Enlightened One. In Mahayana Shaka became just one of infinite numbers of Buddhas, past, present and future, who might send manifestations of themselves able to intervene in human existence (Bodhisattvas). They were attended by other guardian deities, such as the Shitennō ('Four Heavenly Kings') and groups of angel-like figures.

All of these were taken up in Japanese Buddhist art, displaying an elaborate iconography of other-worldly splendour. Because of their state of perfection, Buddhas are normally shown sitting or standing face-on to the viewer, with an aspect of detached peace. From the ninth century onwards they assumed a full, bland face which was remarkably similar to the ideal face of the aristocratic male of the Kyoto court. Bodhisattvas tended to look similar but were allowed greater benevolence, and sometimes with a sense of movement which contrasted with the stillness of a Buddha. For vigorous movement, however, artists had to rely on the attendant deities, some of them of apparent ferocity.

These alarming beings developed further with the esoteric or 'secret' sects of Tendai and Shingon from the ninth century onwards. The proliferation of images needed in esoteric worship continued to keep temple ateliers busy well into the Edo period. One of the most important forms was the *mandala* (Japanese *mandara*), an image of existence shown as emanating from a central Buddha or Buddhas, usually in the form of a highly detailed painting put together on a scheme strictly defined by either central or local traditions (no. 40). Contemplation of a *mandala* was a religious exercise intended to lead the adept to an understanding of the reality beyond the illusory world of perceived phenomena.

In the twelfth century simpler and more popular Buddhist doctrines spread rapidly through the country in the form of the Jōdo sect centred on the Buddha Amida, Lord of the Western Paradise, who admits every believer who calls on his name. His principal Bodhisattva is the

merciful Kannon, who in turn may appear as the monk Jizō. Images proliferated in large numbers to satisfy the rapid spread of this sect – carvings and paintings of Amida in his Paradise, Amida descending to receive the faithful (no. 32), and Kannon and Jizō in many different aspects. The atmosphere of benevolence is reflected in the sweetness of the facial types which, nevertheless, still conform to the aristocratic Japanese norm.

Clearly what was missing from Buddhist art (after an early burst of naturalism in the Nara period) was recognisable humanity, and this need came to be filled in the Kamakura period by the increased popularity of paintings and sculptures of the earthly life of the historical Buddha; of the life of the Japanese 'apostle' Shōtoku Taishi (nos 34, 38); of patriarch priests of various sects, such as Kōbō Daishi of the Shingon, or Jion Daishi of the Hossō (no. 35); and of the groups of *rakan* (disciples of the Buddha and other holy men) whose images were borrowed from contemporary Chinese painting (no. 37). In all of these a wider and more lively range of facial types was found, giving much more scope to the artist's imagination. This greater humanity was

also expressed in instructional or historical handscrolls (no. 38), some of which, like the *Ippen Shōnin e-den* ('The Life of the Priest Ippen', dated 1299), are among the greatest of the medieval period in this most Japanese of painting forms.

An entirely different attitude to Buddhist art was fostered by the contemplative Zen sect, introduced to Japan from China in the thirteenth century and reaching its zenith of influence in the Muromachi period under the patronage of the Ashikaga family shoguns. While the normal observances for the laity in Zen temples were not very different from those of other sects, the monks, priests or other adepts were encouraged to seek for the truth in themselves, not only through meditation but also through the practice of various arts, including the Tea Ceremony (pp. 116–18), flower arrangement, garden design, calligraphy in brush and ink, and ink-painting. The last encompassed landscape, illustrations of Zen *kōan* (riddles or paradoxes) and studies of favourite figures, including the founder of the sect, Daruma (no. 39). The mixture of humour and profundity in these startling images is at the heart of Zen experience.

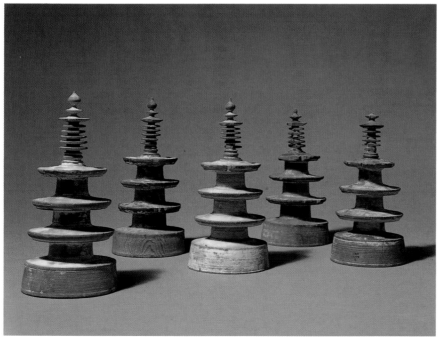

20

20 Group of *stūpas* known as the Hyakuman Tō

AD 764 or soon after
Turned wood; max. H. 21.5 cm
Published: Zwalf 1985, no. 390 (1930.4-24.1)
1892.12-12.1; 1909.5-19.4, 5, 6; 1930. 4-24. 1.
 Given by the Hon. Mrs Walter Levy;
 1931.2-17.1. Given by Sir Percival David, Bt

The Empress Shōtoku had a million wooden *stūpas* made to contain prayers of thanksgiving in gratitude for a victory over dissidents in the Emi rebellion of AD 764. The prayer strips were printed with wood and copper plates, and are the earliest printed matter surviving from Japan. 100,000 of the *stūpas* were given to each of the ten great monasteries in the Kansai region.

21 Kichijōten
('The Female Deity of Fortune')

Heian period, 11th century
Wood; H. 1.19 m
Published: Zwalf 1985, no. 356
1965.4-15.1. Brooke Sewell Bequest

Associated with harvest, fertility and
fortune, Kichijōten is one of the female
deities derived from Laksmi, the wife of
Vishnu, worshipped as the goddess of
fortune in the Indian Hindu pantheon. She
is sometimes depicted together with
Bishamonten, to whom she is wife or sister.
The deity is here dressed, in Heian period
fashion, in Chinese robes, and indeed has
features similar to those of some Tang
dynasty sculptures. One hand makes the
segan'in gesture, signifying the granting of
desires, and in her other hand she holds the
hōkyū jewel.

 The piece is carved in *ichiboku zukuri* style
out of one block of wood, although there is
some later restoration, and the hands and
feet are replacements. Any original pigment
has vanished.

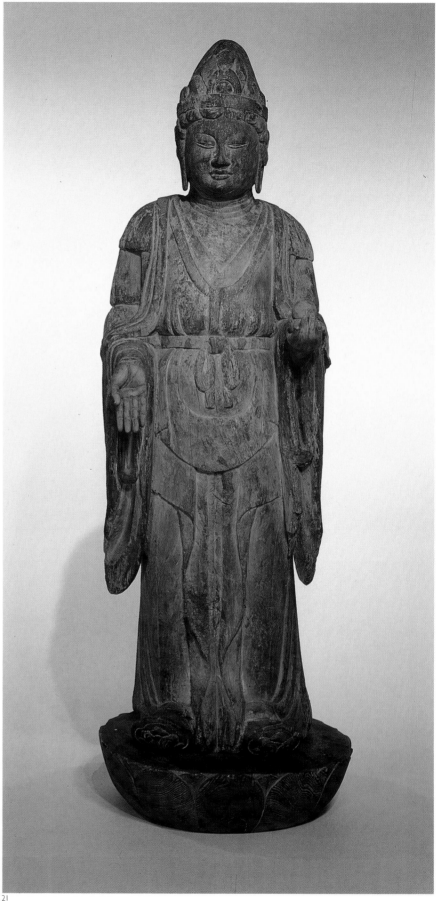

21

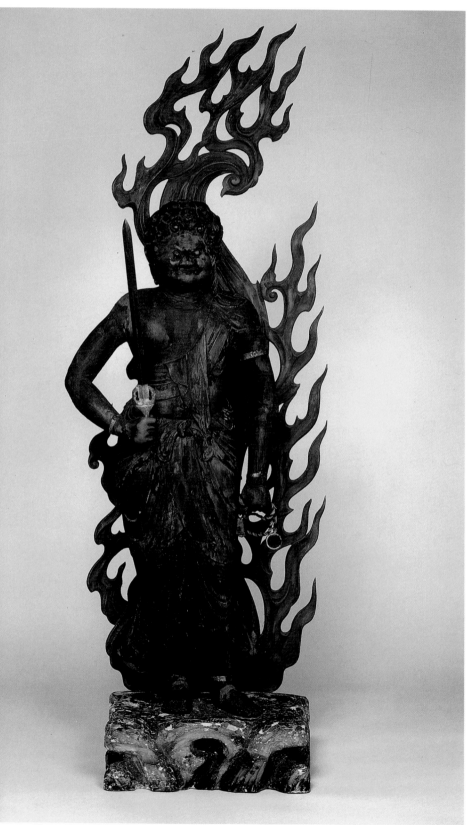

22

22 Fudō Myō-Ō ('The Immoveable King of Light')

Heian period, 12th century
Wood; H. 1.08 m
Published: Zwalf 1985, no. 357
1961.2-20.1

Fudō Myō-Ō is depicted sometimes alone, sometimes as the foremost of the five 'Kings of Light' of the esoteric Shingon sect, and sometimes with his two acolytes Kongara Dōji and Shitaka Dōji. The attributes of the deity are minutely described in a Shingon *sūtra* (AD 709). His fierce aspect shows his intolerance of wickedness, which he seeks out to chastise. The earliest Japanese representations have both eyes wide open and two fangs showing. Later works have one eye half shut, and one fang is sometimes shown on each jaw either side of the mouth. The sword also serves to cut through the evils of the illusory world revealing the *kongōtai*, or ultimately real world, and the rope binds the illusory enemies of enlightenment. The hilt of the sword is in the form of a *sankōshō*, or three-pronged *vajra*, which is one of the ritual implements of esoteric Buddhism symbolising the Buddha, the Lotus and the *kongōtai* itself. Fudō's name means 'Unmoving', indicating the unchanging nature of ultimate reality beneath the illusion of his warlike exterior. Considered a patron deity for swordsmen, he strove to achieve enlightenment beyond the illusion of life and death.

The piece is carved in *ichiboku zukuri* style, the arms made separately.

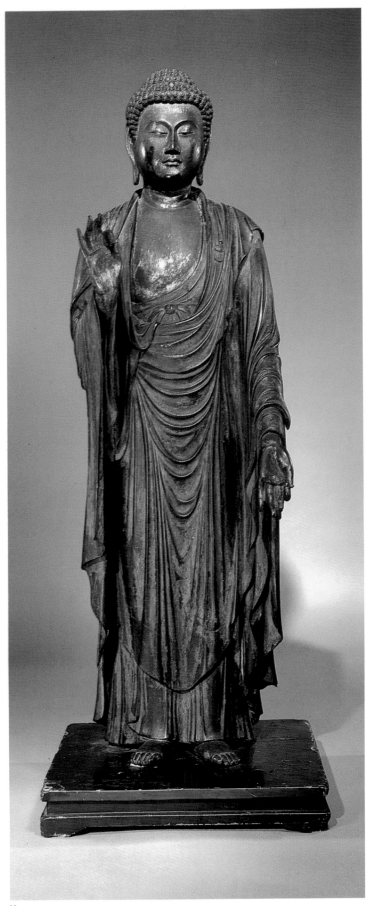

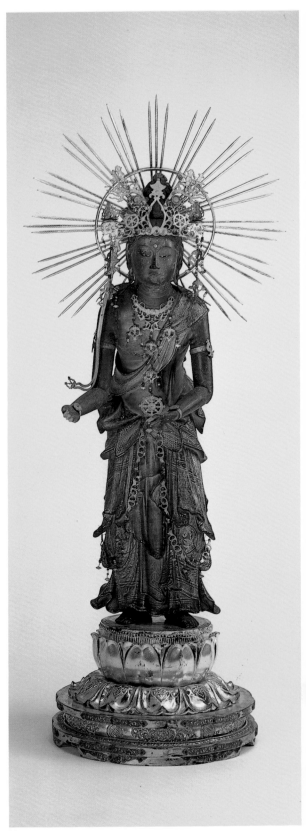

23

24

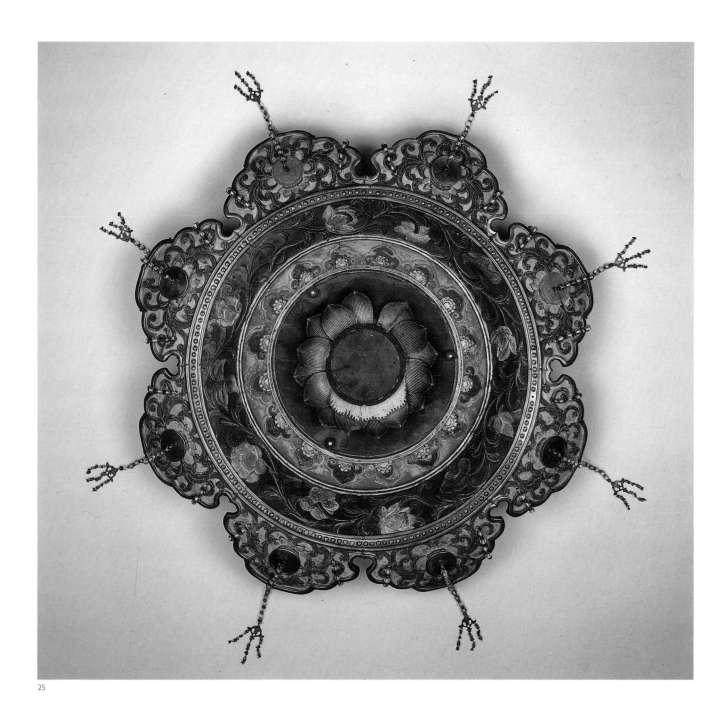

25

23 The Buddha Amida

Kamakura period, 13th century
Lacquered wood; H. 96 cm
Published: Zwalf 1985, no. 358
1945.4-19.1. Given by the National Art
 Collections Fund

The figure is made in the *yosegi zukuri*
method, formed of carved segments fixed
together to make a hollow sculpture. The
eyes are crystal and inserted from inside the
head. The Buddha Amida stands with his
hands in the gesture of welcoming the
faithful followers of Jōdo ('Pure Land')
Buddhism into the Western Paradise.

24 The Bodhisattva Kannon

Kamakura period, 14th century
Gilt and lacquered wood with details in bronze,
 crystal and other stones; H. 87 cm
Published: Zwalf 1985, no. 360
1886.3-22.7

Kannon is the principal Bodhisattva of
Mahāyāna ('Greater Vehicle') Buddhism
throughout East Asia. In the Jōdo ('Pure
Land') sect temples this form of the deity
would have stood together with the
Bodhisattva Seishi flanking a central figure
of the Buddha Amida. The figure originally
held a lotus through the virtue of which the
faithful would be brought upon death to the
Western Paradise.

25 Hanging canopy (*tengai*)

Probably Kamakura period, 14th century, with
 later restorations
Painted wood with gilt, copper and glass fittings;
 DIAM. 60 cm
Published: Zwalf 1985, no. 373
1967.2-20.1. Brooke Sewell Bequest

The *tengai* hangs above the heads of
prominent images in temples. It probably
originated as a sunshade used by the
nobility, and as such occurs in the earliest
representations of the Buddha in India.

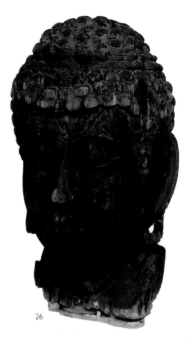

26

26 Head of the Buddha Amida

Kamakura-Muromachi period, 14th–15th century
Wood; H. 1 m
Published: Zwalf 1985, no. 361
1950.10-25.1. Bought with a contribution from the
 National Art Collections Fund

Presumably the head is that of a standing
figure of Amida which would have been
many metres in height, and perhaps
accompanied by the Bodhisattvas Kannon
and Seishi on a slightly smaller scale.

27 Ritual tray (*suebako*)

Muromachi period, 15th century
Wood, gilt-bronze, lacquer, lined with silk;
 33.8 × 29.5 cm
Published: Zwalf 1985, no. 372
1968.2-12.1. Brooke Sewell Bequest

Suebako are used to hold scriptures and
other traditionally ritual articles of esoteric
Buddhism during devotions. This example
is decorated in gilt copper with applied
lotuses, the central symbol of Buddhism.

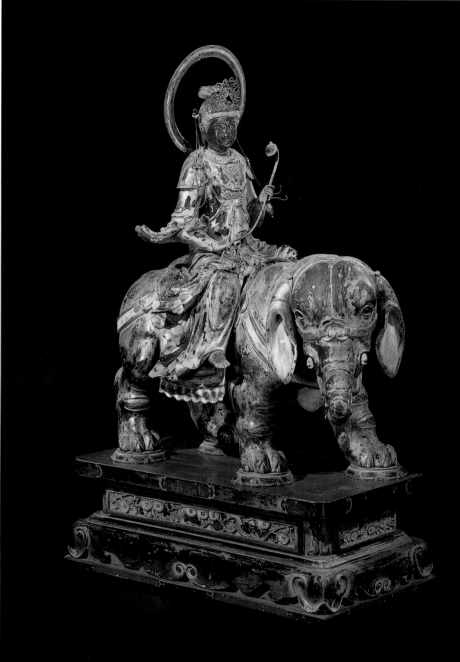

28 Fugen

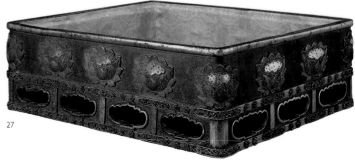

27

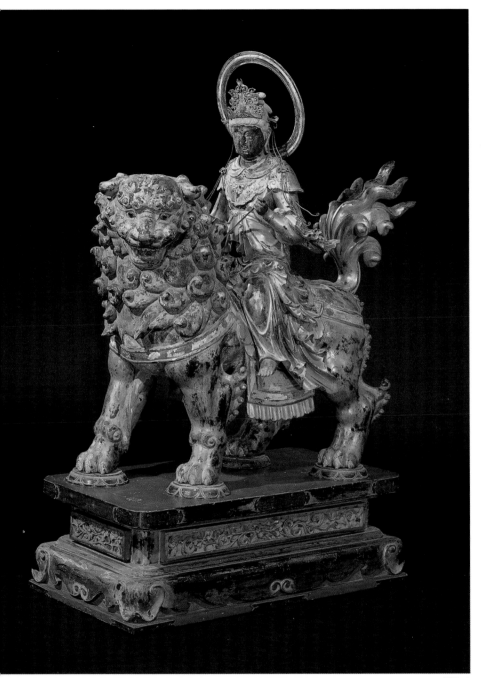

28 Monju

28 The Bodhisattvas Fugen and Monju

First half of 17th century
Lacquered, gilt and painted wood; H. 158 cm
1988.3-14.1-2

The Bodhisattvas Fugen mounted on an
elephant and Monju on a lion were brother
princes born during the lifetime of the
historical Buddha whom they usually flank
in temple triads. The animals are among
those present at the death of the Buddha.
When the Buddha first appeared he either
stood, or sat on a lion throne, and Monju is
accordingly possessor of the power of the
Buddhist Law expressed in the lion's roar.
According to the *Monju Shiri Hannehan-
gyō sūtra*, Monju died in enlightenment 451
years after the Buddha. He is known as the
Bodhisattva of wisdom, and is depicted here
carrying his main attribute, the sword of
knowledge. Inscribed on the back of each
figure is 'The grand sculptor Kōyū, the lay
priest Sakkyō, by Imperial Decree given the
title Hōin [Seal of the Law]'.

The sculptor was one of the leading artists
and restorers of his day, following the
tradition of the twelfth-century master
Unkei.

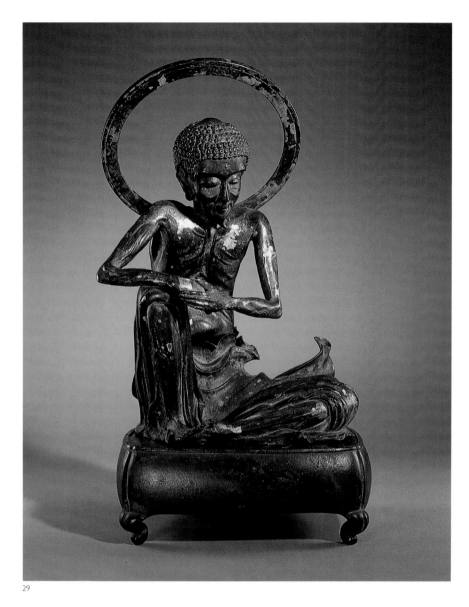

29

29 Shaka, the historical Buddha

Dated equivalent to AD 1630
Signed: Minamoto Masakatsu
Gilt and lacquered bronze; H. 37.8 cm
Published: Smith and Harris 1982, no. 35; Zwalf
 1985, no. 362
1891.9-5.20. Given by Sir A. W. Franks

A further inscription tells that the image
was commissioned by Jōkaku, the third
abbot of Mankōji Temple at Kanazawa in
Kaga Province, and that it was consecrated
on 15 February 1630 (on the day when the
death of the Buddha is celebrated). The dark
lacquer applied over the gilding indicates
that the Buddha's golden skin became
blackened during his period of solitary
contemplation, when his body also took on
the emaciated appearance so movingly
shown here.

ANON.

30 Amoghapasa (Fukūkensaku Kannon) with two Guardian Deities

Kamakura period, 13th century
Hanging scroll; ink, colour and gold on silk;
 1230 × 875 mm
Provenance: Masuda Takashi Collection (1909);
 Hoshino Collection
Published: *Tōyō bijutsu taikan* 1909, pl. 30; Gray
 1968, pp. 123–5, pls XLI–XLIV; *Zaigai Nihon no
 shihō*, vol. 1 (1980), pl. 50; Zwalf 1985, no. 379;
 Tokyo National Museum 1987, no. 1
1967.2-13.02 (Japanese Painting ADD 389).
 Brooke Sewell Bequest Fund

The Bodhisattva Kannon takes in Japanese
Buddhism many forms, similar to the
numerous variant images of the Virgin Mary
in Christian iconography. Here the form is
'Kannon with the Never-Empty Noose' –
the noose, or lasso, is to capture the minds
of the faithful. This is an esoteric form, and
thus full of elaborate visual symbolism. The
main figure has three faces and four arms,
one of which holds the lasso, and sits on a
white lotus on a high rock. These suggest
the lotus-realm of the 'Great Womb
Mandala', the central image of Japanese
esoteric Buddhism (see no. 40). The
guardian deities are (to the right)
Bishamon-ten with a sword and (left) Shitsu
Kongōjin with a *vajra* (thunderbolt). Both
are copied from much earlier images; Shitsu
Kongōjin is very closely modelled on a
ninth-century sculpture in the Tōdaiji
Temple in Nara. This rich composition (the
silk is painted on the reverse side with gold
to strengthen the colours) is a product of the
early Kamakura period revival of Nara
period painting and sculpture styles.

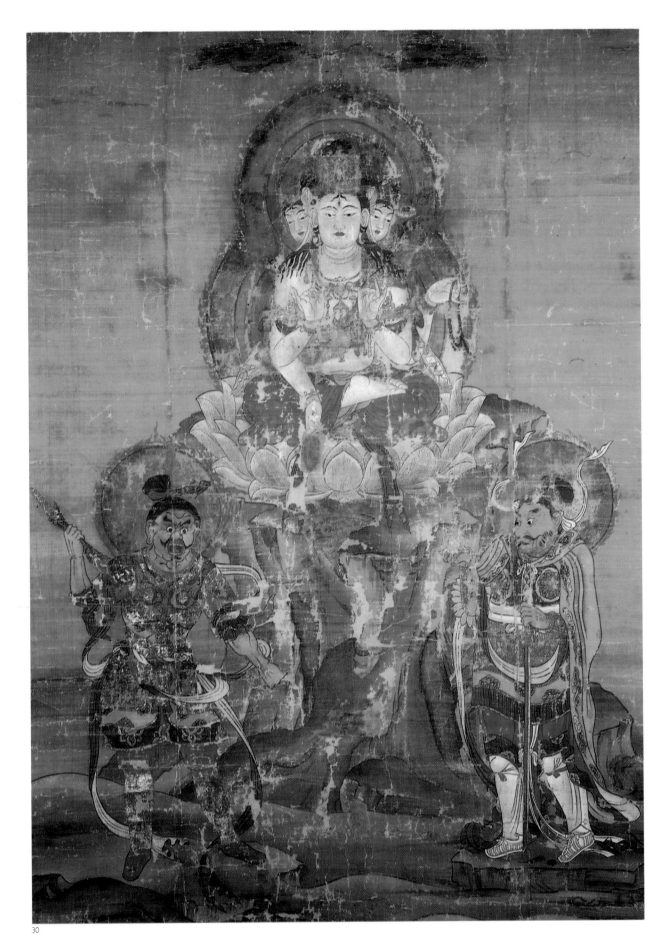

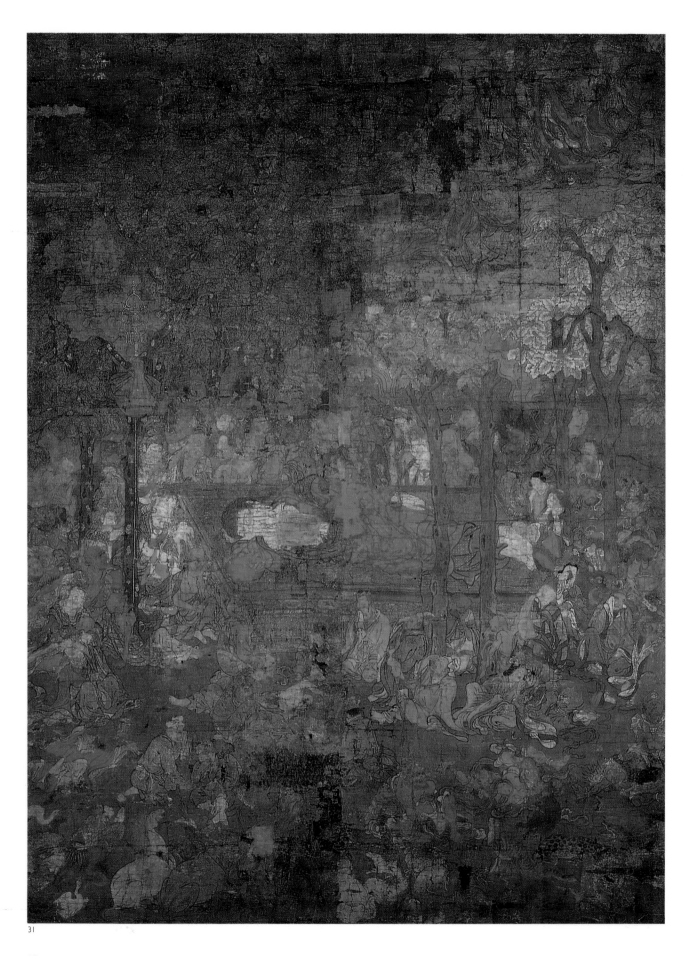

31

ANON.

31 The Death of the Buddha
(nehanzu)

13th century
Formerly a hanging scroll, mounted on a panel;
 ink, colours and gold leaf on silk;
 2260 × 1550 mm
Provenance: William Anderson Collection
Published: Anderson 1886, no. 7; Zwalf 1985,
 no. 380
1881.12-10.7 (Japanese Painting 17)

The entry of the historical Buddha at the point of his death into *nirvana* (Japanese *nehan*), the blessed state of the extinction of personality in the ultimate reality of existence, is of the greatest importance in Buddhist theology, offering as it does a vision of the highest good. Images in sculpture of this event exist in India from as early as the second/third century AD; by the late Tang dynasty it had become a well-established subject for Chinese painting, and such a crucial image must have passed quickly to Japan, where the earliest-surviving example is eleventh century. *Nehanzu*, as they were known, would have been needed by every temple to exhibit on the celebration of the Buddha's death on the fifteenth day of the second month, and this accounts for the relatively large number which survive, however fragmentary, from the medieval period. As here, they often took the form of an unusually large hanging scroll suitable to be hung briefly in a large hall for general contemplation.

The image of the Buddha already transformed in death into a superhuman-sized deity is standard, as are the weeping disciples around his bier. Representatives of the animal world and of heavenly beings could be added according to the artist's imagination, and this crowd tended to increase continually up to the seventeenth century. The spirit of his mother Maya can be seen at top right, a favourite Japanese addition.

FURTHER READING Zwalf 1985

32

ANON.

32 *Amida Raigō*
('The Descent of Amida')

Kamakura-Muromachi period, 14th–15th century,
 but regilded at a later period
Hanging scroll in ink colours and gold on silk;
 1600 × 754 mm
Provenance: Arthur Morrison Collection
Published: Morrison 1911, pp. 47–9 (where it is
 impossibly attributed to Eshin Sōzu, 942–1017)
1913.5-1.035 (Japanese Painting 14). Given by
 Sir W. Gwynne-Evans, Bt

The *raigō* doctrine was a development of the Jōdo ('Pure Land') line of popular Buddhism. Instead of the Buddha Amida's simply welcoming the faithful into the Western Paradise, he was by the Kamakura period envisaged descending to Earth to greet the dying, accompanied by the Bodhisattvas Kannon and Seishi (seen here) and often by a great company of heavenly beings. In the late Kamakura period this familiar form of the icon became the standard one, Amida descending on a cloud diagonally from left to right. This was in itself a humanisation of the earlier full-face impassive image used for a Buddha. The reason is thought to be that a dying person would lie with his head to the north, and would turn to the west where a hanging scroll of *Amida Raigō* would be displayed, apparently moving towards him. All Jōdo temples would have had one or more of these scrolls, and their accumulated sense of sanctity would have led the authorities to have the main figures regilded from time to time, as has happened in this example.

FURTHER READING Rosenfield, J. M., and ten Grotenhuis, E., *Journey of the Three Jewels*, New York, 1979

ANON.

33 The Bodhisattva Akasagarbha (Kokūzō-bosatsu)

Kamakura period, 14th century
Hanging scroll; ink, colour and gold on silk;
 630 × 415 mm
Published: Tokyo National Museum 1987, no. 2
1964.12-12.04 (Japanese Painting ADD 378)

The esoteric or 'secret' sects of Buddhism
included Tendai and Shingon, of which the
latter was the more prolific of visual
imagery. Paintings, sketches and texts were
produced in large numbers and stored in
the temples as acts of virtue. The number of
deities was literally limitless, symbolic of the
ever-opening consciousness of the adept to
reality. Grander pieces such as this example
were intended to be contemplated at length,
and had therefore to combine compelling
power with a refinement of detail; any
roughness of finish would be in danger of
detracting from concentration.

The Bodhisattva sits on a throne of lotus
petals, his right hand in the gift-giving
gesture (gesture or *mūdra* was a significant
part of esoteric ritual and practice). The
fiery halo in red and green contrasts
mesmerically with the white moon, against
which the Bodhisattva is placed. The
original silk of the background has been
almost entirely replaced, suggesting it had
disintegrated as a result of the use of a green
copper-acetate pigment.

Kokūzō ('Treasure of Emptiness')
represents the power of boundless and
timeless space to provide enlightenment to
human beings. This is symbolised by the
golden rays of light spreading in all
directions from the central figure.

FURTHER READING Goepper, Roger, *Shingon: Die
Kunst des Geheimen Buddhismus in Japan*, Cologne,
Museum für Ostasiatische Kunst, 1988

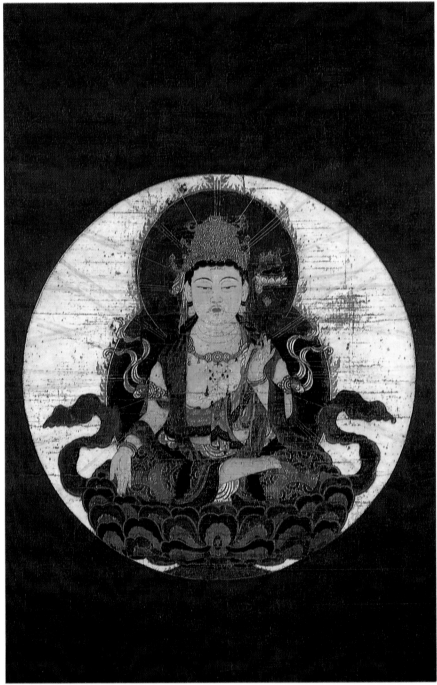

33

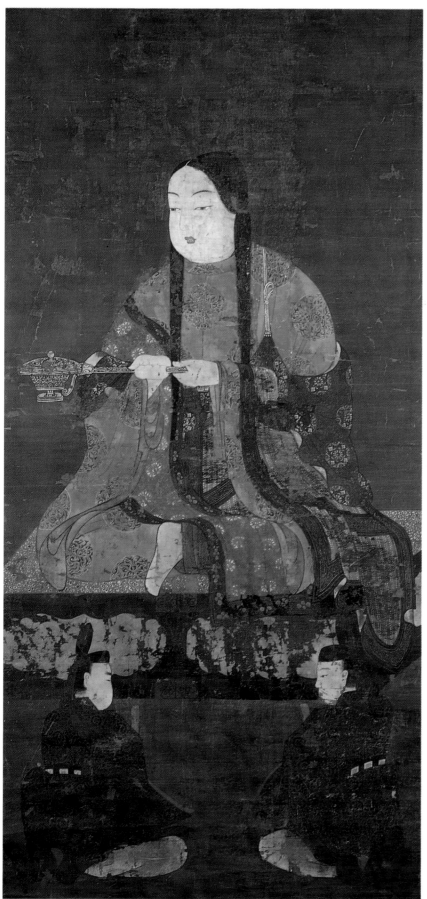

34

ANON.

34 Portrait of the young Prince Shōtoku Taishi (AD 574–622)

Kamakura period, 14th century
Hanging scroll; ink, colours and gold on silk;
 1050 × 515 mm
Published: Gray 1962–3, pp. 47–9, pl. XXVII; Zwalf
 1985, no. 387; Tokyo National Museum 1987,
 no. 4
1961.4-8.01 (Japanese Painting ADD 370)

Prince Shōtoku, who reigned as Regent in
the years 593–622, is revered as the 'apostle'
of Japanese Buddhism. Numerous legends
grew up about his life, many of them
bearing a similarity to those concerning the
historical Buddha, of whom he came to be
considered in the popular mind almost a
later incarnation. Such an opinion, of
course, had no basis in Buddhist theology.
Shōtoku was in fact a political leader of
vision and energy who completed the
establishment of Buddhism as the official
religion of the ruling aristocracy and hence
of the country. While there is no reason to
doubt his piety, he must also have seen the
advantages to Japanese political unity and
stability, and the civilising influences of the
great religion which at that period
dominated most of Asia. Among his
religious achievements were the copying of
scriptures and the founding of the Hōryūji,
Japan's most revered temple.

 In the Kamakura period there was a
revival of interest in Shōtoku which was
paralleled by renewed devotion to the
historical Buddha; both can be seen as a
reaction against the exoticism of the
court-dominated sects of the Heian period.
Kamakura-period portraits abound, of
which this is one type. It is thought to show
the sixteen-year-old prince holding an
incense censer and praying for the health of
his sick father. In the foreground are two
small figures in Kamakura period court
dress. The subdued splendour of colour is
characteristic of the painting of the period,
but the round, sweet, bland face looks back
to Heian courtly traditions.

FURTHER READING Ishida, Mōsaku, *Shōtoku Taishi
sonzō shūsei*, 2 vols, Tokyo, 1976

ANON.

35 Portrait of the priest Jion Daishi

Kamakura period, 14th century
Hanging scroll; ink and colours on silk;
 1675 × 855 mm
Provenance: Baron Furukawa Collection
Published: Anon. *BMQ* 1965, p. 120; Kōfukuji 1982,
 no. 11; Tokyo National Museum 1987, no. 3
1964.7-11.01 (Japanese Painting ADD 377)

Jion Daishi is the Japanese name of the
Chinese patriarch of the Hossō sect, Guiji,
who lived AD 632–82. He brought Hossō
Buddhism to Japan and his portrait was
therefore kept for veneration in the sect
temples, especially in the three greatest of
them – Kōfukuji, Yakushiji and Hōryūji (the
last is no longer a Hossō temple). From the
tenth century onwards special 'Jion Daishi
Meetings' were held, particularly in
Kōfukuji, at which traditional portraits were
displayed, and this accounts for the
relatively large numbers which survive.
This fine, large example is fitting for the
legendary gigantic stature and powerful
presence of the patriarch, especially his
bushy eyebrows and fleshy lips. The
division of the silk vertically into three strips
can clearly be seen. The contemporary
inscription at the top gives a brief history of
Jion Daishi.

FURTHER READING Kōfukuji (Temple) and
Yakushiji (Temple), *Jion Daishi mi-kage shūei*,
Kyoto, 1982

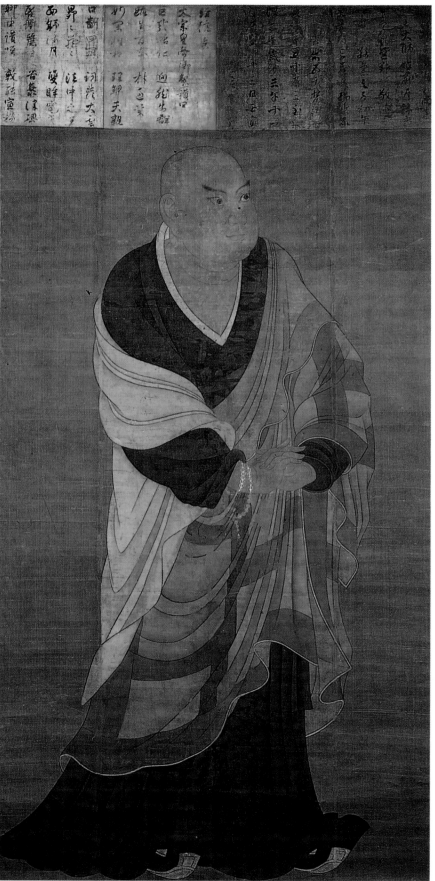

35

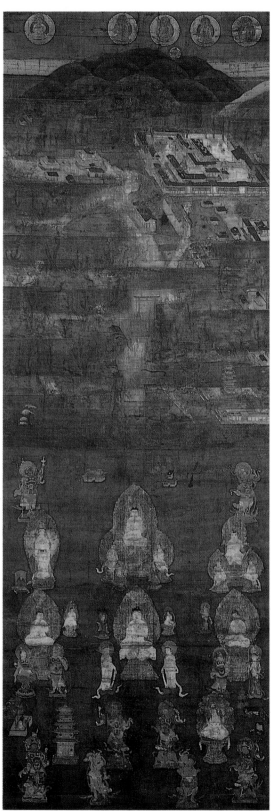

36

ANON.

36 Kasuga shrine *mandala*

Kamakura-Muromachi period, 14th century
Hanging scroll; ink, colours and gold on silk;
 998 × 350 mm
Published: Zwalf 1985, no. 383
1961.4-8.02 (Japanese Painting ADD 371)

A *mandala* is a schematic painting which visually relates elements of ultimate reality to each other in the form of visible symbols (see also no. 40). In Japan one particular form of *mandala* developed expressing and trying to resolve the difficulties caused by tensions between imported Buddhism and the native Shintō religion. This was achieved theologically by the doctrine of Honji Suijaku developed in the Heian period, which explained that the Shintō deities (*kami*) were in fact manifestations of universal Buddhist deities. As part of this process of reconciliation, the Shintō shrines were often linked to Buddhist temples which were assumed to have a protective relationship with them. Of all the shrines close to metropolitan areas the grandest was the Kasuga Taisha in Nara, which still dominates the old eastern end of the town right up to and into the hills.

This *mandala* presents the *suijaku* interpretation in a graphic form easily understood, even by the uneducated. A phalanx of Buddhist deities, emanating from the direction of the Kōfukuji Temple (in the foreground), are ranged before the shrine, and five of these are repeated in roundels in the sky. These represent the five main *kami* of the Kasuga shrine in Buddhist form, together with the moon which is one of the symbols of the principal Kasuga deity. In between spreads the shrine, laid out in pure Yamato-e landscape style, seen from a very high viewpoint and looking across to the nearby hills.

FURTHER READING Sekiguchi, Masayuki, *Suijakuga* (*Nihon no bijutsu no. 274*), Tokyo, 1989

ANON.

37 One of the sixteen disciples of the Buddha

Kamakura-Muromachi period, 14th century
Hanging scroll; ink and colours on silk;
 1495 × 391 mm
Provenance: William Anderson Collection
Published: Anderson 1886, no. 3 (attributed to Chō
 Densu)
1881.12-10.3 (Japanese Painting 347)

The *arhats* (Japanese *rakan*) were thought to
be the disciples of the historical Buddha,
who were requested by him to remain in the
world to spread their enlightenment. In
China, Korea and Japan they became
increasingly popular as images from the
twelfth century onwards, probably because
their purely human origin made them more
accessible and artistically more grateful to
imagination. In late Song-dynasty China
they were often shown in the traditional
line-and-colour technique but set in an
ink-painted landscape of more recent style.
The line of the figure, too, tended to use
more expressive and varied brushwork than
in more formal icons. This is the type
adopted by the Japanese artist in this
example; it is probably earlier than the work
of Chō Densu (Minchō, 1352–1431), the
best-known Japanese painter of *rakan*.

The identification of this *rakan* is
uncertain. He is one of the standard set of
sixteen (there are also groups of eighteen
and 500) among whom are several attended
by a lion. As always, he is shown as a
shaven-headed ascetic, with a
large-featured 'Indian' face.

FURTHER READING Bunkachō (Agency for Cultural
Affairs), *Jūyō Bunkazai*, vol. 8 *Kaiga*, Tokyo, 1973

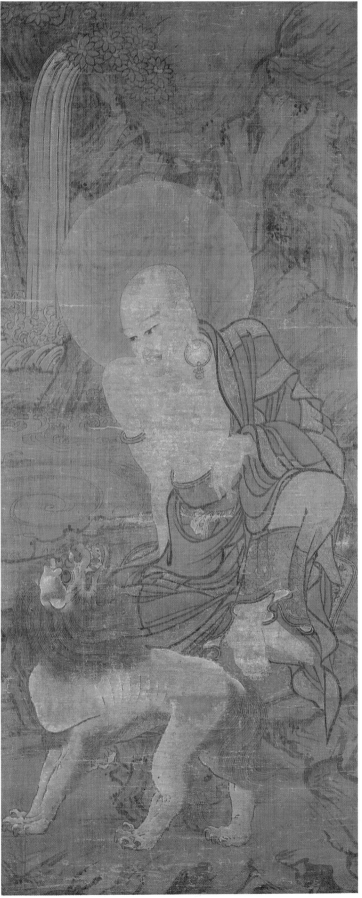

37

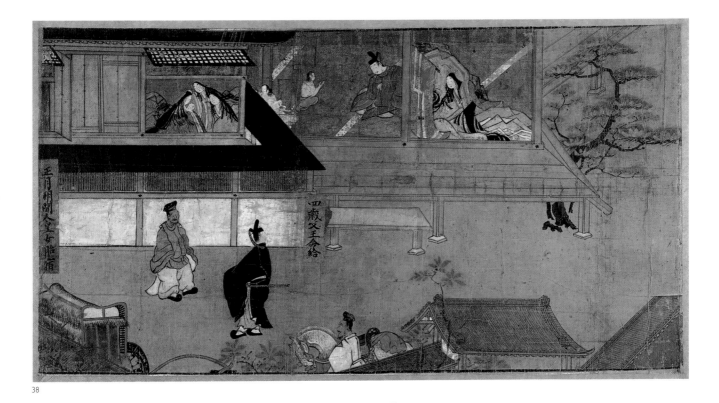

38

ANON.

38 *Shōtoku Taishi e-den* ('Illustrated biography of Prince Shōtoku Taishi')

Muromachi period, late 15th or early 16th century
Sections of a handscroll or hanging scroll, now
 separately mounted; ink and colours on paper;
 H. *c.* 325 mm
Published: Gray 1932, pp. 100–1, pl. XLI; Zwalf
 1985, no. 388; Tokyo National Museum 1987,
 no. 7
1931.11-16.01 (Japanese Painting ADD 85)

The series of sections of scenes from the life
of Shōtoku came to the British Museum
mounted as a handscroll, but later study has
shown it to be far from complete and
perhaps not originally in handscroll format
at all. It is more likely to be assembled from
both handscroll sections and also sections
cut from one or more large episodic hanging
scrolls, on the subject of the Prince's life,
which would have been displayed to the
faithful on commemorative days. In that
state the sections would have been arranged
in vertical bands; this is a type which has
survived in many Japanese temple
collections.

Because of the need to explain the events
to the less well-informed, small written
paper cartouches have been fixed to the
surface to identify the episodes. The section
illustrated shows the birth of the Prince, and
his praying for his father at the age of four.
Since they are not in right-to-left
chronological order, this section certainly
does not come from a continuous
handscroll. This is one of the finest early
examples in the British Museum's collection
of the narrative pictorial tradition in
Yamato-e style (see pp. 50–2). For the
significance of Shōtoku see no. 34.

FURTHER READING Nara National Museum, *Shōtoku
Taishi e-den*, Nara, 1969

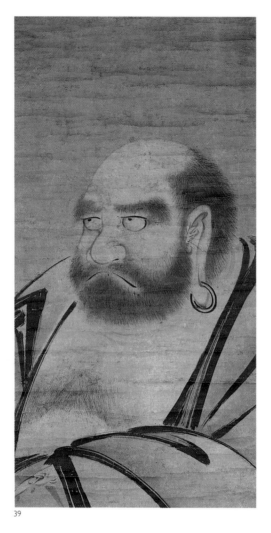

39

('enlightenment'). Both the unconventional power of insight and the quirky humour attributed to the patriarch are found in this painting, and these aspects were encouraged in Zen training. By tradition he is given an 'Indian' appearance, with black beard, bushy eyebrows, sunken eyes, large nose and long ears (the last also generally symbolic of Buddhist sanctity).

The strength of this painting comes from its intense black brushwork, itself derived from the Chinese calligraphic tradition adopted by Zen masters. There is no support for the attribution to Sōami (*c.* 1455–1525), curator of paintings to the Ashikaga shogun, though the painting is from the same period.

FURTHER READING Kyoto National Museum, *Zen no bijutsu*, Kyoto, 1983

ANON.

39 Bodhidharma (Daruma)

Muromachi period, 15th–16th century
Hanging scroll; ink on paper; 765 × 387 mm
Provenance: Arthur Morrison Collection
Published: Morrison 1911, pl. XXIV (attributed to Sōami)
1913.5-1.0101 (Japanese Painting 362). Given by Sir W. Gwynne-Evans, Bt

Daruma (died *c.* AD 532) was the semi-legendary founder of the Zen, or meditative, Buddhist movement, which he brought to China where it developed a notably East Asian character. To paint his portrait in brush and ink became in Japan from the thirteenth century onwards one of the exercises which could help achieve *satori*

ANON.

40 *Mahakaruna-garbhodbhava-mandala; Daihi Taizō Mandara* ('Mandala of the Matrix World of Great Compassion')

Edo period, late 17th century
Hanging scroll; ink, colours and gold on silk; 1280 × 1120 mm
Provenance: William Anderson Collection
Published: Anderson 1886, no. 59
1881.12-10.59 (Japanese Painting 3449)

In the 'secret' or esoteric branches of Buddhism the principal deity was the Buddha Dainichi (or Daihi), the source of all enlightenment and compassion. This type of *mandala* expressed in visual terms the infinite spreading out from the centre of Dainichi's influence into different realms of existence. Dainichi was identified with the sun, and hence in Japan a nationalist connection with the native Shintō sun-gods added to his prestige. *Mandalas* were made as an act of worship in itself, and were then intended for contemplation. They tended therefore to a high level of craftsmanship and great care of detail, as well as compelling general effect. The mountings, as well as the painting itself (which includes a rose-coloured floreate border), are of great richness and splendour. Here the original magnificent gold brocade mounting silks and gilt-bronze fittings survive.

FURTHER READING Rosenfield, J. M., and ten Grotenhuis, E., *Journey of the Three Jewels*, New York, 1979

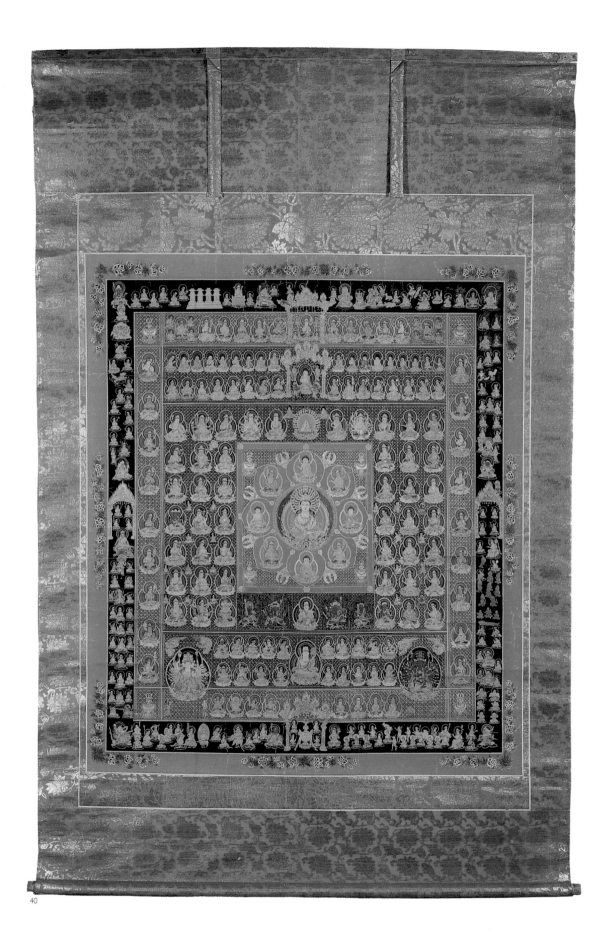

3

PAINTING - THE OLDER TRADITIONS

(nos 41–63)

The term 'older traditions' has been chosen to include all those styles and movements which were already in place by the beginning of Japan's long period of isolation from 1639 to 1853 (for subsequent developments, see pp. 178–81). Because of the extreme reluctance in Japanese cultural history to abandon established modes, a historical survey, however brief, has to record a gradual increase in styles and their range, but rarely their complete abandonment. The inherent respect of Japanese society for tradition, moreover, has led over the centuries to a strong tendency towards revivals of older styles, or at least those aspects of them which suited a later age. Even the school of Sōtatsu, one of Japan's most distinctive painting styles, is simply a revival of the ancient Yamato-e ('Japanese pictures') tradition, and Yamato-e itself has to be regarded as a perpetually self-renewing stylistic tendency. Many of the paintings included in this section were made well after 1639 but retain or revive older styles.

It is necessary to begin with the concept of Yamato-e, because it has been thought of as the 'native' Japanese style since the ninth century. The word, indeed, means simply 'pictures from Yamato', the ancient name of the Kansai district (centred on Nara and Kyoto) which became the cradle of Japanese civilisation. The art and methods of painting were brought there from China in the seventh and eighth centuries. At that time Chinese methods were based on simple black outline, bright flat colours kept separate from each other and neither mixed nor shaded, and a simple pictorial construction which placed the foreground subjects of the painting at the bottom of the available space. More distant parts of the composition moved progressively up the surface, a tendency naturally most exaggerated in the vertical banner/hanging-scroll formats. There was no concept of formal perspective at all. As a result, a landscape would

tend to fill most of the picture surface, the horizon (normally of mountains or hills) placed so high as almost to eliminate the sky. This tended to give the illusion that the viewer was gazing down on the foreground.

This pictorial method became the basis of Yamato-e and survived in many different schools far into the nineteenth century (no. 57). During the ninth century, when the capital had moved to Kyoto, contacts with China began to decrease, but the style was kept more or less intact, while painting in metropolitan China itself moved on. Thus, when these newer Chinese styles were from time to time seen, they now seemed noticeably foreign and were called Kara-e ('pictures from China'). In this way was born the intrinsically Japanese concept of a contrast between 'native' and 'foreign' painting styles, which survives even to this day.

While in Japan the old method had not greatly changed, subject-matter moved firmly in the direction of Japanese courtly interests; this is known from literary and historical records, though virtually no actual examples of this sort of painting survive from before the twelfth century. The partly legendary artist Kose Kanaoka (ninth century) is said to have begun that process. These courtly preferences included the literary classics, and especially the eighth-century poetic anthology, the *Manyōshū* ('Collection of 10,000 Leaves'), the tenth-century *Ise Monogatari* ('Tales of Ise') and the great novel *Genji Monogatari* ('The Tale of Genji') written about AD 1000; subjects relating to the four seasons, the months of the year and beauty spots, mostly in the Kansai region, famed for their attractions at certain times of year; and the festivals and ceremonies of the courtly calendar.

This seasonal bias became the mainstream of the Yamato-e tradition, found again and again in folding screens (no. 44), sliding doors (no. 46), hanging scrolls (no. 57), handscrolls (no. 51), fans and folding albums, and indeed spread into the decoration of lacquerware, textiles and metalwork, and eventually to ceramics. All of these painting formats were in use by the tenth century; the most characteristic of courtly culture were the painted sliding doors (*fusuma*) which decorated rooms designed in the new native Shinden architectural style; and the small-scale detailed handscrolls and albums which could be scrutinised at length by a leisured class. Nos 49 and 51 are descendants of this tradition. The hanging scroll did not achieve its later importance until the fifteenth century, except in Buddhist temples.

The term Yamato-e refers to a very wide grouping of artists and schools working in 'native' style during a period of over 1,000 years. From the ninth until the fifteenth centuries it is rarely known who these artists were, though during that period the leadership of painting was in the hands of the Kose school. However, it is seldom possible to link a name to any specific surviving painting. This leadership was expressed in their hereditary position as directors of the Imperial Painting Office (Edokoro). They also worked on Buddhist commissions, with the result that courtly and religious styles continued to have much in common during that long period, especially in the handscroll format which used much the same pictorial techniques for long narratives, whether they were courtly romances, fairy tales, or accounts of religious leaders or the founding of temples. One feature of these scrolls is especially typical of the Yamato-e tradition – the employment of representations of bands of mist or banks of cloud to link parts of the composition, or to provide a decorative transition between sections which had no direct link with each other. These areas could be painted, usually in blue or white, as in the clouds at the top and bottom of the sixteenth-century 'Tale of Monkeys' scroll (no. 43), or applied with squares of gold leaf, or with gold dust and gold leaf flakes applied over an adhesive agent, as in the seventeenth-century 'Tales of Ise' scroll (no. 51), or simply painted in gold wash.

The extensive use of gold had its origin in Buddhist painting, but its ability to pick up light in dark interiors had by the tenth century led to its widespread use on screens and sliding doors in palaces and great houses. This tradition was to remain a basic feature of Yamato-e right into the nineteenth century, so much so that gold can almost be singled out as the dominant colour of native-style painting. Its adoption by the 'Chinese' Kanō school as part of their decorative screen style from the early sixteenth century onwards ensured its permanent place in larger-scale painting.

By the beginning of the fifteenth century the post of director of the Edokoro had passed to the Tosa school, who claimed a dubious lineage back to the thirteenth century. From then on they remained official guardians of the high courtly Yamato-e style, a position they retained (with one intermission from the late sixteenth century until 1654) until the end of the Edo period. Pure Tosa style can be seen in nos 49 and 51, but elements of it passed into the repertoire of popular genre painting (no. 48) and Ukiyo-e (pp. 196–202). From the

late seventeenth century onwards a branch school founded by Sumiyoshi Jokei (1599–1670) moved to Edo to join the official painters to the shoguns. Sumiyoshi school works have greater vigour and freshness in traditional subjects (no. 57) and a considerable skill in organising scenes wth large numbers of people (no. 55).

The school founded by Tawaraya Sōtatsu (d. *c.* 1643) was to become the most Japanese of all the Yamato-e styles. Sōtatsu, originally a maker of fans, decorated paper, and gold- and silver-leaf screens, found inspiration in the great medieval narrative handscrolls, some of which he copied. He devised a manner using the most stylised, semi-abstract shapes from these sources, placing them on large surfaces with much use of space, with very careful attention to their balance and geometrical relationships. The 'Tales of Ise' screen (no. 50) is typical of the method of his school. He also, by contrast, pioneered the deployment of extremely naturalistic depictions of flowers, birds and animals arranged in dazzling but ultimately unreal patterns (nos 56, 171). The work of his later admirer Kōrin and the Rimpa school are discussed on p. 180.

In contrast to Yamato-e there were the foreign styles; until the mid-sixteenth century they were always Chinese, but after that they might also be European. The biggest and most lasting impact came from the various pure ink-painting traditions of China which flourished from the Song dynasty through the Yuan to the first half of the Ming. These invariably reached Japan as gifts to temples by visiting Chinese priests, or were brought back by Japanese priests who had gone to China. Most of this activity came as a result of the rapid rise in Japan of Zen Buddhism, first introduced in the thirteenth century. Ink-painting, a recognised way to enlightenment in Zen, thus tended to remain the preserve of priest-artists like its most famous Japanese practitioner, Sesshū (1420–1506). Their main subject was the grand mountainous landscape of China, expressed in strong, expressively varied ink line filled in with ink washes or light washes of other colours (nos 59–61) or in gradations of ink wash alone. There could be no greater contrast with the rounded, forested green hills of Japan which provide the backdrop to so much Yamato-e painting.

The late fifteenth century saw the emergence of professional painters in these Chinese styles (now called Kanga), who thrived on the patronage of the Ashikaga shoguns, by now well established in their enthusiasm for Zen. Historically much the most important of these was the Kanō school founded by Kanō Masanobu. He was an official painter (*goyō eshi*) to the shoguns in Kyoto. The school relied for nearly 400 years on its senior members' holding this rank to maintain its considerable dominance in most areas of Japanese painting, except that of the Imperial court in Kyoto. Even there Kanō artists took over as directors for several generations following the reputed marriage between Kanō Motonobu (1478–1559) and the daughter of Tosa Mitsunobu (1434–1525), which gave them the right to use the Yamato-e style.

This was to prove a merger of the greatest artistic importance, for apart from skills in ink-painting (no. 61), the Kanō artists' greatest claim to lasting esteem lies in their screen-painting in a mixed style combining a firm 'Chinese' ink line with broad, bright colours in the Ming academic bird and flower manner, but with a much more Japanese sensibility and choice of subjects and usually an extensive use of gold leaf. The splendid and brilliant outburst in the sixteenth and early seventeenth centuries of painting on folding screens, sliding doors, ceiling panels and the like is centred on the activities of the Kanō school working in temples, palaces and castles. In the Momoyama period they were rivalled in this field by the schools of Unkoku, Kaiho and Hasegawa (no. 46), but their position enabled them to outlast the opposition and survive to the end of the Edo period.

The Kanō artists proliferated so much that some of their members could afford to become unofficial *machi-eshi* ('town painters') working for the newly rich townsmen of Osaka, Kyoto and Edo. The relative vigour of their figure style, rather different from the stilted formalities of the classic Tosa manner, made them the natural choice for recording the scenes of town life, festivals, entertainments and the like which were in demand from the Momoyama period onwards. The whole *fūzokuga* ('popular painting') movement, a notable feature of Momoyama and Edo period art, is thus based on modified Kanō style (nos 45, 52).

ANON.

41 Portrait of the first Shogun Minamoto no Yoritomo (AD 1147–99) in court dress

Kamakura period, early 14th century
Hanging scroll; ink and colours on silk;
 1450 × 885 mm
Published: Tokyo National Museum 1987, no. 5
1920.7-13.1 (Japanese Painting ADD 10). Purchased
 with the assistance of G. Eumorphopoulos and
 the National Art Collections Fund

This portrait is based very closely on that
attributed to the artist Fujiwara Takanobu
(1142–1205), long preserved in the Jingōji
Temple, Kyoto, with two other portraits
(designated in Japan as 'National
Treasures'). The identification of the
subjects of these three has been traditional
but unproved, but the inscription at the top
of the very close British Museum copy
proves it beyond doubt. This inscription
describes Yoritomo as the defeater of the
Taira family and the unifier and pacifier of
Japan. By analogy with other portraits of
great priests and founders (see no. 35), it is
probable that a number of copies were made
for use and suitable reverence in important
political centres. By ending some 600 years
of bureaucratic rule centred on the court and
moving his seat of government to the small
town of Kamakura, Yoritomo had turned
Japanese polity upside-down and needed to
be regarded with reverence as well as fear.
The still impressive sense of a formidable
personality, even in a copy, is testimony to
the incisiveness of Kamakura period
portraiture.

FURTHER READING Kyoto National Museum, *Nihon
no shōzō*, Tokyo, 1978

41

42

43 detail

ANON.

42 Sugawara no Michizane
(AD 845–903) in Chinese dress

Muromachi period, 16th century
Hanging scroll (mounted on a panel); ink and
 colours on silk; 710 × 293 mm
Provenance: Arthur Morrison Collection
Published: Morrison 1911, pl. v; Tokyo National
 Museum 1987, no. 6
1913.5-1.038 (Japanese Painting 1). Given by Sir
 W. Gwynne-Evans, Bt

Sugawara no Michizane (845–903) was a
scholar of Chinese literature and politician
who rose to the rank of Minister of the
Right, and was then exiled to Kyūshū by a
conspiracy of the Fujiwara family.
Calamities in the capital following his death
led to his reinstatement and upgrading to
the rank of a Shintō deity (renamed Karai
Tenjin), and the founding of the Kitano

shrine there to honour his memory. He is still regarded as the patron of scholarship as well as Japan's greatest poet writing in the Chinese language. A revival of interest in *kambun* (Chinese written in a manner understandable by Japanese) in the Muromachi period resulted in his being held in even higher regard; this portrait is from that time. He is shown in pure Chinese dress, holding the plum bough which is one of the symbols of the Chinese scholar-gentleman, as well as being associated with a number of other stories about Michizane himself. One of his poems is inscribed at the top of the painting. His totally Chinese appearance also refers to a complex legend that he studied Zen posthumously in China, a tradition that was maintained in the Zen Tōfukuji Temple in Kyoto.

ANON.

43 *Saru no sōshi* ('Illustrated Tale of Monkeys')

Muromachi-Momoyama period, *c*. 1560–70
Handscroll; ink and colours on paper; H. 310 mm
Provenance: Sir A. W. Franks Collection
Published: Ruch 1981, pls 1, 2; Tokyo National Museum 1987, no. 8; *Muromachi monogatari shū*, vol. 1 (1989), pp. 433–67
1902.6-6.1 (Japanese Painting 59). Bequeathed by Sir A. W. Franks

While lacking some sections, this long handscroll is the only known text of this tale, of the type called *otogi-zōshi* ('servants' tales'). It tells the story of the entertainment of Yoshinari Yasaburō of Mount Hiei by his prospective father-in-law, Prince Shibuzane of the Hie shrine.

All of the characters appear as monkeys, and the illustrations must have been conceived as a satire on contemporary manners, which are described in some detail. Among the sections there are vivid scenes of feasting, of the then relatively new Tea Ceremony, and the earliest-known picture of *renka*, or a verse-capping meeting. The main thrust of the satire is at the religious establishments of Mount Hiei, which had for centuries grown in power, luxury and indeed in turbulence, maintaining their own armies of priest-soldiers. The Hie shrine, allied to this Enryakuji Temple complex, was destroyed in 1571 by the warlord Oda Nobunaga, who had lost patience with the power and pretensions of the religious. This beautifully produced satire in the pure Yamato-e style must have shortly preceded that event.

FURTHER READING Ruch, Barbara (ed.), *Zaigai Nara ehon*, Tokyo, 1981

44 detail

ANON.

44 Four seasons with the sun and moon

Momoyama period, late 16th century
Pair of six-fold screens; ink, colours, gold and
 silver on paper; each *c.* 1473 × 3010 mm
Provenance: Noriyoshi Fujii Collection,
 Nishinomiya (1951)
Published: Narazaki 1951, pls 4, 5; Tokyo National
 Museum 1989, no. 15
1965.10-12.01,02 (Japanese Paintings ADD 381, 382)

The subject of this pair of screens is the four
seasons, beginning with spring on the right,
represented by double cherry blossoms, and
ending in winter, with snow-covered
bamboos, on the left. Spring and summer
are marked by the disk of the sun, the
ancient symbol of the male yang (*yō*)
principle, and autumn and winter by the
young crescent moon, representing the
female principle of yin (*in*). The sun is seen
through the masculine pine and the moon
through the feminine maple. The sun and
moon were also representative of both
Buddhist and Shintō deities. Partly
symbolic, the screens are also decorative,
the foreground filled with bamboo and
brush fences covered in gold leaf over
built-up gesso. The white pigments are also
built up over gesso and originally would
have shown up with greater brilliance. The
painting style is a mixture of Tosa and Kanō
elements and is therefore probably the work
of an independent town painter. The
concept of the composition is late
Muromachi period, but the lack of any sense
of a background points to the succeeding
Momoyama period.

FURTHER READING Tokyo National Museum,
Muromachi jidai no byōbu-e, Tokyo, 1989

ANON. (Kanō school)

45 Genre scenes in the city of Kyoto

Edo period, early 17th century
Six-fold screen; ink, colours and gold leaf on
 paper; 1030 × 2160 mm
Published: *Ukiyo-e taikan* 1 (1987), nos 3–4; Tokyo
 National Museum 1987, no. 12
1961.4-8.03 (Japanese Painting ADD 372)

Since screens were nearly always produced
in pairs, it is assumed that this is the
survivor of a larger composition. The
balance suggests that this is the right-hand
of the pair. Scenes of Kyoto city life painted
on screens were known as *rakuchū rakugai*
('in and out of the city'), beginning with
distant panoramas separated by
conventional clouds of gold leaf or gold dust
in the mid-sixteenth century, and gradually
closing in on more detailed areas as time
went on. This example is from the early
seventeenth century; it is relatively close to
the scenes it portrays, but the heavy use of
gold remains. The appearance in the street
(top right) of a group of *namban* (Portuguese
or possibly Spanish visitors) dates the
painting well before the total proscription of
Roman Catholicism in 1639. The main
subject is a lively round-dance to celebrate
the cherry blossom, performed by the
ordinary people in the courtyard of a noble
house. The upper-class spectators, grandly
dressed, can be seen sitting round the
verandas.

FURTHER READING Takeda, Tsuneo (ed.), *Nihon
byōbu-e shūsei*, vol. 13 *Fūzokuga – Sairei, Kabuki*,
Tokyo, 1978

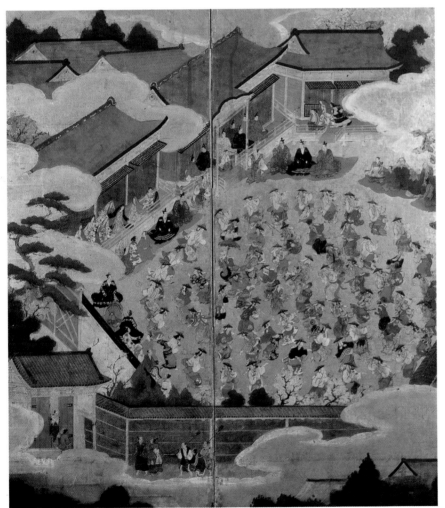

45 detail

ANON. (Hasegawa school)

46 Birds and flowers of the four seasons

Momoyama/Edo periods, early 17th century
Four sliding-door panels (*fusuma*); ink,
 colours, gold and silver on paper; each
 c. 1735 × 1410 mm
Provenance: Said to have come from Danzan
 shrine, Tamumine (Tōnomine), Nara Prefecture;
 Kawaguchi Collection
Published: Gray 1938, p. 47, pl. XVI; Tokyo National
 Museum 1987, no. 9
1937.10-9.01-04 (Japanese Paintings ADD 129–32).
 Given by the National Art Collections Fund

This set of four *fusuma-e* (painted sliding
doors) would have formed one wall of a
room. Other walls would have been
composed of matching *fusuma-e*, probably
by the same artist and also probably on the
complementary theme of spring and
summer. It is known that these *fusuma-e*
were once backed with other paintings on
the subject of the 'four accomplishments',
which were later separated and are now in
the Seattle Art Museum. The British
Museum's set combines symbols of autumn
and winter, unusually running from left to
right, beginning with the red maple leaves
of autumn and ending with the early
camellias of late winter.

The foreground-dominated construction,
filled with strong motifs set among clouds
and mists in gold and silver leaf and dust, is
typical of the Momoyama style. The
hatching of the rocks with thick, angled
brush strokes is of the style of Hasegawa
Tōhaku, and may be the late work of his son
Takanobu (1571–1618).

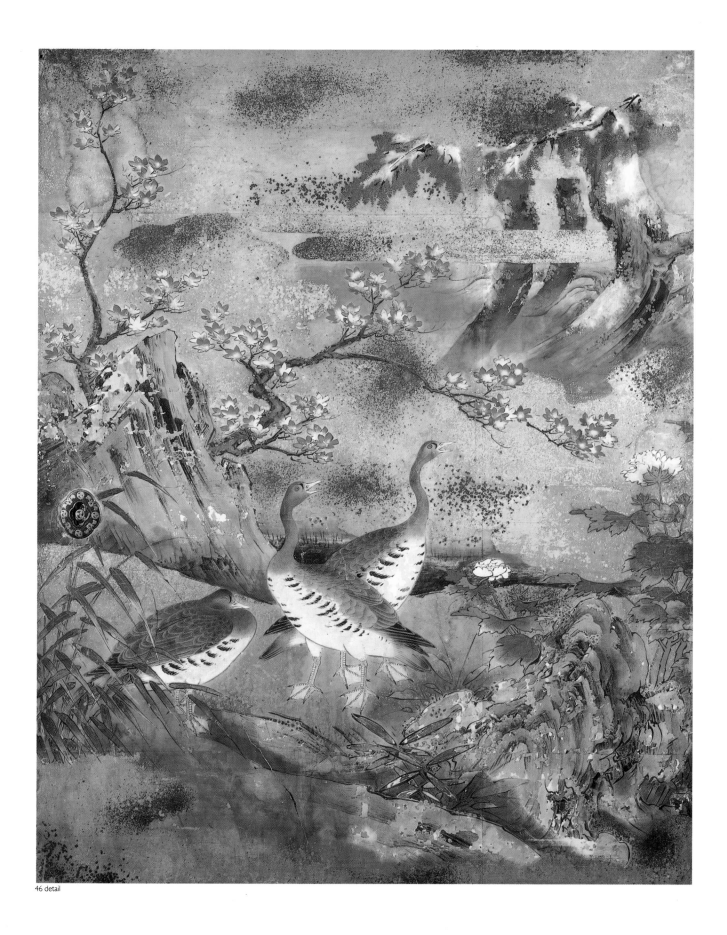

46 detail

ANON.

47 Bamboo in the snow

Edo period, 17th century
Pair of six-fold screens; ink, colours, gold and
 silver on paper; each *c.* 1540 × 3590 mm
Published: Tokyo National Museum 1987, no. 10
1922.11-16.02, 1923.4-17.01 (Japanese Paintings
 ADD 19, 20)

These striking paintings would have once
been even more brilliant when the mists of
silver dust and leaf scattered over the
background retained their original colour,
suggesting a sunny and frosty morning. In
spite of the extreme boldness and sweep of
the composition, a feature normally
associated with the screen painting of the
Kanō, Hasegawa and Kaiho schools in the
Momoyama period, it is closer in its poetic
reticence, suggestiveness and economy of
means to the work of the Tosa school (cf.
no. 51). As normal in a non-narrative pair of
screens, one is female (left) and one male
(right), and the composition continues
across the two. The bamboo is painted in
black ink and green pigment with
considerable finesse of brushwork, while
the snow is laid on in thick patterns of
shell-white (*gofun*) over built-up relief
shapes in the *moriage* technique.

FURTHER READING Yamane, Yūzō (ed.), *Nihon
byōbu-e shūsei*, vol. 7 *Kachōga – shiki sōka*, Tokyo,
1980

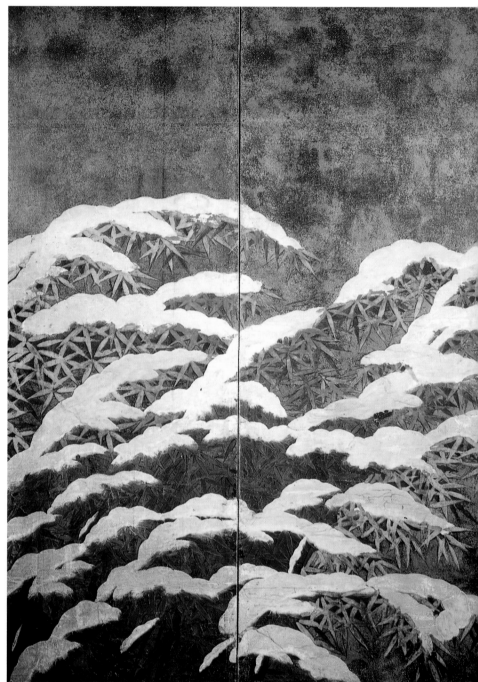

47 detail

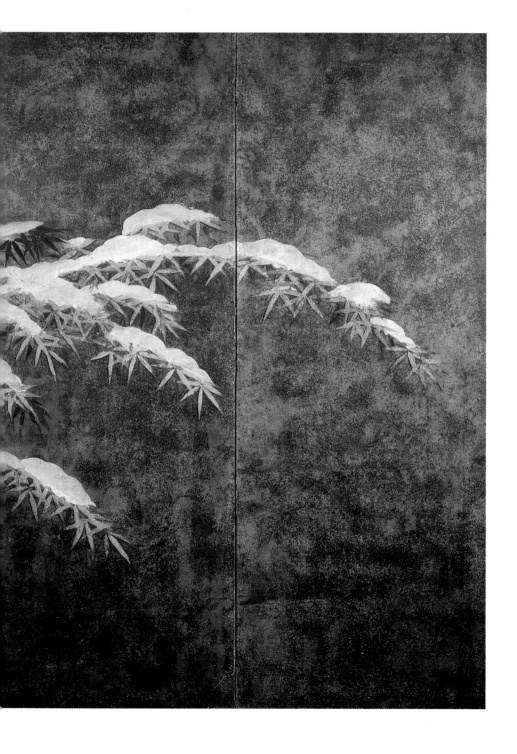

48 detail

ANON. (Kanō school)

48 *Shuten dōji* ('Yorimitsu and the drunken monster of Mount Ibuki')

Edo period, 17th century
Handscroll; ink, colours and gold on paper;
 H. 268 mm
Provenance: William Anderson Collection
Published: Anderson 1886, nos 383–416; Anderson
 1886a, pl. 13
1881.12-10.383-416 (Japanese Paintings 453–87)

One of Japan's most popular stories was the legend of the destruction by Minamoto no Yorimitsu (who actually lived AD 948–1021) of the ogre called the Shuten Dōji ('The Drunken Boy'). This flesh-eating, drunken giant lived in the mountains, where he kept young women captive, some of whom he ate. Yorimitsu and his four companions gained access to his lair disguised as travelling priests, got the monster intoxicated, and cut off his head. The real Yorimitsu was a warrior who helped the court rid Japan of bandits and pirates, hence the attachment of this legend to him.

This vigorous scroll combines breadth of design and a lively narrative sense with elegance of detail without a hint of stilted prettiness. It is clearly the work of an atelier of the Kanō school. Much of its composition is based on a celebrated set of scrolls attributed to Kanō Motonobu (1476–1559), but this seventeenth-century version, judging from its more earthy vigour, is probably a commission from a rich townsman rather than from a *daimyō* family. The section illustrated shows Yorimitsu and his companions crossing a mountain river on their way to the giant's lair.

FURTHER READING Okudaira, Hideo, *Otogi-zōshi emaki*, Tokyo, 1982

ANON. (Tosa school)

49 *Ukifune* ('A Boat upon the Water')

Ch. 51 of *Genji monogatari* ('The Tale of Genji')
Edo period, mid-17th century
Calligraphy attributed to the courtier Ōinomikado
 Tsunetaka (*c.* 1613–82)
Folding album; ink and gold on paper;
 121 × 119 mm (painting)
Provenance: Sir A. W. Franks Collection
1902.6-6.8 (Japanese Painting 114). Bequeathed by
 Sir A. W. Franks

The scene is from Chapter 51 of 'The Tale of
Genji', Japan's greatest work of literature
and one of the most common artistic
subjects. Here, near the end of the story, the
Lady Ukifune (meaning 'Floating Boat'),
occasional mistress of Kaoru, is taken in a
boat in midwinter across the Uji River by
Prince Niou, who is Kaoru's old friend. This
is one of the most striking events in the
story, and one of the most frequently
illustrated. Opposite is a very brief digest of
the incident in fine calligraphy.

The illustration is in the style of the Tosa
school and in the most refined of all
Japanese painting techniques, known as
hakubyō (literally 'white drawing'). Only ink,
heightened with a lacquering agent, is
applied with very fine brushes on to a

49

highly prepared and glazed paper, with
meticulously applied bands of gold mist. It
was used only for courtly classics on the
most allusive and poetic subjects.

FURTHER READING Murase, Miyeko, *The
Iconography of the Tale of Genji*, New York and
London, 1983

50

ANON. (Sōtatsu school)

50 Scenes from *Ise monogatari* ('Tales of Ise')

Edo period, 17th century
Six-fold screen; ink, colour, silver and gold leaf on
 paper; 1510 × 3586 mm
Provenance: Inscription by Sumiyoshi Hiromori
 (1705–77) attributing the painting (falsely) to
 Tosa Mitsuaki (legendary painter, supposed to
 have worked in the 14th century)
Published: Binyon 1928, p. 54; *Ukiyo-e taikan* 1
 (1987), nos 1–2; Tokyo National Museum 1987,
 no. 11
1948.11–27.014 (Japanese Painting ADD 299). Given
 by the Hon. Mrs Robert Wood

This screen, originally one of a pair, uses
three chapters (*dan*) of the tenth-century
poetic collection *Ise monogatari* ('Tales of Ise')
to link in a very loose way a series of
arrestingly decorative visual subjects. The
lower half, set against gold leaf, is from *dan*
23, showing the childhood friends by the
well, who later in life marry. Then the
husband becomes suspicious of his wife; he
is seen hiding in the bushclover (centre),
listening to her soliloquy from her veranda
(left). At top right (*dan* 45) a bereaved lover
is stirred to sadness by the rising fireflies.
Top centre and right (*dan* 69) the artist rather
freely interprets the story of the visit of the

Imperial falconer to Ise on a hunting
expedition and his liaison with the priestess
there. The centre is dominated by a scene of
duck cookery, while the goose motif
painting on the sliding doors refers back to
dan 45. The inevitable exchange of poems is
shown in the writing scene top left. The
whole of the melancholy *dan* 69 section is
enclosed in silver clouds, darkened with
age.

The artist was clearly of the school of
Tawaraya Sōtatsu (died *c.* 1643) and knew
his celebrated album paintings of the *Ise
Monogatari*.

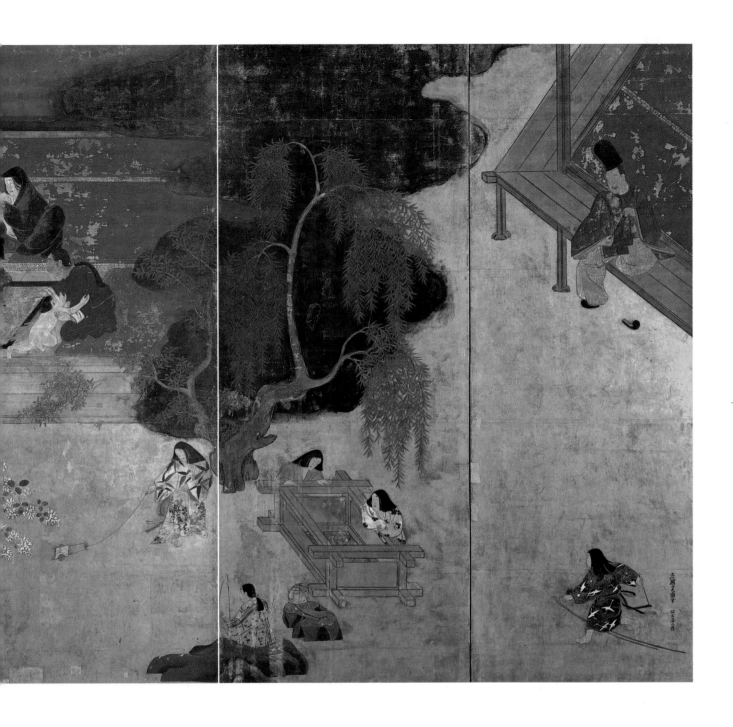

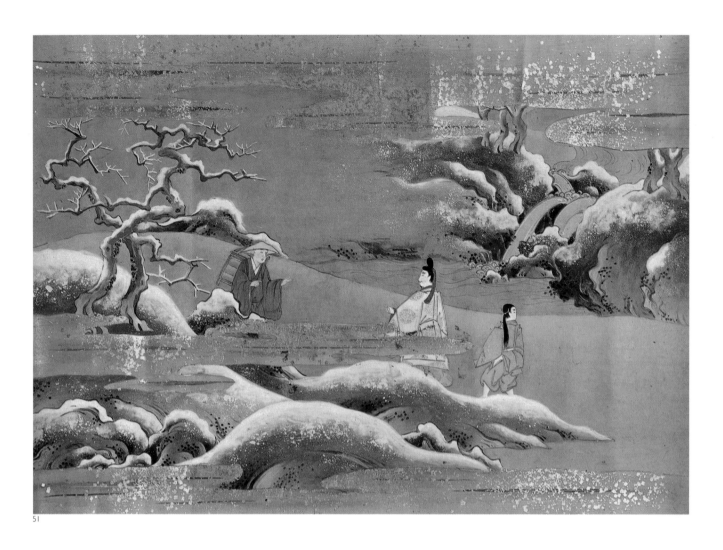

51

ANON. (Tosa school)

51 *Ise monogatari* ('Tales of Ise')

Edo period, 17th century
Set of five handscrolls; ink, colours and gold on
 paper; H. 340 mm
Provenance: Certificate of authentication by
 Kohitsu Ryōchū dated 1848 attributing the
 paintings to Tosa Mitsuoki (1617–91)
1920.5-14.16 (1–5) (Japanese paintings ADD 5–9).
 Given by G. B. Dodwell

These five scrolls alternate the text of the
tenth-century poetic anthology 'Tales of Ise'
with richly worked illustrations in the old
e-makimono ('picture handscroll') manner
which had flourished since before the
twelfth century. 'Tales of Ise' concern the
amorous adventures of a young courtier
traditionally identified with the
ninth-century poet Ariwara no Narihira,
and are no more than introductions to the
poems. The Tosa school had since at least
the fifteenth century been official court
artists in Kyoto, and such works were their
special preserve, characterised by a
minutely finished and colourful style loaded
with allusion. Chapter (*dan*) 9 is one of the
most frequently illustrated, including this

scene where the exiled Narihira and his
companion meet a travelling priest in wild
country. Narihira recognises the priest as
being from the capital and asks him to
deliver a message to his love. The poetic
treatment and fine finish of the first scroll
decline in the later scrolls, suggesting that
they were completed by lesser pupils in the
studio. However, the attribution to
Mitsuoki is very doubtful.

FURTHER READING Murase, Miyeko, *Tales of Japan:
Scrolls and Prints from the New York Public Library*,
New York and Oxford, 1986

ANON. (Kanō school)

52 Tsushima River festival

Edo period, mid-17th century
Pair of eight-fold screens; ink, colours and gold
 leaf on paper; each *c.* 1510 × 4650 mm
Provenance: William Anderson Collection
Published: Anderson 1886, nos 1717, 1718; *Ukiyo-e
 taikan* 1 (1987), nos 8–13; Tokyo National
 Museum 1987, no. 13
1881.12-10.1717, 1718 (Japanese Paintings 1379,
 1380)

Pairs of eight-fold screens of this size are
rare, suggesting that this type was intended
as much as a detailed record of an event as a
decorative object. The Tsushima River
festival (near modern Nagoya) was an
ancient event in which many large
water-borne floats took part. As a
midsummer festival, part of it took place at
night, with boats adorned with astonishing
groups of lanterns which were one of the
specialities of the district (right-hand
screen). At the right is the Tennō bridge and
a glimpse of the red *torii* ('gateway') of the
Tsushima shrine, origin of the festival. The
left-hand screen moves into the daytime
event. These works, the oldest complete set
of their type, record an extraordinary wealth
of detail about the popular entertainments
of the time, including Kabuki and puppet
theatrical performances. The conventional
gold clouds lift the presentation above the
prosaic; the detail is clearly the work of a
popular city-based Kanō artist.

FURTHER READING Takeda, Tsuneo (ed.), *Nihon
byōbu-e shūsei*, vol. 13 *Fūzokuga – Sairei, Kabuki*,
Tokyo, 1978

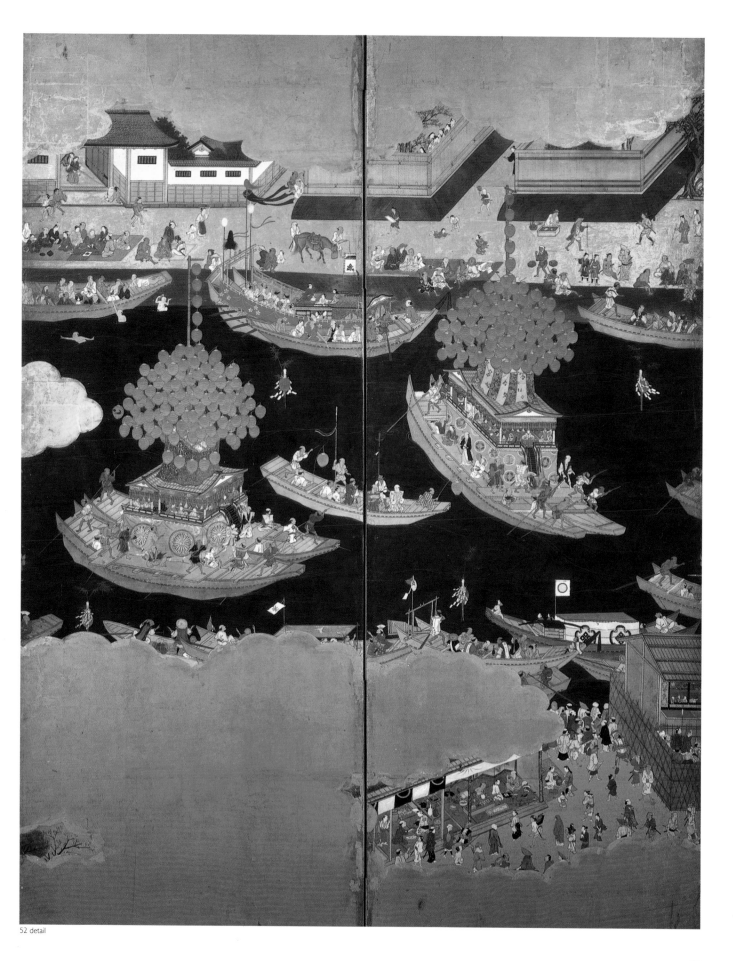

52 detail

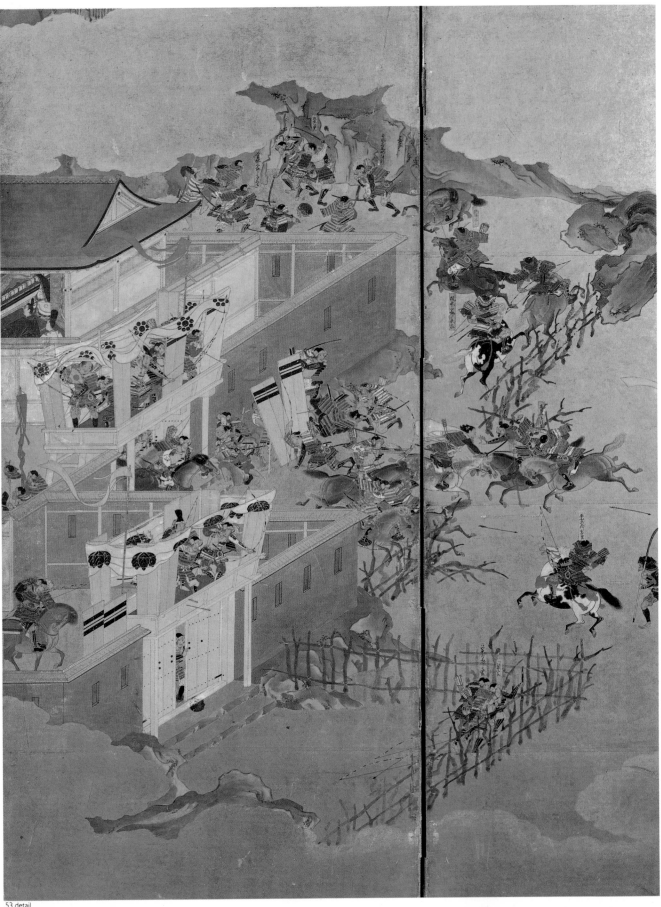

53 detail

ANON. (Kanō school)

53 Battles of Yashima and Ichinotani

Edo period, 17th century
Pair of six-fold screens; ink, colours and gold leaf
 on paper; each *c.* 1554 × 3738 mm
Provenance: Possibly in the collection of James
 Tissot (*c.* 1870); James L. Bowes (1890); Branch
 and Leete, Liverpool (21 May 1901, lot 1781);
 James Martin White Collection
Published: Bowes 1890, pp. 27–8; *Nihon byōbu-e
 shūsei*, vol. 5 (1979), nos 105–6
1950.11-11.022, 023 (Japanese Paintings ADD 324,
 325). Given by the Trustees of James Martin
 White

Two of the last decisive battles of the
Taira-Minamoto Civil Wars are here
depicted in brilliant detail with a formidable
sense of spatial organisation, much aided by
the traditional gold clouds which allow the
different sections to be either separated or
linked by implication. Ichinotani (1184) and
Yashima (1185) were both victories of
Japan's greatest hero, Yoshitsune, on behalf
of his brother, Yoritomo, head of the
Minamoto family (no. 41). Yoshitsune
afterwards fell out with Yoritomo and was
hounded by him to suicide, but he remained
a popular hero and his stories were
constantly told in chronicles, plays and
songs. References to these particular wars
were encouraged in the Edo period,
probably because the Edo shoguns traced
their descent and legitimacy back to
Yoritomo's appointment as Shogun. These
works, of course, were painted nearly 500
years after the events themselves, but the
traditions of warfare of the earlier period
were handed down with surprising
accuracy. The paintings are likely to be the
work of an independent town-artist.

 The detail shown is the final assault on
the Yashima fortress, following
Yoshitsune's surprise descent from the
mountains.

FURTHER READING Yamane, Yūzō (ed.), *Nihon
byōbu-e shūsei*, vol. 5 *Jimbutsuga – Yamato-e kei
jimbutsu*, Tokyo, 1979

54

54 Shell game box

17th-18th century
Paintings on papar pasted on a wooden base;
 H. 35.6 cm
Published: Smith and Harris 1982, col. pl. 2
1933.12-11.1. Given by G. Fenwick Owen

The box is decorated with scenes from the
courtly romance 'The Tale of Genji'. It once
contained pairs of shells, each half painted
with a related design from the story, and
sufficient shells for each day of the year. The
game consisted of finding the matching
halves, the union of which symbolised
matrimonial concord. A complete set was an
important part of the bridal trousseau.
Other literary subjects, such as the 'One
Hundred Poets' Anthology', could also be
used.

55 detail, Ueno

ANON. (Sumiyoshi school)

55 Views of Ueno and Asakusa

Edo period, early 18th century
Pair of handscrolls; ink, colours and gold
 on paper; 295 × 11,010 mm (Ueno),
 295 × 11,110 mm (Asakusa)
Provenance: James L. Bowes Collection (1890);
 Branch and Leete, Liverpool (21 May 1901, lot
 2047); James Martin White Collection
Published: Bowes 1890, pp. 29–30; Ueno 1985, nos
 48, 49; *Ukiyo-e taikan* 1 (1987), nos 69–80; Tokyo
 National Museum 1987, no. 23; Smith 1988,
 no. 48
1950.11-11.021 (1, 2) (Japanese Paintings ADD 341,
 342). Given by the Trustees of James Martin
 White

The amount of fine detailed work, the
complexity of composition, the expensive
pigments and liberal use of clouds of gold
flakes in these two long handscrolls (each
11 m fully unrolled) suggest an order from a
very rich patron. The opulence of the

concept was indeed probably double what
appears, for these scrolls are set respectively
in spring and summer and would almost
certainly have been continued in a further
two scrolls set in autumn and winter. It is
tantalisingly possible at this period that the
artist's signature might have appeared at
the end of the last scroll. From style it is
thought that the scrolls are the work of a
Sumiyoshi school artist who inherited the
skill of Sumiyoshi Gukei (1631–1705) in
organising crowded scenes in handscroll
form. The spring scroll shows crowds
viewing cherry blossom in the hilly Ueno
district, including scenes in the Kan'eiji
Temple, while the summer scenes are set on
the Sumida River, the Ryōgoku Bridge and
the nearby shopping streets. It is notable
that in modern Tokyo these two districts
retain almost the same character as in the
early eighteenth century.

56

ANON. (Rimpa school)

56 Rabbits and autumn grasses

Edo period, 18th century
Six-fold screen; ink, colours and gold leaf on
 paper; 1540 × 3270 mm
Provenance: Ricketts and Shannon Collection
1933.9-29.03 (Japanese Painting ADD 88).
 Presented as a tribute to Laurence Binyon

Usagi ('rabbits' or 'hares') are not a very
common subject of Japanese art, except in
small-scale paintings, prints and carvings
made to greet the Rabbit Year, the fourth in
the twelve-year calendar cycle. This screen,

originally one of a pair, is most unusual in
using rabbits as the principal subject on
such a large scale. They are set against the
waving grasses of summer and autumn
associated in art with the Musashino Plain,
more usually a setting for quail. The bold
freedom of the design, its unerring
decorative grouping of the animals and the
use of light-and-shade effects on their
bodies suggest the Rimpa school in the
mid-eighteenth century in the generation
following the death of Ogata Kōrin in 1716.

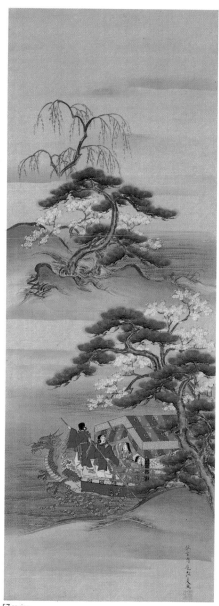

57 spring

SUMIYOSHI HIROSADA (1793–1863)

57 Court amusements in spring and autumn

Edo period, mid-19th century
Signature: Sumiyoshi Naiki Hirosada ga ('painted by Sumiyoshi Naiki Hirosada'); *seal*: (unread)
Pair of hanging scrolls; ink and colours on silk; each *c*. 974 × 362 mm
Provenance: William Anderson Collection
Published: Anderson 1886, nos 216, 217
1881.12-10.216, 217 (Japanese Paintings 270, 271)

This pair of hanging scrolls records in a spirit of considerable nostalgia two of the ancient annual events of the Imperial court in Kyoto known as the Nenjū Gyōji. The pairing is also traditional in that it brings together a spring and autumn scene. One shows an expedition in a courtly dragon-prowed boat to view cherry blossom; the other is a moonlight musical party in autumn to view the maple leaves. The Sumiyoshi artists were Yamato-e style painters who worked in their own version of that traditional manner, but their patrons were, from the later seventeenth century, the shoguns in Edo rather than the court in Kyoto, for which the Tosa school continued to work. There is perhaps more liveliness and a brighter palette marked by stronger colours in Sumiyoshi style, and a more relaxed, less formalised pictorial construction.

The Nenjū Gyōji was a particular province of the Sumiyoshi school, since its founder Jokei (1599–1670) had made a treasured copy of the twelfth-century original, now lost.

58 detail

MIYAMOTO CHIKKEI (b. 1912)

58 *Murasaki Shikibu Nikki* ('The Diary of Musasaki Shikibu')

Completed New Year 1989
Nine handscrolls written in ink on various
 coloured papers; H. 334 mm
1989.12-20.06 (Japanese Painting ADD 917). Given
 by the calligrapher

Chikkei has revived the art of calligraphy in
the *hiragana* manner, the most Japanese of
all writing styles, and has with success
attempted to rediscover or have made
decorated papers of the sort which were
used from the Heian period onwards for the
great literary classics. His works include
complete versions of the *Manyōshū*
anthology and 'The Tale of Genji'
(see no. 49). This text is a diary thought
to be the work of Murasaki Shikibu, author
of 'The Tale of Genji'. It includes much of
her best poetry. Chikkei uses many
variants, some of them obscure, for the
hiragana syllables which compose the
greater part of the text, and for that reason
they are difficult to read; but they give
variety and distinction to the calligraphy
itself.

TERUTADA SHIKIBU (worked early–mid-16th
century)

59 Mountain landscape

Muromachi period, early–mid-16th century
Seals: Terutada, Ryūkyō
Fan painting, mounted as a hanging scroll; ink and
 gold on paper; 260 × 525 mm
Provenance: William Anderson Collection
Published: Anderson 1886, no. 603
1881.12-10.603 (Japanese Painting 373)

Nothing is known of this artist, whose seal
Ryūkyō appears on a number of paintings in
the late Muromachi ink style. The
folding-fan form was much liked by
Japanese and Korean artists, possibly
because its distortions of space gave
opportunities for them to create a sense of
movement and mood, rather than the
rationally expressive grandeur central to
Chinese landscape painting. This example
was probably one of a set pasted to a screen
but was removed and mounted on to a
hanging scroll at a later date. In any case, it
was clearly never folded and actually used
as a fan like the much later painting by
Bunchō (no. 175). The mingling of strong
ink strokes with pale ink wash and gold
shows the influence of the Kanō school of
artists, who by the mid-sixteenth century
were beginning to dominate Japanese
painting in the 'Chinese' tradition.

FURTHER READING Rosenfield, J. M. (ed.), *Song of
the Brush: Japanese Paintings from the Sansō
Collection*, Seattle, Seattle Art Museum, 1979

59

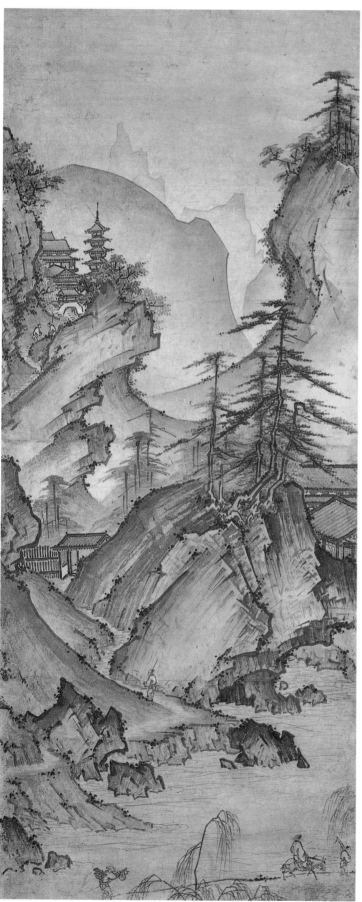

60

ANON.

60 Mountain landscape

Muromachi period, 16th century
Hanging scroll; ink and slight colour on paper;
 1310 × 533 mm
Provenance: Suihyōshi Collection, Kyoto
 (attributed to Kei Shōkei)
1966.7-25.013 (Japanese Painting ADD 387)

There is little to support the attribution to
the Zen priest-painter Kei Shōkei (worked
mid-fifteenth to early sixteenth centuries),
but this Chinese landscape is certainly in an
older tradition than that of the Kanō school.
It retains a lightness, clarity of line and
rationality of composition which were
inherited from the Southern Song school,
especially through the fifteenth-century
priest-painter Shūbun. The temple is set
firmly in the middle ground, and the route
to it from the foreground is clearly
distinguished. The three-plane organisation
inherited from Song painters is completed
in the distant mountains in pale blue wash.
A comparison with the Kanō landscape
(no. 61) of about the same period shows
very vividly the difference between the two
 Chinese' styles. Nevertheless, the relatively
limited scale of the landscape displays a
Japanese preference.

FURTHER READING Shimizu, Yoshiaki, and
Wheelwright, Carolyn (eds), *Japanese Ink Painting
from American Collections: The Muromachi Period*,
Princeton, 1976

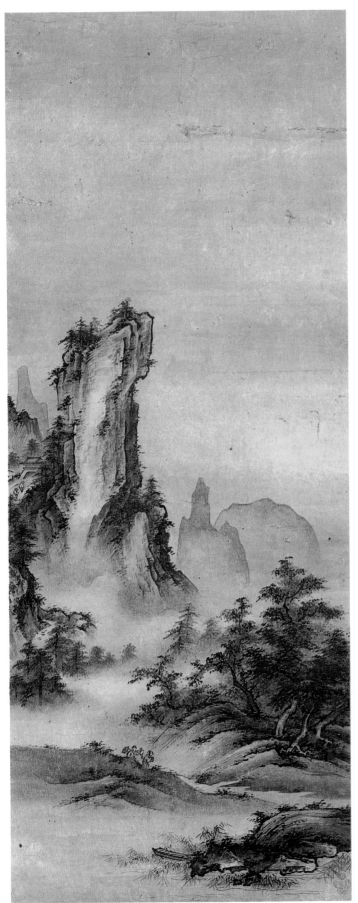

62 detail

ANON. (style of KANŌ MOTONOBU)

61 Mountain landscape

Muromachi period, 16th century
Seal: Motonobu (in jar-shaped seal added later)
Hanging scroll; ink and slight colour on paper;
 1037 × 412 mm
Provenance: Arthur Morrison Collection
Published: Morrison 1911, pl. XXXVII
1913.5-1.0157 (Japanese Painting 440). Given by
 Sir W. Gwynne-Evans, Bt

The ink-painting of the Kanō school in the
late fifteenth and early sixteenth centuries
produced a version of Chinese-inspired ink
landscape which found favour with
Japanese connoisseurs, especially those
from the ruling military class, and was to
remain very dominant in Japan until the
emergence of the Nanga painters in the
mid-eighteenth century. One of its
strengths lay in its very native contrasts of

61

precision and vagueness, expressed respectively in strong, rather hard brushwork and delicately suggestive ink washes. This landscape by a Kanō painter of the mid-sixteenth century demonstrates both admirably, as well as the minimal and symbolic use of colour. The tight, narrow construction is also very suitable for hanging in the *tokonoma* alcove for contemplation. As often in Chinese-style landscape, tiny human figures in the foreground emphasise the grandeur of nature. Careful scrutiny of the painting will show its suitability for expansion, by enlarging the sections of mist, into a large-format screen composition.

FURTHER READING Yamaoka, Taizō (ed.), *Nihon bijutsu kaiga zenshū*, vol. 7 *Kanō Masanobu/Motonobu*, Tokyo, 1978

Attributed to KANŌ TAN'YŪ (1602–74)

62 Landscape

Edo period, mid-17th century
Handscroll; ink and slight colours on paper;
532 × 9639 mm
Provenance: Inscription by Kanō Tanshin
(1653–1718) attributing the painting to Kanō
Tan'yū; Arthur Morrison Collection
Published: Morrison 1913, pl. XLVIII
1913.5-1.0201 (Japanese Painting 558). Given by
Sir W. Gwynne-Evans, Bt

Tan'yū established the very considerable dominance of the Kanō school over Japanese painting, and as a result of this and the studio system of teaching he is best known from dull copies of his most academic works. In fact, an innovative painter of both breadth and sensitivity, his

finest achievements lie in his splendid revivals of the misty landscape style of the Southern Song in China, seen at their most striking in sets of *fusuma-e* (painted doors) for Zen temples such as Tokuzenji, Kyoto. This scroll, reasonably attributed to his brush, consists of a series of sketches, which demonstrate his recapture of the sense of deep space which had been lost since the fifteenth century and was soon to be lost again. There seems to be some reference to Lake Biwa, Japan's largest lake, which was often compared by artists and poets to the landscapes of China.

FURTHER READING Takeda, Tsuneo (ed.), *Nihon bijutsu kaiga zenshū*, vol. 15 *Kanō Tan'yū*, Tokyo, 1978

63

MORI SHŪHŌ (1738–1823)

63 Horses

Edo period, late 18th century
Signature: Hokkyō Shūhō Takanobu hitsu ('Painted
 by Shūhō Takanobu, Bridge of the Law');
 seals: Shūhō betsugō Shūsai, Mori-uji Buntai
Four-fold screen; ink and *gofun* on paper;
 1360 × 2648 mm
Provenance: Mr K. Kishimoto Collection, Takasago
1988.10-18.01 (Japanese Painting ADD 880). Given
 by Mr K. Kishimoto

Mori Shūhō has been considerably
overshadowed by his younger brother, Mori

Sosen (no. 183), and certainly he did not
follow the same path of narrow
individuality. Instead of rebelling against
the dull conventionalities of the Kāno
school, which was virtually the only
thorough teaching in ink-painting method
available until late in the eighteenth
century, he tried to use its best points in a
fresh way, tending towards a pleasing
freedom and lightness of brushwork
admired among the Osaka educated
bourgeoisie which was his milieu. In this

light-hearted screen he takes an old Kanō
subject of running horses done in ink and
wash (itself derived from much earlier
Chinese originals) and recreates it with a
most pleasing understated deftness of touch
and an unerring placement of the subject in
a suggestive space. The screen has been
remounted and its proportions altered at
one point in their history, but their
condition is otherwise pristine.

FURTHER READING Osaka City Museum, *Kinsei
Osaka gadan*, Kyoto, 1983

SWORDS, SWORD-FITTINGS AND ARMOUR

(nos 64–83)

The military successes within Japan of the Yamato state during the Kofun period (fourth to sixth centuries) owed much to its superior iron weaponry. Armour consisted of helmet, sleeves and a cuirass-covering over the shoulders and down to the thighs, all composed of linked and riveted plates. The long swords were straight and single-edged, ending in an angular-edged point, and many were around one metre in length. A clearly defined line ran the whole length of the blade and is known as the *shinogi* ('ridge'). On most early blades there is a single *shinogi* on one side. The first swords were brought from China and Korea, and these were faithfully copied in Japan by smiths whose technology gradually improved. By the Nara period there was a recognised distinction between Chinese swords, Chinese-style swords and *Kōrai no tsurugi* ('swords from Korea'). It is believed that many swordsmiths came from Korea during that period, settling into a profession which came to be considered the most noble of all crafts.

The sword has been known as one of the three items of the Imperial regalia in Japan since the earliest written records; it is invariably found buried in the tombs of nobles of the Kofun period, and examples from at least as early as the seventh century AD have been carefully preserved in Buddhist temples and Shintō shrines as sacred objects. Indeed, some swords are held to be manifestations of Shintō gods, like the Futsu Mitama Ōken, the resident deity in the Kashima shrine (now in Ibaraki Prefecture). Many of these early straight swords have recently been polished by the traditional Japanese method using soft stones, to reveal a complex steel grain, and also a specially hardened cutting edge visually enhanced by complex crystalline forms running the length of the blade. These characteristics appear in the classic curved blade of later periods.

During the Nara period further types of sword

developed, gradually resulting during the early Heian period in the single-edged curved samurai sword, with a ridge line high up each side of the blade. Many blades survive in perfect condition from that time. Those of the Heian period are elegantly shaped, reflecting the aristocratic taste of the period. Reference in the *Engi Shiki* chronicle (901–22) to the several steps of the process of polishing swords indicates that the beauty of the steel was appreciated over 1,000 years ago. Since those days the sword has been considered by the Japanese at once something spiritual, beautiful and, as a weapon, dreadful.

The special method of manufacture of the traditional sword involves first a repeated folding and hammering out, and finally a heating and quenching in water to harden the edge. The resulting blade has a tough and resilient core to withstand the shock of cutting hard objects, and an edge as hard as carbon steel can be while still retaining its strength. The main visual features of a finely polished blade are the grain of the body of the blade and the *hamon*, or pattern due to the hard crystalline structure along the cutting edge. These characteristics together help indicate the age of the blade, and the smith or school of the smith who made it, together with the actual shape and curve.

The changing shape of the sword

The shape of the blade is the most important clue to its age. Blades of the Heian period are long, up to around eighty centimetres from guard to point, deeply curved near the base, and straightening out towards the small angular *kissaki*, or point section. The blades narrow to about half their width towards the point, so that the sword might be light and easy for a horseman to manage with one hand. The point of the sword could thus be used delicately like a rapier to search for the chinks in the opponent's armour, or the lower and broader part could be used to make a strong two-handed cut. These long swords, or *tachi*, were mounted in lacquered wooden scabbards and carried suspended loosely by chains or cords from the belt (no. 73).

Although inscriptions have been found on a few swords of the Nara period and even earlier, from the Heian period onwards it was usual for the smith to sign his name, province and sometimes the date of manufacture on the tang. In no other art was the individual allowed so early to mark his presence and personality, a most telling proof of the extremely high prestige of the swordmaker. This fact, together with the care with which many swords have been preserved, has made possible an accurate, art-historical survey of swords over 1,000 years (no. 64).

The Heian fashion in sword blades continued for some decades after the establishment of the government at Kamakura in 1185, but by the middle of the thirteenth century the blades had become broader and more robust, reflecting the vigour of the now dominant samurai culture. A strange conservatism among swordsmiths, however, kept the length of the *kissaki* the same as those of the preceding period. The result was that the point gave the illusion of being short and stubby, and became known as *ikubizaki* ('bull-neck point'). Daggers, or *tantō*, of the period have no longitudinal ridge on the blade and are almost straight but for a very slight downward curve along the back (no. 68).

Further developments resulted from the experiences of the Japanese armies against the Mongols when Kublai Khan attempted invasion in 1274 and 1281. The Mongols relied on massed archery and combat by close groups of infantry armed with large cutting weapons, in contrast to the Japanese tendency to individual and rather disorganised warfare. From that time onwards swords became longer, with matching longer points and an even curve. Many large glaive-like weapons, or *naginata*, were made during this period. By the end of the Kamakura period and during the fourteenth-century Nambokuchō wars between the supporters of two rival Imperial factions swords became of great length. Many were more than one metre and even one and a half metres in length along the cutting edge. Such swords survive in their original length in temple collections, but most were cut down during the fifteenth to seventeenth centuries to a more usable size (nos 65, 66). Daggers of the period were correspondingly long and broad.

After the re-unification of the country in 1393 and the assumption of the title of Shogun by Ashikaga Yoshimitsu, a few generations of relative peace ensued. The large swords of the Nambokuchō period were abandoned in favour of shorter ones, worn thrust through the belt with the cutting edge uppermost, called *uchigatana* ('striking swords'). The *uchigatana* of the fifteenth and sixteenth centuries were deeply curved at the top of the blade for cutting efficiency (no. 69).

Future warfare was to be a matter for large armies mostly composed of infantry; hence during the long years of intermittent civil war which followed the Ōnin

Rebellion of 1467 many poor-quality swords were made as well as finer ones. During this period the three main centres of sword production were established and recognised in the provinces of Bungo, Bizen and Mino, but following the end of the period of civil wars, as a result of the building of castles in each province and the eventual unification of Japan under the rule of the Tokugawa shoguns in AD 1603, sword production at these three provincial centres virtually ceased.

From then on swordsmiths set up forges in the castle towns, and new traditions were born. Swords made from this period are known as *shintō* ('new swords'), as opposed to *kotō* ('old swords') made earlier. The best smiths were retained by the feudal lords in their provincial centres, although there was also sufficient market in the larger cities of Kyoto, Osaka and Edo to maintain many independent smiths in business.

Momoyama and early Edo period swords were modelled after the old cut-down blades of the late Kamakura and Nambokuchō periods, and were accordingly broad and even-curved. From the middle of the seventeenth century, owing largely to the development of *kendō*, or formal swordplay, a new kind of shallow-curved, almost straight, sword evolved. These Kambun *shintō*, named after the Kambun era (1661–73) in which they appeared, were of a standard length of about seventy centimetres and narrowed somewhat towards the point (no. 72).

There was something of a lull in swordmaking during the early eighteenth century, owing to peaceful times and the declining wealth of the sword-carrying samurai class. But a re-emergence of nationalistic spirit later in the century was to result eventually in the Imperial Restoration of 1867. Revivalist sentiment led to the manufacture of swords in ancient styles, including long swords in Kamakura and Nambokuchō shape, during the late eighteenth and nineteenth centuries. These revivalist styles remain popular among today's collector-clients of the modern swordsmiths, who appreciate their swords wholly as works of art and for their spiritual qualities rather than as weapons of war.

The steel grain and *hamon* of the blades

The major types of grain are *masame* ('straight longitudinal grain'), *itame* ('wood plank grain') and *mokume*, a kind of wood grain with concentric contours. *Masame* is found on some Kofun and Nara period straight swords, and on Kamakura period swords of the Yamato

schools of smiths working within the precincts of armed monasteries. *Itame* and *mokume* are found on the work of many schools from the Heian period onwards. They are further subdivided into 'large' and 'fine' grain, and there are various special names given to the grained steels of noteworthy schools, like the wavy *ayasugi* ('cryptomeria twill') grain of the Gassan school (no. 69), the *konuka hada* ('rice flower grain') of the Hizen school (no. 74), and the *kagami hada* (or almost invisible 'mirror grain') of certain late Edo period smiths.

The *hamon* is the characteristic crystalline-structured steel running along the cutting edge. It results from the special method of hardening the blade. The whole blade is covered with a layer of clay which is scraped away partially along the edge, leaving it only thinly covered and producing therefore a recognisable 'shadow' after tempering. The blade is then heated, according to tradition to the colour of the moon in February or August, and then quenched in water. The resulting more hardened edge structure is classified as of two types, according to the size of the crystals.

Nioi ('fragrance') is a continuous white structure in which the individual crystals are not discernible. *Nie* ('boiling') refers to a continuous band of bright crystals, traditionally likened to frost on grass. The heat treatment also forms less vivid structures on the body of the blade. There is *jinie*, fine *nie* crystals in subtle drifts, and *utsuri* ('reflection') which can be either a continuous or discontinuous band of *nioi*, straight or in wave forms.

There are many running shapes of the *hamon*'s pattern along the blade caused by the way in which the clay is scraped away before tempering. The simplest and oldest is the straight line of crystals, or *suguha*. *Chōjiba* ('clove pattern') is likened to a row of clove flowers. This very picturesque *hamon* was fashionable in many schools during the Kamakura period, but it is specially typical of the Bizen schools. *Gunome* is a reciprocating wave pattern (no. 70), *notare* is an undulating form, and *midareba* ('wild hamon') has no regular form. Both *midare* and *gunome hamon* are found on swords of the Sōshū school, established in the late Kamakura period and typified by the work of Masamune, the most revered of all Japanese swordsmiths. All these patterns are found on swords from the Heian through to the Muromachi periods. From then on the variety increases, with different types of *gunome*, like the distinctive *sambon sugi* ('three cryptomerias') pattern of the school of Kanemoto of Seki in the sixteenth century.

Many smiths of the Edo period worked in old and traditional styles, but some also contrived exotic *hamon* in order to entice the newly rich merchants who had the right to wear a short sword (no. 71). Among these are *hamon* in the form of the waves of the sea, chrysanthemums floating along a stream, a striated form like a bamboo curtain, and various other exaggerated forms which are very typical of the tendencies of Edo period bourgeois culture.

The sword-fittings

Both the *tachi*-type swords, worn suspended by cords with armour (no. 73), and the *uchigatana*-type swords, worn thrust through the belt, were carried in a scabbard of lacquered magnolia wood. The hilt was covered with the hardened and polished skin of the ray fish and bound usually with silk braid. Both ensured a good grip. The metal fittings of the hilt and scabbard (nos 71, 78), and the guard (called *tsuba*, nos 76, 77), were the subject of minute workmanship and regarded as works of art in their own right. Court swords of the Heian period were luxuriously mounted in gold-lacquered scabbards with designs in mother-of-pearl inlay, gilt-copper fittings carved with openwork designs, and even inlaid jewels. Fittings from the more militaristic Kamakura period onwards were either carved or inlaid with motifs, usually in some way symbolising valour. Some indicate the religious awareness of the samurai, with Buddhist or Shintō subjects; some depict the beauties of nature or poetic themes. Some, however, are more light-hearted with references to folk stories or popular deities.

Russet-iron sword guards of the Muromachi period, austerely pierced with stylised openwork designs, are still among the most highly prized. But also from the early Muromachi period right through the Edo period fittings were made with Chinese-inspired decorative motifs for the Ashikaga and after them the Tokugawa shoguns by the Gotō family. The Gotō metalworkers specialised in pieces made of an alloy of copper with a small percentage of gold called *shakudō*, which could be pickled to a rich black or purple-black, said to resemble the colour of a crow's wings in the rain. The *shakudō* base was usually decorated overall with tiny punched marks called *nanako* ('fish roe') and with designs inlaid in gold and silver. The usual themes were *shishi* (lion-dogs), dragons, flowers (especially peonies), birds and animals, and subjects from Chinese legend. In parallel with the work of the Gotō family there were provincial styles

which were well established by the Momoyama period, such as the iron guards inlaid with brass of Higo Province, or the heavy openwork carving of dragons, other beasts and plants by the Kinai school of Echizen Province. In the Edo period studios of *machibori* ('town carvers') sprang up to supply the merchants and richer samurai with elegant pieces with designs free of the restraints of the formal Gotō family work, and in a greater variety of soft metals. These metalworking traditions were to re-emerge, after the prohibition of the wearing of swords in 1873, in the manufacture of ornaments and accessories which were often directed at the Western market. Even sets of cutlery with handles in Gotō style were produced.

Armour

The *ōyoroi* ('great harness') of the Heian period was designed primarily to protect the mounted samurai against arrows, since the bow was the principal weapon at the time. The Japanese bow is taller than a man, but the grip is placed about one-third from the bottom, so that the rider could easily bear his weapon either side of his horse's head when standing high in the stirrups (no. 83). The stirrups were iron platforms large enough to stand firmly in during combat, and their importance is attested by the fine inlaid workmanship found on them.

The helmet was proof against all but the most powerful sword cut, being strongly made of riveted iron plates. It had a hanging neck-guard (*shikoro*) of plates loosely laced together so that it lifted easily when the wearer's arms were raised. Two large flaps on the sides of the helmet called *fukigaeshi* provided shields for the face and throat when the head was lowered. The cuirass covered the whole trunk, and a split apron of lacquered iron plates divided to either side, with a further piece protecting the front. Over the sleeves great rectangular shoulder-pieces were arranged to rise and cover the exposed side when the bow arm was stretched out. Two hanging plates over the breasts performed a similar service. The armour was often richly and complexly decorated, with gilt-copper fittings, much coloured silk braid, and leather, textile or lacquered components. Respect for the armourer's skills is proved, as with sword blades, by the frequent preservation in temples and shrines of historic sets.

Apart from some tendencies towards the appearance of lighter types, armour remained substantially the same until the advent of firearms in the sixteenth century. Then the great shoulder-pieces, the *fukigaeshi* on the

helmets and the cavalry apron became obsolete.and remained only as tokens. The *fukigaeshi* were used only to bear badges, or *mon*. At the same time the need arose for bullet-proof iron breastplates, and many were made copying Western armour. These naturally came to be decorated. In the unstable period of civil wars during the fifteenth and sixteenth centuries any man could rise to a prominent position by personal prowess, and people demonstrated their individuality by wearing suits of exotic armour and even wilder helmets (no. 81), some giving the wearer the appearance of a beast or demon.

Armour remained in use throughout the Edo period for ceremonies such as the annual procession of the provincial lords and their samurai retinues to the capital, and although fine armours in ancient style were still made for the high-ranking samurai, the tendency was towards lighter armour for appearance's sake. Although armour has not been used in battle since the Meiji Restoration, an ongoing programme for reproducing and conserving important early pieces using traditional materials has ensured that the technology of manufacture at least has not been lost.

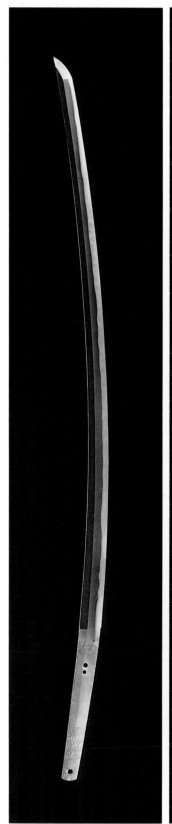

64

64 *Tachi* blade

Kamakura period, 13th century; Bizen Province
Signed: Kageyasu
L. 68.5 cm
Published: Tokyo National Museum 1987, no. 61
1984.7-23.1

The somewhat angular appearance of the
clove-form *hamon*, the deep curve towards
the hilt, the elegant point and the
discontinuous white *utsuri* shadow along
the blade suggest that the sword was made
in Bizen Province in the early Kamakura
period. The name Kageyasu occurs in both
Osafune and Ichimonji schools there, but
the blade characteristics and style of
signature indicate early period old Bizen
work.

65 Shortened *tachi* blade

Attributed in an inscription on *shirazaya*
 (preservation mounting) to the swordsmith Sa
Nambokuchō period, 14th century; Chikuzen
 Province
L. 70.1 cm
Published: Tokyo National Museum 1987, no. 62
1958.7-30.64. Bequeathed by R. W. Lloyd

Sa, said to be short for Saemon Saburō, was
a smith from Chikuzen Province who
studied swordmaking under Masamune in
Sōshū Province during the late Kamakura
period. This sword, although unsigned, is a
fine example of the smith's work. The *hamon*
is rich in activity with bright lines of *nie*
crystals. There are further dense formations
of *nie* on the *ji*, or flat of the blade, together
with a paler shadow characteristic of Sa's
work.

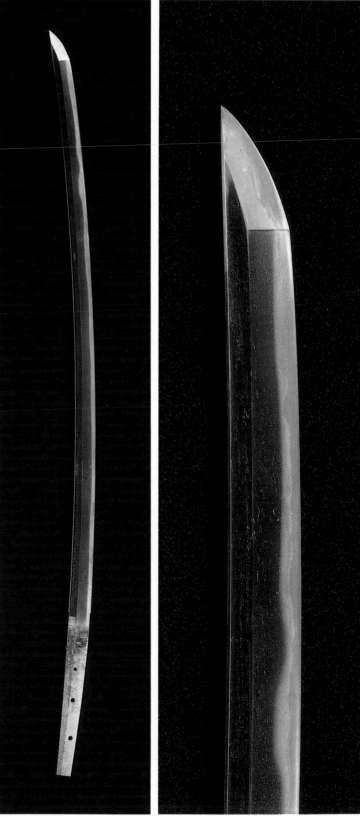

65

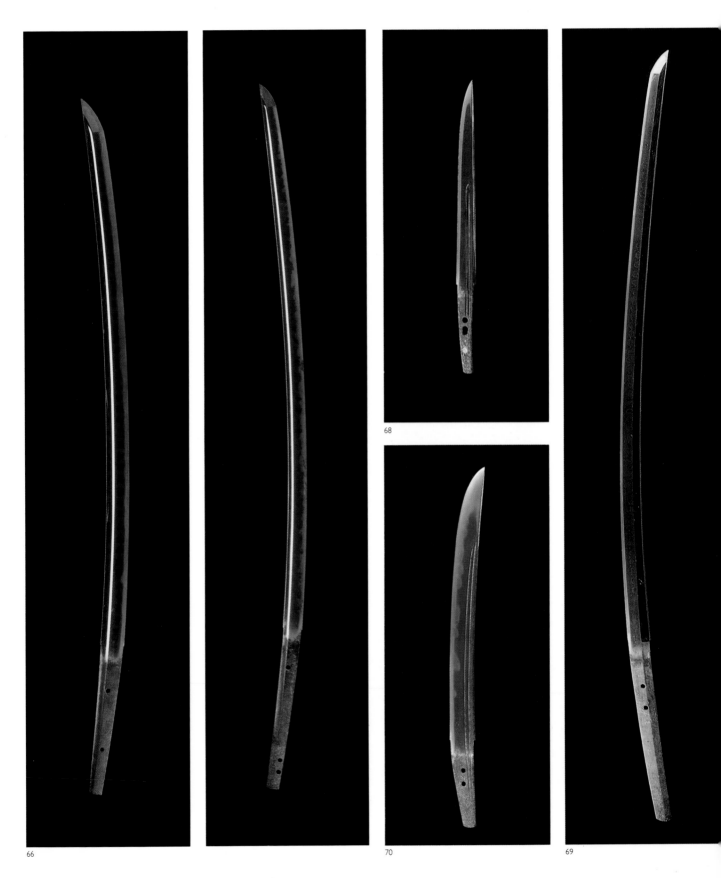

66

68

70

69

66 Shortened *tachi* blade

Attributed in an ink inscription on *shirazaya* to
 Motoshige
Nambokuchō period, 14th century; Bizen
 Province, Osafune school
L. 69.7 cm
Published: Tokyo National Museum 1987, no. 63
1979.7-3.2

The continuous straight *utsuri* shadow
along the blade and the deep sloping
clove-pattern *hamon* are characteristics of
both the Osafune and Aoe schools in the
Nambokuchō period. Many swords of this
period were well in excess of 1 m in length,
and have accordingly lost their inscriptions
when cut shorter in more recent times.

67 *Tachi* blade

Muromachi period, *c.* 1400; Bizen Province
Signed: Bishu Osafune Moro (Kage) ('Morokage
 from Osafune in Bizen Province')
L. 69.3 cm
Published: Tokyo National Museum 1987, no. 64
1979.7-3.1

Morokage was one of the group of smiths,
including Chikakage and Morikage, who
moved from Ōmiya in Kyoto to Osafune in
the fourteenth century. This *tachi* sword is
of typical long and slender Osafune shape
of the Ōei era (1394–1428), with a mixed
hamon of clove pattern and *gunome*.

68 Dagger blade

Probably Muromachi period, 15th century
Signed: Nori[. . .]
L. 22.2 cm
1958.7-30.99. Bequeathed by R. W. Lloyd

The blade is made with the finest steel with
itame grain and an even straight *hamon* in *nie*
crystals. The quality of the blade, the slight
uchizori, or inwards curve, and the carvings
(a *ken*-type straight double-edged sword
with *gomabashi* ritual chopsticks on the
reverse) are characteristic of the earlier
Kamakura period, in which style this blade
has been made.

69 *Katana* blade

Muromachi period, 15th century; Dewa Province
Signed: Gassan
L. 75.5 cm
Published: Tokyo National Museum 1987, no. 65
1958.7-30.79. Bequeathed by R. W. Lloyd

The Gassan group of smiths worked in
Dewa Province from the fourteenth until the
late sixteenth centuries; the line was revived
in the late Edo period and flourishes today
in the persons of the living 'National
Treasures' Gassan Sadakazu, his son,
Sadatoshi, and several pupils. The school
has always been associated with the
mountain called Gassan, the three
mountain deities called Haguro Sanshō
Gongen, and particularly with the
Shugendō sect of mountain ascetics. Work
of the school is characterised by a forging
grain in the form of a continuous seemingly
sinusoidal wave with concentric circles
within the undulations. The *hamon*, known
as *ayasugi*, is remarkably vivid on this blade.

70 Dagger blade

Mino school, 16th century
Signed: Kanefusa
L. 32.1 cm
OA + 3792

The *hamon* is the *hako gunome* (box shaped)
style developed by Kanefusa I, whose work
this is.

71 *Katana* blade

Edo period, 17th century; Osaka
Signed: Omi no Kami Takagi jū Sukenao
 ('Sukenao, honorary official of Omi Province,
 living in Takagi')
L. 71.2 cm
Published: Smith and Harris 1982, no. 19b; Tokyo
 National Museum 1987, no. 67
1958.7-30.67. Bequeathed by R. W. Lloyd

This sword is of the Kambun shape (see
p. 82), with a shallow curve narrowing
considerably towards the point, which
reflects the development of formal
sword-fencing schools during the early Edo
period. Very showy *hamon* patterns were
popular especially in Osaka from that
period onwards, in the taste of the largely
merchant population, who were allowed to
carry a short sword. The *toramba* or 'waves'
hamon pattern on this sword was originated
by Tsuda Echizen no kami Sukehiro, father
of the maker, Sukenao.

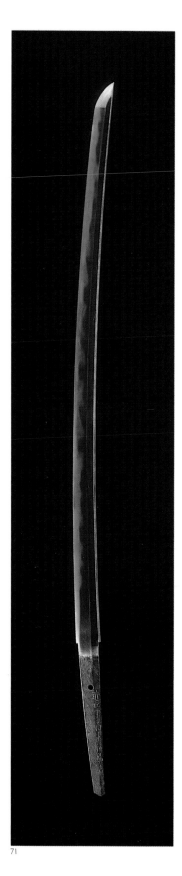

71

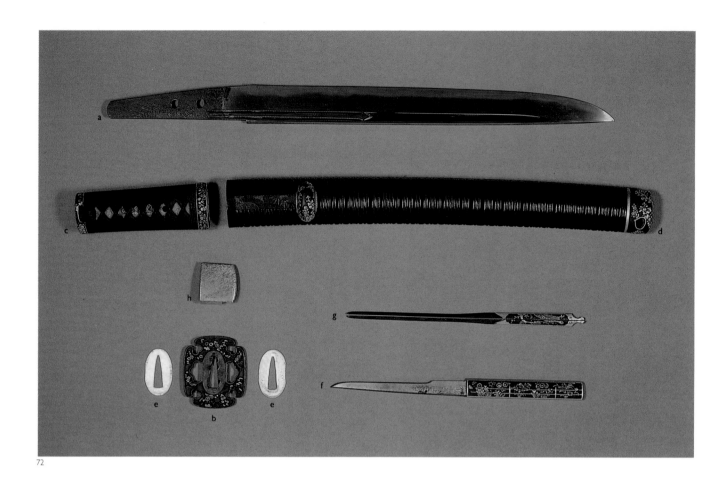

72

72 The parts of a *wakizashi* mounting

Tantō blade (a): early 17th century; Sampin school
Signed: Etchū no Kami Masatoshi ('Masatoshi,
 honorary official of Etchū Province')
L. 30.7 cm
Mounts: 17th century; Mino school
Shakudō with floral designs in gold inlay on a
 nanako ground. They consist of: b) *tsuba*; c) hilt;
 d) scabbard; e) *seppa* (spacers); f) *kokatana* (utility
 knife); g) *kōgai* (bodkin) splitting to form
 chopsticks; h) *habaki* (retainer)
Published: Smith and Harris 1982, no. 20
1958.7-30.46. Bequeathed by R. W. Lloyd

The *wakizashi* (companion sword) is worn at
all times when indoors, and outdoors when
the longer *katana* is also carried. This
example is broad-bladed in Momoyama
style, with a gently undulating *hamon* of *nie*.
It is decorated with a single groove on one
side, and a stylised *ken* (double-edged ritual
sword in esoteric Buddhism) on the other.

73 Sword mounting in *itomaki tachi* style

18th century
Signed (blade): Sukesada (16th-century smith of
 Bizen Province)
L. 97.2 cm
Published: Tokyo National Museum 1987, no. 68
1958.7-30.149. Bequeathed by R. W. Lloyd

The *tachi* mounting was carried suspended
from the belt when full armour was worn.
During the Edo period this cord-bound *tachi*
was carried by *daimyō* and other
high-ranking samurai when travelling in
procession to and from the capital. This
mounting has the triple paving-stone (or
triple chequer) *mon* of the Tsuchiya family of
the Tsuchiura clan.

74 *Wakizashi* blade

19th century
Signed: Hizen Kuni jū Tadayoshi ('Tadayoshi [VIII]
 living in Hizen Province')
L. 45.1 cm
1958.7-30.156. Bequeathed by R. W. Lloyd

The school of Tadayoshi of Hizen continued
throughout the Edo period into the present
century. It was sponsored by the *daimyō* of
the Nabeshima family, making swords
solely for the use of the domain, whereas
most smiths in the Edo period worked on a
commercial basis. The swords are
characterised by the finest-grained bright
steel with minute *nie*; the even *hamon*
patterns are composed of *nie*.

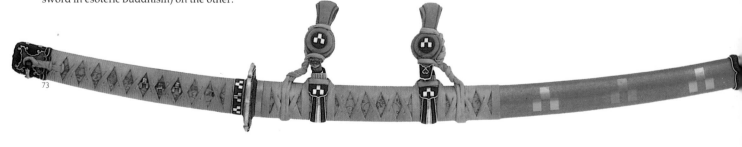

73

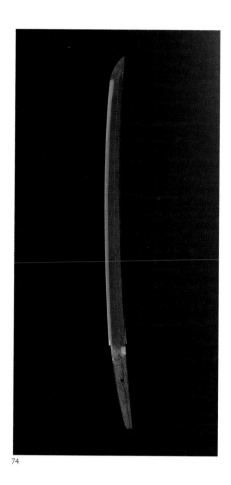

74

75 Sword travelling-case with grapevine design

Momoyama period, late 16th or early 17th century
Lacquered wood with gold *makie* and shell inlay;
 leather outer case decorated with gold leaf;
L. 112.5 cm
Published: Smith and Harris 1982, no. 71; Tokyo
 National Museum 1987, no. 36
1902, 193

Since *daimyō* and their higher-ranking
samurai required swords mounted both as
katana and *tachi* types, and would not wear a
long sword when travelling in a palanquin,
there was always the need to travel with
swords carried by attendants in such cases.

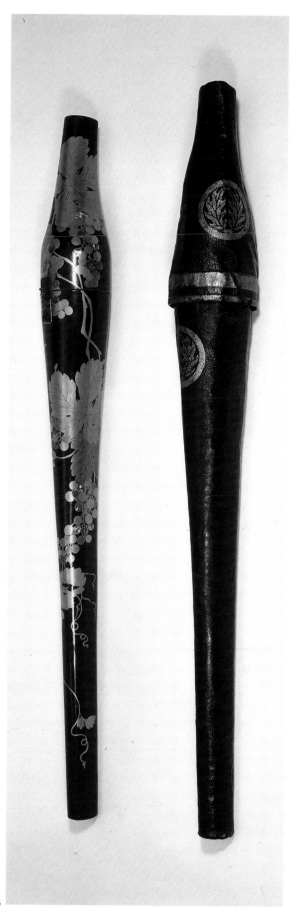

75

76 Group of iron *tsuba*

Iron

a) Pierced with water-wheel design in
 archaistic style and two *ude nuki ana*
Dated equivalent to AD 1845
Signed: Jirō Tarō Naokatsu
L. 8.5 cm
TS47

The maker was the swordsmith Naokatsu,
son of Suishinshi Naotane, master of the
revivalist school. This *tsuba* is reminiscent of
Muromachi period work, in keeping with
the ancient style of his sword blades. The
two *ude nuki ana* are holes through which a
cord could be passed to tie the sword to its
scabbard, thereby preventing its being
drawn hastily or falling out accidentally.

b) Decorated with circular bands of evenly
 spaced inlaid brass dots
Muromachi period, 15th or 16th century
DIAM. 8.6 cm
1948.11-27.1 Given by Henry Bergen

Tsuba like this example were first made in
the Ōnin era (1457–69), although as no
signed works survive nothing is known of
the makers.

c) Pierced with a design of cherry blossoms
18th century
DIAM. 7.9 cm
1948.11-27.43. Given by Henry Bergen

The cherry blossom, since it falls from the
tree suddenly while in full bloom, is
emblematic of the resolution of the samurai
to face sudden death in his prime.

d) *mokkō* form with *mukade* ('centipede')
 design in brass and copper inlay
17th century
L. 8.5 cm
TS1

This design is said to have been first
favoured by the sixteenth-century military
lord Uesugi Kenshin.

e) Decorated with a punt in *sahari* (hard
 alloy of copper, lead and tin) inlay
17th century
Signed: Kunitomo Teiei saku ('Made by Kunitomo
 Teiei')
DIAM. 7.2 cm
1948.11-27.57. Given by Henry Bergen

Teiei was one of the Kunitomo school of
gunsmiths who turned their hand to
tsuba-making after the edicts controlling the
use of firearms in the early seventeenth
century.

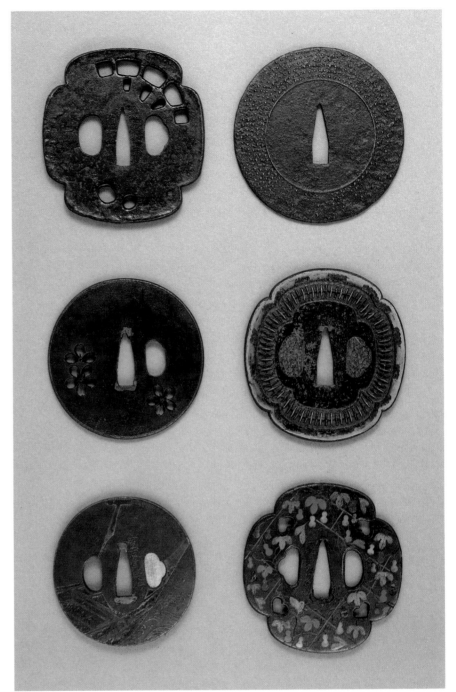

76a, b *top*; c, d *centre*; e, f *bottom*

f) *Mokkō* form with gourd vine in silver, gilt
 copper, copper and lead inlay
Dated equivalent to AD 1683; Kyoto work
Signed: Kunitada
Max. dim. 8.3 cm
1948.11-27.13. Given by Henry Bergen

The pierced heart-shaped 'boar's eye' motif
is a symbol of the wild boar who charges in
a straight line disregarding the hunter's
weapon – a stern reminder of the warrior's
pride during peaceful times.

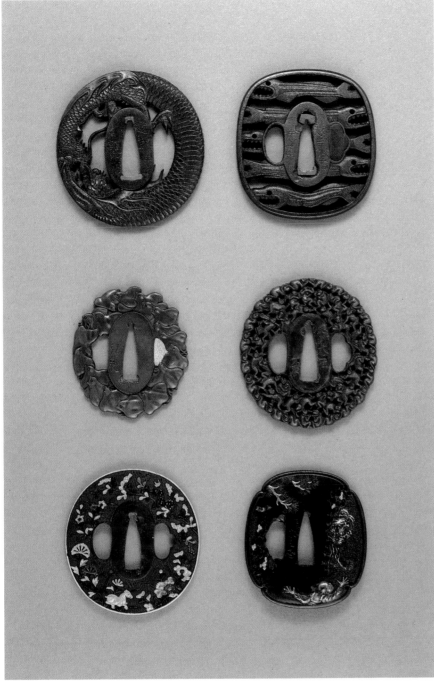

77a, b top; c, d centre; e, f bottom

77 Group of tsuba

a) Iron, pierced and carved with a dragon
motif
17th–18th century
Signed: Echizen jū Kinai Saku ('Made by Kinai,
living in Echizen Province')
L. 7.6 cm
Published: Smith and Harris 1982, no. 21
TS102

The Kinai school was associated with the
Yasutsugu family of swordsmiths appointed
as cutlers to the Tokugawas. They also
carved dragons on sword blades.

b) Iron, pierced and carved with dried fish
motifs
17th–18th century
Signed: Echizen jū Akao ('Akao living in Echizen
Province')
L. 7.3 cm
TS98

Long-keeping dried fish were considered
luxurious campaign rations by the samurai,
and were thus auspicious emblems.

c) *Shibuichi*, with carved decoration of a
flock of plovers
Early 19th century
Signed: Hirochika
L. 6.4 cm
Published: Smith and Harris 1982, no. 24
1952.2-11.33. Given by Mrs Barden

Shibuichi is an alloy predominantly of copper
with about one-fourth part silver. It can be
patinated to a variety of silver and brownish
greys and was favoured by the *machibori*
schools of sword-fittings makers from the
eighteenth century.

d) *Sentoku*, pierced and carved with a host
of monkeys
18th century
Signed: Hishū Yagami jū Mitsuhiro ('Mitsuhiro
living in Yagami in Hizen Province')
L. 7.3 cm
OA + 3319

The inscription on the reverse stated that
the metal used was *sentoku*, a form of brass
which takes its name from the Chinese reign
mark *xuande* (Japanese *sentoku*) found on
imported Chinese vessels. The Three Wise
Monkeys can be seen among their fellows
immediately above the hole for the blade.

e) *Shakudō*, decorated with grasses and deer
in gold and silver inlay on a *nanako*
ground
17th century; Mino school, probably Gotō work
L. 7.1 cm
Published: Smith and Harris 1982, no. 22
TS244

For the Gotō school and *shakudō* see p. 83.

f) *Shakudō*, decorated with the story of
Bukan in high relief with *shakudō*, copper,
silver and gold inlay
19th century
Signed: Taikyuan Katsumi, with a *kakihan* ('written
seal')
L. 6.1 cm
1952.2-11.28. Given by Mrs Barden

Bukan was a Chinese Buddhist priest who is
said to have tested his fellows by surprising
them by appearing with his companion
tiger.

78 Group of *fuchi/kashira*

Shakudō

a) Decorated with a bird and cherries in silver and gold inlay on a *nanako* ground
Late 19th century
Signed: Imai Nagatake
L. (*fuchi*) 3.8 cm
1981.1-30.299. Given by Capt. Collingwood Ingram

b) Decorated with the immortals Gama Sennin and Tekkai Sennin in copper, gold and *shakudō* inlay on a *nanako* ground
18th century
Signed: Eishō
L. (*fuchi*) 3.6 cm
Published: Smith and Harris 1982, no. 25
1939.5-19.48. Given by Mrs Todd

This is by Ōmori Eishō (1705–72), a pupil of Yokoya Sōmin, the first of the town studio metalworkers. Gama Sennin is shown with his familiar three-legged toad, and Tekkai is shown exhaling himself in miniature.

c) Decorated with hares leaping across stepping-stones to reach the moon in copper, *shibuichi* and gold inlay on an *ishimeji* ground
Late 19th century
Signed: Yōundō Toshiyuki
L. (*fuchi*) 3.9 cm
1981.1-30.306. Given by Capt. Collingwood Ingram

Ishimeji ('stone ground') is a decorative surface prepared by hammering to give the appearance of rough worked stone.

d) Decorated with magic fungi and bamboo among rock in *shakudō*, copper and gold inlay on a *nanako* ground
19th century
Signed: Hashimoto Isshi (1820–96)
L. (*fuchi*) 3.7 cm
1981.1-30.304. Given by Capt. Collingwood Ingram

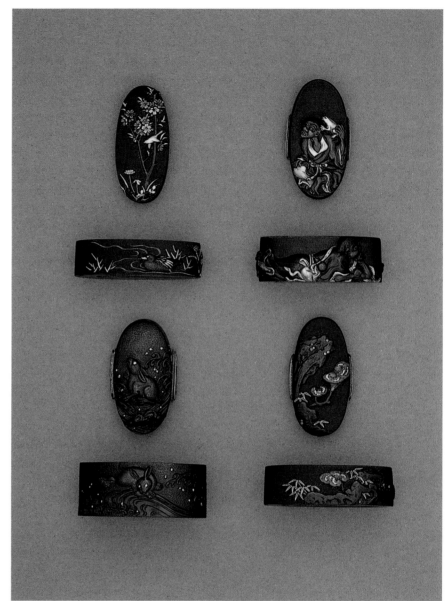

78a, b *top*; c, d *bottom*

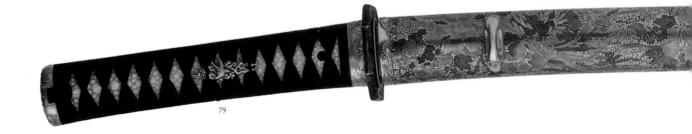

79

79 Sword mounting in *uchigatana* style

Late 19th century; Tokyo
Signed (metal fittings): Nakagawa Isshō
Gold and silver; hilt bound with whale's beard;
 L. (overall) 87 cm
Published: Tokyo National Museum 1987, no. 69
1958.7-30.3. Bequeathed by R. W. Lloyd

The *uchigatana*-type mounting was carried
thrust through the belt with the cutting
edge of the sword uppermost. This mount
was made as a presentation piece, with a
fine-quality gold *makie* chrysanthemum
pattern over the scabbard. The blade is by
Sukesuda of Bizen (see also no. 73) and
dated equivalent to AD 1520.

80 Armour surcoat (*jimbaori*)

Momoyama period, late 16th century
L. 72 cm
1897.3-18.6. Given by Sir A. W. Franks

The decoration is formed from the feathers
of two species of Japanese pheasant and a
drake of an unidentified species of the
genus *Anas* glued on to hemp. The collar is
Chinese silk twill stiffened with paper.
 Originally simple serviceable coats to be
worn over the armour to keep out the
elements, during the Muromachi period the
jimbaori, like the armour itself, became an
object of ostentation revealing the personal
tastes of the wearer. They were decorated
with motifs other than clan *mon*, like the
target on this example.

80 back

93

81

81 Helmet

Momoyama period, late 16th century
Five heavy iron plates riveted together and
 lacquered; w. 19.5 cm
Published: Smith and Harris 1982, no. 58
OA + 722

The exotic design of a stylised sea creature
reflects the mood of the samurai during the
latter half of the sixteenth century when
individuals strove to rise to fame through
their own efforts rather than their birth.

82 Stirrups

17th century
Signed: Osaragi jū Shigetsugu ('Shigetsugu living
 in Osaragi')
Iron, with silver inlay; wood linings lacquered,
 with shell inlay; L. 28.8 cm; H. 25.5 cm
Published: Smith and Harris 1982, no. 17
1940.12-12.1, 2. Given by F. Fairer Smith through
 the National Art Collections Fund

The form of the traditional stirrup has
remained unchanged since the Heian
period, when it was designed primarily to
provide a firm platform on which the
mounted archer could stand to discharge his
arrows.

83 Armour

Cuirass and sleeves: Momoyama period, late 16th
 century; *helmet*: 17th century;
 other parts: 18th–19th century
Signed (cuirass): Unkai Mitsunao
Steel, russet iron, mail, and lacquered iron and
 leather sheet; H. (as mounted) 1.25 m
Published: Smith and Harris 1982, no. 14
OA + 13545

Thick steel-plate bullet-proof cuirasses were
first made in the sixteenth century when
firearms were introduced into Japan, and
many were originally based on European
designs. During the Edo period armour was
worn only on ceremonial occasions, and the
heavy iron and steel gave way to lighter
material; but some provincial lords like the
Date clan of Sendai countinued to maintain
a warlike appearance, perhaps still smarting
under the memory of their ancestors' defeat
by the Tokugawas in the decisive battle of
Seki ga Hara (AD 1600).

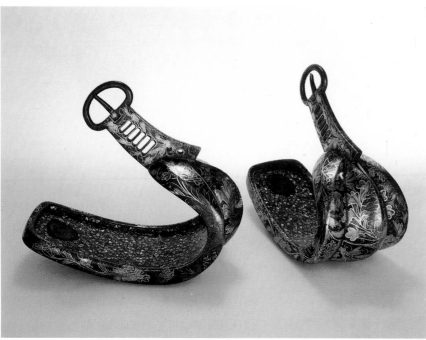

82

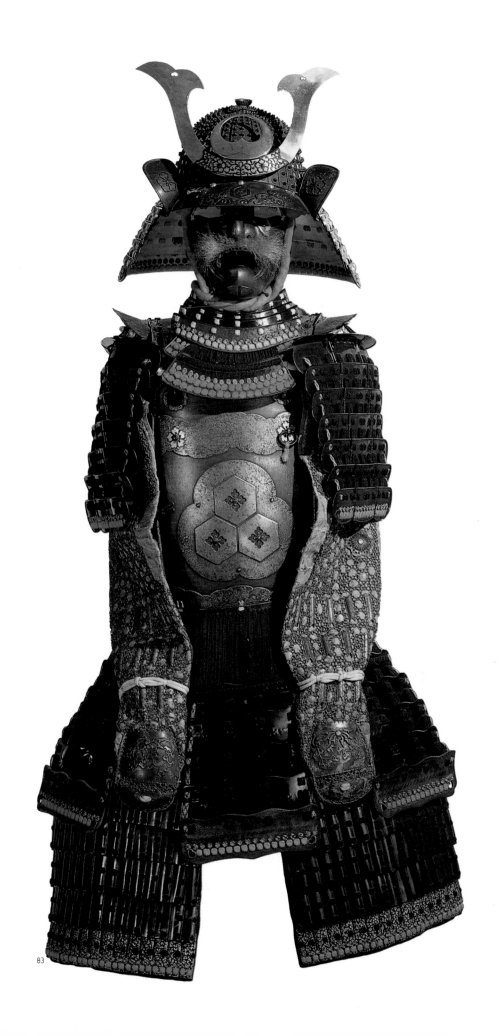

83

LACQUERWARE

(nos 84–104)

5

Lacquer has been used in most countries of East and South-East Asia but is perhaps more important in Japan than in any other. The sap of the lacquer tree has indeed been employed as a surface covering for objects in Japan since the pre-historic Late Jōmon era. Excavated lacquered objects from that time include items for practical use, like wooden combs, bowls and bows, which took advantage of the hard-wearing characteristics of lacquer – for it is tough, hard, waterproof and resistant to heat and corrosion – as well as its decorative nature. It has many uses also as an adhesive, and has traditionally been employed in Japan to repair broken ceramics and old wooden pieces. Lacquerware has been recovered intact after being long buried in the ground and submerged under water. In some excavated objects only the long-lasting lacquer shell survives, the wooden base having corroded away.

Lacquer was also used solely for decoration from prehistoric times – for example, on ritual pottery figurines of the late Jōmon period. These pieces were coloured either black or red, by adding charcoal or cinnabar to the liquid lacquer before coating it, thus anticipating some of the mature techniques of later periods. An early and sophisticated example is the piece of wooden ritual Yayoi period armour in the collection of Hamamatsu City Museum, on which incised bands, concentric circles, whorls, chevrons, linked squares, triangles and star shapes mirroring the designs on bronzes of the period are painted over with red and bands of black lacquer.

Lacquer technology advanced very considerably with the arrival of the higher arts of China in the sixth and seventh centuries. Its use increased particularly during the Nara period in the manufacture of scabbards and hilts of weapons, Buddhist images and equipment, the furniture and architecture of temples in the new

continental style, Shintō shrines, musical instruments and for boxes of every sort. Lacquer was the main ingredient of a form of sculpture called *kanshitsu*, introduced into Japan in the Nara period, which consisted of modelling with textile soaked in lacquer over a skeletal frame. The freedom of expression possible with *kanshitsu* led to the production of some of the most beautiful of all Buddhist sculpture.

It is recorded that at this time lacquer trees were planted in great numbers on wild mountainous land which was unsuitable for other farming or habitation. The demand for lacquer was such that there were government controls over it, with an office for lacquer, Nuribe no Tsukasa. During the Taika era (645–9) a tax of lacquer was levied where the lacquer tree was cultivated, in much the same way as lowland landowners were taxed in rice.

Surviving pieces of lacquerware from the Nara period illustrate a whole range of technical and artistic skills learned from immigrant lacquerers. The finest ware survives in the collection of the Shōsōin storehouse of the Tōdaiji Temple in Nara, consisting of the effects of the deceased Emperor Shōmu which were dedicated to the temple in AD 756 by the Empress Kōmyō. Some of the boxes, furniture, weapons and musical instruments in the Shōsōin are unique surviving examples of the preferred Chinese styles of lacquer decoration, especially the use of inlaid shell (*raden*), and silver and gold sheet inlaid into the surface, in a method used only in the Nara period, called *heidatsu*.

For Japan a technique using gold filings was to show the most lasting potential. In the Nara period gold filings were scattered over a design painted in lacquer so that it set into the soft lacquer before it hardened. Once set, a further layer was applied overall, and then the surface polished with charcoal to reveal the design in gold. This early method, known as *makkinrō*, was the precursor of a range of techniques known as *makie* ('sprinkled illustrations'). As lacquer is almost transparent, being slightly yellowish in colour, metallic dust suspended in it can be revealed by suitable polishing to appear like stars in the night sky, or a speckled pear skin (*nashiji*). Application of more gold powder on to the surface of a thin layer of lacquer gave the appearance of flat gold (*hiramakie*).

If such a surface containing sufficient gold dust is burnished, it adopts a gentle lustre like metallic gold – *togidashi makie*. Probably this is what Marco Polo referred to when he spoke of the island 'Zipangu', where he had heard things were made of solid gold. By the thirteenth century Japanese *makie* lacquerers were celebrated throughout East Asia, and indeed *makie* has been one of the glories of Japanese culture ever since. Nevertheless, it may be misleading to think of the contrast of gold and black as the dominant mode of Japanese lacquerers, for pieces in deep vermilion, usually undecorated, have always been the preferred type for tableware and other uses connected with food, such as low tables, trays and ewers. The fact that they have been less immediately attractive to collectors accounts for their comparative absence from Western museums and private collections.

The great development of *makie* was in the Heian period, but there are no examples in the British Museum; the circular mirror box (no. 84) decorated with scrolling blossoms is a fine example of shell inlay on a *hiramakie* ground, probably dating from the thirteenth or fourteenth century. The wood used for the base is from a surface plank of a large white cypress, which when well seasoned will never warp and does not exude resins. Great care has been taken with the mother-of-pearl inlay, which is polished level with the lacquer and in close contact all round. The geometrical precision of the foliate design is typical of the Kamakura period.

The document box (no. 85), believed to have come from a temple in the town of Kamakura itself, is also characteristic of Kamakura period work, combining sheet silver and shell inlay with fine *makie* decoration, although some features of the method, like the inlaid pewter butterfly wings and the variety of motifs, indicate a possible seventeenth-century date in revival style. Nevertheless, the combination of sensitivity and naturalistic liveliness is very much of the earlier period.

The exacting craft of carving lacquer had flourished in China since the Song Dynasty and was taken up enthusiastically in Japan in the fourteenth century. Because lacquer sets hard by means of a chemical reaction requiring a humid atmosphere in contact with the surface, it is therefore possible to harden it only in thin layers: if a thick lacquer is required, it must be formed of many successively applied and dried layers. Lacquer thus painstakingly formed can be carved into relief designs. Red lacquer carved with Chinese scenes, called *tsuishū*, was popular during the vogue for Chinese culture in the Muromachi period, especially on large dishes and nests of boxes, and was sometimes used for decorating *inrō* (seal or medicine boxes) during the Edo

period. The black variant was called *tsuikoku*. Another form of carving in intertwined whorls was called *guri* (no. 104a); here layers of different coloured lacquer are revealed in the incisions of the carving. This too was introduced from China in the fourteenth century. Initially the layers were red and black, although green and yellow and brown pigments became used during the Edo period.

During the Muromachi period Chinese carved lacquer also provided the inspiration for *Kamakurabori*, in which designs first carved in wood are covered with red and black lacquer. This provided a quick way to produce the effect of *tsuishū*, or *tsuikoku*, with the added advantage that more expansive and deeper carving was possible. On plain vermilion lacquer the gradual appearance of patches of black base lacquer showing through where the red has worn away was deeply admired by the Japanese, who have always liked the legitimate effects of age on works of art and antiquities. The ware known as Negoro is prized for this same effect brought about by age. Originally made by the monks of Negoro temple in Kii Province in the fourteenth century, it consists mainly of red lacquered wood containers, bottles for wine and small items of furniture. No. 87 shows a Negoro bottle with just a little black showing through. By the nineteenth century at the latest the effect was being simulated in new pieces.

Another technique with Chinese origins was *chinkinbori* ('carved sunken gold'), which consists of engraving designs in the lacquer in fine outline and then filling the lines with gold powder. Fine examples of *chinkinbori* are found on lacquer from the Ryūkyū Islands, where the technique had been learned from China in the sixteenth century (no. 96). The Ryūkyūans also often used a method of painting on to a lacquered surface with oil-based pigments, called *mitsuda-e*, which had been popular in the Nara period and was revived to some extent during the Edo period (no. 97).

Perhaps the most significant development in lacquer art during the Muromachi period was *takamakie*, the production of designs in high relief built up of layers of lacquer over primers. The writing-box (no. 86) is a masterpiece of this technique, and incidentally a fine example of *uta-e*, or poetry written in characters incorporated into a picture, also popular during the Muromachi period in courtly and rich merchant circles.

As with other arts during the succeeding Momoyama period, bold, expressive and fresh designs are found on lacquerware. The grapevine decoration on the sword case (no. 75) and the similar design on the box (no. 91) are typical examples, both using mother-of-pearl inlay, which reached a peak of popularity at that time as a result of contact with Korean lacquer. Energetic patterns of flowers, trees and plants known as Kōdaiji *makie* from the Kōdaiji Temple, in which pieces loved by the Regent Toyotomi Hideyoshi and his wife are kept, are the classic expression of Momoyama lacquer style.

The growth of the outgoing Japanese popular culture during the late sixteenth century owed much openness to foreign artistic influences. In addition to the constantly renewed admiration for things Chinese, and the assimilation of new Korean influences, there were new and exotic ideas brought from South-East Asia and Europe. They included *komade* ('spinning-top work') lacquer from South China, with narrow concentric circles of different colours, and *kimmade* designs made by inlaying lacquer into carved cloisons in wood, from Burma and Thailand. European influence was on style rather than technique, resulting in the *namban* ('southern barbarian') pieces made mainly for export during the late sixteenth and early seventeenth centuries. Many of these pieces were made for church use to the order of the Spanish and Portuguese Christian missionaries until the exclusion of all Catholics from 1614. They usually have crowded floral designs in gold *hiramakie* with large pieces of shell inlay and, like export porcelain of the period, owe much to Chinese designs. Examples are the drop-fronted chest (no. 90) and the group including two Christian artefacts (no. 88). Exports continued to be made by the Dutch East India Company throughout the seventeenth century, especially of the large chests which were much in demand in the great houses of Europe. They stimulated the new European industry of japanning furniture, using insect shellac in the place of the unobtainable East Asian lacquer and adopting vaguely Asian designs to an exotic norm. The export cabinet (no. 90) is an example of the best quality.

Although little is known of lacquer workers before the seventeenth century, the artists are better documented during the Edo period owing to the extensive system of official employment by the shogunate and their thorough records. Kōami Nagashige, whose family already boasted ten generations of lacquer artists, was summoned to Edo by Ieyasu to work for the Tokugawa family. Nagashige and his studio made the gold lacquer trousseau known as the Hatsune *makie* for the daughter of the third shogun,

Iemitsu, on her marriage to the *daimyō* of Owari. It consists of an extensive set of free-standing shelves, a set for the incense game, a tooth-blacking set, cosmetics equipment, clothes hangers, and other necessary everyday items, but all decorated in the richest *makie* in the new official Edo style. Two other lacquerers, Koma Kyūi and Kajikawa Hikobei, were also retained by the Tokugawas during the seventeenth century. Their descendants continued making fine lacquerware throughout the Edo period, and branches of these families worked for the lesser *daimyō* in the provinces. Official lacquerers worked on buildings and large objects like furniture, palanquins, armour and saddles. Although large pieces of lacquerware made for the military classes are not signed, many smaller pieces from the seventeenth century often carry inscriptions recording the age and name of the lacquerer, and sometimes of the name of the artist who produced the original design.

The Edo period saw a great increase in demand for lacquerware also among the non-samurai classes, particularly among the wealthy merchant classes in the ever-growing cities. What might well be called a Japanese 'civilian' culture developed, and independent makers began to flourish with the keen demand for sophisticated pieces. Popular themes for decoration included Chinese and Japanese classics, literary themes, folk tales and scenes of everyday life. This varied subject-matter and the full range of lacquer techniques were applied to expensive luxuries, especially *inrō*, which became a sort of substitute jewellery. Among novel techniques was *sumie togidashi makie* which imitated ink-painting. This was a form of *togidashi* in which a design in black lacquer was carefully revealed by selectively polishing away the gold lacquer layer above it. The *inrō* (no. 103c) is an example of the finest *sumie togidashi makie*, signed by the lacquerer Kanshōsai, and also inscribed with the name of the painter who produced the design, Tosa Mitsusada.

During the Edo period some lacquerers worked in the pictorial style of the Rimpa school (see p. 180), especially the bold but evocative designs of Ogata Kōrin (1658–1716) and those favoured by Hon'ami Kōetsu (1558–1637). It should be noted that neither of these men actually made lacquer itself, though pieces have been traditionally ascribed to them in Japan. The British Museum has a number of fine examples of Rimpa work, including the writing-box (no. 93), with a design of maple leaves against a river bridge, which is depicted in

characteristic large pieces of shell and lead alloy inlay. The fondness of this tradition for very good strong visual effects led to the use of large areas of bold inlay in materials such as lead.

Ogawa Haritsu (1663–1747) particularly encouraged the use of new materials, such as ceramics, coral, stones and tortoise-shell, and new colours into lacquer. He also delighted in imitating other materials, like ink blocks, metal and wood, in lacquer, and simulating age and decay. The technical variety and sometimes eccentricity of later Edo-period lacquerers are very much due to his influence. A very particular tradition was the use of very fine shell inlay combined with small pieces of gold sheet perfected by the Somada family of workers.

Some of the most exciting wares were made by the painter and lacquerer Shibata Zeshin (1807–91) in the late Edo and Meiji periods. He was in a sense the inheritor of the tradition of Haritsu. He devised methods of imitating common materials, like black ink and rusty iron, in subdued colours. Among his innovations was the use of the whalebone comb to depict the waves of the sea by deftly running it through the lacquer while it was still only half set. A prominent painter with a varied style, he sometimes used lacquer in place of pigments on large areas to striking effect.

Like the arts of ceramics, metalwork and sculpture, lacquer was taught during the Meiji period at the Tokyo School of Fine Arts. Imperial sponsorship replaced that of the shogun, so that the skills of the feudal age have continued until today, though it seems that the best work this century has tended to be in the previously neglected folk traditions, such as those of the town of Wajima.

84

84 Round mirror box

?Kamakura period
Hiramakie and mother-of-pearl inlay;
 DIAM. 12.0 cm
1945.10-17.379. Bequeathed by Oscar Raphael

The use of delicate pieces of mother-of-pearl set in a burnished *hiramakie* ground is essentially a Kamakura period technique but was reproduced as late as the seventeenth century. It is not quite certain when this piece was made.

85 Lidded box

?Kamakura period
Black lacquer with *makie* and silver, lead and shell
 inlay; tin alloy rims; 25.3 × 15.6 × 11.2 cm
1945.10-17.399. Bequeathed by Oscar Raphael

The vigorous style of decoration, the shape of the box, and the fine engraving over both metal and shell inlay are in the style of Kamakura period work, but the use of lead and the large number of mixed motifs suggest a later date, possibly in the seventeenth century, when there was a conscious revival of medieval lacquer style. Nevertheless, this piece remains in the aristocratic Japanese tradition.

85

86 Writing-box (*suzuribako*)

Muromachi period, 16th century
Black lacquer with gold and silver *makie* and
 takamakie; 24.5 × 22.2 × 5.0 cm
1974.5-13.13. Given by Sir Harry and Lady Garner

The straight bevelled edges, the solid tin rims on base and lid, and the incorporation of a poem into the design are all features of Muromachi period *makie* ware. The written characters *tama, kushi, ge, futa, mino, ni* and *yuru* are selected from and represent the poem by Onaka Tomi Sukehiro recorded in volume 9 of the anthology 'Kinyō Waka Shū' (AD 1127). The complete poem can be translated: 'The bejewelled thickets by the sea of Futamigaura bay, the clusters of pines look like *makie* lacquer'.

Futamigaura near Ise is one of the holiest shrines of the Shintō religion. It has a *torii* gateway overlooking the sea, where the famous 'twin rocks' are situated.

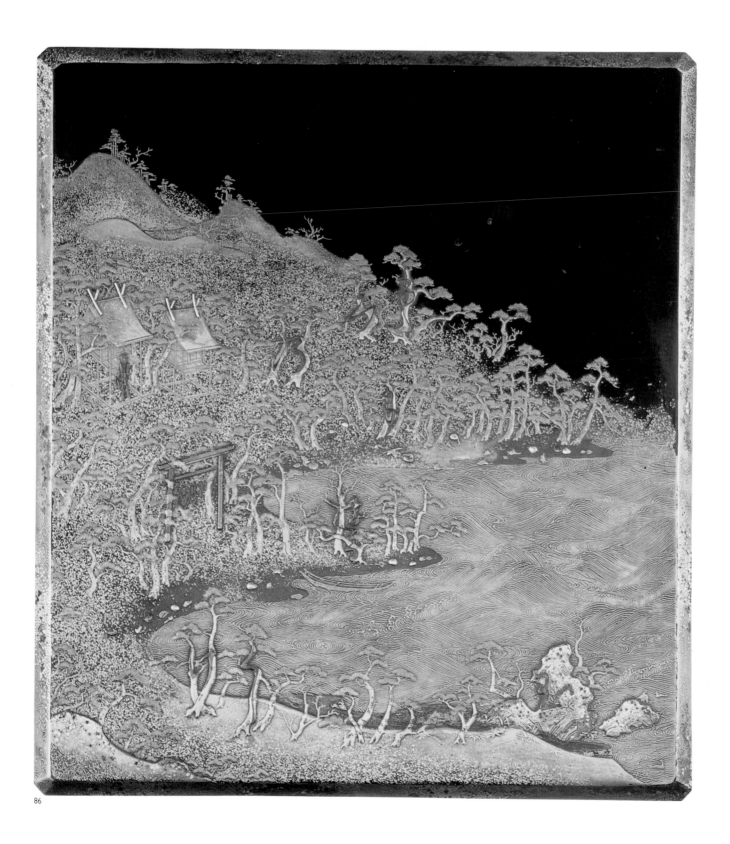

86

87

87 Ritual saké bottle of Negoro type

16th–17th century
Red lacquer over black; H. 33.5 cm; max. DIAM.
 24.5 cm; DIAM. (base) 17.9 cm
Provenance: R. S. Jenyns Collection
Published: Smith and Harris 1982, no. 62
1978.4.21.1

Named after its first place of manufacture at
the Negoro temple in Kii Province, Negoro
ware is robustly carved or turned from
wood and lacquered first with black and
then with vermilion. Bottles like this were
originally for the priest's own saké but came
to be used widely as altar pieces in Shintō
shrines.

 Negoro is highly regarded because of its
appearance of antiquity when the vermilion
wears through in places to reveal the black
base. This century it has also come to be
admired for its simple, unassuming shapes.

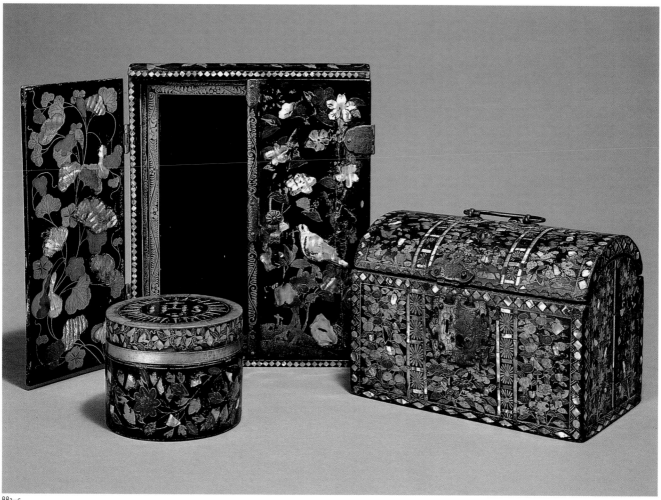

88a–c

88 Group of *namban* pieces

a) Altar piece for a Christian image
Early 17th century
L. 27.5 cm
1974.5-13.6. Given by Sir Harry and Lady Garner

The frame and doors are decorated with birds, trees and gourds in gold *makie* and shell inlay on a black ground. The gilt-bronze fittings are decorated with line-engraved chrysanthemums on a punched *nanako* ground, and the catch is largely a European replacement.

b) Travelling chest
Late 16th–early 17th century
Black lacquer with gold *makie* and shell inlay;
 L. 22.3 cm
1956.2–15.1. Given by Denys F. Bower

This Western-style chest is of the type known in Japan as *kamaboko-bako* because of the similarity in shape to the traditional fish sausage, or *kamaboko*. The dense decoration of flowers and oranges is typical of *namban* taste, consisting of elements of Japanese, Chinese and Indian design in an overall baroque mix.

c) Pyx (sacrament box)
Late 16th–early 17th century
Black lacquer with gold *makie* and shell inlay;
 DIAM. 11.2 cm
1969.4-15.1

The pyx, which is decorated with leaves and flowers, has the monogram of the Society of Jesus (IHS) in shell inlay on the lid. The metal rim is a European addition.

89 Chest

Early–mid-17th century
Inscribed (in *makie* on black-lacquered base):
 'Maquie Roman' in roman script
Black lacquer with gold *makie*, gold and silver foil,
 and mother-of-pearl inlay; 34 × 25.5 × 21 cm
Published: Smith and Harris 1982, no. 59; Tokyo
 National Museum 1987, no. 37
1912.10-12.20. Given by Mrs Seymour Trower

The chest is in European shape for export
but is much finer quality than the
commoner *kamaboko-bako* (see no. 88b) of a
slightly earlier period. The chequered and
saw-toothed edge patterns are typical of
export work, but the panels are in a more
classic Japanese mode. Panels on the front,
for example, depict the conventional
'autumn grasses', and also the legend of
Kiku Jidō, the legendary Chinese
chrysanthemum boy.

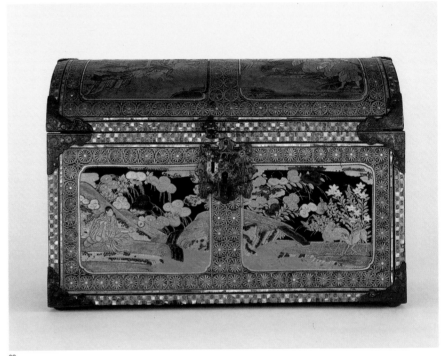

89

90 Drop-fronted cabinet

Mid-17th century
Black lacquer with gold *makie* and mother-of-pearl
 inlay; 57 × 44 × 85.5 cm
1976.4-6.1

This sort of cabinet was made for export to
Europe and continued to be shipped by the
Dutch East India Company until late in the
seventeenth century. The almost baroque
decoration was developed in deference to
European taste and is Japanese only in
detail. As one would expect, the lacquer
hidden by the drop front is brilliantly
preserved, giving some idea of the glamour
which these pieces exerted before the
European japanning industry grew up in
imitation.

 The cabinet has drawers and an arched
central locker; the metal fittings are
decorated with peonies line-engraved on a
punched *nanako* ground.

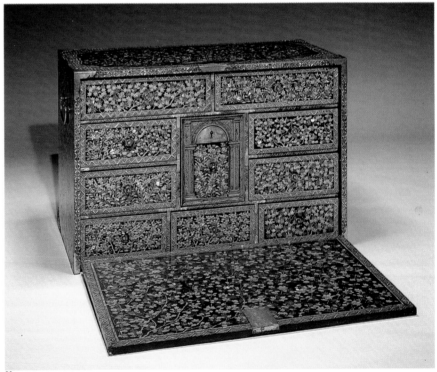

90

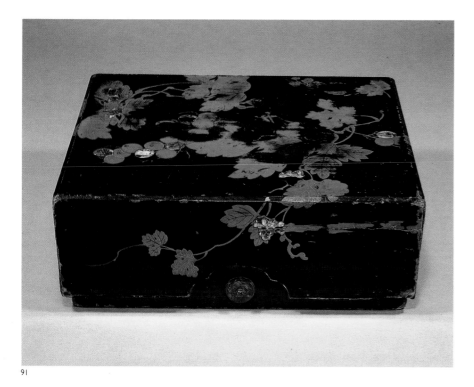

91

91 Box for a Bugaku mask

(see no. 137)

17th century
Black lacquer with red lacquer, gold *makie* and
mother-of-pearl inlay; 40.1 × 32.5 × 14.8 cm
Provenance: R. S. Jenyns Collection
1978.4.21.2

The expansive design of a grapevine is in
the Momoyama tradition, though the piece
may be a little later in date.

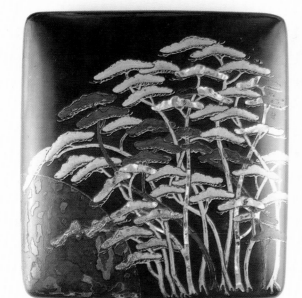

92

92 Writing-box

(detail, inside lid, illus. jacket front)

17th century
Black lacquer with gold *makie* and shell and silver
inlay; inside lid also with copper foil and
mother-of-pearl; 23.5 × 21.0 × 4.5 cm
Published: Smith and Harris 1982, no. 67; Tokyo
National Museum 1987, no. 40
1974.5-13.8. Given by Sir Harry and Lady Garner

The huge silver moon has tarnished to a
gentle brown which if anything enhances
the contrast with the pine trees. The inside
of the lid bears a vignette of deer crying in
autumn and the pine motif is repeated in
the brush-tray. Like no. 93 this is in the
decorative line of Kōetsu. The box holds an
inkstone and a gilt-copper water-dropper.

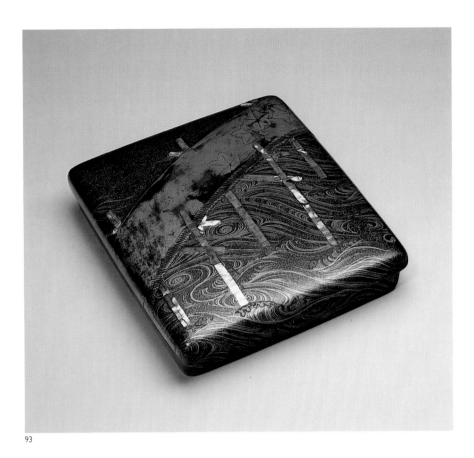

93

93 Writing-box

Mid–late 17th century
Black and brown lacquer with gold *makie* and lead
 and shell inlay; 23 × 20.5 × 4.5 cm
Published: Smith and Harris 1982, no. 77; Tokyo
 National Museum 1987, no. 39
1945.10-17.392. Bequeathed by Oscar Raphael

The box is a fine example of the lacquer
work in the tradition of design promoted by
versatile artist and craftsman, Hon'ami
Kōetsu. The design is inspired by poem
no. 283 in the classical anthology 'Kokin
Waka Shū' (AD 905):

Were one to cross it,
the brocade might break in two,
coloured autumn leaves,
floating in random pattern,
on the Tatsuta River.
 trans. Helen Craig McCullough

Classic poetic themes are invariably the
inspiration for Kōetsu's school, but the
strong, off-centre design was something
new in early Edo period Japan. The inside of
the box is decorated with deer, also in gold
makie and shell inlay (see also no. 92).

94 Tiered picnic box

Late 17th century
Black lacquer with gold *hiramakie* and shell
 inlay; some *nashiji* on poppy petals;
 27.3 × 27.3 × 38.0 cm
Published: Smith and Harris 1982, no. 68; Tokyo
 National Museum 1987, no. 41
1945.10-17.487. Bequeathed by Oscar Raphael

The box would have been used to contain in
its separate compartments rice, fish,
vegetables and pickles. The design is typical
of the exuberant urban taste of the Genroku
era (1688–1704) and is reminiscent of the
painting of the school of Sōtatsu (see p. 52)
and his successors. In places silver powder
has been mixed with the gold powder to
give a paler effect.

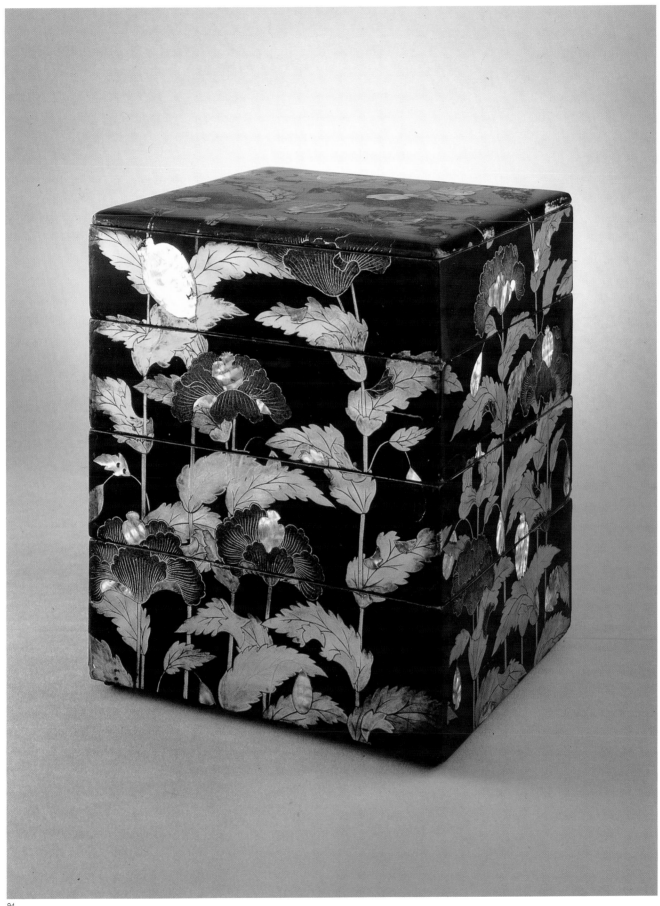

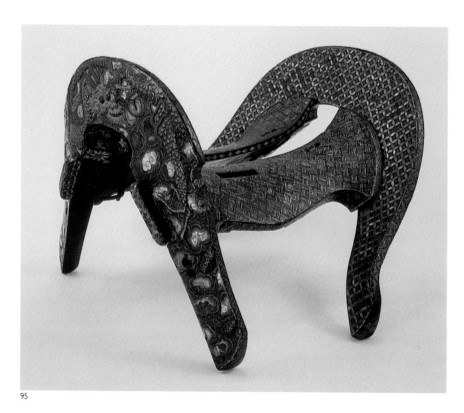

95

95 Saddle

Ink inscription on base gives date equivalent to
AD 1659
Black lacquer over wood; H. (front) 27 cm;
L. (seat) 38.5 cm; H. (rear) 26.5 cm
Published: Smith and Harris 1982, no. 70; Tokyo
National Museum 1987, no. 42
1974.5-13.3

The outer sides are decorated with dragons
among clouds in *takamakie* and tortoiseshell
inlay. The seat and inner sides are covered
with chequered and linked-circles patterns
in fine mother-of-pearl inlay. The piece is
typical of the lively mid-seventeenth-
century revival of Kamakura and
Muromachi lacquer styles.

96 Cup stand

Ryūkyū Islands, 17th century
Red lacquer with *chinkinbori* decoration;
DIAM. 18.0 cm; H. 7.0 cm
Published: Tokyo National Museum 1987, no. 47
1974.2-26.74. Given by Sir Harry and Lady Garner

The design of chrysanthemum motifs (the
rim itself represents a chrysanthemum
flower) is outlined in gold dust forced into
incised lines in the lacquer (*chinkinbori*). The
technique was learned from China and
transmitted through Ryūkyū to Japan in the
seventeenth century. Of two marks under
the base one is legible as *Ten* ('Heaven').

97 Octagonal nest of boxes

Ryūkyū Islands, 17th century
Red and gold lacquer with litharge painting;
H. 38.0 cm
Published: Tokyo National Museum 1987, no. 48
1974.2-26.81. Given by Sir Harry and Lady Garner

The outlining of the painted decorations
with gold foil and the use of shallow patches
of *nashiji* are techniques thought to have
been introduced to Ryūkyū from China in
1663. The mainland Japanese had little
experience of painting a wide range of
colours over lacquer in this way. The formal
decoration of birds and butterflies among
camellias is very Chinese, but its freshness
owes much to mature Ryūkyū style.

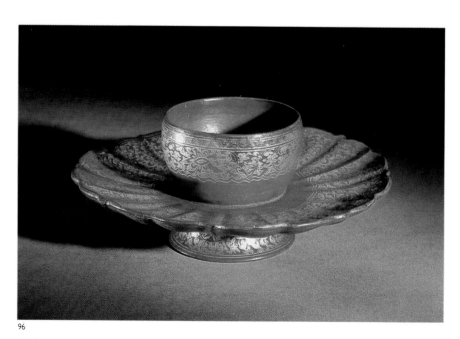

96

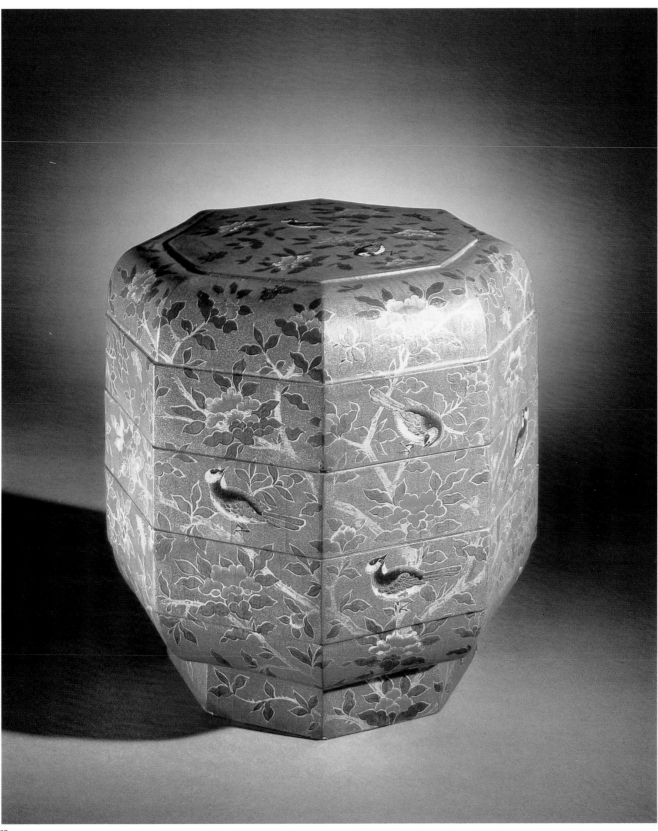

97

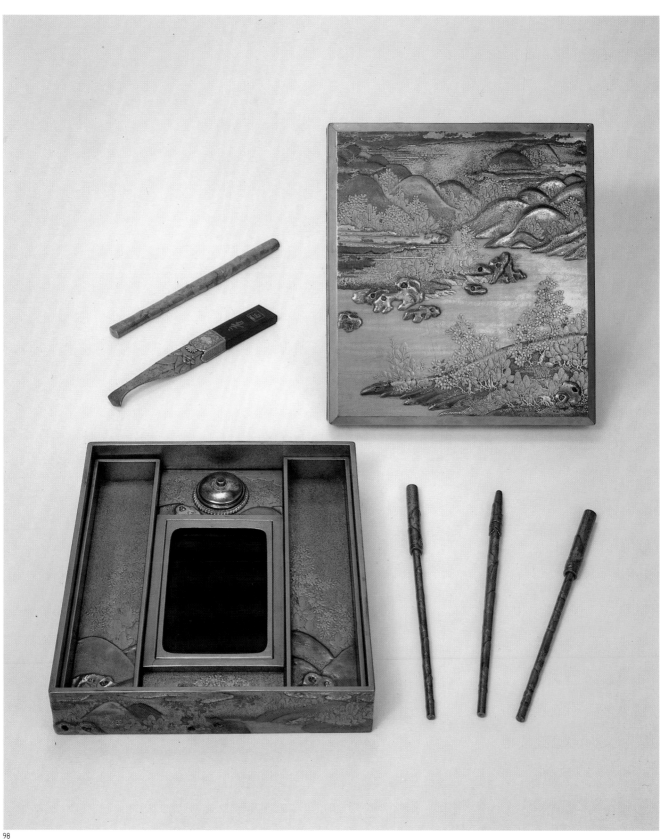

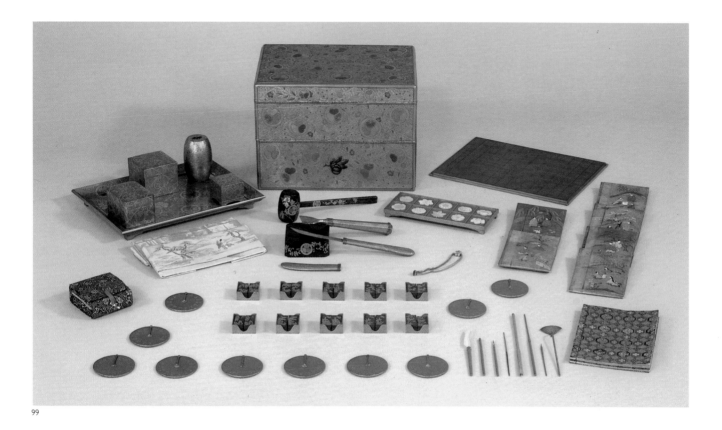

99

98 Writing-box

18th century
Black lacquer with gold and silver *makie*, including
 takamakie; 20 × 21.7 × 4.5 cm
Published: Smith and Harris 1982, no. 65; Tokyo
 National Museum 1987, no. 35
1945.10-17.398. Bequeathed by Oscar Raphael

The writing-box was an important object for
every literate Japanese and had to be as
finely decorated as possible, almost always
in lacquer. The lid of this example is a
representation of a place of natural beauty
by the sea. Although composed in the
Chinese landscape manner, the scene is
probably a native Japanese one as yet
unidentified. The box contains brush
and knife holders lacquered *en suite*, a
carbon ink-stick in a specially fitted handle,
an ink-stone and a silvered copper
ink-dropper. There is every evidence that
this piece was made in the taste of the
daimyō families.

99 Box with equipment
for incense game

18th century
Lacquered wood with contents of various
 materials; 18.4 × 26.7 × 20.2 cm
1912.10-12.21. Given by Mrs Seymour Trower

The box is decorated with the 'Three Friends
of Winter' (pine, plum and bamboo) and the
triple hollyhock leaf *mon* of the Tokugawa
family in gold *makie* with *nashiji* and gold
foil.

Like the Way of Tea and flower
arrangement, the enjoyment of incense had
developed into a complex pastime by the
Edo period and had a large following during
the seventeenth century. The various games
involve guessing a fragrance from among
more than 2,000 varieties, matching
fragrances, and blending incenses to
suggest certain moods. This set contains
tools for cutting and arranging the incense,
a board with playing pieces, score-boards,
guessing slips and a variety of containers.

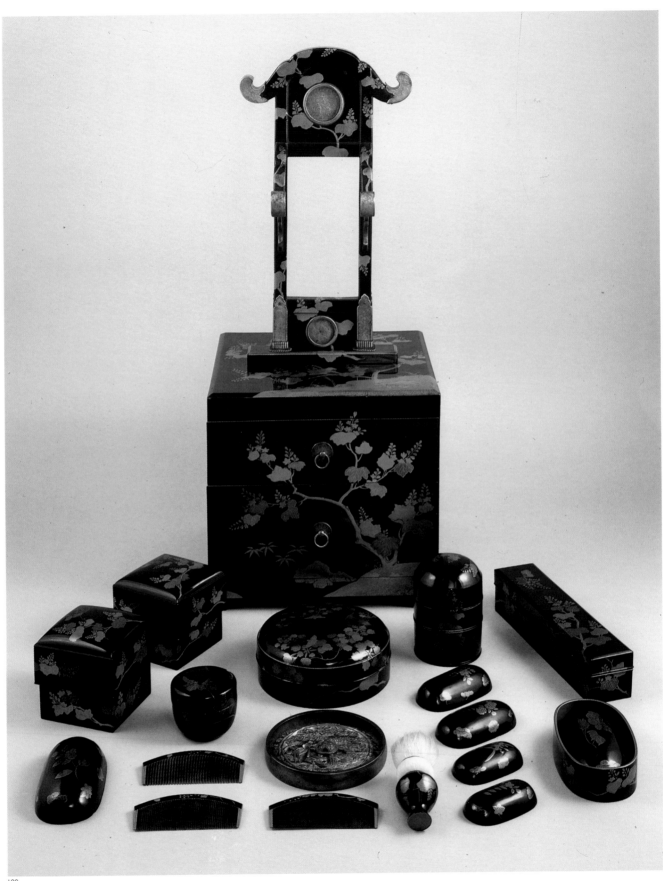

100

101

100 Mirror stand and set of drawers

Late 18th–19th century
Black lacquer with gold *makie*; tinned-bronze
 mirror; 62.0 × 27.0 × 27.0 cm
Published: Smith and Harris 1972, no. 63; Tokyo
 National Museum 1987, no. 45
OA + 7379

This kind of mirror stand was the Japanese
equivalent of the dressing-table, forming
part of the trousseau of the daughters of
daimyō during the Edo period. The whole
trousseau might consist of a set of lacquered

furniture and accessories, including a set of
shelves (no. 101), the incense game (no. 99),
the shell game (no. 54) and lacquered
clothes stands.

 This set includes boxes for face powder,
hair oil, powder brushes, combs, razors,
scents and a mirror. The decoration is
mostly of bamboo and paulownia boughs,
but the mirror box and the six brushes are
decorated with peonies and camellias, and
must have originally belonged to a different
trousseau.

101 Document box with design of interlocking crows and egrets

19th century
Black lacquer and crushed eggshell; eyes inlaid in
 gold lacquer and mother-of-pearl;
 30.5 × 24.3 × 6.2 cm
Published: Smith and Harris 1982, no. 66; *Le
 Japonisme* 1988, no. 68
1946.10-12.1. Given by Dr Bernhard Landan

This gloriously and boldly decorative piece
has perhaps most in common with the
painting of the Rimpa school, but it has no
real precedent in Japanese art, except
possibly the tradition from the seventeenth
century onwards of using flocks of birds as a
theme for screen painting.

102 Set of shelves

18th–19th century
Black lacquer with gold *makie* and gilt-bronze
fittings; L. 97 cm
OA + 972

The free-standing shelves are decorated
with the *kuyō*, or 'nine stars' *mon*, which,
having special significance in Buddhism,
was used by many *daimyō* families during
the Edo period. Similar shelves were used to
display objects in the standard wedding
trousseau of a *daimyō*'s daughter, and were
in fact part of it. They are among the very
few types which can properly be described
as furniture in traditional Japanese living.

102

103 Three *inrō*

Each with four compartments

a) Decorated with a peacock in gold
 takamakie and mother-of-pearl inlay on a
 gold *hiramakie* ground (reverse shows a
 river scene)
Late 18th–early 19th century
Signed: Hasegawa Shigeyoshi; *inscribed*: Hōgen
 Sukekiyo hitsu ('The brush of Hōgen Sukekiyo')
L. 7.8 cm
HG348. Given by Mrs Hull-Grundy

This *inrō* has an ivory *ojime* and netsuke
attached to the donor.

b) Decorated with boats on a lake and with
 chrysanthemums in relief in gold *makie*
 over a black lacquer ground
Momoyama period, late 16th century
L. 9.0 cm
Published: Smith and Harris 1982, no. 72
1945.10-17.403. Bequeathed by Oscar Raphael

This purse-shaped *inrō* was once reputed to
have belonged to the Regent Hideyoshi.
The relief work is a variant of *takamakie*, but
not all of it is gilt.

c) Decorated with shellfish in gold and
 black *sumie togidashi makie*
18th century
Signed: Gyōnen Rokujū Kanshōsai ('Kanshōsai,
 age 66 years'); *inscribed*: Tosa Mitsusada
L. 7.7 cm
Published: Smith and Harris 1982, no. 75
1945.10-17.405. Bequeathed by Oscar Raphael

104 Three *inrō*

a) Four cases carved in red lacquer in
 guri-style arabesques
18th century
L. 7.3 cm
Published: Smith and Harris 1982, no. 61
OA + 356

A matching *manjū*-type netsuke is attached.

b) Five cases carved in red lacquer in *tsuishū*
 style
Edo period, 18th–19th century
L. 8.5 cm
Published: Smith and Harris 1982, col. pl. 1
OA + 340

The motifs are the 'Three Friends of Winter'
(plum, pine and bamboo). The netsuke and
ojime are carved *en suite*.

c) Four cases, black lacquer with coloured
 shell inlay, gold foil and *makie* in Somada
 style
Early 19th century
L. 6.4 cm
Published: Smith and Harris 1982, no. 60
1945.10-17.419. Bequeathed by Oscar Raphael

The piece is in the style of the Somada
school active throughout the Edo period.
Their work is characterised by delicate
coloured shell inlay, *makie*, and especially
the application of small pieces of gold foil
over the lacquer to give a variety of colours.
The decoration here is the traditional theme
of a garden fence and chrysanthemums.

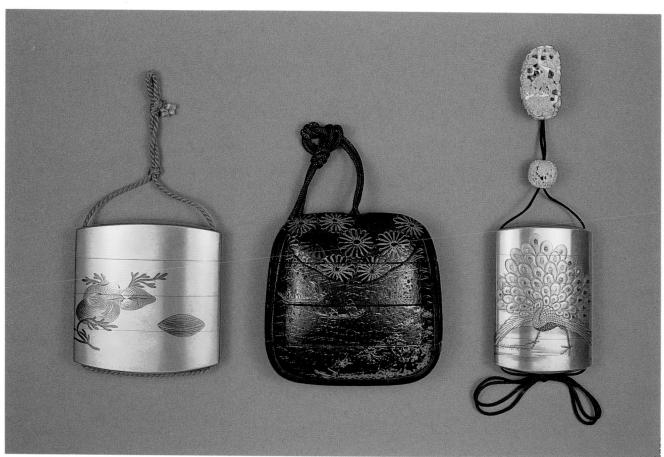

103c *left*; b *centre*; a *right*

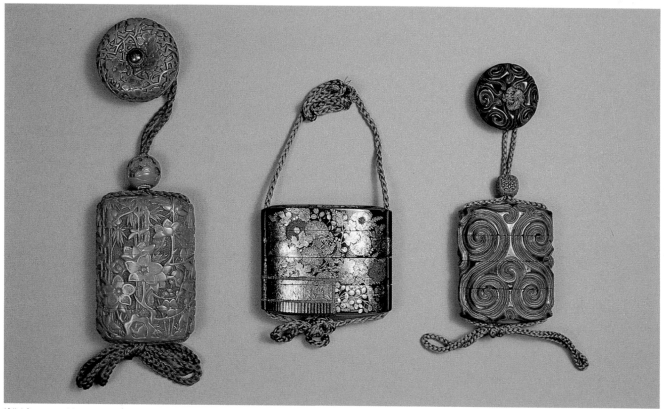

104b *left*; c *centre*; a *right*

6

THE ARTS OF THE TEA CEREMONY

(nos 105–24)

Most of the artefacts discussed in this book are understandable once a little background explanation has been learned. Some of the objects illustrated in this section, on the other hand, may be inherently very difficult to appreciate for a non-Japanese, so far are they from conventional Western aesthetic ideals. Yet the artistic tastes of the Tea Ceremony, its philosophical attitudes, and its suggestions of a way life may be viewed, have been central to Japanese culture since the mid-sixteenth century and in some respects still are. It is no exaggeration to say that between 1550 and 1850 the Way of Tea (Sadō or Chadō) was the single most powerful influence on Japanese culture, and to some extent remains the most potent force in Japan's modern efforts to retain a distinctive cultural identity. Certainly its elements are taught to every Japanese child at school, and it is actively studied by some ten million adults, or about eight per cent of the population. To try to understand its essence is therefore crucial to anyone who wishes to appreciate the culture of Japan. Only calligraphy in brush and ink equals its importance, but even calligraphy itself is only one contributory part of a Tea Ceremony.

The English term 'Tea Ceremony' is in itself misleading. Since the sixteenth century the occasion of serving tea in this very special spirit has been called simply Cha-no-yu ('Hot water for tea'), while the general philosophical and religious attitudes behind it which make it a way of life or at least of thinking about life is called Chadō (or Sadō), the 'Way of Tea'. Different modes of serving tea have more specific names, such as a *chaji*, which comprises the most complete entertainment of formal tea with a meal and relaxation afterwards. In its classic period in the sixteenth and early seventeenth centuries Cha-no-yu was often very relaxed, with the unexpected providing part of its pleasure to the

sophisticated circles from which the guests were drawn. In later centuries it has become somewhat hardened into schools preserving certain styles of presentation which are prescribed in sometimes minute detail; and in this respect it very much resembles the modern attitudes taken by the traditional schools of Nō acting, or of ikebana (flower arrangement). The extreme formality which has often existed in more recent Cha-no-yu probably gave rise to the Western interpretation of it as a 'ceremony', but it is at heart not that at all.

What then, is it? According to Sen no Rikyū (1522–91), Japan's greatest interpreter of Cha-no-yu, it is simply making tea and serving it to congenial people in the right surroundings and with the right spirit. Already in Rikyū's time this in fact implied standards of artistic sensitivity and of personal behaviour so refined that they required the existence of Masters of Tea who served as the undisputed arbiters of taste in their day. It is therefore necessary to go back even further in history to find the origins of the Spirit of Tea, and those origins, like those of so many other Japanese cultural activities since the fifteenth century, lie in the Zen branch of the Buddhist religion.

Zen, or meditative Buddhism, is said to have reached China from India in the sixth century AD, finally arriving in Japan in the thirteenth century, where it soon began to find powerful support among the samurai class. Its austerity and simplicity appealed to them as a reaction against the luxuries of the traditional courtly sects, while its insistence that enlightenment is to be found in a person's interior being chimed with their cultivation of the internal military spirit. Furthermore, Zen's broad-minded acceptance of almost any true discipline as an aid to enlightenment, and its belief in the power of the intuitive soul, gave a spiritual basis to the samurai's single-minded pursuit of skills in swordplay and archery.

In Tang dynasty China Zen priests had encouraged the drinking of tea within temples to enhance meditation; and to do this in simple surroundings, the more powerfully to bring out the significance lying deep below all phenomena. In Japan this practice had taken root very soon; records show that a reverence for simple, unassuming pottery, as used by Chinese Zen monks, was by the thirteenth century an important part of these exercises and that they were indeed already being copied at the Seto kilns. Here lies the origin of the essentially Japanese Cha-no-yu, where, however important the various arts brought together by the occasion, it is the

ceramics which take the greatest precedence. (It was partly from the canons of Tea Taste ceramics, indeed, that the whole modern studio pottery movement was derived, with its overwhelming influence in Europe and North America in the twentieth century.)

During the fifteenth century in Kyoto the adoption of Zen by the samurai class became general and reached the highest level in the patronage of the Ashikaga shoguns, who as aesthetes outrivalled at that time the Imperial court itself. It was almost inevitable in these circumstances of the highest official approval of Zen that its practices should tend to move towards the aesthetic and aristocratic and away from the specifically religious. Thus the Zen priest Murata Shukō (1422–1502), despite being a pupil of the popularist, authority-hating priest, Ikkyū, became Curator of Chinese Paintings and Teamaster to the Shogun Yoshimasa. The first tea-house (chashitsu), in the modern sense and style, was built in the grounds of Yoshimasa's Ginkakuji Temple. Although only four and a half mats (tatami) in area (about 9 sq m) and properly rustic in concept, it in fact marked the beginning of Cha-no-yu as a preserve of the cultivated, and its slow but sure movement towards the secular.

This does not mean, however, that Cha-no-yu lost its religious basis. On the contrary, the great Teamasters to this day must remain versed in Zen practice and meditation. But the chashitsu did allow ordinary (or fairly ordinary) life and Zen to meet and mingle in a known setting comfortable for all the participants. This is the essence, then, of a Tea 'Ceremony' – a meeting of like minds enjoying formalised refreshment in a quasi-religious atmosphere of peace and meditation, in a setting where the host has ensured that all the physical and atmospheric elements form a harmonious whole.

This concept of harmony is 'Tea Taste'. Certainly there have been strong tendencies, amounting sometimes almost to sets of rules, but the central concept is that everything – place, utensils, people – is unified by a common spirit, which it is the host's duty to foster. The great successive masters of the semi-secularised Cha-no-yu – Shūkō, Takeno Jōō, Rikyū, Furuta Oribe (1544–1615) and Kobori Enshū (1579–1647) – were in a sense impresarios presiding over every detail, however large or small. These included the design of the chashitsu itself; its garden, and especially the path (roji) leading from it to the waiting-room; the choice of scroll and/or flower arrangement for the display alcove (tokonoma); the time of day and season of the Ceremony; the choice of all

the utensils, especially a different teabowl (*chawan*) for each guest; the choice of guests themselves; the type of tea to be used; the order of the Ceremony and the menu, where a meal was served; the choice of incense, and of the 'tea-screen' (no. 178); and most important of all the imposition by the Teamaster of a mood. The bringing together of all these complex elements into a harmonious whole was rightly seen as the achievement of a superior personality, but a superiority which brought peace and enjoyment to the guests. It was this concept that made Cha-no-yu at its best an integrating cultural force of unequalled strength in Japanese history.

In the field of artefacts, which concerns this book, Cha-no-yu was most influential in two areas: the choice and mountings of the calligraphy or painting for the *tokonoma*; and ceramic utensils and containers. The significance of the *tokonoma* was very great. In the classic tea-room, with its echoes of the rustic hut, this alcove was the one place available for overt, if restrained, display. Because of the high prestige of Chinese ink-painting and Zen-style calligraphy, both of which traditionally used the hanging-scroll format, the *tokonoma* was designed with the height and shape suitable to that format. The lasting effect on Japanese painting was to make the hanging scroll (*kakemono*) the most prestigious format, and in turn to make a *tokonoma* essential in every building of any pretension.

In a formal Cha-no-yu Zen calligraphy was always preferred, but on less severe occasions a suitably restrained painting was in order. The atmosphere of the tea-house was always simple, reticent and 'rustic', and the back wall of the *tokonoma* was generally plastered, sometimes papered, in muted tones of off-white, straw, grey, brown or the like. The silk or paper mounts (*hyōgu*), which often more than double the surface area of the scroll, had therefore to fit this ambience (no. 112), while enhancing the painting or calligraphy itself. The sober styles of mounting for Cha-no-yu replaced the brilliant brocades used on temple paintings and have remained an ideal ever since. Only in the predominantly colourful Ukiyo-e school (not, of course, used in Tea) did there emerge a gaudier alternative.

Even more prestige lay in the equipment which actually touched the water and the tea. Among these was the great iron kettle (*chagama*) set in the hearth, the

bamboo scoop (*chashaku*) to take the powdered tea from the caddy (no. 106) and the bamboo ladle to transfer water from the water jar to the kettle. The reverence for such things, once they had been used by a Master, is one of the most recondite aspects of Japanese culture. Even more important were the ceramics used in Cha-no-yu – the water jar (*mizusashi*), the caddy (*chaire*) and the teabowl (*chawan*) – and, to only a slightly less extent, the flower-vase (*hanaire*) for the *tokonoma*.

It is in these ceramics that one can see most clearly the central aesthetic concepts of *wabi* (austerity) and *sabi* (literally 'rust' or 'patina'). These had always been inherent, since the thirteenth century, in the preference for simple, restrained pottery in muted colours based on Chinese and Korean wares. The Teamaster Jōō developed these concepts more formally and taught the connoisseurship of Tea pottery, taken much further still by Rikyū, his successor. Rikyū made the decisive shift of seeking out native Japanese types and patronising them, thus turning them overnight into lasting representatives of a Japanese cultural ideal, and incidentally ensuring that the qualities of rural unaffectedness and spontaneity would be lost in a more self-conscious sophistication. The best-known types thus selected by Rikyū and his successors were Raku (no. 107), Shino (no. 117), Oribe (no. 118), Bizen (no. 120), Karatsu (no. 119), Takatori (no. 114), Seto (no. 113), Ōhi (no. 121) and Iga (no. 108). The last-named is the most extreme example of the vigorous but subtle irregularities of shape and glaze favoured by the Teamasters. Foreign pieces continued to be used, including rather surprisingly blue and white porcelain (no. 109). But one strength of the Way of Tea is its ability to integrate objects which do not obviously go together. In this respect it had the edge on the culture of more unified but also more limited circles, such as that of the Kyoto aristocracy, which eventually died for lack of outside nourishment.

The school of Rikyū separated in the seventeenth century into three, of which the biggest today is Urasenke, 'The Rear House of Sen'. Urasenke are the guardians of the traditions of 'Commoners' Tea', the one nearest in fact to Rikyū's own ideals that Tea could bring diverse humanity together in the timelessness of the *chashitsu*. Seven of the pieces included have been lent by Urasenke, some used by Rikyū himself.

105

105 Tea scoop and case

By Sen no Rikyū (1520–91)
Bamboo; L. 178 mm
Published: Urasenke Foundation 1985, pl. 7
Lent by the Urasenke Foundation, Kyoto

One of the crucial moments of a Tea
Ceremony is that at which the Master
scoops a little powdered tea from the *chaire*
(tea-caddy, no. 106) into the teabowl. At this
moment all eyes are on the Master and his
movements. It is not surprising, therefore,
that he would appreciate a scoop which
would be easy to handle elegantly and that
Rikyū should have carved his own. The
long, narrow shape is necessitated by the
normally narrow neck of the tea-caddy. The
bamboo case has been inscribed by his
successor Sen Sōtan (1578–1658) and reads
Sōyō Saku ('Made by Sōyō' – a name used by
Rikyū).

106 Tea-caddy (*chaire*)

Late 16th century
Pottery with turned ivory lid, Seto ware (Owari
 Province); H. (with lid) 101 mm
Published: Urasenke Foundation 1985, pl. 6
Lent by the Urasenke Foundation, Kyoto

106

It was one of Sen no Rikyū's most important
contributions to Japanese culture to
recognise the aesthetic merit of simple and
rough wares which in a later age would
have been included in the designation of
mingei ('folk crafts'). Among these were the
everyday wares glazed in brown and black
produced in the Seto district, which soon
came to be known as 'Rikyū Seto'. His
admiration for the natural distortions of
unselfconscious potters led, it is suspected,
quite soon to their conscious production for
Tea devotees. This old piece, however, has
the rugged spontaneity most admired by
the Master. Ceramic caddies were used only
for the formal powdered *mattcha* (thick
tea). They invariably had a lathe-turned
ivory lid, replaced with such venerable
pieces only in the most extreme necessity.
This lid is mended with gold lacquer.

107

107 Teabowl named *Hōrinji*

By Raku Chōjirō (1516–92)
Raku pottery with thick black glaze; H. 89 mm
Published: Urasenke Foundation 1985, pl. 26
Lent by the Urasenke Foundation, Kyoto

Raku Chōjirō of Kyoto was almost a
contemporary of Sen no Rikyū, Japan's
most famous Teamaster; he owed his
reputation to Rikyū's choice of his low-fired
pottery as the best Tea Ceremony ware
Japan had to offer. Through this connection,
Raku potters continued to work during the
whole of the Edo period and into this
century. Since 1945 Raku has become an
internationally practised style. It has
remained the first choice for teabowls,
because of its lively but very individual
pottery, its seriousness, its sombre colours
which contrast interestingly with the green
tea, its pleasantness to the touch, and its
ability to retain the heat of the tea without
communicating it to the hands. Many of the
most celebrated Raku bowls have names
awarded by Teamasters. This one, named
by Rikyū's successor Sōtan, is after a temple
at Arashiyama in the north-west of Kyoto,
and is thought to suggest the mists of that
district. As in all grand Raku teabowls, the
relationship between the shape and the
irregularly cut rim is crucial. The
straight-sided, high-footed, black-glazed
type is perhaps the most classic of all.

108

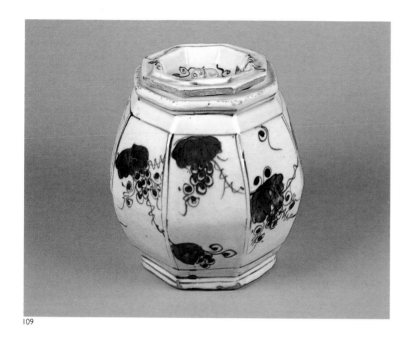

109

110

108 Flower-vase (*hanaire*)

Late 16th–early 17th century
Pottery with ash glaze, Iga ware (Iga Province);
 H. 275 mm
Lent by the Urasenke Foundation, Kyoto

A Tea Ceremony normally required a flower arrangement of suitable spareness and allusiveness, and the vases used were of appropriate austerity. It could stand on the floor of the *tokonoma* (alcove) or hang on its back or side wall, in which case it could even replace the hanging scroll. These long, slender hanging vases could be made of bamboo, metal or ceramic and, if pottery, were provided with a slot, on which to suspend them, at the back of the rim. This example is typical of the extraordinary rough wares of Iga, which were admired by the Teamasters for their extremely varied, natural-looking glazes, often resembling fissured volcanic rocks. They were made from an impure, gritty clay which was ash-glazed and baked very slowly in the kiln. This would sometimes produce an astonishingly interesting piece with the feeling of a natural phenomenon rather than an artefact. Although not necessarily attractive in itself, a vase like this could be transformed in use by its perceptive matching with a suitable flower.

FURTHER READING Jenyns 1971, pp. 117–21

109 Water jar (*mizusashi*)

Late 16th–early 17th century
China, Jingdezhen kilns
Porcelain decorated in underglaze blue;
 H. (with lid) 197 mm
Lent by the Urasenke Foundation, Kyoto

The Japanese taste for pottery with a strong sense of individuality extended in the sixteenth and seventeenth centuries to a type of Chinese porcelain which was by the urbane standards of the great Jingdezhen kilns rather roughly potted, decorated and glazed. This type was so liked by the Japanese, who refer to it as *ko-sometsuke* ('old blue and white'), that it was especially made for export there, the main impetus coming from the Teamasters. This faceted piece, freely decorated with grape arbours under a white glaze, has the tactile qualities sought after for the Tea Ceremony. Imitations were soon being made in Arita (see p. 164), and there is some uncertainty in distinguishing them. In the early nineteenth century the style was self-consciously reproduced by Kyoto makers.

110 Tea container (*natsume*)

18th century, probably Kyoto
Lacquer decorated with *makie* and *nashiji*;
 H. 69 mm
Lent by the Urasenke Foundation, Kyoto

This type of lacquered container is used for the less formal tea called *usucha* ('thin tea'), served for relaxation at the end of a full *chaji* (tea and food) ceremony. The leaf tea used obviously makes a narrow-necked container impractical. This piece is lacquered in a typically smooth eighteenth-century style, with roundels bearing a motif of paired sparrows and bamboo, alternating with the 'nine-stars' Buddhist symbol. These are done in gold *hiramakie* (flat gold) against a *nashiji* ('pearskin') ground achieved by setting flakes of gold at different depths in the lacquer. A discreet *nashiji* was considered suitably restrained for Tea use.

111

TAKUAN SŌKŌ (1573–1643)

||| 'Like Moving Clouds and Running Water'

Dated 'Kanei Hinoe Ne no Aki' (equivalent to autumn 1636)
Signature: Takuan Okina sho ('the calligraphy of the Old Man Takuan'); *seals*: Takuan (2)
Ink on paper; hanging scroll; 1.115 m × 311 mm
Lent by the Urasenke Foundation, Kyoto

Takuan Sōkō was the 153rd abbot of the Daitokuji Temple in north-west Kyoto, one of the great Zen Buddhist *daihonzan* (equivalent to a cathedral) of Japan. Calligraphy in brush and ink being valued as the greatest of the arts of East Asia, and the Way of Tea being firmly rooted in Zen, it was inevitable that Zen calligraphy hung in the *tokonoma* alcove should become an essential adjunct to the most formal Tea Ceremonies, especially in the Urasenke line, where the close connections with Daitokuji have continued since the late sixteenth century. The thrusting sense of motion in deep black ink is the essence of Zen brush-writing. Here, after the almost prosaic first character *gotoshi* ('like'), the moving clouds and flowing waters act out their visual drama.

MATSUMURA KEIBUN (1779–1843)

112 Morning glory

1830–40
Signature and seal: Keibun
Ink on paper; hanging scroll; 250 × 405 mm
1983.11-11.04 (Japanese Painting ADD 771)

This simple ink-painting would have been
suitable for a less formal Tea Ceremony in
summer. The morning glory (*asagao*) would
also obviously be used for a morning
occasion. The scroll is mounted in a most
carefully selected series of materials to
enhance the painting and to hang with
propriety in the *tokonoma* of the tea-room.
The brocade edgings at the head and foot of
the painting are decorated with dewy grass
in very restrained gold, green and silver on
a beige ground. The silk surround is a
damask figured in blue with a motif of
waves on water, the colour hinting at the
blue of the morning glory which is
represented only by ink in the picture itself.
The finishing mounts at top and bottom are
in a brown, hand-crumpled paper, adding a
sense of faded age to the whole ensemble,
and merging quietly into the inevitably
muted background of the wall. The
traditional *fūtai* (hanging tabs) are replaced
by restrained strips of white paper, and the
rollers are lathe-turned from carefully
selected bamboo with a dappled skin.

FURTHER READING Hillier, Jack, *The Uninhibited
Brush*, London, 1974, ch. 6

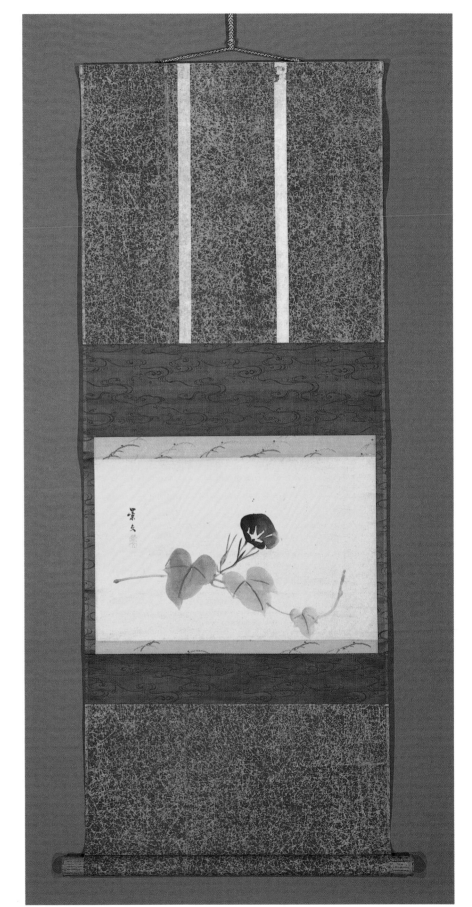

112

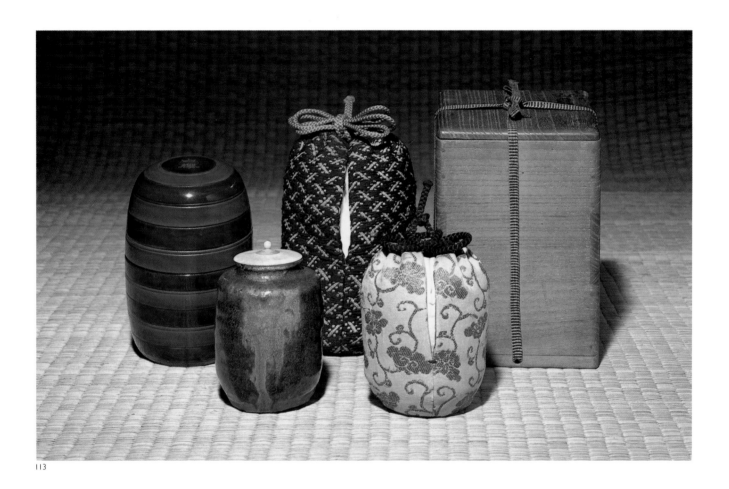

113

113 Tea-caddy, with its set of bags and containers

Caddy: 17th century
Pottery with varied brown glazes and ivory
 lid, probably Seto Ware (Owari Province),
 H. 85 mm
The set comprises *inner bag*: gold silk brocade on a
 cream ground; *container*: wood lacquered in
 brown and red in *komade* style (p. 98); *outer bag*:
 gold silk brocade on a dark blue ground; *outer
 box*: cherry-wood, with bark on lid
Provenance: Arthur Morrison Collection
1947.4-18.5

This set is included to demonstrate the love
and reverence given to admired tea-wares
by Teamasters. The caddy, probably from
the extensive Seto area kilns which
provided so many of Japan's ceramics in the

Edo period, has a glaze somewhat
reminiscent of the bark, faded by time, of
the mountain cherry (*yamazakura*). This
name has consequently been given to the
piece by a Teamaster and is inscribed on the
lid of the lacquered container, the colours of
which more accurately recall the reds and
browns of a living cherry tree. The outer
box, also inscribed with the name,
continues the cherry theme. The undoing of
these successive layers would naturally add
to the sense of ceremony and expectation as
the Master prepared the tea.

 The date of the containers and bags is
uncertain, but they were probably put
together in the late eighteenth or early
nineteenth century.

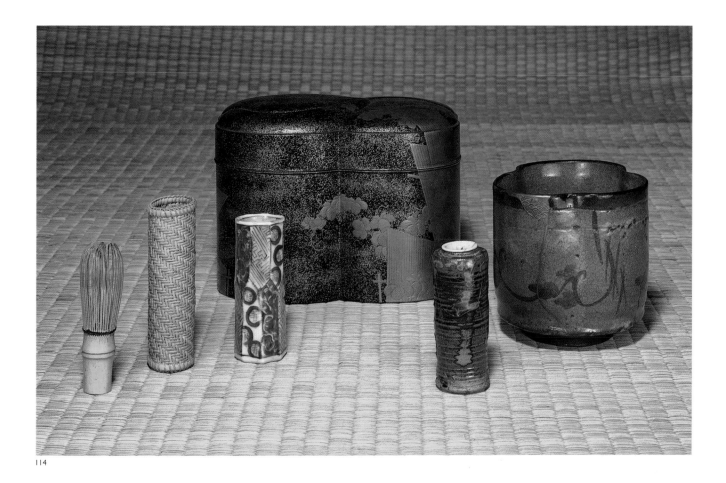

114

114 Portable set for an outdoor Tea Ceremony

Teabowl: 17th century; *remainder*: probably 18th century

The set comprises *teabowl*: painted Karatsu pottery (Hizen Province); *tea-caddy*: probably Takatori pottery (Chikuzen Province) with turned ivory lid; *napkin-holder*: Porcelain decorated in underglaze blue in *sometsuke* style; *tea-whisk and holder*: bamboo; *container*: black lacquer with gold *makie*; H. (container) 120 mm

Published: Smith and Harris 1982, col. pl. 7b; Tokyo National Museum 1987, no 44

1955.2-21.1. Given by Mr and Mrs D. Hewitt

It is likely that the container was made later to fit the teabowl, which is of classic but irregular E-Karatsu type, painted with

simple motifs in underglaze iron brown. It has been repaired in gold and silver lacquer at the rim. The tea-whisk is made from a single node of bamboo, split and split again into curved tines of extraordinary delicacy. The whisk-holder is of woven bamboo. The container is richly decorated in gold *makie* and *nashiji* with an ivy-covered fence, suggesting the outdoor venue for which this set would be used. For *sometsuke* see no. 109.

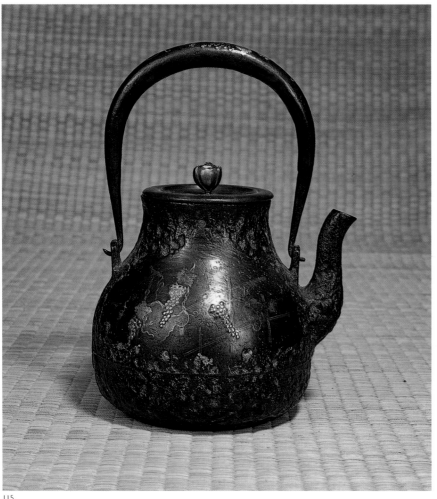

115

115 Kettle for informal Tea

18th–19th century
Impressed (on lid): Ryūbundō
Cast iron with gold and silver inlay; lid copper
 with gilt-copper knob; H. (excl. handle) 122 mm
Published: Smith and Harris 1982, no. 13
1969.9.25-1

The British Museum's collection does not
include an example of the massive iron
chagama kettle traditionally used on the
hearth in the most formal Tea Ceremonies.
This smaller, more decorative type has an
up-and-over handle for easier use in
less formal circumstances or for an outdoor

Tea. Cast in two halves, the lower is roughly
and austerely textured in the manner of the
true *chagama*, while the upper is burnished
and inlaid with a grapevine pattern in gold
and silver, a technique more associated with
firearms, armour breastplates and sword
furniture. The copper lids of such kettles are
most frequently signed Ryūbundō, a
nineteenth-century firm of iron-casters.
These lids appear so often, however, that
they may have been made in large numbers
for fitting to kettles by other makers.

FURTHER READING P.L.W. Arts, *Tetsubin*,
Groningen, 1988

116 Jar, probably for ceremonial use

9th or 10th century
High-fired pottery with natural ash glaze, Sanage
 ware (Owari Province); H. 246 mm
1987.6.2.1

In the Nara and early Heian periods the
numerous kilns of Sanage (close to
present-day Nagoya) were the main centre
of production in Japan for high-quality
ceramic wares. They were a continuation of
the tradition of high-fired pottery,
sometimes thrown on the wheel, which had
flourished in the ceremonial Sue wares of
the late Kofun period (nos 7, 9, 10, 11). Sue
had gradually come to capitalise on the
natural glazes which could result from
deposits of ash from the kiln itself, and in
Sanage wares it became a norm which was
to continue into the later medieval period.
These glazes were greyish, brownish or
yellowish, and helped establish the
Japanese preference for sombre pottery
which was to find its fullest expression in
Tea Ceremony taste.

Despite its relatively rough appearance to
modern eyes, this piece must have been
among the finest available at the time in
Japan, when the technology of all-over
coloured glazing of the Chinese was rarely
attempted, though occasionally pieces were
imported. Its crisp potting and stately shape
suggest a piece for temple, shrine or court
use. Indeed, similar examples complete
with lids have been recovered from
sūtra-mounds of the period, when they
were used to hold religious relics or
devotional objects.

117

117 Cake dish

17th century
Pottery with cobalt-blue decoration under crackled
 creamy glaze, Shino ware (Mino Province);
 Diam. 200 mm
Published: Smith and Harris 1982, no. 86
F1825

The provision of a small, elegant cake is
essential in every Tea Ceremony. It is eaten
before the tea is drunk. The small size of the
confection brings the dish into some
prominence, and etiquette demands it
should be inspected and appreciated by the
guest. Shino ware was almost as highly

prized by Teamasters as Raku (no. 107), and
for some of the same reasons, such as
unaffected potting, a thick glaze which
would draw back from the light body giving
both tactile and visual variety, and
unpredictable developments in the
pigmentation as a result of low-temperature
firing. Shino differed, however, in its light
palette and use of very simple stylised
decorative motifs. In contrast to the Ofuke
revival piece (no. 123) this example has been
hand-dipped in the glazing mixture,
producing a less predictable result.

FURTHER READING Hayashi *et al.* 1974

118

118 Food dish

Early 17th century
Pottery with green, tan and white glazes and
 iron-brown underglaze patterns, Oribe ware
 (Mino Province); DIAM. 223 mm
Provenance: J. W. Peer Groves Collection
Published: Smith and Harris 1982, no. 87
1955.4-29.1

The serving of a formal meal (*kaiseki*)
completes the most formal Tea Ceremony;
this dish could well have been used for one
of the courses. The rather racy wares of the
Oribe kilns owed their fame to the
promotion and approval of the Teamaster
Furuta no Oribe (1545–1615). With their

tendency to sharp, square shapes and
smart, semi-abstract designs based on
textile motifs, they were among the most
chic wares of the Momoyama period. This
example is typical of the Oribe palette,
which relied on contrasts between the three
main colours. The dark, thick green is a
characteristic feature of the ware, as is the
bold division of the surface into two
completely different halves; the latter is a
particularly Momoyama period style which
continued well into the Edo period in Oribe
pottery.

FURTHER READING Hayashi *et al.* 1974

119

119 Bulbous jar

17th century
Pottery with white crackled glaze, Karatsu ware
 (Hizen Province); H. 150 mm
F1804+

It is not quite certain what the original
function of this piece was but it may have
been used in the Tea Ceremony for a *kensui*
(slop-jar), a rather unobtrusive function. It
is one of the styles of Korean pottery and
porcelain of the sixteenth and seventeenth
centuries brought to the island of Kyūshū
and to south-western Honshū by
immigrants and developed into an
important industry. In the case of pottery it
was the patronage of Teamasters which
brought it into respectability and gave it a

wider demand. This sort of simple crackled
white-ware was one of the types made in
the kilns of Karatsu, some way north of the
porcelain-producing town of Arita. It
became admired for its unaffected shapes
and natural and varied glaze effects,
including the near-random way in which it
was dipped in the glaze, leaving an
unglazed area on the base by which it was
held. The respect with which this particular
piece was regarded is proved by the gold
and silver lacquer repairs to the rim.

FURTHER READING Jenyns 1971, ch. 6

120 Water jar (*mizusashi*)

17th century
High-fired pottery with ash glaze and lacquered
 wooden lid, Bizen ware (Imbe district, Bizen
 Province); DIAM. 232 mm
Published: Smith and Harris 1982, no. 102
Provenance: The late 19th-century dealer and
 pottery specialist Noritani Ninagawa
F1891

The Teamasters of the late sixteenth and
seventeenth centuries searched widely for
pottery types suitable to provide the variety
and interest essential to preserve their
professional reputations as arbiters of taste.
The long-established kilns of Bizen which
had since the Middle Ages produced an
almost metallically hard and high-glazed
practical dark pottery were among those
singled out. Since Bizen wares were at their
best in larger shapes, it is not surprising that
they were most often used for the water jar
in which water was brought to the hearth of
the tea-room. It had to have a lid, and a
wide mouth, because water was ladled from
it into the kettle. This impressively massive
sculptural piece is enlivened by the
apparently random slashes the potter has
cut into the clay. The hollow cylindrical
handles would allow it also to be suspended
by cords.

FURTHER READING Jenyns 1971, pp. 98–108

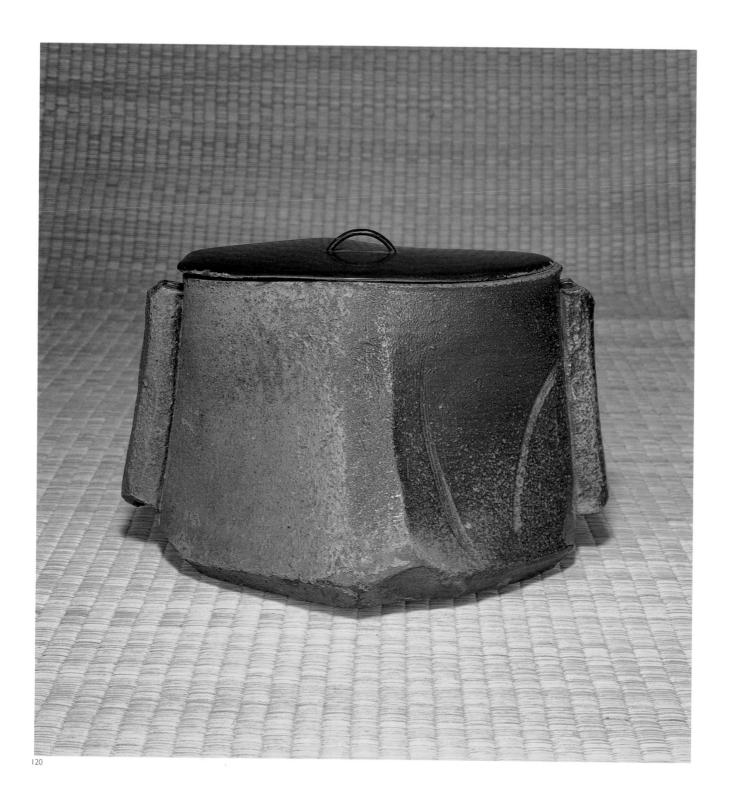

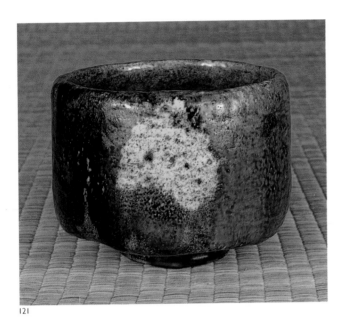

121

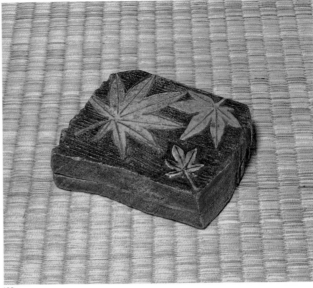

122

121 Teabowl

Probably 18th century
Pottery glazed in Raku-style shades of brown and
 yellow, Ōhi ware (Kaga Province); w. (across
 mouth) 116 mm
Published: Jenyns 1971, pl. 89b (3)
1945.10-17.490. Bequeathed by Oscar Raphael

Certain pottery types in Japan have owed
their reputation almost entirely to the
patronage of Teamasters – Raku, Shino and
Oribe are the best known. Among them are
the subtly potted and glazed wares of Ōhi,
in the Raku tradition, rather less accessible
to the Kyoto-based Tea Ceremony industry
of the late sixteenth and seventeenth
centuries, but discovered and used first by
the Teamaster Sensō of the Urasenke line in
the mid-seventeenth century. This example
has all the sturdiness and individuality of
shape and warmth and liveliness of glaze
expected in a great teabowl – a delight
equally to the eye and the touch, and a
perfect foil to the pale-green foam of the
whisked tea.

FURTHER READING Jenyns 1971, pp. 277–8

122 Incense box

Late 18th–early 19th century
Impressed: Ban, Ko
Pottery with brown, rust, beige and green glazes,
 Banko ware (Ise Province); DIAM. 45 mm
1954.4-18.15. Given by E. S. de Beer

The use of incense was an important part of
the most formal Tea Ceremonies, and the
burners and containers consequently had to
conform to the general concepts of taste.
This very stylish little box simulates stone,
with maple leaves in carved relief fallen on
it, glazed in the colours of early and
mid-autumn, at which time of year it would
have been used. The freedom and boldness
of the design, combined, nevertheless, with
poetic sentiment, suggest the artistic line of
Kenzan (1663–1743), the potter brother of
the great Rimpa artist Kōrin (p. 180), whose
work was frequently imitated by the
founder of the kilns, Nunami Rōzan
(1718–77), and his successors. The inside lid
is decorated with a poem in underglaze iron
brown, but it has become illegible during
the firing.

FURTHER READING Jenyns 1971, pp. 295–99

123 Water pitcher

c. 1840
Impressed: Shuntai (Katō Soshirō, 1799–1877)
Pottery with designs in blue under a white glaze,
 Ofuke ware (Owari Province); H. 251 mm
Published: Jenyns 1971, pl. 57b
1972.6-22.1. Given by R. S. Jenyns to mark the
 centenary of the birth of R. L. Hobson, CB

This fine piece gives the lie to the opinion
that Shino-style pottery was of merit only in
the sixteenth and early seventeenth
centuries: it is made in the artificially
preserved manner of the Katō family, who
had moved to Ofuke (near Seto) in the
seventeenth century. The potter vigorously
exploits the contrast between the
iron-brown colour assumed by the cobalt
blue when uncovered by the milky-white
glaze, and the soft grey-blue it bakes to
when protected by the glaze. There is a
similar contrast between the glaze and the
rich rusty-red of the unglazed body.
Because Shuntai has brushed his glazing
mixture on to the body, he has achieved this
natural effect with some artfulness.

The motifs are pine-fronds, and on the
other side water-wheels, both handled with
freedom and an unerring sense of placing.

FURTHER READING Hayashi *et al.* 1974

124

124 Water jar (*mizusashi*)

c. 1985
By Keiko Hasegawa (b. 1941)
Impressed: Ha
Pottery in Raku style; H. 185 mm
1986.6-27.8

The continuity of Tea Ceremony taste is amply demonstrated in this contemporary *mizusashi*, relying for its power on the simple yet subtle strength of its shape and the natural effects of its crackled and pitted glaze. Hasegawa, who has lived and worked in England since 1977, makes pottery in the now internationally practised Raku manner (see no. 107); her finest pieces are considered by many to be those made specifically for the Tea Ceremony. As the largest ceramic piece used for tea, the water jar must be both visually compelling and restrained, as well as practical; this example notably succeeds in all three objectives. The finely crackled yellowish glaze recalls the Ki Seto (Yellow Seto) pieces of Mino Province of the late sixteenth and early seventeenth centuries.

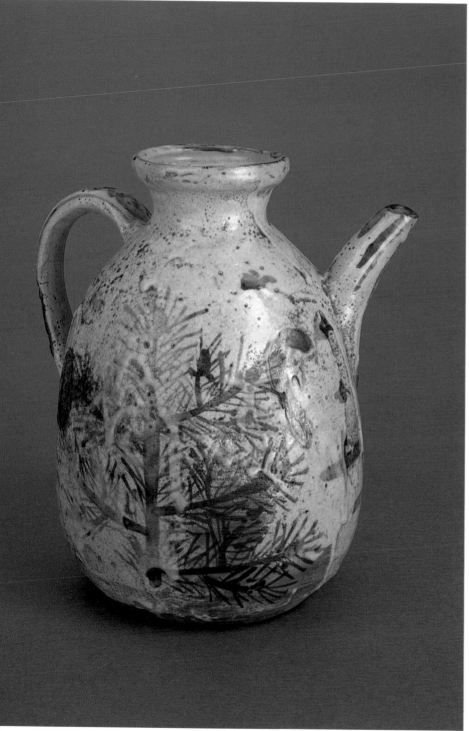

123

7

MONEY, MIRRORS AND CLOCKS

(nos 125–34)

Money (no. 125)

Coins were first used in Japan during the Nara period (646–794). Although weighed amounts of gold and silver were already used to make payments, the idea of coinage was introduced from China as part of the Imperial court's policy of establishing an administration modelled on the Chinese Tang court. Chinese bronze coins were already in circulation during the late seventh century, and a mint to cast imitations was established by the court before the end of the century. In 708 the Empress Gemmei ordered the issue of the first purely Japanese coinage. The shape and design of the imported Chinese coins were retained, but the new silver and bronze coins were inscribed *Wadō kaichin*, meaning 'the precious money of the opening of the Wadō period' (707–15). Imperial coins, mostly bronze, continued to be issued until the end of the Nara period and during the succeeding Heian period.

In 958, however, the official coinage came to an end, and the official monetary system reverted to payments with weighed precious metal and commodities such as rice and cloth. Japan abandoned the use of coinage until the thirteenth century, when it was resumed, again under Chinese influence. The adoption of paper money in China made large quantities of unused bronze coins available for export. Japanese traders brought sufficient quantities of these coins into Japan for them to become the principal means of payment. Imported Chinese coins and locally made copies provided Japan with a coinage system during the next three centuries.

During the late sixteenth century new forms of coinage joined the Chinese bronze coins in use in Japan. As well as making their own versions of the imported coins the local feudal lords also began to issue stamped gold and silver ingots for use as money. This innovation was formalised during the first decade of the seventeenth century by the Shogun Tokugawa Ieyasu (1543–1616)

whose mints at Edo (Tokyo) issued new gold and silver coins with designs derived from the feudal ingots. These were a success and continued to be used as the model for Japan's coinage until the end of the Tokugawa shogunate (1603–1868). In 1606 and 1619 his son Hidetada (reigned 1605–23) also attempted to establish a bronze coinage to replace the imported coins. A successful bronze coinage, however, was not introduced until 1626, when the Shogun Iemitsu initiated the *kanei tsūhō* issue, which remained current until the change to modern currency in the nineteenth century.

Although the Tokugawa coinage system survived into the nineteenth century, the seeds of its disintegration were already sown in the seventeenth century by the introduction at Osaka of private paper money. From 1661 the feudal clans were also permitted to issue their own notes. Paper money inflation soon overtook the official coinage and led to progressive reductions in the weight and fineness of the precious metal coins and the replacement of the bronze coins by token and iron issues. During the nineteenth century the clans were issuing most of the money in circulation and even began to issue their own coins.

The re-establishment of a stable official coinage came only with the overthrow of the Tokugawa shogunate in 1868 and the reforms of the Meiji emperor. In 1870 Japan's currency system was modernised after Western models and the yen became the standard unit. The yen was a Japanese equivalent of the Mexican silver dollar, which Western traders used as their main means of payment in East Asia. Mexican dollars had been used in Japan's ports since they were opened to foreign trade in 1854. In 1870 a Western mint was acquired from Britain (via Hong Kong) and established at Osaka to mint the Meiji emperor's new gold, silver and bronze coins, which were issued for circulation in the following year. Since 1871 until the present day the Osaka mint has continued to provide Japan's coinage.

125 Coins

Max. H. 13.4 cm

a) *Wadō kaichin* ('precious money of the
 opening of the Wadō period') of Empress
 Gemmei, cast in AD 708
Silver
CM 1884-5-11-17. Tamba Collection

b) *Mannen tsūhō* ('ten thousand year
 circulating money') of Emperor Junnin,
 cast in 760
Bronze
CM 1884-5-11-26. Tamba Collection

c) *Kisei tsūhō* ('circulating money of the
 turtle well'), privately issued copy of
 Chinese coin, cast during 15th century
Bronze
CM 1884-5-11-522. Tamba Collection

d) *Seikō tsūhō* ('circulating money of the
 Seikō period') of King Shōtoku, Ryūkyū
 Islands, 1460-5
Bronze
CM 1978-9-6-40

e) *Eiraku tsūhō*, copy of Chinese bronze
 Yongle tongbao ('circulating money of the
 Yongle period') of Ming Dynasty (issued
 1408), cast during late 16th century
Gold
CM 1935-4-1-12703. Clarke-Thornhill Bequest

f) *Kōshū ichibu-kin* ('gold one *bu* of Kōshū'),
 feudal gold coin from Kōshū district,
 struck in late 16th century
Gold
CM CH 0196

g) *Tenshō tsūhō* ('circulating money of the
 Tenshō period') of Toyotomi Hideyoshi,
 cast in 1587
Silver
CM 1884-5-11-107. Tamba Collection

h) *Keichō koban* (small piece of Keichō
 period) one *ryō* coin of Tokugawa Ieyasu,
 struck at Edo in 1601
Gold
CM CH 0235. Marsden Collection

i) *Genna tsūhō* ('circulating money of the
 Genna period') of Shogun Hidetada, cast
 in 1619
Bronze
CM ES 11. Ernest Satow Collection

j) *Kanei tsūhō* ('circulating money of the
 Kanei period') of Shogun Ietsuna, cast at
 Kyoto in 1653
Bronze
CM 1884-5-11-364..Tamba Collection

k) *Bunsei nibu-kin* ('gold two *bu* of the
 Bunsei period') of Shogun Ienari, struck
 at Edo in 1828
Gold
CM 1921-1-5-152. Given by C. W. Simpson

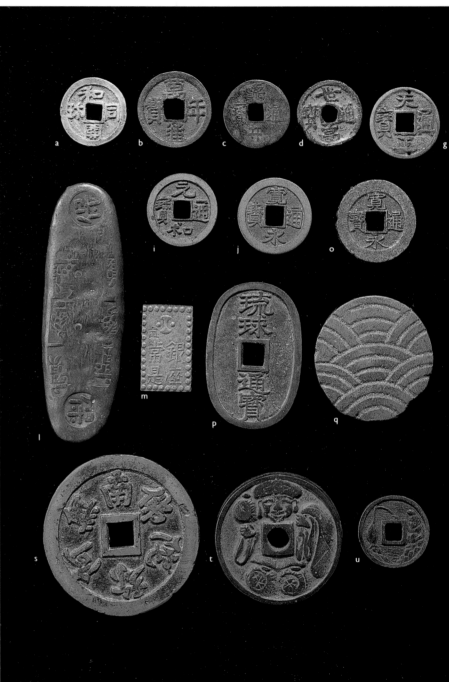

125

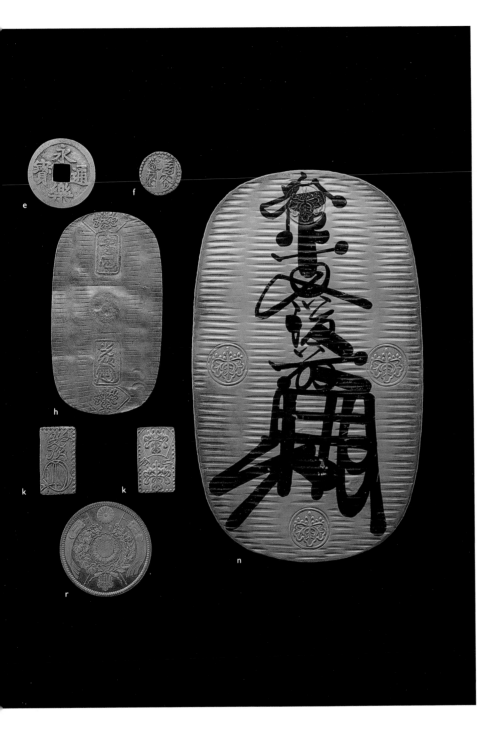

l) *Tempō chōgin* ('long silver of the Tempō period') of Shogun Ieyoshi, struck at Edo in 1837
Silver
CM 1935-4-1-12701. Clarke-Thornhill Bequest

m) *Ansei nibu-gin* ('silver two *bu* of the Ansei period') of Shogun Iemochi, struck at Edo in 1859
Silver
CM CH 0183

n) *Mannen ōban* ('big piece of Mannen period'), ten *ryō* coin of Shogun Iemochi, struck at Edo in 1860
Gold
CM 1947-6-4-3. Given by E. T. Sykes

o) *Kanei tsūhō* ('circulating money of the Kanei period') of Shogun Keiki, token for four standard coins, cast at Morioka in 1866
Iron
CM 1973-3-3-7. Stephen Cribb Collection

p) *Ryūkyū tsūhō* ('circulating money of Ryūkyū Islands'), feudal token for 100 standard coins, cast for Ryūkyū Islands at Kagoshima in Satsuma in 1861
Bronze
CM 1887-11-5-215

q) *Akita namisen* ('Akita domain wave-coin'), feudal token for 100 standard coins, cast at Akita in 1862
Bronze
CM 1973-3-3-1. Stephen Cribb Collection

r) *Meiji jūyen-kin* ('gold ten yen of the Meiji period') of Meiji Emperor Mutsuhito, struck at Osaka in 1870, issued 1871
Gold
CM 1892-10-1-2. H. Cargill Gift

s) Coin-shaped charm inscribed with Buddhist prayer *Namu Amida Butsu* ('Hail Amida Buddha'), cast during 17th century
Bronze
CM CH 0536

t) Coin-shaped charm decorated with image of Daikoku, god of wealth, cast during 17th century
Bronze
CM 1887-11-5-5

u) Coin-shaped charm decorated with image of Ebisu, god of fishermen, cast during 17th century
Bronze
CM 1884-5-11-2414. Tamba Collection

Mirrors (nos 126–30)

Until the Meiji Restoration in 1867, when glass mirrors became widely used, mirrors were cast in bronze with a highly polished surface and decorative motifs in relief on the back.

Round mirrors were introduced into Japan from China and Korea during the Yayoi era. The fact that they were excavated together with ritual *dōtaku* bells (no. 15) suggests that they had a religious function from the beginning. This becomes clearer during the Kofun era. Mirrors presented to the rulers of Japanese states during the third century AD were immediately considered symbols of authority and handed on to succeeding generations as such. From this time until the Heian period mirrors in Japan comprised imported examples, copies of imports of more or less accuracy, and more purely Japanese developments.

Chinese mirrors decorated with beasts and deities of the late Han (AD 25–220) and Three Kingdoms (AD 220–80) eras were copied in Japan with interesting variations, since the religious ideas behind the Chinese designs were not thoroughly understood (no. 19). By the Kofun period mirrors were being made in some quantity in Japan, first as direct copies of Chinese and Korean, and then developing purely Japanese characteristics, such as the uniquely Japanese ritual ringing mirror with peripheral bells (no. 19b). All of these types appear regularly from tomb excavations, pointing to their high status and ritual significance. Chinese Tang dynasty mirrors were imported during the Nara period. Their designs, which included animals, grapes, auspicious flowers and pairs of phoenixes, were also adapted by Japanese makers.

During the Heian period mirrors became almost wholly native using favourite Japanese auspicious symbols. The Chinese phoenixes became cranes, sparrows, or the long-tailed *onagadori*, and the Chinese flowers were replaced with such plants of good omen as bushclover, cherry blossom, chrysanthemum and pine. From the Kamakura period onwards one of the most popular designs was the auspicious Hōraizan, the Chinese Island of Immortality, with a sandy beach, pines, cranes and a tortoise, all emblems of longevity.

Most of the early mirrors were round with a raised rim. The Heian period mirrors tended to be thin with slender rims. In the Kamakura period the rims became rather more robust, and the designs more vigorous and naturalistic, often filling the whole surface in high relief. Mirrors of this period often have raised concentric ridges dividing the design into a central and outer portion (no. 126d). The boss in the centre, pierced so that a loop of cord could be attached in order to hold the mirror in the hand, developed into a tortoise shape, and this remained in common use on mirrors without handles.

During the Muromachi period the variety of designs increased, and repeating designs like the chrysanthemums on a tortoise-shell ground in no. 127d became popular. Towards the end of the period the first handled mirrors appeared, generally small with long slender handles. Earlier mirrors had sometimes been inscribed with religious, poetic, or archaistic inscriptions, but from this period the name of the maker or the title Tenka-Ichi ('First under Heaven') are first found.

Most mirrors in everyday use until this time were small and could be easily held in the palm of the hand. But in the Edo period larger mirrors were made and diameters of twenty to thirty centimetres are common, possibly in response to the vogue for exotic hairstyles. Indeed, in theatre dressing-rooms examples of well over fifty centimetres' diameter were used. These mirrors had more robust handles, shorter in proportion to the diameter, and normally rested on a stand. As there was a plentiful native supply of bronze, and an increasing demand for mirrors, many inferior castings were produced. Some of these were mass-produced from impressions made by pressing an existing mirror into a mould. Japanese bronze had a very high content of copper containing small amounts of other elements, and readily became darkly patinated. An increase in tin gave a white sheen to the polished surface, but the surface of a copper mirror could also be 'tinned' by wiping molten tin on to it. There were specialist itinerant tinners and polishers to do this work, and the great Edo Ukiyo-e artist Hokusai was said to have come from such a family.

Since mirrors were given during the Edo period as wedding gifts, many were decorated with auspicious symbols or characters, and some bear the two *mon* of the united families. On the whole the pieces of the mid- and later Edo period degenerate into a rather arid

formalisation which stands in surprising contrast to the more adventurous decorative styles on lacquer, ceramics, textiles and metalwork of the same era.

As the mirror together with the sword and the jewel comprised the three objects of the Imperial regalia, their makers were highly regarded craftsmen and were sometimes, like swordsmiths, given honorary titles (for example, no. 128c). The use of the title Tenka-Ichi was allotted to certain craftsmen during the Momoyama period, and it is found on many early Edo period mirrors, having been rapidly adopted by many makers until its use was prohibited in 1682. Nevertheless, it appears on many low-quality casts of clearly much later date and is itself of very little meaning.

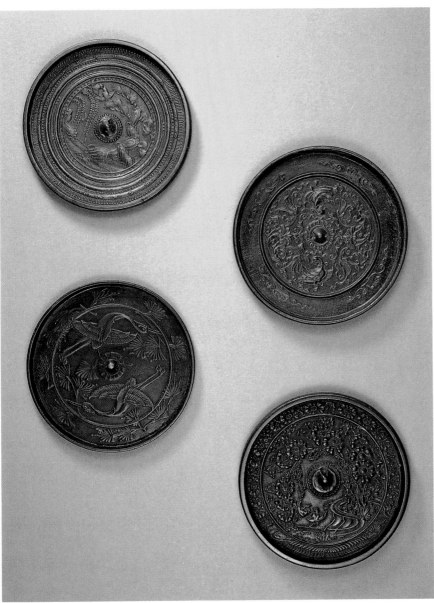

126d, b *top*; a, c *bottom*

126 Four mirrors

Bronze

a) Decorated with cranes and pines
Late Heian period, *c.* 12th century
DIAM. 11.1 cm
1927.10-14.2. Given by H. Yamakawa

b) Decorated with stylised birds among floral scrolls
Kamakura period, 13th–14th century
DIAM. 11.5 cm
1927.10-14.1. Given by H. Yamakawa

c) Decorated with birds and chrysanthemums over a stream
Possibly Kamakura or Muromachi period
DIAM. 11.4 cm
1927.10-14.3. Given by H. Yamakawa

d) Decorated with birds, pines and wisteria within concentric bands
Kamakura period
DIAM. 11.0 cm
1927.10-14.7. Given by H. Yamakawa

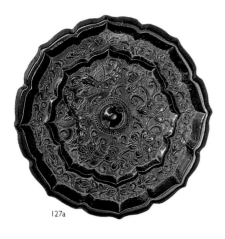

127a

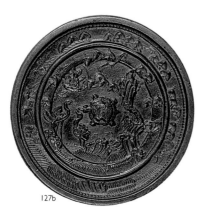

127b

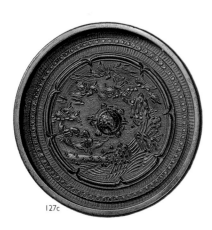

127c

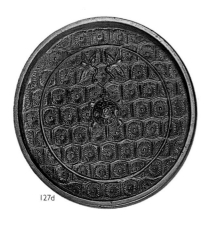

127d

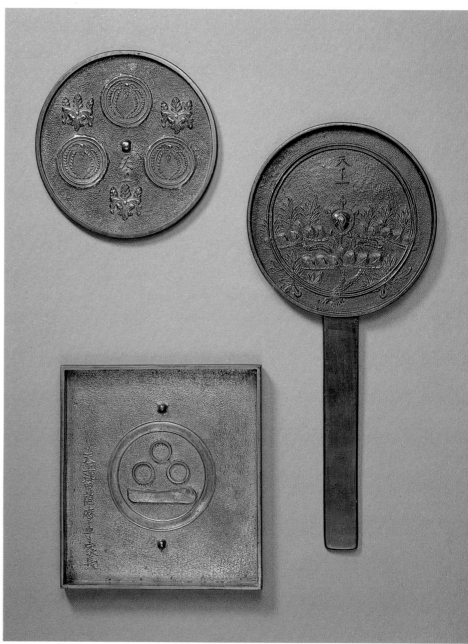

128b top left; a right; c bottom

127 Four mirrors

Bronze

a) Lotus form, decorated with birds and
 butterflies among floral scrolls
 Muromachi period, 15th–16th century
 DIAM. 12.2 cm
 1927.10-14.8. Given by H. Yamakawa

b) Decorated with Hōraizan (Island of
 Immortality), cranes and pines, the
 esoteric Buddhist deity Aizen Myō-Ō
 and a central boss in the form of a turtle
 Muromachi period, 15th century
 DIAM. 11.5 cm
 1984.12-14.1

c) Decorated with birds, pines and a central
 boss in the form of a turtle
 Muromachi period, 15th–16th century
 DIAM. 11.5 cm
 1927.10-14.9. Given by H. Yamakawa

d) Decorated with chrysanthemum blooms
 set in a tortoise-shell pattern, two cranes
 and a central boss in the form of a turtle
 Muromachi period, 16th century
 DIAM. 11.3 cm
 1927.10-14.10. Given by H. Yamakawa

128 Three mirrors

a) Handled and decorated with pine fronds
 and a central boss in the form of a
 tortoise
Momoyama period, early 17th century
Inscribed: Tenka-Ichi ('First under Heaven')
Bronze; DIAM. 9.5 cm; L. 21 cm
1944.4-1.5. Given by Dr W. L. Hildburgh

b) Decorated with paulownia and wisteria
 mon
Momoyama period, 16th century
Inscribed: Tenka-Ichi ('First under Heaven')
Bronze; DIAM. 9.1 cm
1944.4-1.7. Given by Dr W. L. Hildburgh

c) Square, with the 'Three Stars and
 Character One' *mon* of the Watanabe
 family
Late 17th century
Inscribed: Tenka-Ichi Tsuda Satsuma (no) Kami
 Ienaga ('Ienaga, honorary official of Tsuda in
 Satsuma Province, First under Heaven')
Tinned bronze; H. 10.9 cm
1927.10-14.18. Given by H. Yamakawa

129 Mirror

Decorated with the figure of a boatman
Genroku style, late 17th–early 18th century
Inscribed: Tenka-Ichi ('First under Heaven')
Bronze; L. 32.4 cm
Published: Smith and Harris 1982, no. 12
1944.4-1.3. Given by Dr W. L. Hildburgh

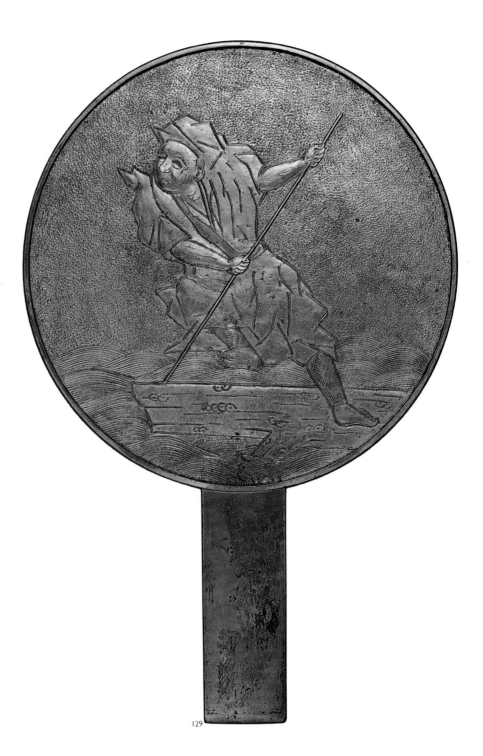

129

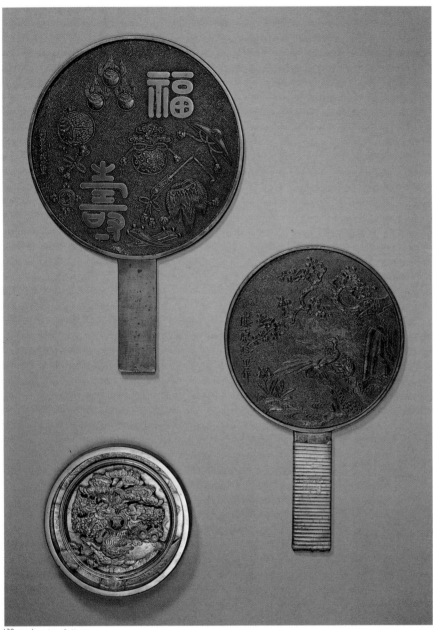

130a *top*; b *centre*; c *bottom*

130 Three mirrors

a) Handled and decorated with the
 characters *fuku* ('good fortune') and
 kotobuki ('long life'), and auspicious
 emblems including the flaming jewels of
 Buddhism
18th century
Inscribed: Nishimura Bungo (no) Jo Masashige
 ('Masashige, honorary official of Nishimura in
 Bungo Province)
Bronze: L. 27.0 cm
1972.9-23.1. Given by Mrs A. M. Nevill in memory
 of her husband Capt. G. A. Nevill

b) Handled and decorated with peacocks
 beneath a flowering prunus tree
18th century
Inscribed: Fujiwara Masashige saku ('made by
 Masashige of the Fujiwara family')
Bronze: DIAM. 15.0 cm
1944.4-1.2. Given by Dr W. L. Hildburgh

The handle has its original rattan binding.

c) Decorated with Hōraizan (Island of
 Immortality) supported on the back of a
 long-tailed turtle
17th–18th century
Inscribed: Tenka-Ichi Tajima no Kami ('honorary
 official of Tajima Province, First under Heaven')
Tinned bronze; DIAM. 12.1 cm
1927.10-14.16. Given by H. Yamakawa

Clocks (nos 131–4)

Although timepieces in the form of candle clocks, water clocks and sundials had been used in Japan for some centuries, the true clockwork mechanism was unknown until the sixteenth century when it was introduced from Europe. There were three basic types of clock used with little change of form and mechanism during the Edo period: the lantern clock (no. 131), so named because of its similarity to the Japanese lantern with its dome-shaped bell on top; the pillow clock, which resembled the hard Japanese pillow and forms of which were also known as bracket clocks (no. 132b); and the pillar clock (no. 133), which was of a long vertical narrow format and fitted on to the wooden pillars of the typical Japanese house. Each of these types was originally driven by travelling weights, but coil-spring drives were introduced later in the Edo period.

Until after the Imperial Restoration of 1868 the system of time measurement used the ancient Chinese zodiac. The twelve animals of the zodiac in their fixed order represented twelve 'hours' of day and night, divided into six hours of day and six hours of night, in theory from sunrise and sunset. The lengths of hours of both day and night thus varied according to the season. The signs for the 'hours' were shown on clock dials with the sign of the horse at the position of midday in the clockwise order shown below. The numeral attached to each sign indicates the number of chimes struck, which rather bafflingly have no arithmetical relationship with the number of the hour itself.

HORSE, 9 (noon); GOAT, 8; APE, 7; COCK, 6; DOG, 5; BOAR, 4;
RAT, 9 (midnight); BULL, 8; TIGER, 7; HARE, 6; DRAGON, 5; SERPENT, 4.

Several ingenious devices were developed to compensate for the variation in the length of the 'hours'. An early method was to provide means for changing manually the positions of two weights on the single foliot at sunset and sunrise, thus altering its effective period. Another method for circular-dial clocks was to replace the single moving hour hand with a fixed hand and to connect a moving dial into which sliding plates representing the hours were fixed. The clock could then be run at a single speed both night and day, and the proportion of the circle appropriate to night and day simply altered. Some such dials have black *shakudō* plates for night and white silver plates for day. A later more advanced device was the provision of a double foliot, with a mechanism for automatically switching from one to the other at sunrise and sunset. Seasonal adjustments were still necessary.

The pillar clocks indicate time by a pointer which travels in a vertical straight line past metal hour plates which could easily be adjusted by hand. These are numbered from four to nine as described above. A later development was a changeable set of scales inscribed on a black-lacquered vertical slat, which would be fitted into the pillar of the clock. These slats allowed for the variations in the length of hours in any specified period of ten days in the year. A still later and more sophisticated scale provided vertical parallel markings indicating the seasons, with the variation in length of hours shown by curved lines crossing these season lines, so that the time during any of the fixed ten-day periods could be read by looking where the horizontal travelling pointer crossed the appropriate season line. This device demonstrates how the Japanese maintained their skill in mathematics during the period of Isolation.

Some clocks also incorporated calendars with the twelve signs of the zodiac and the five pairs of 'elemental' signs displayed through their sixty combinations, which in their fixed order produce a continuously running cycle of sixty years, months, days, hours or even seconds.

In the late Edo period watches were also developed, and some used the *inrō* case as a convenient way of carrying the mechanism (nos 134b, c). For *inrō* see Chapter 5, p. 99.

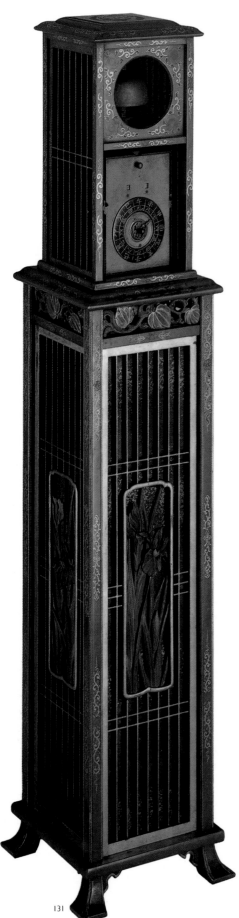

131

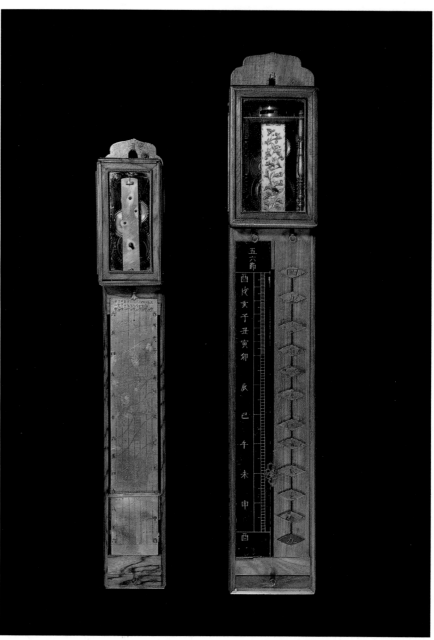

132

131 Lantern clock

18th century (the wooden stand later)
Brass, with double calendar and fixed dial with
 lacquered chapter-ring; weight-driven iron
 movement with single foliot; H. (overall) 122 cm
MLA CAI 2037

132 Two pillar clocks

19th century
Brass movements with balance; H. 43 cm and
 51 cm
MLA CAI 1994 and MLA 1975.12-2.1

These clocks indicate the time by the
descending weight.

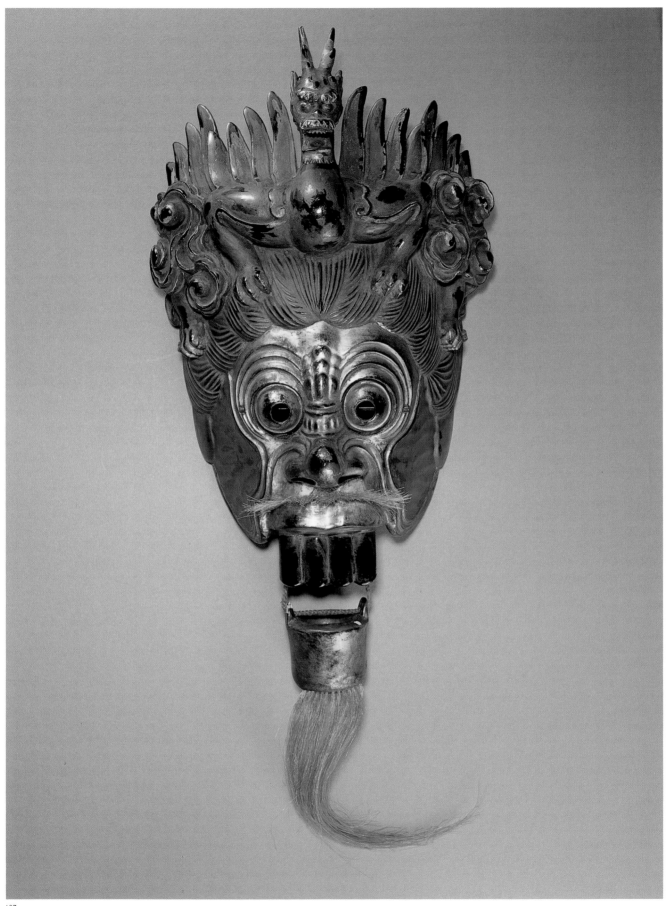

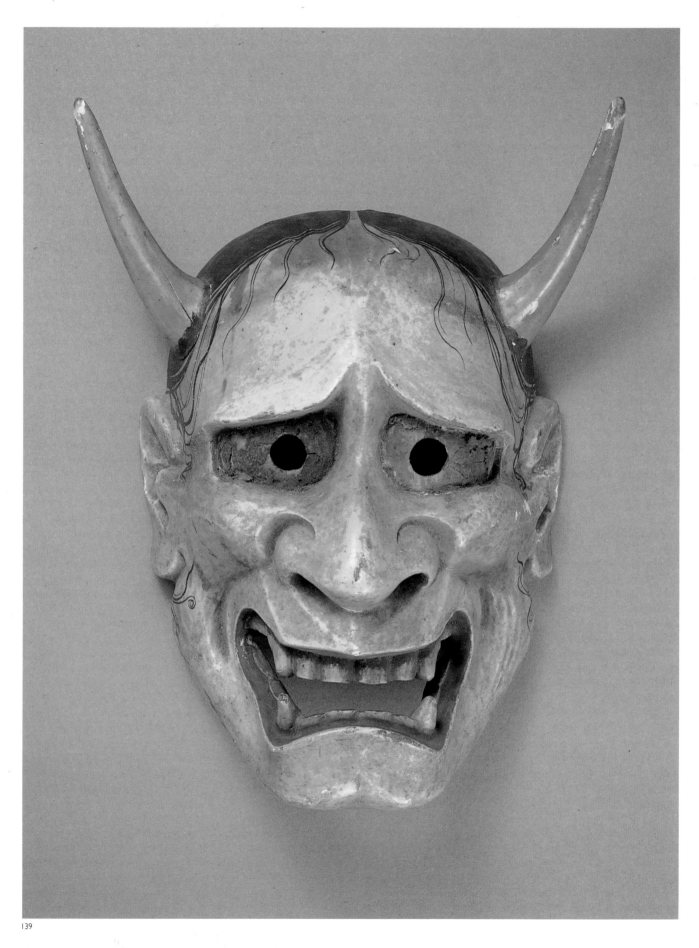

139

138 Nō mask

(detail illus. pp. 2–3)

18th–19th century
Signed: Norinari and Hōshō Daiyū
Painted wood; H. 21.2 cm
Published: Smith and Harris 1982, no. 38
OA + 7105

This mask is one of several variations on the general character of 'young woman' used in a number of different plays. The tradition is based on a design by the fourteenth-century master Zōami.

139 Nō mask of Hannya

Edo period, 18th–19th century
Painted and lacquered wood with gilt horns and
 teeth; H. (excl. horns) 20.4 cm
1946.12-16.2. Given by Miss C. Winch

Hannya represents a once beautiful woman transformed by jealous rage into a demon. The mask is worn in the plays *Aoi no Ue* and *Dōjōji*.

140 Panel from a shrine or temple

17th century
Wood with gesso and pigments; 73.0 × 35.1 cm;
 frame 81.4 × 43.7 cm
1987.4-16.1

Openwork panels were a favourite feature of Edo period architecture. For internal use they were normally cut in silhouette, but this is an external panel more deeply carved and brightly painted. Openwork allowed the passage of air in the hottest summer weather. The tiger and bamboo represent symbolically two alternative types of strength and are often found together in art.

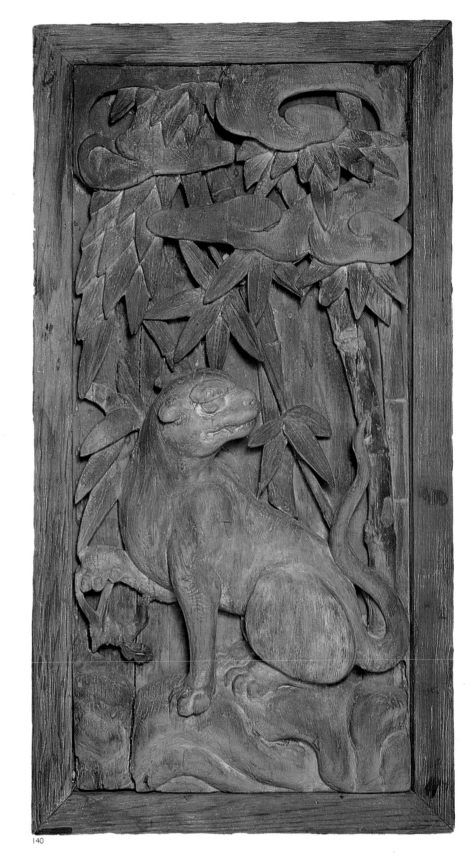

140

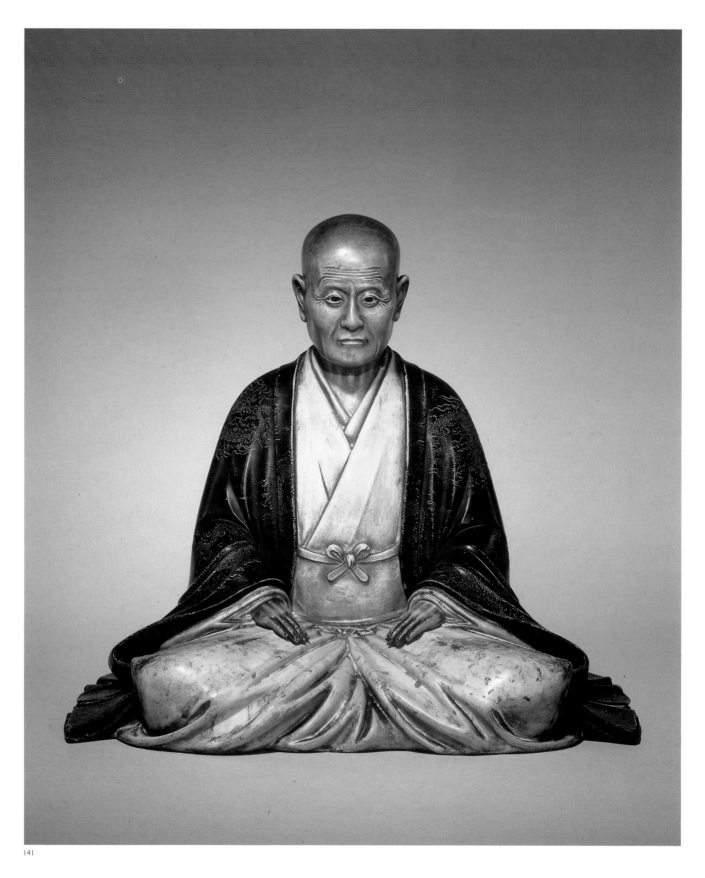

141 A retired townsman

Edo period, late 17th–early 18th century
Wood (*yosegi* construction) with lacquer and
 pigments, eyes crystal; H. 42.5 cm
Published: Smith and Harris 1982, no. 33; Zwalf
 1985, no. 364
1885.12-27.98. Given by Sir A. W. Franks

142 The artist Sesshū Tōyō
 (1420–1506)

Dated equivalent to AD 1787
Signed: Miwa
Wood; H. (incl. stand) 23.5 cm
1981.6-12.1

Sesshū Tōyō, Japan's most celebrated
ink-painter, was a Zen priest, and he is
shown here dressed as such. An inscription
on the figure records that the portrait was
commissioned by one Kakehi Chōtetsu and
was made after a painting by Kanō Eisen'in
Tenshin (1730–90). Miwa is today better
known as a carver of netsuke.

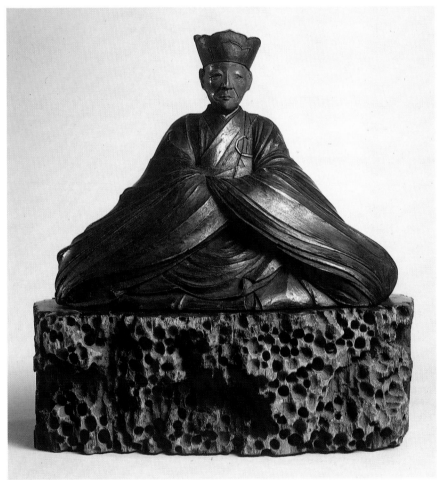

142

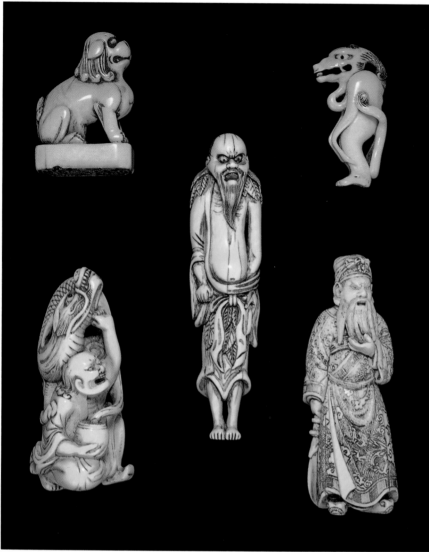

143b, e *top*; d *centre*; a, c *bottom*

143 Group of unsigned netsuke of types illustrated in *Sōken Kishō* (1781)

18th century
Ivory

a) Handaka Sonja
H. 7.8 cm
1930.12-17.75. Bequeathed by James Hilton

One of the sixteen disciples of the Buddha called *rakan*, Handaka Sonja is always depicted with his dragon which he carries in a bowl or gourd bottle.

b) *Shishi* on a seal base
H. 5.2 cm
1891.9-5.24

The *shishi* was a common subject in Chinese decorative arts and would have been a natural subject for an early ivory netsuke, since many were made in imitation of imported Chinese seals.

c) Kanyū
H. 9.3 cm
Published: Barker and Smith 1976, no. 340
F690

Kanyū was a Chinese general whose exploits are fêted in the classic 'Tale of Three Kingdoms' and who came to be regarded as the God of War.

d) Bearded *sennin*
H. 11.1 cm
Published: Barker and Smith 1976, no. 324
1930.12-17.62. Given by James Hilton

There are numerous *sennin*, immortals from Chinese legend, rarely distinguishable from each other unless displaying a recognisable attribute.

e) Mythical beast
H. 5.3 cm
Published: Barker and Smith 1976, no. 367
F817

144 Three netsuke

Late 18th century
Signed: Masanao (active *c.* 1781–1800)
Ivory

a) Rat
L. 5.5 cm
Published: Barker and Smith 1976, no. 43
F782

b) *Kirin*
H. 3.6 cm
Published: Barker and Smith 1976, no. 44
F816

The *kirin* is a creature of good omen with a bearded humanoid face, two horns, a dome-like protrusion on its head, four horns on its back, the tail of a *shishi* and cloven hooves.

c) Bird's claw
L. 5.8 cm
Published: Barker and Smith 1976, no. 42
1945.10-17.628. Bequeathed by Oscar Raphael

145 *Bokutō* and three netsuke

a) *Bokutō* in the form of a dragon
1849
Signed: Toyomasa Nanaju nana sai ('Toyomasa in his seventy-seventh year')
Wood; L. 45.1 cm
1985.11-7.1

Wooden swords (*bokutō*) were carried by those who had no right to carry a real sword; as cudgels they could be used as weapons in their own right. They were often carved with auspicious motifs.

b) Three netsuke
Early 19th century
Signed: Toyomasa
Wood

i) Wasps' nest
L. 4.0 cm
Published: Barker and Smith 1976, no. 212
F0984

ii) Netsuke carved as Handaka Sonja emerging from his gourd
Eyes inlaid in amber; H. 3.8 cm
Published: Barker and Smith 1976, no. 211
F900

See no. 143a.

iii) Handaka Sonja
Eyes inlaid in amber; H. 5.3 cm
Published: Barker and Smith 1976, no. 213
1912.10-12.13. Given by Mrs H. Seymour Trower

The *sennin* has relieved his dragon of the Buddhist *hōkyū*, or 'treasure jewel', which he guards. According to legend, dragons were thought to possess a jewel which enabled them to control the waves.

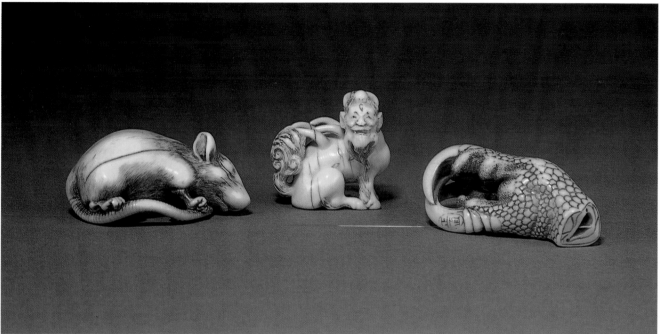

144a–c

145a top; b (i, iii, ii) bottom, from left to right

146b *left*; a *right*

146 Two *okimono*

19th century
Wood

a) Gama Sennin astride his toad (with a
 young toad on his back)
Signed: Hōkyūdō Itsumin (active *c*. 1830–67)
Eyes inlaid in amber; H. 7.3 cm
OA + 14268

b) Snake and tree trunk
Hida Province
Signed: Sentei Sukeyuki
H. 9.7 cm
Published: Smith and Harris 1982, no. 54
1980.10-16.2

147 A falconer

Meiji period, late 19th century
Seal: Tokyo
Ivory; H. 42.5 cm
Published: Smith and Harris 1982, no. 53
1979.7-2.7

The restoration of Imperial rule in 1867 was
followed by a rapid growth in the export of
traditional arts and crafts to the West. The
sculptors of ivory had until then mainly
made netsuke, but with increasing
awareness of the taste of the overseas
market many turned to purely ornamental
sculpture. The government supported
groups like the Tokyo Ivory Sculptors'
Association, one of whose members
probably made this fine piece.

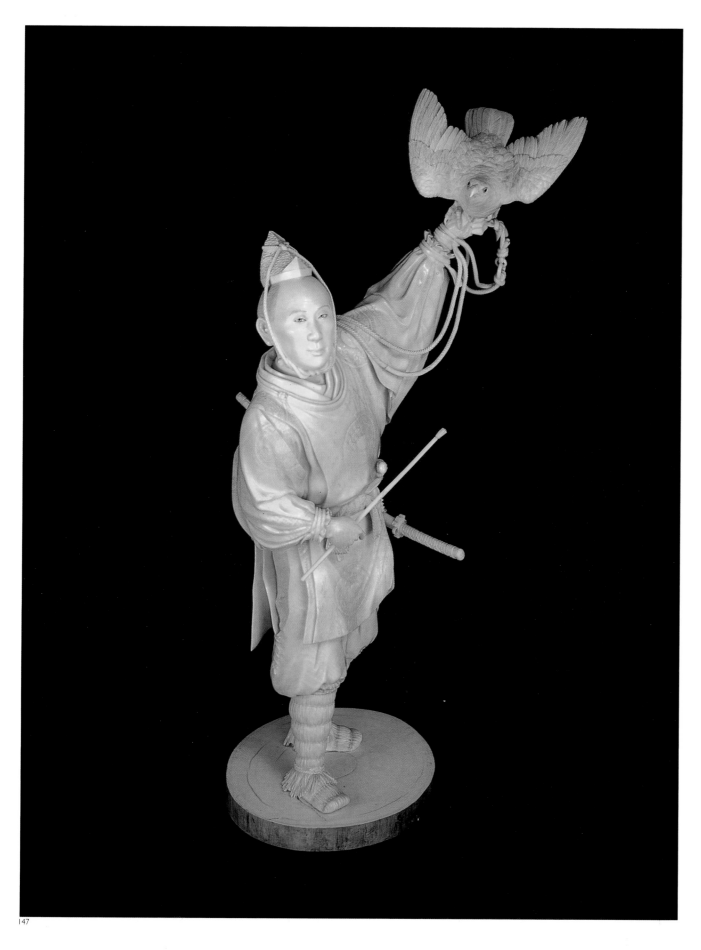

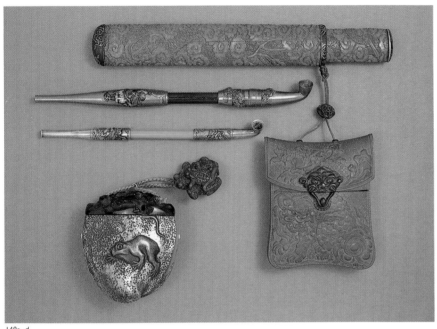

148a–d

148 Group of pipes and smoking-sets

19th century

a) Tobacco box and netsuke
Signed (box): Shōmōsai (a lacquerer) with a *kakihan*
 (written seal); (netsuke): Yoshitada
w. (box) 10.5 cm; L. (netsuke): 5.0 cm
1981.2-3.116. Given by Capt. Collingwood Ingram

The box is made from two joined *Haliotis*
shells, with a frog, slug and serpent in
high-relief *makie*. There is a further carved
ivory slug inlaid into the ebony lid, and the
netsuke is also in the shape of a frog.

b) Pouch and pipe-case
Signed (pouch): Ikko
Carved wood; H. (pouch) 11.5 cm;
 L. (pipe-case) 26.4 cm
1896.7-6.18

The pouch is carved with a *shishi* and
peonies on the front and a long-tailed bird
(*onagadori*) on the back. The pipe-case is
carved with dragons among clouds.

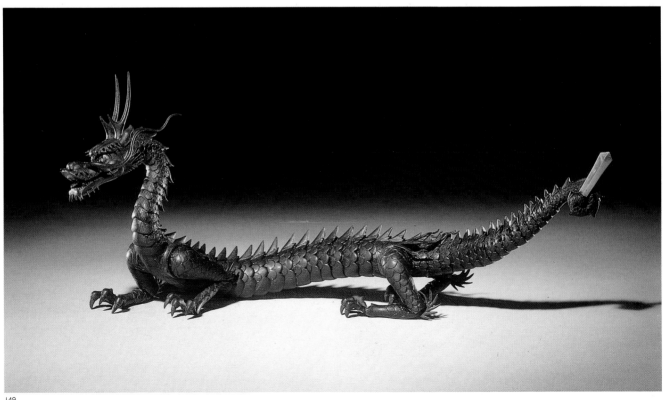

149

c) Pipe

Wood, with silver mouthpiece and bowl;
 L. 19.9 cm
1981.2-3.121. Given by Capt. Collingwood Ingram

The pipe is decorated with a *hiden* (*apsara*)
and a *tengu* (winged goblin).

d) Pipe

Signed: Ichiōkan Shunchō
Wood, with silver mouthpiece and bowl decorated
 in high-relief *shakudō*, copper and gold inlay;
 L. 24.8 cm
1981.2-3.122. Given by Capt. Collingwood Ingram

The pipe is decorated with the figure of
Kojima Takanori writing on the cherry tree.
The allusion is to an incident in the
fourteenth-century *Taiheiki* chronicle. When
the Emperor Godaigo was exiled in 1332,
Kojima Takanori wrote a poem expressing
his fealty on a cherry tree at an inn where
the emperor was due to stay.

149 Articulated model dragon

18th–19th century
Signed: Myōchin Kiyoharu
Iron; L. 34.5 cm
Published: Tokyo National Museum 1987, no. 29
HG371. Bequeathed by Professor John
 Hull-Grundy

150 Group of articulated animals

All except (d) 19th century
Iron

a) Pheasant

L. 58.0 cm
Published: Tokyo National Museum 1987, no. 33;
 Le Japonisme 1988, no. 41
1939.7-15.1. Given by Oscar Raphael

b) Crayfish

Signed: Muneaki saku ('made by Muneaki')
L. 67.5 cm
Published: Smith and Harris 1982, no. 15; Tokyo
 National Museum 1987, no. 28
1937.12-18.1. Given by A. C. Jahn

c) Carp

Signed: Muneyori
L. 44.1 cm
Published: Tokyo National Museum 1987, no. 31
HG765. Bequeathed by John and Mrs Hull-Grundy

d) Crab

18th–19th century
W. 27.5 cm
Published: Tokyo National Museum 1987, no. 32
HG303. Given by Mrs Hull-Grundy

e) Snake

Signature: Muneyoshi saku ('made by Muneyoshi')
L. 155.5 cm
Published: Tokyo National Museum 1987, no. 30
HG207. Given by Mrs Hull-Grundy

The animals are made by later members of
the Myōchin family of armour component
makers. Although often signed with names
similar to those found on armour, it is
difficult to identify any single maker who
produced both armour and models.

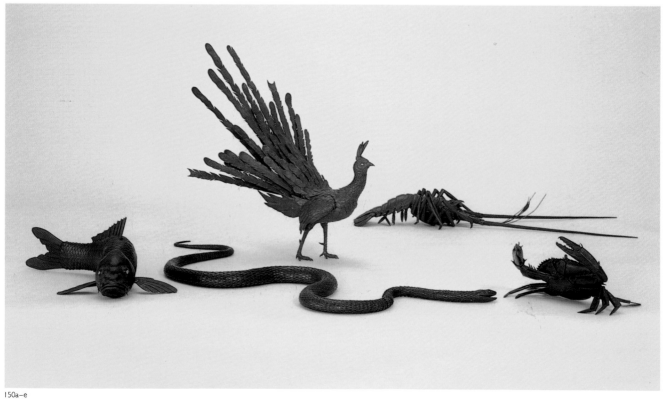

150a–e

151

151 Tortoise

Late 18th–early 19th century
Signed: Seimin (i.e. Murata Seimin, d. 1837)
Bronze; L. 14.7 cm
1954.4-17.6. Given by E. S. de Beer from the
 collection of his late aunt, Mrs A. F. Barden

Seimin specialised in precise bronze
sculpture using the lost-wax method (see
p. 29). Much of his work was of Buddhist
subjects, such as the casting of 500 *arhats*
(disciples of the Buddha) at Kenchōji
Temple in Kamakura. His other work
included vases and ornaments, and he was
famed for his studies of tortoises, which
may at this period have been used as
paperweights.

152 Hanging flower-vase

Meiji period, late 19th century
Iron, with gilt and patinated bronze decoration;
 L. 1.22 m
Published: *Le Japonisme* 1988, no. 66
1969.2-10.1

The vase is in the form of a gourd entwined
with a vine and leaves, a snake, birds and
insects. The inscription on a metal plate
inset in the back of the piece can be
translated 'Made by Shōami Katsuyoshi,
grandson of Shōami Michiyoshi, the ninth
generation of the Shōami family of sword
mounters and inlayers'.
 A hanging vase of this dimension and
decorative extravagance betrays the
confused taste of the Meiji era, but its
dazzling technique can only excite
admiration.

152

PORCELAIN OF THE EDO AND MEIJI PERIODS

(nos 153–70)

Porcelain was first made in Japan in the late sixteenth century in the province of Hizen in Kyūshū, which was governed by the Nabeshima family. The Nabeshimas sponsored all manner of arts and crafts, and readily adapted overseas technology for their own use. They brought back with them on their return from Hideyoshi's 1592 and 1597 invasions of Korea immigrant Korean potters with superior kiln technology and glazing skills, though there is also evidence that some Korean ceramicists may have emigrated voluntarily to western Kyūshū at an earlier date. One of these Korean potters might have been the Ri Sampei who is credited with the discovery of porcelain clay at Izumiyama in Hizen, thus establishing the basis of the porcelain industry in Japan.

The new kiln technology depended on the construction of the *noborigama* ('rising kiln'). These were built on hillsides in the form of rows of interconnecting chambers arranged so that a continuous draft could be achieved along the kiln and higher temperatures of up to around 1,400 degrees C maintained. By the middle of the seventeenth century production was well established.

The first decorated porcelains were painted, like most pieces exported from China, under the translucent glaze with blue cobalt oxide, also imported through China. These blue and white wares are known as *sometsuke* (literally 'dyed ware'). The earliest pieces are in a far from refined, almost folky style, similar to the crude provincial Chinese blue and white wares exported in large quantities to Japan as well as to many other places in Asia. This style became established as a general tradition in Japanese wares for everyday use which lasted well into the twentieth century, and stands in complete contrast to the more refined types described below. This semi-folk style has sometimes been wrongly assumed by Western writers to have been made only in the earliest period of porcelain production.

Porcelain began to be exported from Nagasaki to South-East Asia from early in the seventeenth century, and also along the coasts to eastern Japan. However, beginning in the year 1641 only the Dutch and the Chinese were permitted a presence on Japanese soil, in the form of small trading posts in Nagasaki. From the tiny man-made island of Deshima in the harbour there the Vereenigde Oostindische Compagnie (Dutch East India Company) began from *c.* 1660 to ship porcelains to Europe and South-East Asia. By then the Japanese were prevented by their own government from sailing abroad.

The well-established European trade in Chinese porcelain for Europe had declined *c.* 1660 with the end of the Ming dynasty and was replaced by the products of the young Japanese porcelain industry. The earliest designs on this porcelain were largely inspired by the Chinese export wares in the Wanli and Transitional styles in blue and white, but once the export industry was well under way, feedback from Europe began to dictate new types in both decoration and shape. Export pieces were made in both the familiar blue and white style, long known from Chinese types, and also in the overglaze enamelled colours which are described below. Orders were submitted through the Dutch for sets of European-style tableware decorated with family arms (no. 153b); beer flagons; apothecaries' bottles (no. 153d); barbers' bowls; candlesticks; and sets of purely ornamental pieces for which there was no place in a Japanese house. These all came to Europe in the latter part of the seventeenth century in some quantity and can still often be seen in palaces and other great houses.

Once the skills of underglaze blue decoration had been mastered, the next step was to follow the coloured enamelling techniques popular in later Ming China. This led to several distinctive types of coloured porcelain being made.

By far the largest group of porcelain kilns was that centred on the town of Arita in Hizen. North from Arita was the port town of Imari, through which Arita wares were shipped round the coast south to Nagasaki. Both blue and white and enamelled wares from Arita have been long called Imari ware in Japan, but in the West the name has traditionally referred to one class of porcelain combining underglaze blue with dense decoration in coloured enamels, dominated by rust red with gilding. The greater part of Japanese enamelled porcelain in Western collections is this kind of Imari ware (nos 155, 157, 158).

It was widely copied by Europeans in both the eighteenth and nineteenth centuries and still occasionally is. In addition to translucent glazes on a fine white body, opaque white glazes were developed to apply over the clay to make it a better colour. This is known as *nigoshide* and it provides a milky white ground ideal to show off the finer coloured enamels to best effect. Where the crowded decoration of Imari had covered up a generally poor and greyish body, the pure white of *nigoshide* allowed a more Japanese use of space and a sparer and more effective decorative style.

The most admired enamelled ware of this type is known as Kakiemon, the name of the enameller said to have perfected the use of the distinctive orangey red persimmon (*kaki*) colour traditionally from 1643. Typical Kakiemon ware is elegantly and sparely painted in this orangey red, plus greens, blues and yellows over a milky white *nigoshide* ground, but there are also combinations with the less vivid underglaze blue (nos 159b, d, 161, 165). Kakiemon, it must be noted, cannot be attributed to any one kiln or group of kilns in Arita at that period. The finest Kakiemon type ware was in high demand from the seventeenth until the mid-eighteenth century in Europe.

An even more distinguished ware was manufactured at Okawachi near Arita for use at the sole discretion of the governing Nabeshima clan. This is usually known as Nabeshima ware. The designs of Kakiemon ware had owed much to Chinese motifs, though the freer use of space was very Japanese; but the designs of Nabeshima ware used essentially Japanese motifs, combining boldness and sophistication in a manner very similar to the textile designs of the late seventeenth and eighteenth centuries (no. 166).

The Okawachi kiln produced underglaze blue and white ware on the finest pure white body, celadons and coloured enamel ware or combinations thereof. The underglaze blue designs were painstakingly painted, both in solid and in outline, using guidelines taken from paper transfers. The enamels applied over the glaze were used with either great boldness or extreme delicacy. The commonest shapes are the food dishes made in sets of five; they are of the size and shape of dishes of lacquered wood, until then the most prestigious food dishes used by the military aristocracy, and have a correspondingly high formal foot. The foot is usually decorated with a repeating 'comb tooth' pattern in underglaze blue, and on the underside of the rim are generally found scrolling or stylised and intertwined motifs, also in underglaze

blue. But the real glory of Nabeshima lies in its arrestingly beautiful designs, generally in coloured enamels, over the main surfaces of the dishes. These appear even more effective in full sets of five, which rarely survive complete, however.

The pride of the feudal lords of Nabeshima in the technology of their own clan is reflected in their practice throughout the Edo period of giving presents of porcelain (and swords) made by their own subjects to the lords of other provinces in Japan. Almost no pieces of this type were exported to Europe until the Meiji period, by which time they were being copied by other kilns.

From the seventeenth or early eighteenth century at Mikawachi just over the border in Hirado Province (but very close to Arita) very fine white wares utilising the most refined clay were made, painted in underglaze blue with Chinese figures and landscapes. The Mikawachi potters were skilled in moulding and applied work, and many of their pieces made from c. 1800 onwards are complex in structure, made as purely decorative presentation pieces, in contrast to the, in theory at least, functional Nabeshima porcelain. There are exotically shaped vases, impractical incense burners, models of animals and flowers, and pieces painted in underglaze blue by specially commissioned non-artisan artists. These Hirado porcelains enjoyed a considerable export vogue to Europe and North America in the second half of the nineteenth century (no. 169).

The highest-prized coloured enamelled porcelain within Japan is that known as Ko-Kutani, or 'Old' Kutani ware. Ko-Kutani is usually a white opaque *nigoshide*-type glazed ware enamelled with dark, bold colours – typically aubergine, black, blue, mustard yellow and green. The glaze, generally greyish rather than pure white, is applied thicker than on other porcelains and often contains cracks and bubbles. In addition dark spots from impurities in the body may show through. The enamelling also is applied thicker than in other ware, but its brilliance and boldness of design mask the technical defects. Typically the dishes are bordered with illustrated panels, like the Chinese Wanli wares; the motif in the centre roundel is often also basically Chinese, but it is always balanced as if the painter were painting a hanging scroll rather than adapting the illustration to fit the round format of the dish. Strangely, this combination produces a power which has been recognised by the Japanese as their most admired porcelain style (nos 167, 168).

Ko-Kutani ware has long been supposed to have been made from the mid-seventeenth century in the village of Kutani in Kaga Province, remote from Arita in the north-west of the main island of Honshū, where traditions of ceramic ware and metalwork thrived during the Edo period. However, it has been shown that the early ware was probably made and enamelled at a kiln or kilns in Arita, and was first developed as an imitation of coarse Chinese enamelled wares for export to South-East Asia, where the dark palette, dominated by green, was admired. However, the style acquired increasing prestige in Japan itself, and by the early nineteenth century at least was being made in the Kutani district itself in a revivalist spirit. It is still not known if such wares were made there at an earlier period, as well as at Arita. Later wares are often marked 'Kutani', whereas Ko-Kutani never is. From the nineteenth century a new style decorated in red and gold was developed in the Kutani area and became their main product, exported in large quantities to the West. It is rarely distinguished and normally marked 'Kutani'.

From the late eighteenth century onwards porcelain manufacture spread rapidly to many centres in Japan including Kyoto and Seto (near Nagoya), and the types became very diverse both for native consumption and for export. In the late nineteenth century enamellers and even potters were working at the port cities of Yokohama and Tokyo. New technqiues, especially in the hitherto almost unattainable underglaze colours, led to a whole new class of decoration influencing and influenced by the international *art nouveau* movement. Some of these porcelains, notably those of the Makuzu Kōzan kilns (originally in Kyoto and then in Yokohama) are now recognised as a splendid late flowering of the Japanese porcelain industry.

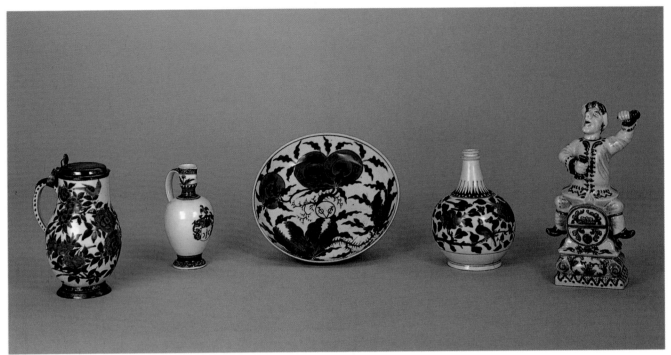

153a–e

153 Arita ware

17th century
Porcelain decorated in underglaze blue, all made
 for European market

a) Tankard decorated with motifs of
 peonies and butterflies
H. 24.5 cm
Published: Jenyns 1965, pl. 16b; Tokyo National
 Museum 1987, no. 54
1952.11-13.1

The silver fittings bear the mark of Wierwick
Somer II of Antwerp (1645/7–1717). The use
of such mounts suggests the high value
placed on Japanese porcelain at the time.

b) Jug with European coat of arms
H. 22.1 cm
1963.4-22.1. Bequeathed by the Hon. Mrs Basil
 Ionides

c) v.o.c. dish
DIAM. 34.3 cm
Published: Tokyo National Museum 1987, no. 55
1961.12-12.5. Bequeathed by W. P. D. Stebbing

The v.o.c. mark is that of the Dutch East
India Company (Vereenigde Oostindische
Compagnie) who commissioned the dish for
use by their officers and specified the bold
Chinese design of auspicious peaches and
the 'Buddha's fingers' plant. The great
depth of the transparent glaze and the five
spur marks on the base indicate that the
dish was probably made in the years of
great technological advancement between
1690 and 1700.

154

d) Apothecary's bottle
H. 23.3 cm
Published: Jenyns 1965, pl. 10a
1953.11-20.1

The initials P.V.D. appear on the base in underglaze blue.

e) Carouser astride a barrel
H. 36.5 cm
Published: Jenyns 1965, pl. 13a
1927.11-14.1. Given by Lt.-Col. Dingwall DSO
 through the National Art Collections Fund

This favourite model was based on a Dutch faience original. Versions with overglaze enamels also exist.

154 Large dish

17th century
Porcelain painted in underglaze blue;
 DIAM. 37.0 cm
1960.5-16.1

This is a good example of the more mature Japanese adaption of Chinese export ware made at Arita late in the seventeenth century. The freedom of brushwork and placing of the central roundel distinguish it from Chinese models.

155 Coffee pot

Late 17th century
Porcelain decorated in underglaze blue and
 overglaze enamels in green, red, brown, salmon
 pink, purple and gold in Imari style; H. 42.8 cm
Published: Jenyns 1965, pl. 28a
F493A

Although the shape is entirely European, the decoration is a cheerful jumble of the seven gods of good fortune, widely popular throughout the Edo period. They are figures of light-hearted amusement but had serious devotees, especially in rural areas. Ebisu, usually depicted together with a carp, was the patron of fishermen, while the other main deity, Daikoku, whose attributes are rice bales, rats and a magic mallet from which all sorts of riches shower, was to be found in the household shrines of farmers and merchants alike. The metal spout is a European addition fitted into the hole provided by the potter.

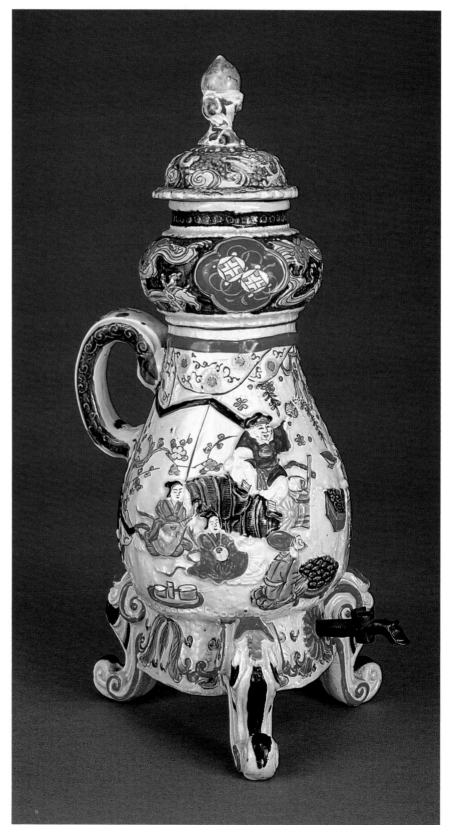

155

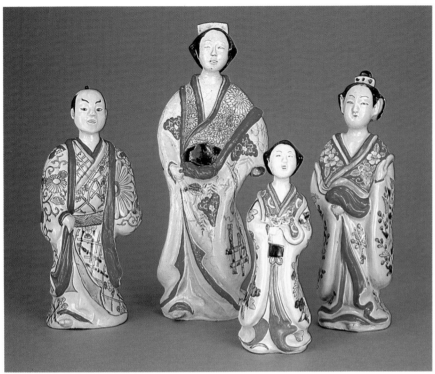

156a–d

156 Four export figures

Porcelain decorated in underglaze blue and
 overglaze coloured enamels in Imari style

a) Man
Late 17th–early 18th century
H. 36.5 cm
1964.7-15.1

b) Woman with hair comb
Late 17th century
H. 48.0 cm
Published: Jenyns 1965, pl. 28b
1976.12-6.2. Given by Douglas Barrett in memory
 of Soame Jenyns

c) Woman
Late 17th–early 18th century
H. 29.9 cm
F486

d) Woman with a hair comb
18th–19th century
H. 39.0 cm
1964.7-15.2

These light-hearted, almost caricature-like
figures seem to have been made very largely
for export to Europe, where they were
rarely recognised as specifically Japanese,
though clearly Japanese in style.

157a–g

158

157 Group of export wares

All except (g) later 17th century
Porcelain decorated in underglaze blue, overglaze
 coloured enamels and gold in Imari style

a) Covered dish
H. 11.4 cm
Published: Jenyns 1965, pl. 45b
Provenance: Sir A. W. Franks Collection
F1698

b) Large platter
DIAM. 55 cm
Provenance: Sir A. W. Franks Collection
F494

c) Cup and saucer
DIAM. 11.3 cm
Provenance: Sir A. W. Franks Collection
F1057(2)

A mark in ink (N = 50 +) on the base
identifies the piece as belonging to King
Augustus the Strong of Saxony and Poland,
whose collection of porcelain was
ammassed between 1694 and 1705, and
inventoried in 1721 in the king's 'Japanese
Palace' in Dresden which he had built to
house his collection. It is known that some
pieces were sold off during the nineteenth
century.

d) Covered *potiche* with openwork handles
H. 17.5 cm
Provenance: Sir A. W. Franks Collection
F1050

e) Teapot
H. 9.7 cm
1953.4-13.1

The gilt metal fittings are European, and the
small size suggests the early date when tea
was still very expensive.

f) Fluted dish
DIAM. 21 cm
F523
Provenance: Sir A. W. Franks Collection

g) Bowl
18th century
Mark: Kotobuki ('Long Life')
DIAM. 24.9 cm
1926.7-8.1. Given by Dr W. L. Hildburgh

This piece with its central roundel of a
Dutch ship and surrounding border of
Dutchmen may be of a later date, when
general knowledge of the appearance of
Europeans had spread more widely into the
general pictorial repertoire of the Japanese.

158 Two trumpet vases and two lidded jars

Late 17th–early 18th century
Porcelain decorated in underglaze blue and
 overglaze enamels and gold in Imari style;
 H. (jars) 64.5 cm; H. (vases) 40.4 cm
Published: Jenyns 1965, pl. 27
Provenance: Sir A. W. Franks Collection
F488 (jars), F489 (vases)

The two jar lids are surmounted by figures
of *bijin* ('beauties') rather similar to those in
no. 156. Garnitures of varying numbers
of vases and jars, generally in Imari
decoration, were popular as ornaments in
great houses in Europe.

159

159 Group of porcelains

Porcelain decorated in overglaze coloured enamels

a) Handled jug
1660–70
H. 24.0 cm
Provenance: Sir A. W. Franks Collection
F1041

b) Four-sided faceted bottle with floral
 sprays
Late 17th century
H. 20.3 cm
Published: Jenyns 1965, pl. 59c
1948.7-14.1

c) Bulbous bottle
Late 17th century
H. 36.7 cm
Published: Jenyns 1965, pl. 82a
Provenance: Sir A. W. Franks Collection
F1025

d) Hexagonal bowl
Early 18th century
H. 11.6 cm; max. w. 26 cm
1940.6-1.1

e) Bulbous bottle
Late 17th century
H. 26.0 cm
Published: Jenyns 1965, pl. 55a
1956.5-16.1

This group illustrates the progression from
early enamels closely based on Chinese
models (a) into a more native Arita style (c),
and the specifically Kakiemon type on a fine
white body and glaze (b and d), while (e)
combines elements from both.

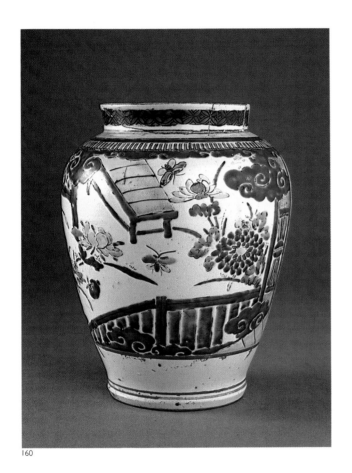

160

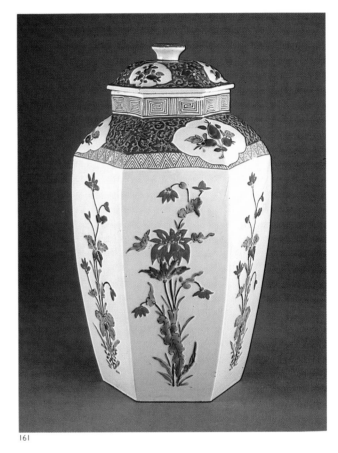

161

160 Bulbous jar

c. 1670
Porcelain decorated in overglaze coloured
 enamels; H. 21.1 cm
Published: Tokyo National Museum 1987, no. 53
1953.11-19.1. Given by Gordon Hand

This is an early example of ware with a thick
opaque white glaze supporting rich
coloured enamels, a forerunner of the
Kakiemon style. The composition is a
reinterpretation of a Ming Chinese garden
scene, in which the Japanese artisan has
typically arranged the elements of fences,
veranda, flowers and clouds to produce a
pleasing pattern and an emotional impact
rather than a rational composition.

161 Hexagonal lidded jar

c. 1680
Porcelain decorated in overglaze coloured enamels
 in Kakiemon style; H. 27.1 cm
Published: Jenyns 1965, pl. 65b(ii); Smith and Harris
 1982, no. 95; Tokyo National Museum 1987,
 no. 50
Provenance: Sir A. W. Franks Collection
F478

This jar represents the perfection of
Kakiemon ware which so attracted
Europeans who were used to a greyer body,
with its faultless milky-white ground and its
jewel-like enamelling in clear colours.
Existing jars of this type have all been found
in European palaces and grand houses,
notably at Hampton Court, where they
were used as ornaments and rarely show
signs of wear. They were widely copied by
European ceramicists in the eighteenth
century.

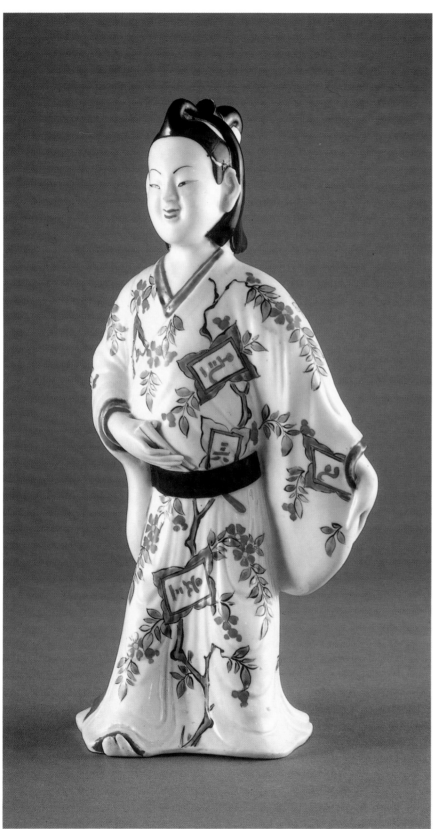

162

162 Figure of a young man

c. 1680
Porcelain decorated in overglaze enamels in
 Kakiemon style; H. 30.2 cm
Published: Jenyns 1965, pl. 55b; Smith and Harris
 1982, no. 96; Tokyo National Museum 1987,
 no. 58
F1214+

This *wakashū*, or young man about town,
wears his hair in the *koshō-mage* style
popular in the Genroku era (1688–1704). His
foppish manner is in keeping with his
kimono decorated with flowering boughs;
and his smile leads one to wonder what he
is carrying so carefully concealed in his left
sleeve. This piece was inventoried as being
in Burghley House in 1688–90 (described as
'an Indian Queen').

163 Large platter

c. 1680
Porcelain decorated in overglaze enamels;
 DIAM. 41.5 cm
Published: Tokyo National Museum 1987, no. 59
1959.7-24.1

This magnificent large dish is based on
earlier seventeenth-century Chinese models
decorated in underglaze blue which were
widely exported around the old world. It is,
however, a superb example of enamelling
in the palette which came to be called
Kakiemon, though the use of these enamels
on such a crowded surface was probably
discontinued because of its expense.

164 Pair of model elephants

Late 17th century
Porcelain decorated in overglaze enamels in
 yellow, red, green and blue in Kakiemon style;
 H. 35.5 cm
Published: Jenyns 1965, pl. 62a
Provenance: Garner Collection
1980.3-25.1, 2

Models of this sort (there were also dogs,
cats, deer, boar, horses and eagles) were
purely ornamental pieces for European
mantels.

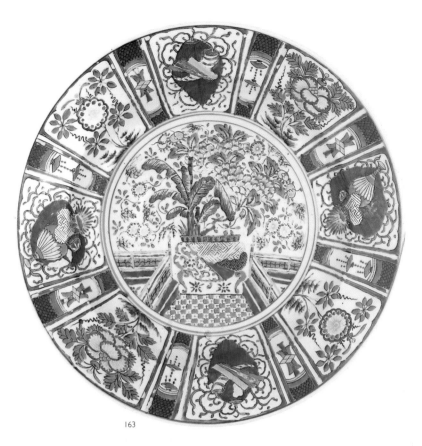

163

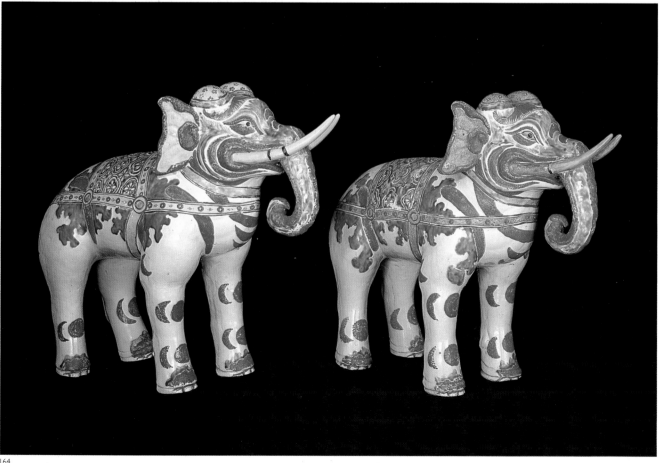

164

165 Teapot

Late 17th century
Porcelain decorated in overglaze red, blue and
 green enamels in Kakiemon style; H. 15 cm
1954.7-16.1

The floral panels are typical of the more
formal Kakiemon type. The size of the
teapot (European in shape) suggests a
period when tea was becoming cheaper.

166 Three Nabeshima dishes

Porcelain decorated in underglaze blue and
 coloured overglaze enamels

a) Decorated with three jars on a
 background of stylised waves
18th–19th century
DIAM. 20.3 cm
Provenance: Sir A. W. Franks Collection
F1021

b) Decorated with maple leaves over a
 rushing stream
18th–19th century
DIAM. 20.5 cm
Published: Smith and Harris 1982, col. pl. 8
F1283+

c) Decorated round rim with a gourd vine
18th century
DIAM. 15.07 cm
1940.6-1.9. Bequeathed by Kington Baker

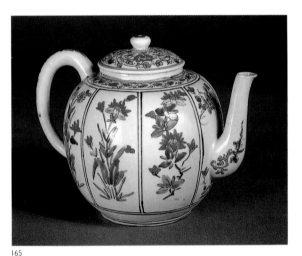

165

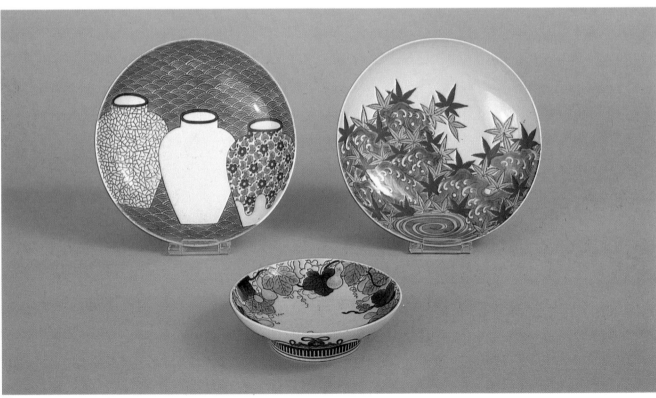

166a–c

167 Nine-lobed dish

Late 17th century
Inscribed (on base): Fuku ('Fortune')
Porcelain decorated in overglaze enamels and
underglaze blue on underside in Kutani style;
DIAM. 35.0 cm
Published: Jenyns 1965, pl. 93a, b; Smith and Harris
1982, no. 94; Tokyo National Museum 1987,
no. 51
Provenance: Sir A. W. Franks Collection
F498A

The border panels of iris, plum and paired
birds is in a semi-Japanese style, while the
central roundel is of the purely Chinese
subject of scholars under a pine in a
mountain landscape. It is not proven that
this lustrously enamelled piece is indeed of
seventeenth-century date, but it is a
splendid example of the Kutani style.

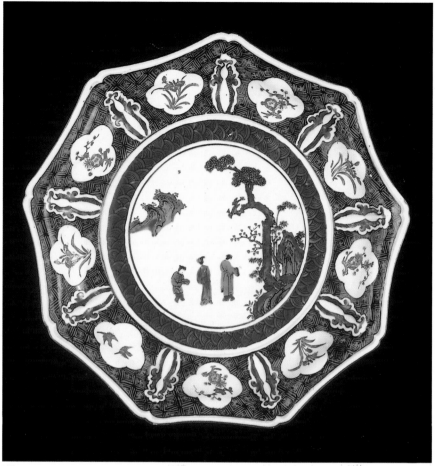

167

168 Lobed dish

Late 17th century
Inscribed (on base): Fuku ('Fortune')
Porcelain enamelled in overglaze colours in Kutani
style; DIAM. 23.1 cm
Published: Tokyo National Museum 1987, no. 52
F1704

The designs on 'five colour' (*gosaide*) pieces
were copied from more refined Chinese
originals. This typical piece has a border of
lotus-shaped panels filled with varied
patterns and symbols, and a central roundel
of birds on a rock besides a tree peony. The
rather rough boldness of enamelling in
sombre colours is very much in Japanese
taste.

168

169a–f

169 Group of Hirado ware

Mid–late 19th century
Porcelain decorated in underglaze blue

a) Long-necked bottle
H. 22.0 cm
1982.6-29.1

The motifs of Chinese boys and pine trees
are the most commonly found on Hirado
style ware.

b) Ring-handled jar
After August 1871, when Prefectural system was
 adopted
Signed: Dai Nippon Nagasaki Ken Mikawachi
 Satomi Takejirō ('Satomi Takejirō of Mikawachi
 in Nagasaki Prefecture, Japan')
H. 26.5 cm
1986.6-31.1

The rings hang from *shishi* heads. The
decoration of pines and cranes indicates
long life and the New Year.

c) Incense burner

Inscribed: Dai Nippon Hirado san Mikawachi
 Kōseki sei ('made by Kōseki of Mikawachi,
 product of Hirado, Japan')
H. 36.8 cm
F1313+

This piece is a display of technical brilliance
in openwork modelling. The bells hang free
on their hooks. Only the top chamber could
be used for burning incense. The others are
for ostentation.

d) Lidded jar

Inscribed: Sato Take sei ('made by Sato Take [short
 form for Satomi Takejirō])
H. 21.8 cm
1980.2-27.20. Given by David King

The main motifs are dragons, another
favourite theme of later Hirado ware.

e) Small model of *shishi*
H. 9.5 cm
1980.2-27.38. Given by David King

f) Large model of *shishi*
H. 24.2 cm
1983.11-12.2

Both *shishi* have their paws on a ball, in this
case done in openwork moulding.

170 Bulbous bottle

Late 19th century
Porcelain decorated in underglaze green and
 purple; H. 49.5 cm
Signed: Makuzu Kōzan sei ('made by Makuzu
 Kōzan')
Published: *Le Japonisme* 1988, no. 67
1980.8-1.1

A brilliant technician, claiming
tenth-generation descent from the early
seventeenth-century potter Miyagawa
Yūkansai, Makuzu Kōzan moved from his
native Kyoto to Yokohama in 1870 and there
manufactured an extraordinary variety of
porcelains mostly for export to the West.
This large piece shows his mastery of
moulding and his success in the difficult
process of firing colours other than blue
under the glaze. Pieces of this sort both
inspired and were inspired by the *art
nouveau* movement.

170

PAINTING
– THE NEWER
TRADITIONS

(nos 171–89)

Edo period schools and styles

One of the most individual aspects of Japanese culture has always been the apparent contradiction between an enthusiasm for experimenting with new ideas – often derived from outside Japan – and an inherent conservatism, which manifests itself in a reluctance to abandon older cultural forms once these have become established. The result is frequently that new ideas settle themselves alongside the old, forming a rich mixture of continuity and change.

There have been few artistic cultures as complex in this respect as that of Edo period Japan. Whereas in the West we have become accustomed to the idea of successive revolutions in visual culture – the constant 'shock of the new' – by the beginning of the nineteenth century in Japan at least ten major schools of painting had been established and were continuing their activities *at the same time*, constantly influencing one another but never losing their particular distinctive artistic character.

A major reason for this rich blossoming of artistic activity was the long period of peace and prosperity which prevailed under the stable, not to say static, social hierarchy of samurai/farmer/artisan/merchant established by the ruling Tokugawa family in the early years of the seventeenth century. This peculiar social structure in turn encouraged a proliferation of groups, lineages and schools, in scholarship and the arts, each patronised by different sectors of society. Edo Japan was a highly literate culture with a large-scale and well-developed publishing industry using sophisticated techniques of woodblock printing.

Another important factor was Japan's deliberate national isolation, the policy of a 'closed country' (*sakoku*) maintained from 1639 to 1853. Natural physical isolation, too, protected Japan from foreign colonial inroads. A constant stream of information, artefacts and works of art

from the outside world did arrive, however, through the southern part of Nagasaki, where a regulated quota of Dutch and Chinese trading vessels were allowed to call each year. As the eighteenth century progressed, European and Chinese artistic styles steadily filtered into the consciousness of Japanese artists, always fast enough to encourage experiment, but never in such large quantities as to swamp native styles.

This, then, is part of the background to the existence of the rich variety of schools and styles of Edo painting – Kanō, Tosa, Sumiyoshi, Buddhist, Rimpa, Ukiyo-e, Nanga, Nagasaki, Western-style, Maruyama, Shijō, Zen, Fukkō Yamato-e – most of which are represented in the British Museum's collection. This very richness is, however, understandably bewildering to the first-time reader, and this short essay can do no more than describe the general character of some of the main schools, as well as something of their origins and development. Information concerning certain individual artists will be found in the text accompanying the plates. It must be emphasised that this division of Edo painting into various schools is not merely a convenience of the art historian for describing differences in artistic style, though it serves that purpose well enough. It also reflects the actual complex structure and organisation of the art world in Japan at that time, and the stylistic differences we describe today were equally apparent and significant to the artists and patrons involved, even if they may have used somewhat different terms to describe them. Nevertheless, some of the most interesting Edo painters and works of art are unclassifiable according to the division of schools alone, either because they are too eccentric or because they combine a number of styles. To attempt here to describe eccentric or mixed styles would be to court confusion. This can be done only when the character of each school has been fixed in the mind.

The schools which continued into the Edo period from earlier times were those associated with the ruling classes: the Kanō school of ink-painters for the military aristocracy (nos 45, 48, 52, 53, 61–3), the Tosa school who worked principally in a small-scale, polychrome style for patrons connected with the ancient Imperial court in Kyoto (nos 49, 51), and painters of religious images for Buddhist temples and Shintō shrines. Their origins and development have been discussed in Chapter 3, and important differences can be seen between these traditional schools and the new schools and styles which arose during the Edo period (1600–1868).

The Kanō school

Knowledge of the Kanō school forms a key to understanding the nature of artistic activity as a whole in Edo Japan. Since its rise to prominence in the fifteenth century, the Kanō family of ink-painters had shown a skill for linking themselves in service to successive political élites, and after the Tokugawa clan finally established their rule over the country in 1603, the Kanō school came to form in effect an official painting academy with a virtual monopoly of commissions from the shoguns and their provincial vassals. The most dynamic phase of Kanō school activity was under the leadership of Kanō Tan'yū (1602–74, no. 62), when there was a constant flood of commissions to decorate suites of rooms in newly constructed castles, palaces and temples. After Tan'yū's death, however, Kanō training became increasingly preoccupied with merely replicating the works of earlier masters; and though the school continued to produce painters of technical distinction right up to the end of the Edo period, experimentation with new subject-matter and styles was discouraged and creativity withered. In its role as a painting academy, however, the Kanō school did provide basic training in skills with brush, ink and colour for artists who later went on to join other schools or establish independent styles. The long apprenticeship of copying earlier masters expected of Kanō pupils served, unintentionally, as an incentive for restless artistic spirits to break away and experiment in new styles.

Genre painting and Ukiyo-e

The establishment of nationwide peace after over a century of ruinous civil war and the growth of the urban centres of Edo, Osaka, Kyoto and Nagoya gave rise to a demand for genre paintings which depicted views of the cities, the new pleasure quarters, Kabuki theatre, beauty spots, festivals and displays of military arts (nos 45, 52, 53), all teeming with crowds of people. These works were painted on a ground of gold leaf on folding screens, usually by artists of the Kanō school; but as the new Confucian-based social system became more firmly established, Kanō painters were encouraged to choose either edifying Chinese or historical themes, or else decorative (and innocuous) bird and flower compositions. The growing demand for genre scenes from increasingly wide sections of urban society thus came to be met by the more commercial artists of the Ukiyo-e ('floating world') school, who were able to make

their works known in greater numbers from the second half of the seventeenth century onwards by working in the medium of the woodblock print (see Chapter 11).

Rimpa painting

Whereas genre painting and Ukiyo-e celebrated a brash new world of urban affluence, there were in the old Imperial capital of Kyoto in the early seventeenth century artists and patrons who sought a more sophisticated artistic idiom drawn from the classical courtly tradition and the Yamato-e painting style associated with it (see Chapter 3). This was both an expression of cultural nostalgia and also a declaration of independence from and superiority to the newly established military regime in the eastern capital of Edo. The two artists at the centre of the movement, a painter, Tawaraya Sōtatsu (died c. 1643, see Chapter 3), and a calligrapher, Hon'ami Kōetsu (1558–1637), each in his own way reworked ancient courtly cultural forms in a new, bold and very stylish manner. Kōetsu revived court calligraphy styles – with a new self-conscious attitude to accent, flourish and placement – and wrote court poems over Sōtatsu's painted papers.

Sōtatsu's decorative style was revived and developed at various times during the Edo period, most notably by Ogata Kōrin (1658–1716) in Kyoto and Edo around 1700 and by Sakai Hōitsu (1761–1828) in Edo a century later, and has become known to art historians as 'Rimpa' (the school of Kōrin). Later Rimpa painting focused increasingly on flower, or bird and flower subjects, reducing the shapes of these natural motifs to their most simplified, quintessential forms and distributing these in daring arrangements across a painting surface (nos 171–3). Rimpa is a uniquely native Japanese style, having no precursor or equivalent among schools of painting in continental Asia.

Foreign influences after 1720

It was the arrival in Japan of new Chinese and European prints and paintings from the early eighteenth century onwards which fostered several new currents of experimentation among Japanese artists. In particular, the lifting of a ban on the importation of certain categories of formerly prohibited foreign books and other goods in 1720 was a significant turning-point. Three new schools developed in Japan under the influence of these foreign works: Nagasaki bird and flower painting; Bunjinga (scholarly) painting; and Western-style painting.

In Chinese artistic practice there was a centuries-old division into academic court painting and non-academic literary painting, a division reaffirmed by the Ming painter and theorist Dong Qichang (1555–1636) when he categorised the great Chinese painters of the past into 'northern' (academic) or 'southern' (literary) schools. Though such theories were known to Japanese artists, it was rarely possible for them to see actual examples of paintings by the Chinese artists being discussed. Often the only source would be a woodblock-printed reproduction in an imported painting manual, a flat and simplified modification of the original painter's work. Furthermore, the Chinese paintings merchants did import to satisfy the Japanese market were in a variety of styles, both academic and literary, and often not of particularly high quality.

The Nagasaki school

Occasionally, minor Chinese painters would visit Nagasaki for several years at a stretch, giving Japanese artists the opportunity to study directly with a foreign teacher. Particularly influential in this respect was Shen Nampin who visited Nagasaki from 1731 to 1733. Shen's hanging scrolls of birds, animals and flowers in the colourful, meticulous style of Qing court painting gave rise to several generations of Japanese imitators, who spread the style throughout the country and formed what is now known as the Nagasaki school (no. 181). In addition to the strict imitators of the Nagasaki school, Chinese bird and flower painting also provided a source of inspiration for artists working in a variety of other styles, including such eccentric individualists as Itō Jakuchū (1716–1800).

Scholarly (bunjin or Nanga) painting

Even more pervasive was the spread of 'scholarly' or 'literary' painting. Leaving aside the question of whether they completely understood the distinction made by Chinese theorists between 'northern' and 'southern' styles, Japanese bunjin ('scholar') or Nanga ('southern painting') painters certainly felt their opposition to an official academic style – in their case the Japanese Kanō style – every bit as intensely as their Chinese counterparts. The ethos of the scholars was to stress their 'amateur' status. The deliberate non-professionalism, even awkwardness, of their painting style – landscapes using unconventional brush techniques; paintings of bamboo, orchid, plum and chrysanthemum (the 'four

gentlemen') in monochrome ink – was in strong contrast to the meticulous polychrome bird and flower subjects of the Qing court painters. Great importance was given to the idea of establishing oneself in the great scholarly tradition by painting 'in the style of master so-and-so', and considerable emphasis placed, too, on the traditional Chinese union of the sister arts of painting, calligraphy, poetry and music. Though Japanese scholar-painters were often obliged to sell their paintings to make a living, the Bunjinga or Nanga school never lost its basic unofficial character and continued to attract a wide variety of both eccentric and talented adherents into the present century (nos 174–7).

Western-style painting and prints

The reforms of 1720 also lead to European books and prints being imported into Japan in increasing numbers, introducing to Japanese artists the completely alien techniques of linear perspective and *chiaroscuro* developed by Western artists since the Renaissance to depict spatial recession and light and shade. Particularly influential were Western prints called *vues d'optiques*, used in viewing devices, which featured very emphatic perspective lines converging towards a horizon; these were copied by Japanese woodblock artists of the popular Ukiyo-e school from around 1740. In the next generation scholars and painters such as Hiraga Gennai (1726–79) and Shiba Kōkan (1747–1818) began to study what few Dutch texts on the theory of drawing they could obtain and experimented with Western techniques such as oil-painting and etching, as well as with Western-influenced compositions and subject-matter.

Maruyama Ōkyo (1733–95)

Such experiments in pure Western-style art remained rare, but Western ideas of spatial structure in painting were introduced to a much wider audience through the work of the Kyoto painter Maruyama Ōkyo (1733–95). Ōkyo designed perspective views for viewing devices as a young man, and in his mature works succeeded in integrating Western ideas of unified spatial recession with native traditions of landscape, figure and animal subjects, often in soft, understated ink and wash techniques (nos 178, 179). Ōkyo also brought about a revival of large-scale schemes for painting on sliding-door panels in suites of rooms and on large folding screens, giving them life through the wide range of artistic techniques at his disposal.

The Shijō school

Though the Maruyama line of artists continued to perpetuate Ōkyo's style far into the nineteenth century (nos 180, 186), one of his major associates, Matsumura Goshun (1752–1811), synthesised in the 1790s elements of both Maruyama and Bunjinga styles into a popular new Kyoto manner which came to be known as Shijō, after the street where Goshun's studio was situated.

Shijō painters followed Ōkyo's lead in terms of subject-matter, but did not seek to match the grand scale and serious conception of his art. A playful ink and wash style came to the fore which took a delight in displaying virtuosity with the brush for its own sake, treating familiar figure, animal, bird and flower, landscape and still-life subjects in a genial and humorous manner (nos 185–8). There are comparatively few screen paintings in Shijō style and artists favoured the more intimate formats of hanging scroll, fan, album and handscroll. In addition, Shijō became the first major school apart from Ukiyo-e to design works specifically for the colour woodblock-print medium – in single-sheet *surimono*, book and album formats – and thus found favour with a wide audience of ordinary townspeople, in Edo as well as the cities of western Japan (no. 229).

Meiji era painting (1868–1911)

After the re-establishment of diplomatic and trading ties with the outside world in 1854 and more particularly after the collapse of the shogunal government in 1868, Japan was swamped with new foreign artistic influences, and the art world after a time polarised into 'Western-style painting' (Yōga) and 'Japanese-style painting' (Nihonga), a division which has been largely maintained ever since. The British Museum's collection includes few paintings in either of these new idioms, and the examples from the Meiji era (1868–1911) included in this catalogue are by artists who continued working in traditional styles.

This brief essay has tried to map out the basic outlines of the rich and varied schools of painting during the Edo period, but many significant artists and artistic currents have had to be omitted. Japanese art historians are still at the stage of establishing the complete *oeuvre* of most Edo painters, major and minor alike, and few scholars have even begun to examine the intriguing issues of the structure of the art world at the time. A complete, integrated account of Edo period painting has to await further research.

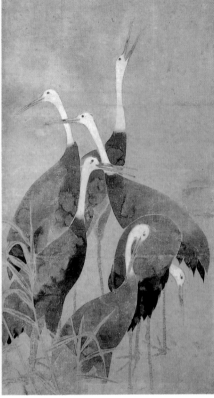

171 left screen

ANON. (Rimpa school)

171 Cranes

18th century
Pair of two-fold screens; ink and colour on paper;
 each c. 1520 × 1700 mm
Provenance: Yamanaka and Co.
1967.6–19.06 (1, 2) (Japanese Painting ADD 391, 2).
 Brooke Sewell Bequest

The paintings are presently mounted as a
pair of two-fold screens, but the surfaces are
considerably worn and show evidence of
having been well used as two pairs of
sliding-door panels (*fusuma*). The repaired
holes half-way up the sides of each screen
would have contained metal door fittings.
Though clearly influenced by the great
Ogata Kōrin (1658–1716), the screens do not
have the full bold stylisation associated with
this master's work. Their softer, flatter style
and gentle manner of execution suggest a
possible attribution to the artist Tatebayashi
Kagei, known by a small number of signed
works dating from the generation after

Kōrin, in the first half of the eighteenth
century.

The basis of the Rimpa style was to reduce
motifs taken from the natural world to their
most quintessential shapes and forms and
then to place them in strikingly asymmetric
arrangements across a composition. On the
left screen (illustrated) a flock of eleven
female cranes stand in a dry reed bed, while
on the right two males and a single female
are grouped beside a stretch of open water,
one male observing the flock of females with
obvious interest. Though crane-like, the
forms themselves are very simply painted:
long white necks, circles with a dot for the
eyes, and grey plumage differentiated by a
technique of 'puddling' the still-wet ink,
known as *tarashikomi*. The various
silhouettes are set off to full effect against
the large unpainted areas of the screens.

FURTHER READING Yamane, Yūzō (ed.), *Rimpa kaiga
zenshū, Vol. 4: Kōrin-ha 2*, Tokyo, 1977

NAKAMURA HŌCHŪ (worked late 18th–early 19th
century)

172 Flowers of the seasons

c. 1800
Signature: Hōchū ga ('painted by Hōchū');
 seal: (?) Hōchū
Pair of six-fold screens; ink and colours on gold
 leaf; each *c.* 783 × 3520 mm
Published: Hulton and Smith 1979, nos 33, 34
1978.3-6.04 (Japanese Painting ADD 574). Brooke
 Sewell Fund

The mid-eighteenth century crane screens
(no. 171) show a subdued side to Rimpa
school painting, in restricted tones of black
ink and pale pigments alone, but Hōchū's
paintings of plants and flowers on gold-leaf
screens show Rimpa art at its most brilliant
and gaudy. From dwarf azaleas and
sprouting fern fronds of spring, through
poppies, melons and aubergines of summer
(right screen) and finally to Chinese bell
flowers, chrysanthemums, bushclover,
trailing beans and peppers of autumn (left
screen, illustrated), a profusion of plants
bloom in seasonal order across the twelve
panels of gold leaf, with a true decorator's
disregard for the relative sizes of nature.
Though there is a basic concern to capture
the fundamental character of each plant in
simplified form – the spikiness of a rye grass
or gentle curving of a branch heavy with
berries – the flowers and leaves are mostly
turned towards us, as if pressed, so as to
display their elegant silhouettes against the
gold. The green pigment of the leaves has
been allowed to puddle and mix with other
colours in an almost arbitrary way according
to the *tarashikomi* technique much used by
Rimpa artists.

Though he lived almost a century after
Ogata Kōrin (1658–1716), Hōchū
assiduously studied works by the earlier
master. Indeed, he is best known to book
lovers for a colour-printed album of designs
after Kōrin, *Kōrin gafu*, published in 1802
during his stay in Edo.

FURTHER READING Honolulu Academy of Arts,
Exquisite visions: Rimpa Paintings from Japan,
Honolulu, 1980

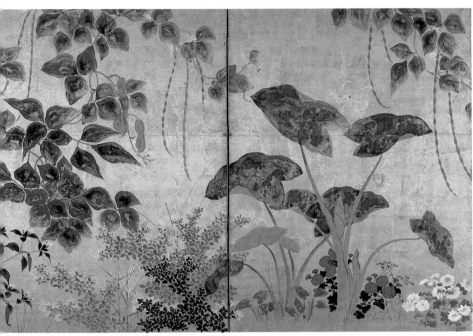

172 detail, left screen

SUZUKI KIITSU (1796–1858)

173 Flowers and grasses of the seasons

c. 1840s
Signature: Seisei Kiitsu; *seal*: Shukurin
Pair of hanging scrolls; ink and colours on silk;
 each *c.* 1032 × 346 mm
Provenance: Ralph Harari Collection
Published: Hillier 1973, nos 226 a, b; Tokyo National
 Museum 1987, no. 20
1978.3-6.04 (Japanese Painting ADD 715,6)

It was particularly in flower paintings that artists of the Rimpa school expressed their skill for brilliant decoration. Kiitsu was the principal pupil of the Rimpa revivalist Sakai Hōitsu (1761–1828) and worked in the city of Edo. The seasonal flowers which cascade down the hanging scrolls take on an almost enamelled polish, a combination of the use of rich pigments such as azurite blue and

Kiitsu's hard-edged, accurate brushwork. But the brittle quality of the painting of the flowers is softened by the hazy puddling and mixing of the water-logged green pigment applied to the leaves and stems, and by the gently curving shapes of the bushclover and orchid leaves. Earlier Rimpa artists such as Kōrin had used a bold pattern of stylised flower forms, but by Kiitsu's time much more naturalism had crept into the spatial relationships in paintings of all schools, and he attempts here a much more complex tangle of intertwining plants. The right scroll brings together flowers of spring and summer: aster, orchid, violet, thistle and lily; and the left scroll, those of autumn and winter: bushclover, narcissus, hibiscus, miniature chrysanthemum and bellflower.

FURTHER READING Nakamura, Tanio (ed.), *Hōitsu-ha kachō gafu*, 6 vols, Kyoto, 1978–80

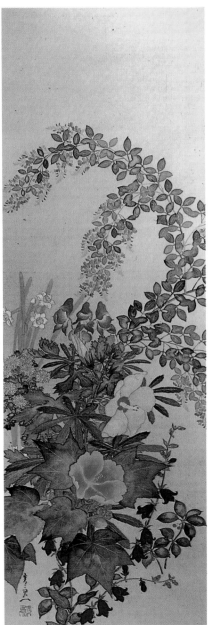

173 left scroll

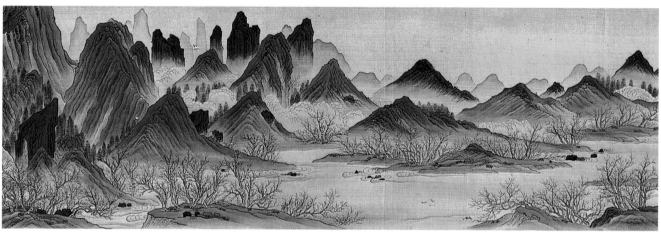

174 detail

TANI BUNCHŌ (1763–1840), after the Chinese artist QIU YING

174 'Peach Blossom Spring'

c. 1780s (?)
Signature: Qiu Ying Shi Fu hua; *seals*: Shi Zhou (seal of Qiu Ying); (unread) (seal of Bunchō)
Handscroll; ink, colour and gold on silk; 246 × 5024 mm
Provenance: Matsunaga Zensaburō Collection
Published: Tochigi Kenritsu Bijutsukan 1979, no. 4; Kōno 1987, no. 65
1980.2-25.04 (Japanese Painting ADD 608)

Since this handscroll ends with a reproduction of the signature and seal of Qiu Ying (d. 1552?) followed by one of Bunchō's own seals, Bunchō may have been working directly from a work by this celebrated Ming painter or a copy of it.

'Peach Blossom Spring' tells how a fisherman of Wuling loses his way and comes across a village hidden deep in the peach forest, where the inhabitants are blissfully unaware of the outside world. Qiu Ying, and Tani Bunchō after him, set the story in a vast panorama of mountains in the archaic 'blue and green' (*qinglu*) landscape style. Bunchō's painstaking, highly decorative version shows some of the most noticeable characteristics of Japanese painting as compared with Chinese.

FURTHER READING Tochigi Prefectural Art Museum, *Edo nanga no sōshi: Tani Bunchō*, Tochigi, 1979

TANI BUNCHŌ

175 Bamboo

1835
Signature: Bunchō; *seal*: Nanajūsan okina ('old man aged 73')
Folding fan; ink on paper; 166 × 463 mm
Provenance: Jack Hillier Collection
1973.2-26.058 (Japanese Painting ADD 470)

Since the great Wen Tong (1018–79) of the Northern Song dynasty, mastery of the spiky brush strokes necessary to paint bamboo was one of the basic skills learned by all scholarly (*bunjin*) painters in China, Korea and Japan. Together with pine and plum, bamboo was one of the 'Three Friends of Winter', while orchid, chrysanthemum, plum and bamboo constituted the 'Four Gentlemen', often painted by scholar-artists.

Though painted with spontaneous verve, the curving stems of bamboo have been deliberately arranged so as to echo the shape of the fan, and the tonality of the ink modulated to suggest spatial recession.

FURTHER READING Kōno, Motoaki, *Tani Bunchō (Nihon no bijutsu no. 257)*, Tokyo, 1987

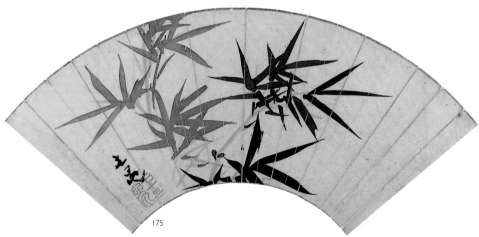

175

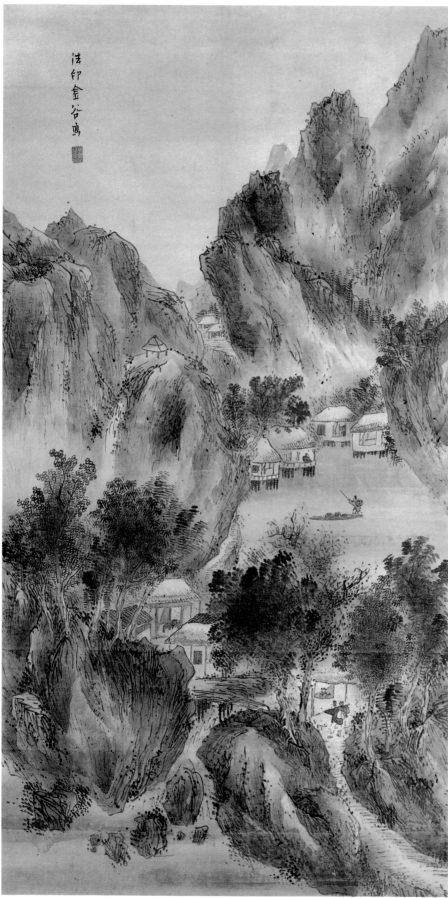

YOKOI KINKOKU (1761–1832)

176 Lakeside village in the mountains

After 1809
Signature: Hōin Kinkoku sha ('painted by Kinkoku of Hōin rank'); *seals*: Kinkoku, Bokuchi
Hanging scroll; ink and colour on paper;
 1632 × 853 mm
1972.1-24.01 (Japanese Painting ADD 408). Brooke Sewell Fund

Surrounded by looming mountain crags, a village of stilt houses nestles around the edge of a mountain lake. A traveller in the foreground follows a path that crosses a simple wooden bridge, then snakes along a narrow rock ledge above the lake and disappears off through a pass in the mountains to distant huts. The only other figures in this grand composition are a boatman and a solitary scholar seated contemplating the landscape from the window of one of the huts. The rich texture of the rocks and dense summer foliage has been achieved with a combination of saturated colour washes and lively outlines and dotting in black ink. Brush strokes in a variety of shapes are employed to suggest different types of tree, and the white of the paper is used to create a sense of space between each rock formation. Many of these techniques were learned by Kinkoku through studying works by the earlier master, Yosa Buson (1716–84).

Kinkoku was one of the few Japanese literati painters whose lifestyle was actually close to the free and untrammelled Chinese ideal of the scholar-artist. Skilled in military arts, calligraphy and poetry, he was also an enthusiastic adherent of the Shugendō mountain-climbing religious sect. After one particularly extensive climb in 1809 he was awarded the ecclesiastical title 'Hōin' ('Seal of the Law'), used in the signature of this painting. The second seal, Bokuchi, means 'ink mania'.

FURTHER READING French, Calvin L., *The Poet-Painters: Buson and his Followers*, Ann Arbor, University of Michigan Museum of Art, 1974

176

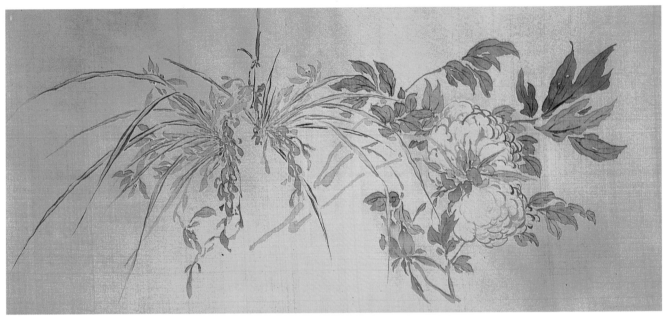

177 detail

TSUBAKI CHINZAN (1801–54), in the style of the
Chinese painter CHEN DAOFU (CHEN SHUN)

177 Flowers

c. 1850
Signature: Chinzan Tsubaki Hitsu; *seals*: Chinzan,
Hitsu in
Handscroll; ink and colours on silk; 346 × 4327 mm
Published: Hulton and Smith 1979, no. 68
1978.5-22.01 (Japanese Painting ADD 576). Brooke
Sewell Bequest

One ideal of the scholar-artists (*bunjin*) of
China, Korea and Japan was the union of
the sister arts of poetry and painting. It was
also important to establish one's place in the
great tradition by mastering the techniques
of earlier periods and executing works 'in
the style of master so-and-so'.

In the postscript to this handscroll
Chinzan explains how he selected eight
poems about flowers from *Xiangguanzhai
yushang bian*, an anthology by the Qing
dynasty poet Chen Chao, and then painted
these in the style of the Ming artist Chen
Daofu (Chen Shun, 1484–1544). The eight
flowers depicted are peony, orchid,
hollyhock, gardenia, lotus, flowering reed,
chrysanthemum and camellia. The
postscript also says that the completed scroll
was presented to one Baidō, the pen-name
used by Asano Nagayoshi (?1816–80), a
high-ranking retainer of the shogunate who
had served as City Magistrate of Kyoto.
Asano seems to have been an enthusiastic
patron of and writer about Chinzan's
works.

178

Though Chen Daofu was celebrated for his bird and flower paintings, the so-called 'boneless' (*mogu*) style of colour washes without outline used here is in fact closer to works by early Qing dynasty painters such as Yun Shouping (1633–90). In the section illustrated the paler washes of colour used for the long, trailing orchid plant and flaccid peony leaves are brought into focus by the intense, saturated pink of the peony bud.

MARUYAMA ŌKYO (1733–95)

178 Cracked ice

c. 1780s
Signature: Ōkyo; *seal*: Ōkyo
Two-fold screen; ink on paper with sprinkled mica; 605 × 1820 mm
Provenance: Maekawa Family Collection (box inscription)
Published: Tokyo National Museum 1987, no. 14
1982.10-21.01 (Japanese Painting ADD 723)

As a young man, Ōkyo was employed by a Kyoto toy merchant, Nakajima Kambei, to design prints and paintings incorporating Western-style 'vanishing-point' perspective, for use with novelty viewing machines that contained a mirror and a lens to accentuate the three-dimensionality of the images. Ōkyo applied the lessons of these early experiments to his mature works which, for the first time in the history of Japanese art, have a structure based on integrated spatial recession.

This low two-fold screen (*furosaki-byōbu*) would have been placed behind the various utensils used in the Tea Ceremony when these were laid out on the *tatami* mat of the tea-room, and the minimalist composition consisting of nothing more than cracks in the ice covering a pond is typical of the austere taste associated with the world of tea during the Edo period. Even in such a seemingly simple work, however, Ōkyo has taken pains to arrange the cracks so that they suggest the absolutely flat surface of

the ice receding far into the distance. Each brush stroke is executed with sharp, unwavering precision. Though the subject suggests the dead of winter, the intention may have been to provide a touch of cooling décor at a stifling summer Tea Ceremony.

FURTHER READING Saint Louis Art Museum, *Ōkyo and the Maruyama-Shijō School of Japanese Painting*, Saint Louis, 1980

MARUYAMA ŌKYO

179 Tiger (illus. p. 1, jacket back)

6th month, 1775
Signature: Ōkyo; *seals*: Ōkyo no in, Chūsen
Hanging scroll; ink and colour on silk; 1287 × 149 mm
Provenance: Nakamura Hambei, Kyoto (1909)
Published: Tajima 1909, pl. 29; Tokyo National Museum 1987, no. 16
1977.4-4.02 (Japanese Painting ADD 542)

From between the narrow confines of this tall, slender hanging scroll a crouching tiger stares with large, luminous green eyes. His front paws are brought stiffly together, concentrating all the power of his body into the hunched shoulders above the head, and the end of the tail seems about to flick with a life of its own. The off-centre placing of the eyes and slight tilt to the head give the tiger a quizzical, almost mocking air.

To capture the instant – the crouching of a tiger, or geese about to land on a stretch of open water – was one of the goals of Ōkyo's realism. Another was to suggest the solid underlying structure of things, and this convincing portrait of a tiger is all the more remarkable for the fact that Ōkyo would never have seen a live beast to sketch at first hand.

Each individual hair of the fur has been painstakingly drawn, but it is above all the skilful handling of the background washes which really conveys the softness of the coat, the distribution of the markings being used to suggest the musculature underneath. Tigers had been painted many times in East Asian art, but rarely in such an arresting composition, which triumphantly overcomes the limitations of its format.

FURTHER READING Price, Joe D., 'Tiger Paintings by Ōkyo and Ōyō', in *Essays on Japanese Art Presented to Jack Hillier*, London, 1982, pp. 135–42

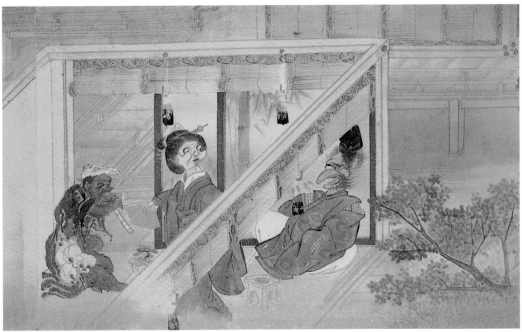

180 detail

KOMAI GENKI (1747–97)

180 Haunted palace

2nd month, 1778
Signature: Genki; *seal*: Genki no in, Shion
Handscroll; ink, colour and gold on paper;
 273 × 11,375 mm
Provenance: William Anderson Collection
Published: Anderson 1886, no. 2366; Hillier 1974,
 nos 58, 59; Smith 1977, pp. 86–100
1881.12-10.2366 (Japanese Painting 2411)

Japanese ghost paintings are populated
with a teeming horde of hideous monsters,
inanimate objects come to life, and eerie
spooks. Particularly from the mid-
eighteenth century onwards picture-books
and paintings abound showing all manner
of things which go bump in the night,
though the comic situations in which they
are often depicted suggests that the
supernatural was no longer a source of
much genuine terror. Telling ghost stories
and looking at pictures of spooks was a
popular pastime for a stifling summer night,
when any chill running down the spine
would be welcome.

Genki's handscroll populates the halls
and gardens of an aristocratic mansion with
bizarre creatures which are often dressed as
courtiers acting out suitably leisured
pursuits: in the scene reproduced a
dignitary with a long beak poking out from
under his court hat is watching a repulsively
ugly maid do a fan dance, while a creature
dressed in skulls – who is normally shown
gnawing bones – is providing a tune on the
shakuhachi bamboo flute. The scroll comes
to a close with a scene of comforting
normality, as servants in the kitchen
prepare food for a midsummer 'spooks'

day' banquet, and after a cock crows the sun
rises to drive away the fetid monsters of the
imagination.

The lyrical landscape passages show the
strong stylistic influence of Maruyama Ōkyo
(1733–95), Genki's famous teacher.

FURTHER READING Smith, Lawrence, 'The early
influence of Maruyama Ōkyo's New Style: A
Handscroll by Komai Genki in the British
Museum', in *Artistic Personality and Decorative Style
in Japanese Art* (ed. William Watson), London,
1977, pp. 86–100

KISHI GANKU (1749–1838)

181 Cat killing a bird

4th month, 1782
Signature: Ransai Ganku sha ('painted by Ransai
 Ganku'); *seals*: (unread), Ransai, (unread)
Hanging scroll; ink and colours on silk;
 954 × 350 mm
Published: Narazaki 1983, p. 3; Toyama Art
 Museum 1987, no. 11, p. 107
1984.3-1.01 (Japanese Painting ADD 773)

A black and white cat pounces on a bird,
while up above, half-obscured by the large
spreading leaves of a banana tree, two other
birds cower in alarm. A splash of bright
colour is provided by a cluster of poppies
growing from the side of a rock, and in an
attempt to stress the suddenness with
which the cat has attacked one torn red
poppy petal is shown falling in mid-air. The
arrangement of meticulously observed
animal and plant forms into a contrived,
highly decorative hanging-scroll
composition is typical of the Chinese Qing
academic bird and flower style, introduced

to Japan by Chinese painters who visited
the southern trading port of Nagasaki –
most notably Shen Nampin, who visited
Japan from 1731 to 1733. The realistic
'Nagasaki' style, as it is now known, was
introduced to Edo in the 1760s and 70s by Sō
Shiseki (1712–86) and his pupils and also
spread to other parts of the country,
including Kyoto.

It was to Kyoto that Ganku came as a
young man, in 1779 or 1780, willing to
satisfy the demands of patrons for works in
the fashionable Chinese style. Whilst it is
tempting to see in the dramatic subject and
bold composition of this painting a hint of
Ganku's mature style, it is equally likely that
he took the design from an existing Chinese
or Nagasaki school work.

FURTHER READING Toyama Art Museum, *Ganku*,
Toyama, 1987

KISHI GANKU

182 Tiger

c. 1784–96
Signature: Utanosuke Ganku; *seals*: Kakan, Ganku
Hanging scroll; ink and colour on silk;
 1690 × 1145 mm
Provenance: 'in England since 1862, and was
 bought in Japan at Hakodate' (Binyon 1931);
 E. A. Barton Collection
Published: Binyon 1931, pl. IX; Binyon 1934, pl. 39;
 Hillier 1974, no. 161; Tokyo National Museum
 1987, no. 19
1931.4-27.01 (Japanese Painting ADD 79)

A wild tiger has climbed on to a jagged
outcrop of rock beside a foaming mountain
torrent and bares his teeth in a ferocious

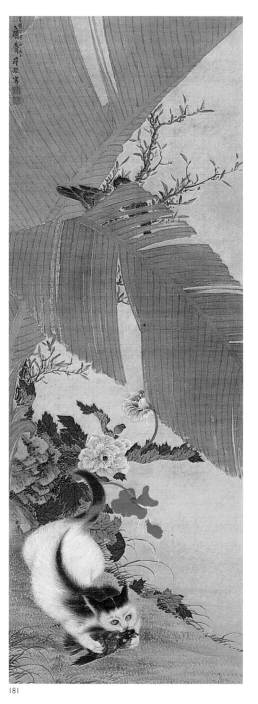

181

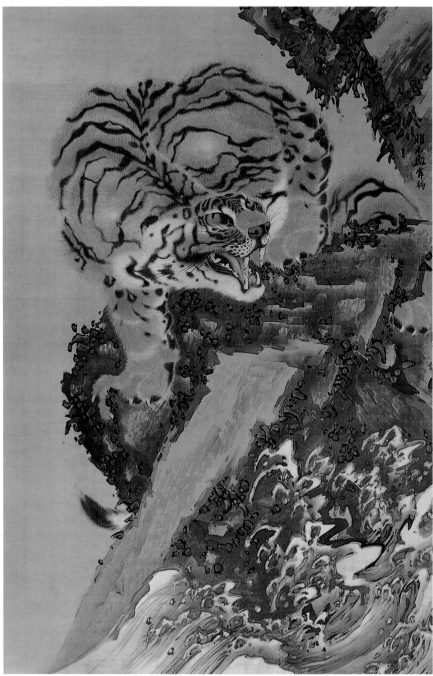

182

snarl. As with Ōkyo before him (no. 179), Ganku could not have seen a live tiger; which may explain why the head is strangely flattened, as if the artist was drawing from the skin of a dead animal. Nevertheless, he has more than compensated for this lack of direct observation by painting the limbs and tail in dynamic movement.

Ganku was born in Kanazawa but went to Kyoto in 1779 or 1780 to pursue a more

active artistic career. In 1784 he entered the service of Prince Arisugawa and was granted the art-name Utanosuke, which he used on this painting. From the study of other dated works it seems that he ceased to use the name after about 1796.

Stylistically, the painting combines careful, meticulous execution of the tiger in the manner of Chinese academic painters with much wilder, bravura brushwork in the rock and water that heralds Ganku's

idiosyncratic later ink and wash works.

The British Museum also has an inferior copy of this composition by a certain Kyūhō Shōei, painted 'at the orders of my lord' in the 6th month, 1803 (Japanese Painting 2518).

FURTHER READING Toyama Art Museum, *Ganku*, Toyama, 1987

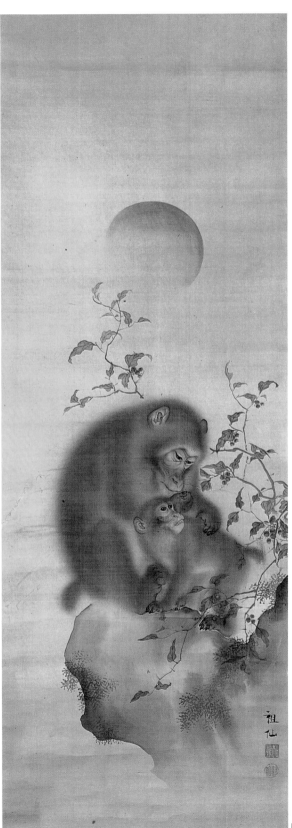

183

184 detail

MORI SOSEN (?1747–1821)

183 **Monkeys**

Before *c.* 1810
Signature: Sosen; *seals*: Mori Shushō, Sosen
Hanging scroll; ink and colours on silk;
 1055 × 385 mm
Provenance: Arthur Morrison Collection
Published: Morrison 1911, pl. 46; Tokyo National
 Museum 1987, no. 17
1913.5-1.0531 (Japanese Painting 2500). Given by
 Sir W. Gwynne-Evans, Bt

Sosen and his elder brother Shūhō
(1738–1823, no. 63) were founders of a line
of artists in Osaka who specialised in
painting animals and formed, in a sense, a
parallel school to that of Maruyama Ōkyo
(1733–95, nos 178, 179) in Kyoto. Indeed,
Shūhō's son Tetsuzan (1775–1841) was sent
to become one of Ōkyo's principal pupils
and there must have been familiar relations
between the two schools. Though he
painted many species of animal, Sosen was
(and is still) best known for his paintings of
monkeys: some quickly executed in a bold
ink style (*sōga*), and others, like the present
example, in which the almost imperceptible
individual hairs of the fur are painstakingly
built up over background washes to suggest
a soft, springy resilience.

A mother and baby monkey have climbed on to a rock and the mother is scrutinising a blue berry she has picked, while the baby crouches close to her and turns to look at the plant. It was with this ability to enter into the psychology of animals and render their intelligent gazes and characteristic attitudes with subtlety and precision that Sosen established a supremacy which his many later imitators could not match.

When he was sixty-one years old, in about 1810, Sosen changed the first character of his name to one meaning 'monkey'; this work predates the change in name.

FURTHER READING Osaka City Museum of Art, *Kinsei Ōsaka gadan*, Osaka, 1983

KAWAMURA BUMPŌ (1779–1821)

184 Japanese festival scenes and Chinese scholars

c. 1810
Signatures: Bumpō Basei sha ('painted by Bumpō Basei') and Bumpō; *seals*: Bumpō, Basei, (?) Nanzan-ju
Pair of handscrolls; ink and colour on silk; 297 × 10,155 mm (Japanese subjects), 294 × 10,470 mm (Chinese subjects)
Provenance: Richard Lane Collection
Published: Hillier 1974, nos 183, 184, 185; Lane 1976, no. 511, p. 83
1981.4-8.01, 02 (Japanese Paintings ADD 639, 40)

This pair of handscrolls, a masterpiece among the few paintings by Bumpō so far published, demonstrates to us the cheerful artistic personality and dual worlds of interest of this brilliant stylist who worked in Kyoto in the early nineteenth century. One scroll shows Chinese subjects – elderly sages meeting to compose poetry, paint, drink and carouse – and the other, scenes at Japanese festivals and idyllic country landscapes. Bumpō dutifully studied Chinese paintings both directly and through the work of his teacher Kishi Ganku (1749–1838, nos 181 and 182) but temperamentally seems to have been drawn

to the purely native, soft Shijō style that predominated in the Kyoto art world at the time. Though the wriggling line of his figure work echoes Ganku's idiosyncratic style, the bold sense of placement and the warm humour with which the faces of the figures are distorted are entirely his own.

In the scene reproduced a drunken scholar is supported by young acolytes, while an aged artist is poised to paint before a self-important official: despite the Chinese costumes one can imagine that parties held by painters and poets in Bumpō's own Kyoto were equally convivial. The scroll of Japanese subjects includes the procession of the Uzumasa autumn festival, which also appears in the second (west) volume of Bumpō's illustrated book *Teito gakei ichiran* ('Elegant Views of the Capital at a Glance', 4 vols, 1809–16). Woefully unthreatening wearers of devil masks are followed by a huge blazing torch, while bringing up the rear is a group of solemn village farmers leading a reluctant ox on which sits a priest wearing the strangest of masks.

FURTHER READING Hillier, Jack, 'Kawamura Bumpō and Kawamura Kihō', in *The Art of the Japanese Book*, London, 1987, pp. 686–703

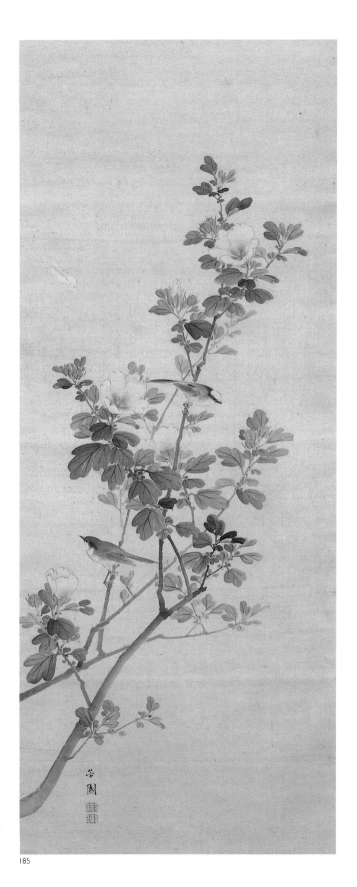

185

186 right screen

NISHIYAMA HŌEN (1804–67)

185 Birds and hibiscus

c. mid-19th century
Signature: Hōen; *seals*: Hei Seishō, Kotatsu-uji
Hanging scroll; ink and colours on silk;
 1041 × 425 mm
Provenance: Arthur Morrison Collection
Published: Hillier 1974, no. 256
1913.5-1.0484 (Japanese Painting 2478). Given by
 Sir W. Gwynne-Evans, Bt

The Shijō school is the name given to the
lineage of painters working mainly in Kyoto
(later Edo and Osaka as well), which grew
out of the style practised by Matsumura
Goshun (1752–1811) and his followers. In
Shijō painting it is usually the polished
brushwork in pale, translucent colours
which dominates, with subjects drawn from
everyday life – figures, animals, birds,
flowers, still lives, landscapes – and treated
in a warm, genial manner. Compositions

are often spare, leaving the deftly brushed-in forms to resonate in the space around them. The touch is always light, never over-rich.

This work shows Shijō painting at its most quietly decorative. Each leaf is executed in scrupulously modulated wash – a touch of black ink mixed into the green pigment used for the larger, more mature leaves, and a fresh lime green reserved for the new buds. The pale lemon flowers with their crimson centres have petals delicately etched in pale grey ink and precisely delineated stamens. Each bloom turns in a different direction, creating a sense of natural tangle among the branches, and each branch is drawn with a single, uninhibited sweep of the brush.

FURTHER READING Hillier, Jack, *The Uninhibited Brush*, London, 1974

MORI IPPŌ (1798–1871)

186 Pine trees at Maiko no Hama beach

10th month, 1847
Signature: Ippō; *seals*: Mori Keishi, Shikō-uji
Pair of six-fold screens; ink and colour on paper;
each *c*. 1570 × 3665 mm
1984.6-1.01, 02 (Japanese Painting ADD 790, 791)

Though no title is written on the painting itself, the box inscription identifies the subject. Situated between Suma and Akashi, beauty spots celebrated in classical court poetry, Maiko no Hama is a stretch of white sand dotted with wind-swept pines. Ippō has painted a frieze of twisting and tilting trees looming up close to the picture plane and then added a gentle sea landscape fading off into the distance beyond. Ippō's teacher, Mori Tetsuzan (1775–1841), was a pupil of the great Maruyama Ōkyo (1733–95), who revived

and re-invigorated large-scale landscape paintings on folding screens and sliding-door panels during the late eighteenth century. With their soft, decorative washes in ink, pale blue and gold and sense of deep space, Ippō's screens display the enduring techniques and attitudes to composition of the Maruyama school which Ōkyo had founded: the pattern of brushwork used in the trees and rocks, and water, too, is particularly close to the manner of the earlier Kyoto master.

Folding screens are intended to be seen from a low viewpoint, seated on a *tatami* mat floor. Ippō has so organised the composition that the viewer would have the vivid sensation of actually looking out between the trunks of the pine trees to the sea beyond.

FURTHER READING Yamaguchi Prefectural Art Museum, *Maruyama-ha to Mori Kansai*, Yamaguchi, 1982

187 detail

SHIBATA ZESHIN (1807–91)

187 New Year subjects

1st month, 1848 (on accompanying certificate)
Signature: Reisai Den Zeshin (on accompanying
 certificate); *seals*: Koma, Reisai, Zeshin (on
 accompanying certificate)
Handscroll; ink and colour on paper;
 268 × 8714 mm
Provenance: Ralph Harari Collection
Published: Hillier 1973, no. 277; Hillier 1974, no. 272
1982.7-1.014 (Japanese Painting ADD 699). Given
 by Dr and Mrs Michael Harari

Zeshin was equally celebrated as a lacquer
craftsman, trained from the age of eleven in
the techniques of Koma Kansai II
(1766–1835), and as a painter in Shijō style,
which he studied under Suzuki Nanrei
(1775–1844) from the age of sixteen. In
later life he even combined these two
professions, developing a special technique
of painting with lacquer pigments.

 In addition to studying painting in Edo
with Nanrei, Zeshin went to Kyoto for three
years from 1830 to 1833 to receive teaching
from Okamoto Toyohiko (1773–1845), a
leading master of the Shijō school. The
present handscroll is mounted together
with a certificate dated 20th day/1st
month/Kōka 5 (1848) in which Zeshin
bestows a new art-name 'Ōshin' on a pupil
whose family name is Matsuno; the scroll
may thus have been intended as a
graduation present. Very few pre-Meiji
period (that is, pre-1868) paintings by
Zeshin are yet known, and this handscroll
provides valuable evidence of Zeshin's early
Nanrei-influenced Shijō style.

 The section illustrated shows a boldly
cut-off arrangement of special foods,
utensils and decorations for a New Year

meal: a low black lacquer tray-table carrying
a red snapper fish decorated with a fern leaf;
deep black and red lacquer soup bowls; a
wooden stacked food container; shallow
saké cups on a stand; and a metal saké kettle
with a sprig of leaves tied to the handle.
With a variety of broad, moist brush strokes
Zeshin finds painterly equivalents for the
various rough and smooth textures and
surfaces of the still-life objects.

FURTHER READING Honolulu Academy of Arts, *The
Art of Shibata Zeshin*, London, 1979

SHIOKAWA BUNRIN (1808–77)

188 Fireflies over a river

c. 1875 (?)
Signature: Bunrin; *seals*: Bunrin, Shion
Hanging scroll; ink and gold on silk;
 1304 × 506 mm
1980.7-28.04 (Japanese Painting ADD 625)

Bunrin trained in the Shijō style under
Okamoto Toyohiko (1773–1845), became
painter in attendance to the princely Yasui
family, and was in general patronised by
sections of the Kyoto aristocracy. In 1866, on
the eve of the Meiji Restoration, he founded
the Jōunsha art society which served as an
important source of support and patronage
for artists of all schools working in Kyoto
during the upheavals of the restoration era.

 In this large hanging scroll of fireflies
dancing over a river on a summer's evening
Bunrin is striving to express effects of light
and spatial continuity in a manner which
few earlier Shijō artists would have
attempted, and this is a measure of his

'modernity' and willingness to adopt certain
aspects of Western-style painting. Until this
period Japanese artists had very rarely tried
to depict darkness naturalistically. The low
viewpoint and structured progression
through a series of planes carefully
modulated to fade into the dusk are
especially effective. Along the water's edge
a large brush loaded with dark ink has been
dragged quickly to leave pools of lighter ink
showing through from underneath.

 However, much of the beauty of the
painting derives from the elegant rhythms
of the dark silhouettes of the dwarf bamboo
leaves, which are in pure Shijō brushwork.
The conceit of restricting colour to just the
golden glow of the fireflies is typical, too, of
the sophistication of Kyoto painting. A pair
of screens of similar subject by Bunrin in the
Nelson-Atkins Gallery, Kansas City, bear
the date 1875.

KAWANABE KYŌSAI (1831–9)

189 Susano'o no Mikoto subduing
the eight-headed serpent

1887 (according to Conder)
Signature: Seisei Kyōsai; *seal*: (unread)
Hanging scroll; ink and colours on silk;
 1001 × 297 mm
Provenance: Josiah Conder (Sotheby's, London,
 18 January 1965, lot 26)
Published: Conder 1911, pl. IV; Smith 1988a,
 frontispiece
1969.4-14.01 (Japanese Painting ADD 397)

Susano'o no Mikoto was the younger
brother of the sun goddess Amaterasu
Ōmikami. After his obnoxious behaviour

188

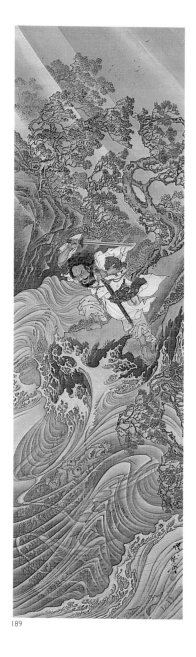

189

had driven his sister to hide in a cave, plunging the world into darkness, Susano'o was banished from the High Celestial Plane to the Izumo region in western Japan. Here he intoxicated and then slew an eight-headed, eight-tailed serpent (*yamata no orochi*) and rescued Princess Kushinada. In the tail of the serpent he discovered the sword which became one of the three regalia of the Imperial family. Kyōsai appears to have modified the standard version of the story by showing the snake as

a dragon coming up out of a raging sea on a storm-swept rocky coast, and by having Susano'o brandish his sword before the monster has been pacified with drink.

Though trained in the academic Kanō school, Kyōsai was a master of many painting styles, ranging from highly finished 'serious' exhibition pieces like this one to wild, satirical sketches dashed off impromptu under the influence of saké. Here the composition is cleverly organised so the viewer focuses first on the

brightly coloured figure of Susano'o, before noticing the serpent lurking in the foaming waves beneath.

The painting was formerly in the collection of Josiah Conder, the English architect working in Japan in the 1880s, who was a pupil, patron and biographer of Kyōsai.

FURTHER READING Conder, Josiah, *Paintings and Studies by Kawanabe Kyōsai*, Tokyo, 1911

THE ART OF UKIYO-E

(nos 190–230)

Genre painting and Ukiyo-e

The man of breeding never appears to abandon himself
completely to his pleasures; even his manner of enjoyment is
detached. It is the rustic boors who take all their pleasures grossly.
They squirm their way through the crowd to get under the trees;
they stare at the blossoms with eyes for nothing else; they drink
sake and compose linked verse; and finally they heartlessly break
off great branches and cart them away. When they see a spring
they dip their hands and feet to cool them; if it is the snow, they
jump down to leave their footprints. No matter what the sight,
they are never content merely with looking at it.

Yoshida Kenkō, *Tsurezuregusa*, c. 1330–2
(Trans. by Donald Keene as *Essays in Idleness*, New York, 1967, p. 118)

. . . Living only for the moment, turning our full attention to the
pleasures of the moon, the snow, the cherry blossoms and the
maple leaves; singing songs, drinking wine, diverting ourselves in
just floating, floating; caring not a whit for the pauperism staring us
in the face, refusing to be disheartened, like a gourd floating along
with the river current: this is what we call the *floating world* . . .

Asai Ryōi, *Ukiyo monogatari*, c. 1661
(Trans. by Richard Lane in *Images from the Floating World*, Oxford, 1978, p. 11)

Ukiyo-e, 'pictures of the floating world', grew out of
earlier traditions of genre painting during the second half
of the seventeenth century. The differing comments of
the two authors quoted above – Yoshida Kenkō writing in
the early fourteenth century and Asai Ryōi in a book
published in the early 1660s – suggest a useful
comparison for appreciating the different flavours of
genre paintings (nos 45, 52, 55) and Ukiyo-e (nos 190,
191, 193). The central issue is the attitude towards
enjoying oneself. Yoshida, an urbane, not to say slightly
jaded, courtier writing for a like-minded audience, mocks
the lively antics of a fun-loving holiday crowd: a person

with any breeding at all would never take his pleasures so enthusiastically, he says. Asai's preface to his 'Tales of the Floating World' (*Ukiyo monogatari*), on the other hand, is a manifesto for hedonists; consumers voracious for pleasurable experience, living life for the moment and to the full.

This revolution in attitudes reflects the enormous changes in Japanese society during the seventeenth century. After over one hundred years of ruinous civil war, peace was finally restored in 1603 under a military regime headed by the Tokugawa shoguns, who established their headquarters in a huge new fortress at Edo in eastern Japan. Edo (now modern Tokyo) had been a small castle town in 1600 but by 1700 was a vast metropolis of a million inhabitants, one of the largest cities in the world at that time. It became the arena for competing displays by the new feudal aristocracy of pomp and wealth that reflected the delicate political balance between loyal vassals of the shogun and recently subdued enemies. Sumptuous mansions for these provincial lords and their large samurai retinues were constructed around Edo castle in an arrangement of symbolic subservience; while in the lower-lying areas of the city along the banks of the Sumida River there grew up teeming conurbations inhabited by the merchants and artisans who purveyed goods and services to this élite. Although these lower classes were completely debarred from any involvement in the political life of the nation, the great irony (and perennial crisis) of shogunal government was that the merchants quickly took control of the expanding money economy. By the time Edo was rebuilt after the great fire of 1657, there was a large urban population with money to spend and time to enjoy it.

There were perfectly innocent pleasures to be had in Edo, such as shopping (Echigoya, forerunner of the present Mitsukoshi department store group, opened its doors on a 'cash only' basis in 1673) and outings to temples, shrines and other beauty spots in the city, or a trip to one of the three large government-licensed Kabuki theatres; but it was inevitable in a city where the constant coming and going of large samurai retinues from the provinces meant that men considerably outnumbered women that prostitution should become a major industry. The shogunal government recognised and to an extent condoned the existence of the sex industry, seeking to regulate it by relocating a major self-enclosed licensed pleasure quarter, Yoshiwara, in open fields to the north of the city after the fire of 1657. Despite the

setting up of the regulated Yoshiwara quarter, illicit prostitution continued to operate in many other areas, in the informal *okabasho* (unlicensed pleasure quarters). Up to the end of the nineteenth century at any one time there were some 2,000 to 3,000 women working in the Yoshiwara district. Though samurai and merchant patrons alike often went to this special world to escape the stifling formality of everyday social relations, it is ironic that the grander courtesans were ranked in a hierarchy operating according to an etiquette in many ways as rigid as the feudal society outside.

To put it simply, in the second half of the seventeenth century various currents came together to produce Ukiyo-e, the art special to this society of pleasure seekers. These included the tradition of genre painting; the growth of a popular culture focusing on the licensed district of Yoshiwara and the Kabuki theatre; and the adaptation of age-old techniques of woodblock printing to make images commercially available to a wide audience living in the cities.

Woodblock printing and early Ukiyo-e

Until the end of the sixteenth century woodblock printing had been used in Japan almost exclusively for reproducing religious texts and images in Buddhist monasteries and temples. With the growth of an increasingly literate urban audience during the seventeenth century, however, popular editions of classical tales started to be produced in the format of woodblock-printed books with illustrations enlivened with simple green and orange hand-colouring (*tanroku-bon*). Other black and white illustrated books showed blood-and-guts tales of muscular heroes (*Kimpira-bon*), which had much in common with the plots of the developing Kabuki theatre in Edo. To describe these early books as 'crude' is simply factual: they did not have any particular pretensions to technical or aesthetic sophistication and told their stories simply and economically.

A major change took place in the 1660s and 70s, however, when publishers began to employ professional artists, who were probably already working as genre painters, to provide designs from which engravers and printers could produce woodblock prints. The first such artist to design a large corpus of printed materials signed with his name was Hishikawa Moronobu (?1618–94), and for this reason Moronobu is sometimes rather

misleadingly described as the 'founder' of the Ukiyo-e 'school'. Here it should be mentioned that although Ukiyo-e artists often attracted considerable numbers of pupils into their studios, they never constituted a formal academic system such as the Kanō, Tosa and Sumiyoshi schools, supported by the guaranteed patronage of the ruling classes. If an Ukiyo-e artist's style became unfashionable and unsaleable, he would quickly be eclipsed by rivals more in tune with the times. Moronobu's style had all the elegance and visual sophistication of the genre painting tradition, spiced with a new racy energy derived from the burgeoning popular culture. Many of his works are books or albums of erotic scenes, of a wonderfully robust, celebratory power and sensuous beauty. Erotica continued to be one of the most important aspects of every Ukiyo-e artist's *oeuvre* and provide a key to the understanding of the eroticism inherent in many less explicit works.

The 'Ukiyo-e quartet'

The harnessing of woodblock printing was the key to the commercial success and popularity of images in the new 'floating world' style. The artist supplied a sketch to the publisher who then had printing blocks prepared and printed by separate workshops of specialist engravers (in fact, carvers) and printers: the artist, engraver, printer and publisher (who reaped the overall profits from the venture) constitute what has been called the 'Ukiyo-e quartet'. This division of labour freed Ukiyo-e print designers to be tremendously prolific. By the nineteenth century when woodblock printing was carried out on an almost industrial, mass-production scale, an individual artist such as Utagawa Kunisada (1786–1864) was responsible for an estimated 50,000 designs, including book illustrations, during a working life of over fifty years. This staggering total is put into perspective when we realise that one of the most prolific illustrators in the West, Honoré Daumier (1808–79), has an estimated total *oeuvre* of 7,000 to 8,000 designs. There was nothing to limit the size of editions of a particular design beyond how many a publisher could sell and how many could be printed before the hard cherry-wood printing blocks started to deteriorate. They could always, if necessary, be recut, but this was rarely done because of the large investment in labour it needed. One tradesman called Fujiokaya recorded in a diary written in 1848 that he was able to sell 8,000 sets of a three-sheet print showing the shogun hunting at the foot of Fuji at 72 *mon* per set.

In general, the price of colour prints seems to have been about 20 *mon* per sheet, the equivalent of the price of a cup of buckwheat noodles (*soba*) at the time. In the eighteenth century editions were probably somewhat smaller, though the naturally high casualty rate of early prints makes this hard to estimate, and written records stating the number printed have not yet been found. It would not make commercial sense to go to the trouble of engraving a block if a sizeable edition were not envisaged: an experienced printer could run off as many as 3,000 impressions from a black outline block in a working day. Clearly, then, there were literally millions and millions of 'floating world' images in circulation during the Edo period, purchased in shops at a price which almost all could afford. The audience for printed books was further extended by the activities of itinerant book-lenders (*kashihon'ya*) who would rent out copies of bestsellers for a few coppers a day.

Developments in subject-matter and technique

Images of beautiful women and Kabuki actors remained the core of the repertoire of Ukiyo-e artists, but also popular were genre depictions of people of all classes parading their stylishness in various locations in the city. In the eighteenth century there was considerable interest, too, in topographical views of the city in imitation of imported Western prints using the (to the Japanese) exotic conventions of linear perspective; and these rather prosaically topographical views developed into more aesthetically pleasing 'pure' landscape views, as in the 1830s, 40s and 50s artists led by Katsushika Hokusai (1760–1849) and Andō Hiroshige (1797–1858) broadened their horizons beyond the city of Edo to explore the beauties of the Japanese countryside (nos 219, 220, 223). In fact, the nineteenth century witnessed an explosion of new subjects for woodblock printmaking – the historical, warrior and humorous prints of Utagawa Kuniyoshi (1797–1861, no. 221) or the still-life compositions of *surimono* artists (no. 218) – to the point where Asai Ryōi's more limited mid-seventeenth-century definition of the 'floating world' (quoted at the beginning of the chapter) becomes no longer applicable.

Techniques of woodblock printing became evermore complex and refined as the Edo period progressed. Late seventeenth-century examples were almost always black and white prints (*sumizuri-e*) printed from a single block, with rarely any hand-colouring at all (nos 204, 205). The

period *c.* 1700–20 saw a vogue for lively hand-colouring in a bright orange-red lead pigment (*tan*) as well as shades of yellow (no. 206). Accompanying the sudden shift from the large *kakemono* format (which imitated a painted hanging scroll or a theatrical signboard) to the small narrow *hosoban* around 1720, a new, much wider and more delicate palette of hand-applied colours appeared, centring on a pale crimson colour (*beni*) derived from the petals of the safflower. To compensate for the small size some of these 'pink pictures' (*beni-e*) were further decorated with sprinkled brass filings in imitation of the gold dust used on paintings; and areas of black costume were coated with a shiny glue to give the appearance of black lacquer (*urushi-e*, no. 207). Techniques of colour registration using simple notches carved into the blocks called *kentō* had been known since at least the mid-seventeenth century, but it was not until the early 1740s that the technique was used for commercial single-sheet prints, generally printed in shades of green and pale crimson (*benizuri-e*, no. 208). Other colours, notably blue and yellow, were added during the 1750s to produce three- and four-colour prints.

The year 1765 saw a major new departure in the development of colour woodblock printing in Edo. Patronage became available from groups of samurai poets which encouraged publishers to experiment with sophisticated techniques of full-colour printing in a dozen shades or more, to designs by the artist Suzuki Harunobu (1724–70, no. 209). So great was the enthusiasm with which these so-called 'brocade prints' (*nishiki-e*) were received by the print-buying public that – despite the considerably higher cost – after this date only certain categories of illustrated book and the humblest of scandal sheets continued to be printed in black and white.

During the next hundred years the engraving of blocks progressively reached an astonishing level of finesse. Engravers vied to outdo one another in the number of fine lines they could cut in the hairline of an actor portrait or just how minutely they could render the pattern of a brocade robe. Special printing techniques, too, proliferated. Already in the first full-colour prints of Harunobu in 1765 there are examples of blind (or *gaufrage*) printing (*kara-zuri*), as well as the printing of a background in a single solid colour (*ji-tsubushi*). In the lavish illustrated albums designed by Kitagawa Utamaro (1754–1806) to the private commission of *kyōka* poetry

clubs during the late 1780s and early 90s the publisher Tsutaya Jūsaburō (1750–96), impresario of *de-luxe* woodblock colour printing, had his printers work in a whole new range of metallic and mineral pigments – notably shiny ground mica (*kira-zuri*). Mica was also used by Tsutaya for the backgrounds of the extraordinary portraits of actors designed by Tōshūsai Sharaku (dates unknown) in the summer of 1794 (no. 215). In the nineteenth century embossing, blind printing and printing with metallic pigments were brought to a peak of complexity in the special-edition *surimono* prints produced for private distribution by poetry clubs (no. 218), and in the case of actor prints new techniques such as burnishing (*tsuya-zuri*) and embossing with textile weave (*nuno-zuri*) were added to suggest more richness of texture in the players' costumes and wigs.

The landscape prints of Katsushika Hokusai (1760–1849) and Andō Hiroshige (1797–1858) would have little of their spatial depth and nuance for seasonal atmosphere, time of day or weather conditions, were it not for the various techniques which proliferated during the 1830s for partially wiping the blocks before printing to give gradated tones (*bokashi*, nos 219, 220, 223). This 'printerly' quality, if it may be so described, became an increasingly significant element in the overall aesthetic impact of Ukiyo-e woodblock prints as the Edo period progressed, as significant in its own way as the quality of the design conceived by the artist. Put another way, Ukiyo-e prints represent an equal partnership of art and craft-artistry.

Ukiyo-e painting

Ukiyo-e was born out of genre painting and the first Ukiyo-e artists were painters. In fact, almost all Ukiyo-e artists were painters, despite the fact that some art historians have chosen to write the history of Ukiyo-e as if it were a history of printmaking alone. The number of paintings – albums, handscrolls, hanging scrolls and screens on silk or paper – produced by Ukiyo-e artists was naturally small compared with their output of print designs, and the most prolific artists produced only hundreds of paintings as compared with sometimes tens of thousands of print designs. To execute a highly finished hanging scroll on silk demanded the undivided attention of the painter for many days, unassisted by supporting workshops of engravers and printers. One late eighteenth-century novel includes the observation that 'a painting by [Katsukawa] Shunshō [1726–92] is

worth a thousand pieces of gold' and even allowing for considerable exaggeration paintings must have been expensive, often specially commissioned. It should also be borne in mind that many of the grandest Ukiyo-e paintings – the signboards painted by successive generations of the Torii school to hang outside Kabuki theatres – have not been preserved. A few mid-eighteenth-century examples were presented to shrines as votive plaques (*ema*) and have survived, but we can do little more than imagine the power of the now lost paintings of Kiyonobu I and Kiyomasu I, based on a knowledge of their forceful prints (no. 206).

It is possible to trace a lineage of artists from the late seventeenth to the mid-nineteenth centuries, often linked as master and pupil, which constitutes the 'main line' of the course of development of Ukiyo-e painting and accounts for many of its most talented practitioners – Hishikawa Moronobu (?1618–94, no. 191), Miyagawa Chōshun (1683–1753, no. 193), Miyagawa Shunsui (dates unknown), Katsukawa Shunshō (1726–92), Katsushika Hokusai (1760–1849, no. 199) and Teisai Hokuba (1771–1844). On the whole the range of subject-matter of Ukiyo-e paintings was not so wide as that of prints. Paintings customarily showed the single standing figure of a beautiful woman (often a courtesan) – well suited to the usually tall, narrow format of the hanging scroll – or series of erotic scenes naturally fitted to the handscroll and album format. But though the choice of subject-matter might be unadventurous, artists often rose to the challenge of displaying their technical and compositional virtuosity in a way which collaborative printmaking did not allow. The English architect Josiah Conder, who observed the painter Kawanabe Kyōsai (1831–89) working on a meticulous Ukiyo-e-style painting during the 1880s, leaves us a twelve-page description of the painstaking stages of underdrawing and building up of rich layers of mineral and vegetable pigments, one by one (no. 189). It is surely significant that certain Ukiyo-e artists, such as Shunshō, Isoda Koryūsai (worked *c*. 1766–88) and Hosoda Eishi (1756–1829, no. 197), retired from designing prints at the height of their careers so as to be able to devote themselves exclusively to the art of painting.

Idealisation

During the eighteenth century the increasing technical complexity and sophistication of both Ukiyo-e prints and paintings paralleled a process of increasing refinement of style and idealisation of subject-matter. Ukiyo-e pictures were always in the business of promoting and beautifying the image of the 'floating world', concentrating on its most positive aspects. Though we learn from popular literature, historical accounts and diaries of the time of the seamier side to the world of pleasure – the street walkers at the pitiful lower levels of the hierarchy of prostitution such as the 'night hawks' (*yotaka*) and 'boat girls' (*funamanjū*) – these low-class women were never depicted alongside the elegant high-class courtesans of Yoshiwara. Nor do we see even passing visual references to other darker aspects of life in Edo: fire, famine, epidemic, poverty, old age or infirmity. Though Ukiyo-e prints are an almost inexhaustible source of reference for cultural historians, it is all too easy to be beguiled by their persuasive visual rhetoric into believing that Edo was a kind of happy-go-lucky paradise. The 'floating world' should never be confused with the real one. The deliberately refined style of Edo prints is put into sharp focus when compared with the more robust, down-to-earth, even ungainly figure style of print artists of the Shijō school in Kyoto and Osaka (no. 229).

Another aspect to this issue of 'image building' is of course that this is precisely what many purchasers of Ukiyo-e prints expected. What was the point of a Kabuki actor who was not larger than life or a Yoshiwara courtesan who was not impossibly glamorous? Men may have viewed an Ukiyo-e print of a high-ranking courtesan as a substitute for an unattainable sex-goddess, but women were equally keen to scrutinise and emulate the latest fashions. In this sense Ukiyo-e prints were not just passive records of the passing urban scene but active agents for creating and reinforcing popular cultural values. One can appreciate something of the mania for Ukiyo-e (which has infected not a few modern collectors as well) from the following passage in *Ukiyo-buro* ('Floating World Bath'), a serial novel by Shikitei Samba (1776–1822) published over a period of thirteen years from 1809. In the women's section of the public bath the mothers are complaining:

. . . And then there are those things they call 'switch pictures' or whatever they are, the ones you fold one way or the other to change the pictures, you know, to make an actor do quick costume changes for instance. Anyway, my children buy them one after another, and then put them in a box. You wouldn't believe how packed that box is! And then my third one, the oldest boy,

buys those – what are they? *gōkan* – those little illustrated novels, anyway, and *they* pile up in a *basket*. 'Toyokuni's the best!' 'Kunisada's the best!' – they even learn the names of all the illustrators! Children these days are up on simply everything!

(Trans. by Robert W. Leutner in *Shikitei Sanba and the Comic Tradition in Edo Fiction*, Cambridge, Mass., 1985, pp. 174–5)

Ukiyo-e and popular literature

One way of assessing the place of Ukiyo-e within Edo culture as a whole is to examine the links between the visual images and the popular literature of the 'floating world'. Some artists were equally active as popular authors or poets: Okumura Masanobu (1686–1764), Toriyama Sekien (1712–88), Kitao Masanobu (1761–1816) and Keisai Eisen (1790–1848); and many other artists collaborated with authors such as Ōta Nampo (1749–1823), Takizawa Bakin (1767–1848) and Shikitei Samba (1776–1822). Certain genres of popular literature – *kibyōshi*, *gōkan*, *yomihon* – relied just as much on their striking illustrations by Ukiyo-e artists as their written text to tell a story, integrating pictures and text as only comic-books have ever done in the West. Perhaps the most important aspect of this interdependent development is the way in which it served to channel certain elements of the 'high' culture of the samurai class into Ukiyo-e, as many popular authors (and some Ukiyo-e artists) came from the samurai, rather than the merchant or artisan classes.

Ukiyo-e, the samurai class and censorship

Ukiyo-e artists avoided, and indeed were forbidden to depict, the world within the samurai mansions or Edo Castle. When Utamaro designed a triptych showing the military leader Hideyoshi viewing cherry blossom with a retinue of court women, he was sentenced to fifty days in handcuffs – in spite of the fact that the events depicted had occurred two centuries earlier! But the ban did not work so effectively in the other direction and many talented samurai were active patrons of and participants in popular 'floating world' culture. The artist Hosoda Eishi (1756–1829), scion of a high-ranking military family who had studied painting alongside the future Shogun Ieharu, dropped out of his official duties in the 1780s to pursue a successful career as a painter and printmaker of Yoshiwara courtesans (no. 197). In one of the few instances in which the circumstances surrounding the commissioning of an Ukiyo-e painting are known it was none other than a feudal lord, Mizoguchi Naoyasu, who

in 1781 commanded Kitao Shigemasa (1739–1820) to paint a hanging scroll showing a geisha who had taken his fancy to hang on the wall of his study 'as the companion of my heart . . .' It was groups of samurai patrons, too, who sponsored the first full-colour 'brocade' prints designed by Harunobu in 1765 (no. 209); and the *kyōka* poetry clubs, who commissioned lavish colour-printed albums from the publisher Tsutaya during the late 1780s and early 90s, were often dominated by samurai members.

However, although many individual members of the ruling class were tempted by the pleasures of the 'floating world', the official attitude of the shogunal government towards Ukiyo-e was generally hostile. In the Kyōhō (1720), Kansei (1787–93) and Tempō (1841–3) reforms, during which the government sought to limit what they saw as the luxurious excesses of popular culture and redefine the social demarcation between samurai and commoner, laws were passed limiting the lavishness of colour printing and attempting to restrict subject-matter. The Tempō reforms were particularly Draconian and succeeded in stopping colour-print production altogether in Osaka for a period of five years from 1842 to 1847:

To make woodblock prints of Kabuki actors, courtesans and geisha is detrimental to public morals. Henceforth the publication of new works [of this kind] as well as the sale of previously procured stocks is strictly forbidden. In future you are to select designs that are based on loyalty and filial piety and which serve to educate women and children and you must ensure that they are not luxurious.

(Quoted from Akai Tatsurō, 'The Common People and Painting' (trans. by T. Clark), in Nakane Chie and Ōishi Shinzaburō (eds), *Tokugawa Japan*, Tokyo, forthcoming)

The penalties for contravening such regulations were often severe. When Kyōden and his publisher Tsutaya were judged to have broken laws promulgated during the Kansei reforms, as in the case of Utamaro above, the author was handcuffed for fifty days and Tsutaya had half his assets seized. The military government was able to use the threat of such punishment to operate a system of self-censorship, administered by the publisher's guild: almost all single-sheet prints produced after 1791 bear the official seal of some kind of government-appointed censor. Political censorship of this kind is thus another important factor which must be taken into account when considering the seeming reluctance of Ukiyo-e artists to depict anything of the darker side of urban life.

Mitate-e ('parody pictures')

One subtle but important way in which Ukiyo-e artists could cock a snook at traditional culture was to use the weapon of parody. From the earliest period of Ukiyo-e printmaking in the late seventeenth century there are examples by Sugimura Jihei (dates unknown) of *mitate-e* (which can be loosely translated as 'parody picture') in which the artist reworked traditional painting themes in a modern guise (no. 204). The range of themes suitable for use in this way was expanded and codified by Okumura Masanobu (1686–1764), and the British Museum's collection includes a rare early album from *c.* 1710 in which there are fairly scurrilous images of courtesans of the day exchanging clothes with the Buddha or entertaining ancient Chinese holy men in their boudoirs (no. 226). In a preface to a similar album the publisher explains what Masanobu was up to:

The painting of a falcon by Emperor Huizong [of the Northern Song, 1082–1135] and Lin Huoqing in the plum-tree orchard [a typical Kanō school subject] are certainly grand, but may be too classic for the present day. When I showed such old paintings to Okumura Masanobu and asked him how he would treat such old subjects in a modern Ukiyo way, he lost no time in making these drawings . . .

(Quoted from Helen C. Gunsaulus, *The Clarence Buckingham Collection of Japanese Prints, vol. 1: The Primitives*, Chicago Art Institute, Chicago, 1955, p. 121)

As with many parodies, there is the desire to emulate mixed in with the intent to poke fun; the desire to show that one had taken classical culture and made it one's own. Parody was a means of stressing the new-found cultural confidence of the urban classes when confronted with the august weight of artistic masterpieces and styles of the past. There may also be a desire to associate with courtly culture of a period when the warrior government had not yet fully developed. Later parodies are of varying kinds: subtle visual games in which the reference to the past is discreetly hidden, as in the case of Harunobu's prints (no. 209); or increasingly stereotyped depictions of courtesans in the guise of a deity or a character from history or legend, in which there is little significance remaining in the parallel drawn with the past and simply a wish to show the figure in an interesting compositional setting.

Conclusion

Ukiyo-e art was very directly moulded by the nature of the feudal society around it: the peculiar hothouse environment of the city of Edo nurtured exotic blooms. The only avenue of self-expression and self-affirmation open to the wealthy merchant class was the creation of a brilliant culture of performance, display and consumption, within the limits allowed by the military government. These were the arenas of pleasure in the lower-class districts of the city such as the licensed and unlicensed prostitution quarters, Kabuki theatre, fashionable restaurants, boating parties, and the like. This vibrant popular culture in turn attracted many talents and intellects from samurai society, enriching the levels of patronage and taste which were to maintain the aesthetic and technical sophistication, the sense of vitality and constant experimentation in Ukiyo-e art, throughout the two centuries of its development.

190

MORITOSHI (dates unknown)

190 Courtesan in a white kimono

c. Kambun era (1661–73)
Signature: (in gold) Moritoshi hitsu ('the brush of
Moritoshi'); *seal*: Moritoshi
Hanging scroll; ink, colour and gold on paper;
853 × 311 mm
Provenance: Ralph Harari Collection
Published: Hillier 1970, vol. 1, no. 9; *Ukiyo-e taikan* 1
(1987), no. 21
1982.7-1.015 (Japanese Painting ADD 700)

A grand courtesan is shown wearing a
white short-sleeved kimono decorated with
an all-over tie-dyed pattern of white circles,
and an azure-blue *obi* with a design of
delicately interlacing tendrils in gold. As if
walking in the formal afternoon parade in
the pleasure quarter, she has her left hand
placed on her hip inside the kimono so as to
fan out the sleeve in display. With her right
hand she pulls up the skirt at the front, and
the simple, flowing outlines of the drapery
suggest the ample curves of her body
underneath. The ends of her long hair have
been swept up and knotted to form the loop
of the *hyōgo-mage* style.

Hanging scrolls of this sort, depicting
single figures of courtesans set against a
plain background, sometimes with a poem
written by the woman herself in elegant
calligraphy above, were painted in large
numbers during the third quarter of the
seventeenth century and are now known as
'Kambun beauties' after the Kambun era
(1661–73). Most of them are thought to have
been produced in Kyoto, showing
courtesans of the Shimabara pleasure
quarter, before the focus of new
developments in popular *ukiyo* ('floating
world') art shifted to the new eastern capital
of Edo (Tokyo).

It is rare for a Kambun beauty painting to
be signed, though nothing is known of the
artist, Moritoshi. Unusual, too, is the degree
of characterisation of the face, in what is
frequently a stereotyped genre, suggesting
that this may be a portrait of a particular
high-ranking Kyoto courtesan.

HISHIKAWA MORONOBU (*c.* 1618–94)

191 Scenes in a theatre tea-house

1685
Signature: Jōkyō ni kinoto ushi fuyu Hishikawa
 Moronobu hitsu ('painted by Hishikawa
 Moronobu in the winter of 1685');
 seal: Moronobu
Handscroll; ink and colour on silk; 315 × 1470 mm
Provenance: William Anderson Collection
Published: Anderson 1886, no. 1710; Narazaki 1975,
 pp. 9–12; *Ukiyo-e taikan* 1 (1987), no. 38
1881.12-10.1710 (Japanese Painting 1375)

The new Ukiyo-e, or 'pictures of the floating
world', of the last quarter of the seventeenth
century differed from earlier genre
paintings in their increasingly narrow
choice of subjects taken from the two main
arenas of urban pleasures. These were the
great licensed pleasure quarters such as
Yoshiwara in Edo, and the Kabuki theatres
and associated tea-houses. The present
fragment, from what may have been a
longer handscroll including on-stage
scenes, shows one of the luxurious theatre
tea-houses (*shibai-jaya*) located near the
main theatres, where actors would meet
their patrons, and young trainee female
impersonators (*onnagata*) would provide
services of homosexual prostitution. In a
parlour room on the right a wealthy
customer is having his shoulder rubbed by a
blind masseur and is being entertained with
saké and music by two young actors; while
in the bed chamber to the left an *onnagata*
relaxes with his client beneath the mosquito
net. The scroll concludes with a view of the
entrance gate to the establishment, where a
distinguished-looking samurai is arriving
with servants bearing expensive gifts for the
actor who has caught his fancy.

A set of seven similar fragments by
Moronobu and his atelier, dated between
1672 and 1689, showing scenes in the
pleasure quarters and Kabuki theatres is in
the collection of the Tokyo National
Museum.

FURTHER READING Narazaki, Muneshige (ed.),
Nikuhitsu ukiyo-e 2: Moronobu, Tokyo, 1982

MATSUNO CHIKANOBU (worked early 18th
century)

192 Standing courtesan

c. 1705–15
Signature: Hakushōken Matsuno Chikanobu kore
 o zu su ('pictured by Hakushōken Matsuno
 Chikanobu'); *seal*: Sen (?)
Hanging scroll; ink and colour on paper;
 750 × 300 mm
Provenance: Arthur Morrison Collection
Published: *Ukiyo-e taikan* 1 (1987), no. 103
1913.5-1.0283 (Japanese Painting 1405). Given by
 Sir W. Gwynne-Evans, Bt

From the so-called 'Kambun beauties'
(no. 190) of the 1660s onwards, one of the
commonest subjects for Ukiyo-e painters
was the single standing figure of a beautiful
woman – often a courtesan – set against a
plain or very simple background. The long,
vertical hanging-scroll format had always
been ideally suited to single standing
figures; but artists of earlier periods had
mostly limited themselves to figures of
religious patriarchs, Buddhist deities, or
Chinese sages.

Chikanobu was one of a number of
painters working contemporary with, and
to a certain degree influenced by, the major
Kaigetsudō school during the early decades
of the eighteenth century. Chikanobu's
women have certain immediately
recognisable characteristics: hair combed
straight back from a sweetly smiling face
with a small upturned mouth, and a
rhythmical, dancing line describing the
outlines of the drapery.

Here the courtesan is shown wearing an
over-kimono decorated with bold
chrysanthemums, a seasonal flower of
autumn, and a sash of brown and blue
swirls tied in front in an ostentatious bow.
This was the traditional signal of a
prostitute. The left sleeve of the
over-kimono has been thrown off to display
the bright red kimono patterned with
snow-covered dwarf bamboo leaves
representing winter.

192

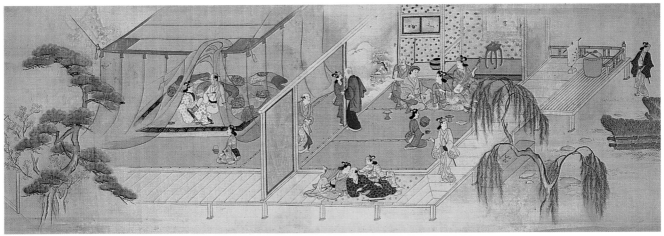

191 detail

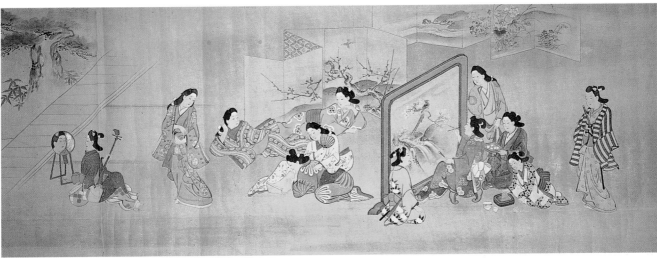

193 detail

MIYAGAWA CHŌSHUN (1682–?1752)

193 Pastimes of the New Year and flower viewing

c. 1720s
Signature: Nihon-e Miyagawa Chōshun zu
 ('picture by the Japanese painter Miyagawa
 Chōshun'); *seal*: Chōshun no in
Pair of handscrolls; ink, colour and gold on paper;
 each *c.* 401 × 5100 mm
Provenance: William Anderson Collection
Published: Anderson 1886, nos 1707 and 1708;
 Ukiyo-e taikan 1 (1987), nos 98–100
1881.12-10.1707, 1708 (Japanese Paintings 1390,
 1391)

Painted scenes of pleasures and pastimes
associated with the various seasons and
months of the year (*shiki fūzoku-e* or
tsukinami fūzoku-e) were popular at least as
early as the courtly Heian period (794–1185);

and although eighteenth-century Ukiyo-e
artists tended to focus mainly on the twin
worlds of the pleasure quarters and Kabuki
theatres, there remained a more basic
market for general depictions of seasonal
events in and around the city of Edo.

Miyagawa Chōshun was one of the major
Ukiyo-e painters of the first half of the
eighteenth century, rather unusual in that
he designed no woodblock prints, albums
or illustrated books. Chōshun's paintings
show the pervasive influence of Hishikawa
Moronobu (*c.* 1618–94) in their style, choice
of subject-matter and formats. Certain
groups of figures, indeed, are copied almost
unchanged from works by the earlier
master.

In the first scroll (illustrated) elegantly
dressed families engage in indoor and

outdoor games and pastimes associated
with the New Year holidays – battlecock and
shuttledore, bouncing ball, backgammon,
cards, painting, etc. – while the second
scroll shows scenes of lively parties and
dancing under the blossoming cherry trees
in the hilly Ueno district in the north of Edo.

Like Moronobu before him, Chōshun was
a master of the arrangement of figures into
lively groups; each figure is economically
drawn with a few calligraphic lines and with
a keen eye to the rich harmonies of kimono
fabrics which, as so often in Ukiyo-e
painting, are the most keenly felt subject of
the whole work. The comparatively large
size of the figures suggests an early date
within Chōshun's career, perhaps the
1720s.

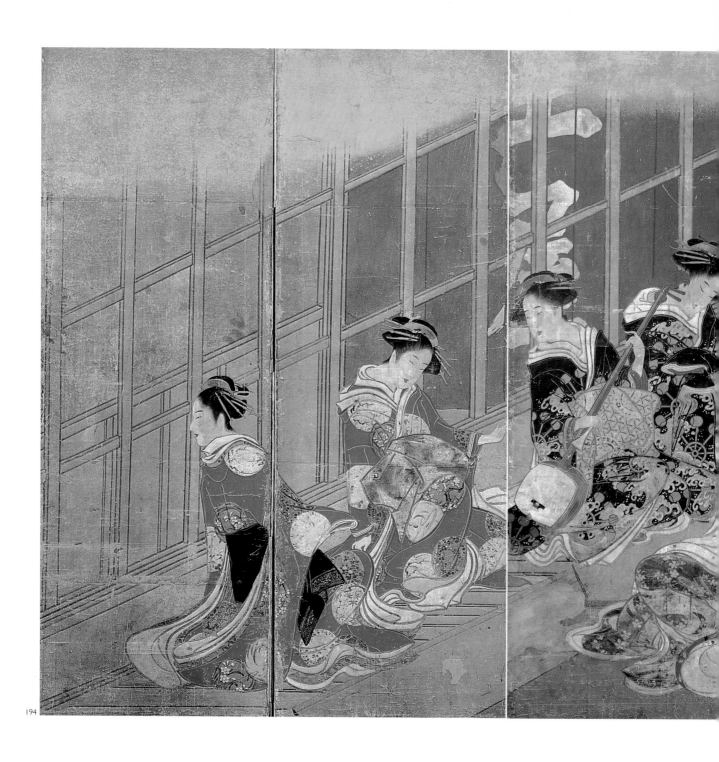

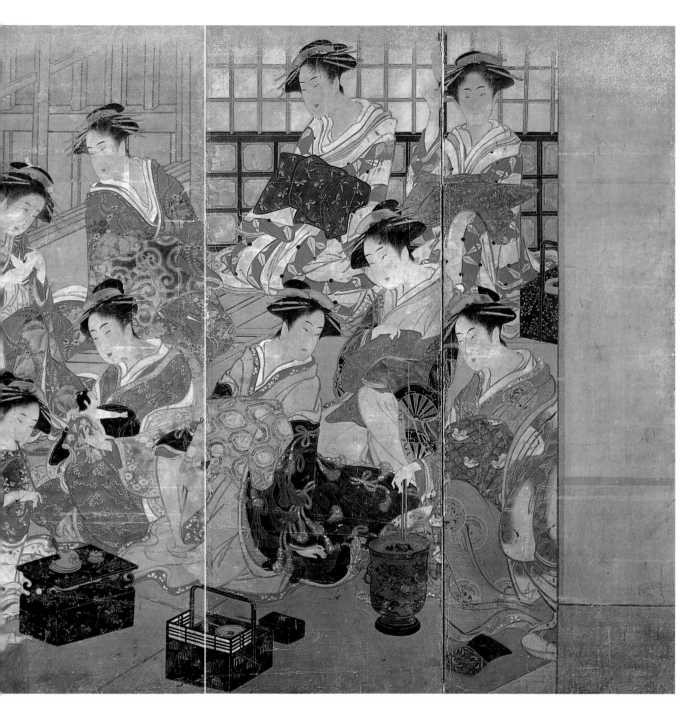

Attributed to UTAGAWA TOYOHARU (1735–1814)

194 Courtesans of the Tamaya house of pleasure

Late 1770s or 1780s
Six-fold screen; ink, colour and gold on paper;
 1441 × 3146 mm
Provenance: Ralph Harari Collection
Published: Hillier 1970, no. 48
1982.7-1.02 (Japanese Painting ADD 687)

Among the daily rituals in the life of courtesans of the Yoshiwara pleasure quarter in Edo (Tokyo) were the hours spent seated, dressed in their gaudy finery in the display room (*harimise*) facing on to the street where prospective clients passed by. This six-fold screen shows a total of thirteen courtesans seated in the display room, with its characteristic latticed windows, through which can be seen the entrance curtain (*noren*) bearing the name of the establishment 'Tamaya' ('Jewel House'). The highest-ranking women are seated on the carpet in the centre of the room with a brazier and smoking-sets on the floor before them. The lower-ranking women, wearing matching kimonos in pairs, are seated around the walls – one making a folded-paper crane, another holding a *shamisen*, and a third even dozing off.

Large Ukiyo-e screens of this type are extremely rare, and no comparable works are known to have survived in Japan. Though unsigned, this example can be dated on the basis of the hairstyles to *c.* 1775–85, and the characteristic manner of drawing the faces suggests an attribution to Utagawa Toyoharu, one of the most prolific painters of beautiful women of the late eighteenth century. Though the facial features conform to an idealised stereotype, Toyoharu has animated the large composition with a lively variety of expressions, poses and gestures.

KITAGAWA UTAMARO (1753–1806)

195 Beauty washing her face

c. 1800
Signature: Utamaro hitsu ('The brush of Utamaro');
 seal: Utamaro
Hanging scroll; ink and colour on silk;
 394 × 549 mm
Published: *Ukiyo-e taikan* 1 (1987), nos 119–20
1965.7-24.04 (Japanese Painting ADD 380).
 C. Maresco Pearce Bequest

In both his prints and paintings Utamaro
was a master at capturing subtle nuances in
the moods of his female subjects. A woman
kneels by a metal basin of water, having
washed her face in preparation to applying
white make-up. Utamaro captures her as
she pauses from drying her face and turns
her head to glance at a potted morning
glory, establishing a moment of arrested
movement as our attention shifts between
her face, the morning glory and the basin of
water. Utamaro uses a similar triangular
composition in several other hanging-scroll
compositions.

There is a much stronger sense of
three-dimensional substance in Utamaro's
paintings than in many of his woodblock
prints. The larger format allows for more
space to surround the figures, and the
intense, saturated pigments suggest more
solid forms than the usually flat, translucent
colours printed from woodblocks.

FURTHER READING Narazaki, Muneshige (ed.),
Nikuhitsu ukiyo-e 6: Utamaro, Tokyo, 1984

195

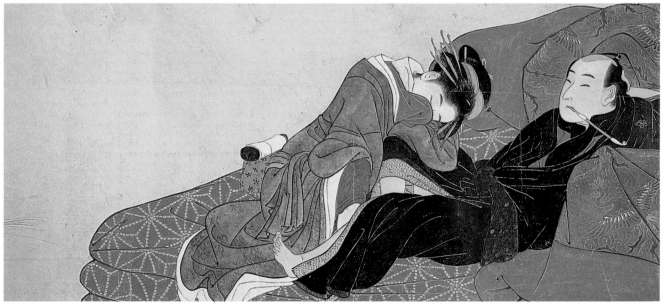

196 detail

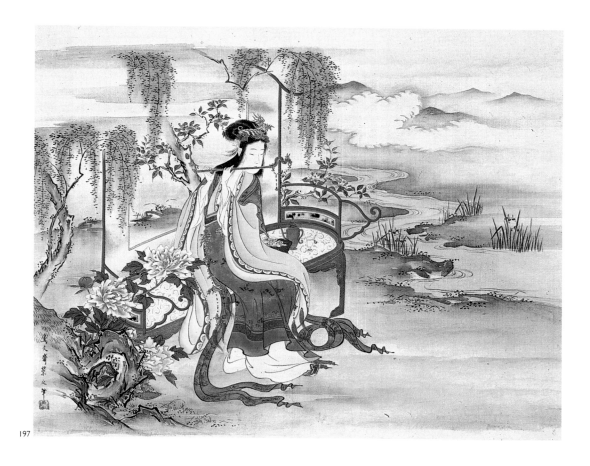

197

Attributed to KATSUKAWA SHUN'EI (1762–1819)

196 Ten scenes of lovemaking

c. 1800–10
Handscroll; ink, colour and mica on paper;
 280 × 6373 mm
1980.3-25.04 (Japanese Painting ADD 615)

Given the importance of the pleasure
quarters in the cultural life of the city of Edo,
it is natural that a significant proportion of
the works by Ukiyo-e artists were erotica,
produced in the suitably discreet formats of
the painted or printed handscroll, album or
illustrated book. It is necessary to our
understanding of the sensuality inherent in
many non-erotic prints and paintings of
women to be aware of this aspect of
Ukiyo-e.

Though this handscroll is unsigned,
the racing dry brushwork and certain
mannerisms of the drawing of the faces
(particularly the sensuous long eyelashes)
suggest an attribution to Katsukawa
Shun'ei, who designed actor prints during
the 1780s and 90s, as well as a small number
of paintings of women remarkable for the
unusually wide range of emotions
portrayed. In these scenes of lovemaking
the artist is at pains to break away from
stereotyped settings and poses and he
shows a wide variety of expressions of
shared ecstasy.

The most monumental composition

among the ten shows a customer wearing a
black kimono leaning back against a pile of
scarlet bed quilts, casually smoking a pipe.
The sleepy courtesan presses up against his
knee, her hand tucked up inside her red
under-robe to cover her face.

Erotic scenes generally formed a sequence
of twelve, so one of the two scenes missing
from this handscroll may have included the
signature and seal of the artist.

FURTHER READING Evans, Tom and Mary Anne,
Shunga: The Art of Love in Japan, London, 1975

HOSODA EISHI (1756–1829)

197 Yang Guifei, the Chinese femme-fatale

c. 1800–20
Signature: Chōbunsai Eishi hitsu ('the brush of
 Chōbunsai Eishi'); *seal*: Eishi
Hanging scroll; ink, colours and gold on silk;
 439 × 603 mm
Provenance: Arthur Morrison Collection
Published: Tokyo National Museum 1987, no. 24;
 Ukiyo-e taikan 1 (1987), no. 126
1913.5-1.0405 (Japanese Painting 1424). Given by
 Sir W. Gwynne-Evans, Bt

Yang Guifei was the fabulously beautiful
consort of the Tang Emperor Xuanzong

(AD 685–762). At his command, the poet Li
Bai composed poems likening her beauty to
the peony, most prestigious of flowers, and
comparing her to female deities and
immortals. As the archetypal exotic Chinese
beauty, Yang Guifei was a popular subject
for Japanese Ukiyo-e painters and
printmakers, and Eishi himself painted her
many times, on occasion comparing her
with the fabled Japanese court beauty Ono
no Komachi. In compositions by other
artists Yang Guifei is shown playing the
flute with Emperor Xuanzong, but here
Eishi – perhaps taking his idea from Li Bai's
poem likening her to female mountain
hermits – has seated her alone on a
Chinese-style throne set amid trees and
flowers in an otherwise open mountain
landscape.

Eishi was unusual among Ukiyo-e
painters in that he was of noble samurai
birth and began his artistic career as a pupil
of Kanō school artist Eisen-in Norinobu
(1730–90), the leading academic painter in
attendance to the shogun. This early Kanō
training is clearly apparent in the ink-wash
technique used here in the landscape, and,
combined with Eishi's hyper-refined figure
drawing, produces a work with an
exceptionally rich range of tonalities.

FURTHER READING Brandt, Klaus, J., *Hosoda Eishi,*
Stuttgart, 1977

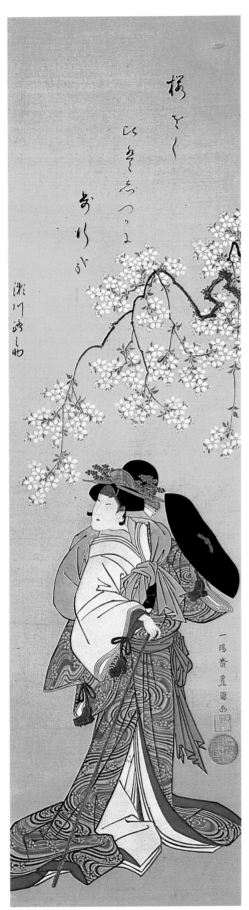

198

UTAGAWA TOYOKUNI (1769–1825)

198 The Kabuki actor Segawa Ronosuke in a female role

Between 1801 and 1807 (?1803)
Signature: Ichiyōsai Toyokuni ga ('painted by
 Ichiyōsai Toyokuni'); *seals*: Ichiyōsai, Toyokuni
Hanging scroll; ink and colour on silk;
 938 × 255 mm
Provenance: Arthur Morrison Collection
Published: Morrison 1911, pl. xxiv; *Ukiyo-e taikan* 1
 (1987), no. 134
1913.5-1.0399 (Japanese Painting 1439). Given by
 Sir W. Gwynne-Evans, Bt

Standing beneath branches of pale pink
cherry in full bloom, the young actor
Segawa Ronosuke (who used this name
from 1801 to 1807) is dressed for travelling.
The female character he plays has a bundle
tied around her shoulders and carries a
large, flat black lacquer hat and a long
walking-stick. The over-kimono, one
sleeve of which has been shrugged off to
accommodate the bundle, is decorated with
a dazzling pattern of yellow blossoms
scattered on stylised flowing water.

A short *haiku* poem, probably composed
and written by the actor himself, is inscribed
in elegantly scattered lines of calligraphy at
the top of the painting:

Sakura saku	In the season of
Koro wa shizuka in	Blossoming cherry
Hokō kana	Why not proceed more slowly?

Aside from the obvious invitation to linger
on one's travels and admire the blossoming
cherry, the poem contains a punning
allusion to the name of Princess Shizuka,
who is probably the character being
portrayed here by Ronosuke. Shizuka's
flight to Mount Yoshino, famous for its
cherry trees, was one of the most poignant
scenes in the play *Yoshitsune Sembon-zakura*
('Yoshitsune and the Yoshino Cherry
Trees'), and Shizuka a role particularly
associated with Ronosuke's great
predecessor, Segawa Kikunojō iii.
Ronosuke is recorded as having played the
role of Shizuka only once – at the Ichimura
theatre in the eighth month of 1803 – and it
is likely that this is the performance
Toyokuni has painted.

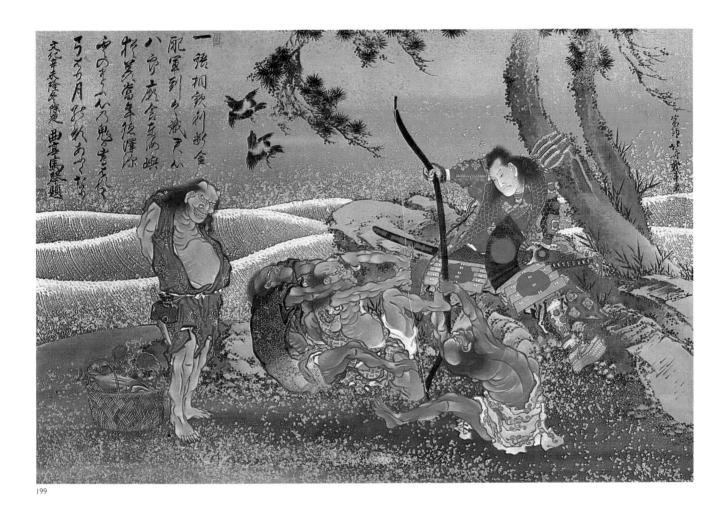

199

KATSUSHIKA HOKUSAI (1760–1849)

199 Tametomo and the Demons

1811
Signature: Katsushika Hokusai Taitō ga ('painted
 by Katsushika Hokusai Taitō'); *seal*: Raishin
Inscribed: Takizawa Bakin (1767–1848)
Hanging scroll; ink, colour and gold on silk;
 549 × 821 mm
Provenance: Box inscription by Hirabayashi
 Shōgorō III, dated 1854; William Anderson
 Collection
Published: Anderson 1886, no. 1747; Gray 1948,
 no. 162; Ueno 1985, no. 166; Tokyo National
 Museum 1987, no. 25; *Ukiyo-e Taikan* 1 (1987),
 no. 140; Smith 1988, no. 166
1881.12-10.1747 (Japanese Painting 1479)

During a long life of artistic activity that
spanned some seven decades, Hokusai

managed to pursue several careers as an
innovative painter, printmaker and book
illustrator, any one of which would have
been the envy of lesser men. The period
1804–15 found him collaborating with
popular authors such as Takizawa Bakin
(1767–1848) in the production of a
succession of illustrated serial novels
(*yomihon*) in which eye-catching illustrations
were just as important as the action-filled
text.

In the spring of 1811, to mark the
profitable completion of one such novel, the
twenty-nine-volume *Chinsetsu yumihari-zuki*
issued over a period of years since 1807,
the publisher Hirabayashi Shōgorō
commissioned Hokusai to execute this scroll
showing the scene in the novel where the

hero Tametomo demonstrates his strength
to the demons of Onoshima Island. The
painting was then inscribed by Bakin on
New Year's Eve at the end of the same year.

It is impossible to categorise a painting by
Hokusai such as this as being in the style of
any one particular school. The rugged ink
outlines of the rocks and trees may be
described as in academic Kanō style but
have about them a much more animated
sense of windswept movement than most
Kanō painters were capable of. The figures
demonstrate Hokusai's skill at the subtle
layering and modulation of pigments, as
well as a painstaking attention to fine details
of patterns and textures. Every single line
and dot of the painting is imbued with his
tremendous vitality.

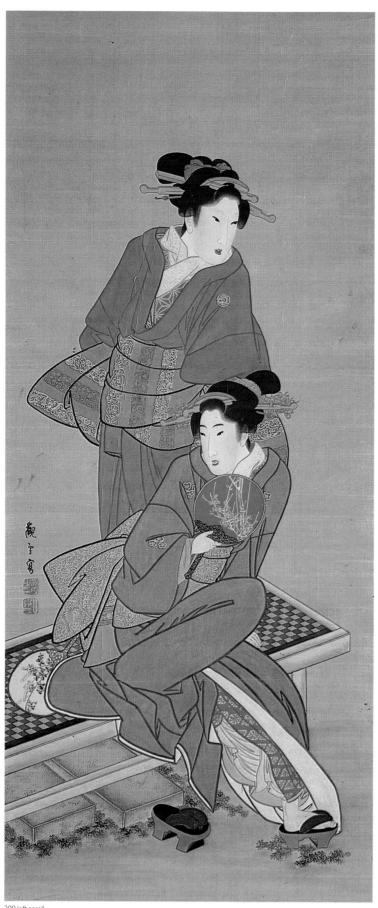

200 left scroll

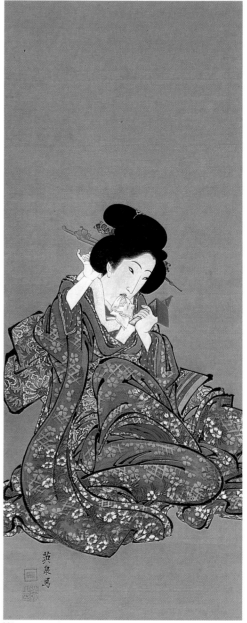

201

KITAGAWA TSUKIMARO (worked *c.* 1794–1836)

200 Geisha

c. 1820s
Signature: Kansetsu sha ('painted by Kansetsu');
 seals: Kansetsu no in, Shisen-uji
Pair of hanging scrolls; ink, colour and gold on
 silk; 1264 × 548 mm (left), 1187 × 533 mm (right)
Provenance: William Anderson Collection
Published: Anderson 1886, nos 2311, 2312; *Ukiyo-e
 taikan* 1 (1987), nos 121, 122
1881.12-10.2311, 2312 (Japanese Paintings 2632,
 2633)

Though originally mounted with different
brocade surrounds and of slightly different
sizes, these two hanging scrolls seem
nevertheless to form a pair of scenes of
geisha indoors and out. This is further

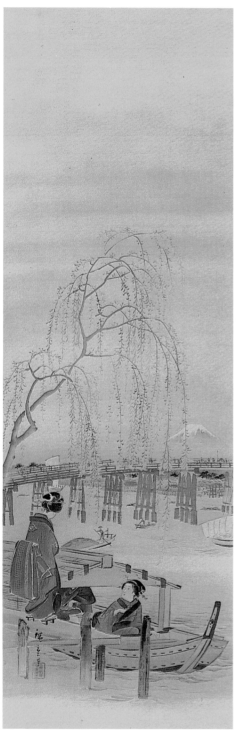

202 left scroll

borne out by the complementary poses: the two standing figures leaning in towards one another and the two seated women facing outwards in *contraposto*. The colour schemes of the two paintings are similar, too – each with kimonos of plain purple and green set off by florid accessories, sashes and undergarments, in the characteristic fashions of the Bunsei era (1818–30). In the indoor scene the standing woman carries a finely worked metal saké kettle on a stand, while her seated companion leans on a similarly elaborate metal tobacco pipe. In the outdoor scroll (illustrated) the young geisha is seated on a garden seat, and both women have fans, suggesting summer. The standing woman has shaved her eyebrows and blackened her teeth, indicating that she is married.

Early in his career Tsukimaro designed woodblock prints in the manner of Utamaro, but from about 1820 onwards he concentrated on large, finely executed paintings of beauties in a style showing the influence of the Kyoto Maruyama/Shijō school. These bear the signature Kansetsu.

FURTHER READING Narazaki, Muneshige, 'Kitagawa Tsukimaro no nikuhitsu ukiyo-e ni tsuite', *Kokka* 1096 (August 1986), pp. 40–50

KEISAI EISEN (1791–1848)

201 Beauty rearranging her hair

c. 1820s
Signature: Eisen sha ('painted by Eisen'); *seals*:
 Keisai, Eisen no in
Hanging scroll; ink and colour on silk;
 851 × 340 mm
Provenance: Ralph Harari Collection
Published: Hillier 1970, no. 90; *Ukiyo-e Taikan* 1
 (1987), no. 139
1982.7-1.018 (Japanese Painting ADD 703)

A young woman, probably the daughter of a well-to-do merchant family, is seated looking into her pocket mirror to rearrange her hairstyle, and the paper tissue held in her teeth suggests that she has corrected her make-up as well. Her knees are crossed in her lap in the ungainly manner of a still-awkward teenage girl.

Eisen's treatment of her costume is a *tour de force* of dark, rapid brush ink outlines and rich, gaudy patterning. Particularly astonishing is the handling of the transparent gauze over-kimono painted with flowering pinks, through which can be seen the scarlet under-kimono decorated with a more stylised design of cherry blossoms against a wicker fence. The broad *obi* is of a bold blue and white floral brocade,

with gold threads worked into the background.

The rich, almost overripe style of nineteenth-century Ukiyo-e paintings and prints has often in the past been described as 'decadent'. Certainly, many nineteenth-century images of women have little of the balance and restraint of, say, a late eighteenth-century Harunobu or Kiyonaga print, assaulting the viewer in a more directly passionate way. They are representative products of the last and most highly wrought phase of Edo culture.

UTAGAWA HIROSHIGE II (1826–69)

202 Beauties beside the Sumida River

c. 1860–5
Signature: Hiroshige hitsu ('the brush of
 Hiroshige'); *seal*: Nisei Ichiryūsai Hiroshige gain
Pair of hanging scrolls; ink and colours on silk;
 each 888 × 298 mm
Provenance: Arthur Morrison Collection
Published: *Ukiyo-e taikan* 1 (1987), nos 165, 166
1913.5-1.0298, 0299 (Japanese Painting 1554, 1555).
 Given by Sir W. Gwynne-Evans, Bt

The Sumida River, the main river in the city of Edo (modern Tokyo), passed through the neighbourhoods where the merchant and artisan classes lived, the 'low city' (*shitamachi*), as distinct from the more elevated Yamanote district inhabited by the feudal aristocracy and samurai classes. Apart from a few riverside villas and various government buildings such as boathouses and rice granaries, the river was given over largely for the enjoyment of commoners and samurai alike. In this pair of views of the river in spring and early summer geisha are shown enjoying the blossoming cherry trees which clustered along the embankment near Mimeguri shrine (right), and preparing for a trip with a client in a covered boat at a landing-stage near Ryōgoku Bridge, under the fresh green hanging branches of a willow tree (left, illustrated).

The style of the paintings – soft wash landscapes with accents of stronger colour to the figures – is a faithful continuation of the techniques perfected by Hiroshige I (1797–1858). In fact, the compositions are copied from two designs in Hiroshige I's last print series, *Thirty-six Views of Mount Fuji* (no. 223), with slight modifications being made to suit the hanging-scroll format. Though the size of Mount Fuji has been exaggerated for artistic effect, the sacred peak could still be seen from the city of Edo in the era before industrial pollution, and still can today after a high wind.

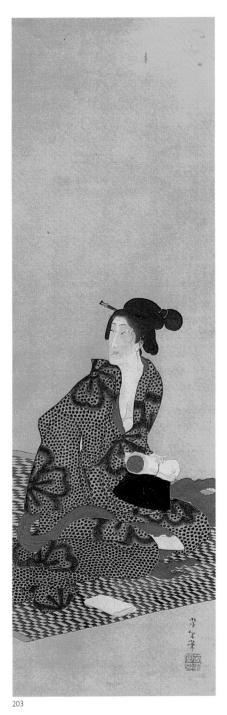

203

TSUKIOKA YOSHITOSHI (1839–92)

203 Courtesan with a pillow

c. 1865–70
Signature: Yoshitoshi hitsu ('the brush of
 Yoshitoshi'); *seal*: Yoshitoshi no in
Hanging scroll; ink and colour on silk;
 957 × 300 mm
Provenance: William Anderson Collection
Published: Anderson 1886, no. 1754; *Ukiyo-e taikan* 1
 (1987), no. 182
1881.12-10.1754 (Japanese Painting 1588)

In this erotically charged painting
Yoshitoshi shows a courtesan kneeling on a
thin summer quilt. She holds a round,
padded pillow on a black lacquer stand held
in her lap. She has already untied the long
scarlet crepe silk sash, which lies scattered
around her, and is pulling her arm from the
sleeve of her tie-dyed blue and white robe.
Her face is flushed, and a few stray strands
trail down from an otherwise stiff hair
arrangement. Her gaze is perhaps fixed on
the customer.

 Even compared with the sensuality of
Kunisada and Eisen, Yoshitoshi's painting
is remarkably candid. A sense of arrested
movement is conveyed by the informality of
the pose and the piercing glance, and a
nervous visual excitement created by the
vivid blue dots of the robe and the black
diamond weave of the quilt. The
characteristic drawing of the face with a
long aquiline nose and jutting lower lip is
found in all artists of the Utagawa school,
Yoshitoshi's teacher Utagawa Kuniyoshi
(1797–1861) included.

FURTHER READING Keyes, Roger, and Kuwayama,
George, *The Bizarre Imagery of Yoshitoshi*, Los
Angeles, County Museum of Art, 1980

Attributed to SUGIMURA JIHEI
(worked *c.* 1680–1705)

204 *Fushimi Tokiwa*
('Tokiwa at Fushimi')

c. 1690
Publisher: unknown
Woodblock print with slight hand-colouring;
 560 × 305 mm
Published: Ueno 1985, no. 3; *Ukiyo-e taikan* 2 (1987),
 no. 2; Smith 1988, no. 3
1968.10-14.2

Tokiwa Gozen, mistress of the warrior
Minamoto no Yoshitomo, fled with her
three sons after Yoshitomo's defeat in the
Heiji war of 1159. At Fushimi they were
offered refuge from a violent snowstorm by
a humble elderly couple. By the end of the
seventeenth century this touching scene
had entered the repertoire of popular ballad

204

singers (*sekkyō jōruri*), and this large print
may in fact have been used to illustrate such
a public recitation. Tokiwa is dressed not in
historical costume but in a fashionable
kimono of the day.

 Large prints from the end of the
seventeenth century by Sugimura and his
contemporary Hishikawa Moronobu
(*c.* 1618–94) are extremely rare, and this may
be the only impression of this handsome
design to have survived.

KAIGETSUDŌ ANCHI (worked early 18th century)

205 Courtesan

c. 1710–20
Signature: Nihon giga Kaigetsu matsuyō Anchi zu
 ('a Japanese painting done for pleasure by
 Anchi, of the Kaigetsudō line'); *seal*: Anchi
Publisher: Maruya, Edo
Woodblock print; 590 × 319 mm
Provenance: W. B. Paterson
Published: Binyon 1916, p. 3; *Ukiyo-e shūka* 11
 (1979), no. 219; Royal Academy of Arts 1981,
 no. 99; Ueno 1985, no. 6; *Ukiyo-e taikan* 2 (1987),
 no. 1; Smith 1988, no. 5
1910.4-18.175

The Kaigetsudō group of artists, specialising
in paintings and large-format prints of

205

FURTHER READING Lane, Richard, *Kaigetsudō*, Kōdansha Library of Japanese Art, vol. 13, Tokyo, 1959

TORII KIYOMASU (worked *c.* 1700–20)

206 The actors Ōtani Hiroji (left) and Ichikawa Danzō (right) in an 'armour-tugging' (*kusazuri-biki*) scene

1717
Signature: Torii Kiyomasu; *seal*: Kiyomasu
Publisher: Sagamiya Yohei, of Yushima Tenjin, Edo
Woodblock print with hand-colouring;
 525 × 315 mm
Provenance: Arthur Morrison Collection
Published: Binyon 1916, p. 9; *Ukiyo-e shūka* 11
 (1979) no. 16; Ueno 1985, no. 13; *Ukiyo-e taikan* 2
 (1987), no. 4; Smith 1988, no. 13
1906.12-20.18

The 'Armour-tugging' episode, originally a trial of strength between the characters Soga no Gorō and Kobayashi Asahina, was a scene often inserted into other, unrelated Kabuki plays. Actor critiques of 1717 describe how it was due to be performed 'underwater' in the play 'The Battle of Coxinga' (*Kokusenya gassen*) at the Ichimura theatre that summer. A large signboard was painted to hang outside the theatre, but then the scene was cancelled at the last moment. This large print, showing Hiroji bursting out through the side of a boat to grasp Danzō's armour, may well have been based on that (now lost) signboard, since Torii artists were responsible for designing them as well as prints and illustrated programmes.

The exaggerated, muscular drawing style of the early Torii artists was aptly described by a later Japanese critic as 'gourd-shaped legs and wriggling worm line' and was admirably suited to capturing the 'rough stuff' (*aragoto*) acting style of Edo. The print is enlivened with bold orange lead pigment (*tan*) applied by hand.

single standing figures of high-ranking Edo courtesans, formed a close-knit atelier under the painter Kaigetsudō Ando. Nothing is known of their biographies, except that Ando was banished to islands off the Izu peninsula as a result of the famous scandal involving Lady Ejima in 1714. Anchi was perhaps the principal student of Ando, since he is the only one of the group to share the 'An' character of his teacher's name. He seems to have had a special relationship with the publisher Maruya, who issued six of Anchi's eight known designs (and nothing else). As is the case with other Kaigetsudō pupils, many more paintings have survived by Anchi than the small number of prints. This may be due to the high attrition rate of early prints in general, or else suggests that printmaking was a minor sideline. In any event, Kaigetsudō prints and paintings are always in a very similar style: broad, calligraphic outlines to describe the robes contrasted with small, delicate facial features. No other impression of the print is known.

206

207

NISHIMURA SHIGENAGA (?–1756)

207 The actor Sanjō Kantarō as a tea-seller

c. 1720–30
Signature: Nihon gakō Nishimura Shigenaga hitsu
 ('the brush of the Japanese painter Nishimura
 Shigenaga'); *seal:* Shige
Publisher: Igaya, of Motohama-chō, Edo
Woodblock print with hand-colouring;
 328 × 159 mm
Provenance: Arthur Morrison Collection
Published: Hillier 1966, no. 6; Ueno 1985, no. 31;
 Smith 1988, no. 31
1906.12-20.49

Sanjō Kantarō here plays the Kabuki role of
a fashionably dressed woman who sells Uji
tea from her portable stall, in which the
necessary brazier, kettle, tea jar, water pot
and cups, etc., have all been carefully
delineated. The hand-colouring of this
specimen is particularly rich and sensitive –
dominated by hues of red, pink and purple
– and is further enlivened by glossy glue
applied to the black over-kimono (in

208

imitation of black lacquer) and sprinklings
of brass dust on the *obi* ('sash'), butterfly
crest on the sleeve, and lid of the kettle.

Kantarō has slipped off the right sleeve of
the over-kimono to display a wave- and
chrysanthemum-pattern kimono
underneath, and his elegantly arched
eyebrows and cocked little finger suggest
the role of some celebrated beauty in
humble disguise.

OKUMURA MASANOBU (?1686–1764)

208 Two geisha and a boy carrying a *shamisen* case

1756
Signature: Hōgetsudō Tanchōsai Okumura
 Bunkaku Masanobu ga ('painted by . . .');
 seals: Tanchōsai, Masanobu
Two-colour woodblock print; 423 × 302 mm
Provenance: Fine Art Society, London
Published: Morrison 1909, no. 26; Binyon 1916,
 p. 22; Ueno 1985, no. 29; *Ukiyo-e taikan* 2 (1987),
 no. 16; Smith 1988, no. 29
1910.6-14.1

Two geisha scrutinise a playbill for the
Nakamura theatre for the season 1755–6 as
they make their way to perform at a New
Year party, accompanied by a servant boy
carrying a *shamisen* in its case. The comic
senryū poem written above suggests that the
women are more interested in sneaking off
to the theatre than attending to their work:

Hikizome ya	First tune of the year;
Omou shibai e	Stealing off to the theatre we adore;
Shinobi-goma	Mute on the *shamisen*!

Many of the most attractive mid-
eighteenth-century prints show a group of
large, ample figures set against a plain
background in this way. Though only two
printed colours are used – pink and green –
the complex patterns, overprinting and use
of the white of the paper combine to suggest
a much richer palette.

FURTHER READING Vergez, Robert, *Early Ukiyo-e
Master: Okumura Masanobu*, Tokyo, 1983

SUZUKI HARUNOBU (1724–70)

209 Hunting for insects

c. 1767–8
Signature: Suzuki Harunobu ga ('painted by
 Suzuki Harunobu')
Colour woodblock print; 261 × 194 mm
Provenance: Oscar Raphael Collection
Published: Morrison 1910, no. 67; Joly and Tomita
 1916, no. 21; Waterhouse 1964, no. 49; *Ukiyo-e
 shūka* 11 (1979), no. 22
1945.11-1.08

Against a jet-black night sky, lovers are
shown hunting for insects. The young man,
wearing a striped brown kimono, has
placed a small cage ready on the ground
beside him and is kneeling down to examine
a branch of flowering bushclover (*hagi*). His
companion, dressed in an elegant kimono
with a pattern of flowering morning glory
(*asagao*), holds out a lantern above his head.
The black background must have been

printed several times to achieve such
intensity and creates a setting of gently
enveloping stillness, as the lovers exchange
an intimate glance. In many of Harunobu's
prints there are conscious echoes of the
world of courtly romance of the distant
Heian period (794–1185), and this design
too may be intended as an oblique reference
to the insect-hunting scene in 'The Tale of
Genji', chapter 25.

 Techniques of full-colour printing were
only a few years old when this print was
issued. Yet the public must have been
astonished and delighted by the
sophistication of its colour harmonies and
the delicacy of Harunobu's figures, with
their small sweet faces and tiny gesturing
hands.

FURTHER READING Waterhouse, David, *Harunobu
and his Age*, London, 1964

209

210

211

KATSUKAWA SHUNSHŌ (1726–2)

210 The actor Ichikawa Danjūrō V as Fudō Myō-Ō

11th month, 1780
Signature: Shunshō ga ('painted by Shunshō')
Colour woodblock print; 328 × 151 mm
Provenance: Ernest Hart Collection
Published: Binyon 1916, pp. 78–9; *Ukiyo-e taikan* 2
.(1987), no. 87
1902.2-12.202

Shunshō revolutionised the portrayal of
Kabuki actors during the later 1760s by
designing prints which for the first time
captured an actual likeness (*nigao-e*) of the
actors' facial features. Such a talent is made
startlingly apparent in this print, where the
immediately recognisable long nose, large
downturned mouth and small, wide-set
eyes of Danjūrō v have been 'superimposed'
on to a statue-like figure of the ferocious
Buddhist deity Fudō Myō-Ō (Acala). Fudō
Myō-Ō was regarded as the tutelary deity of
the leading Ichikawa Danjūrō line of actors,

and had been portrayed on stage by the
family since the times of Ichikawa Danjūrō I
(1660–1704).

Danjūrō v played this part four times in
his career, and this print is thought to have
been issued to commemorate the last
occasion, a tremendously popular scene,
'The stone statue of Fudō' (*Sekizō no Fudō*),
in the play *Kite kaeru nishiki no wakayaka*,
the opening-of-the-season (*kaomise*)
performance at the Nakamura theatre in the
eleventh month of 1780. The deity is shown
standing on a rock in a waterfall,
surrounded by flames, holding a sword to
quell evil and rope to snare wrongdoers.

TORII KIYONAGA (1752–1815)

211 A girl dancing with shell clappers under her feet

c. 1784
Series: *Fūryū mitsu no koma* ('A Fashionable
Presentation of Three Young Ponies')
Signature: Kiyonaga ga ('painted by Kiyonaga')
Colour woodblock print; 382 × 248 mm
Provenance: S. Katō
Published: *Ukiyo-e shūka* 11 (1979), no. 37
1924.3-11.01

A small girl, wearing a kimono decorated
with the lucky treasure pattern, is clomping
around on half clam-shell 'hooves', held in

212

place beneath her feet by silk cords which
she pulls up taut with her hands. Musical
accompaniment on the *shamisen* is provided
by one of a group of four women who form
an admiring, and doubtless indulgent,
audience. The other design known from the
series shows a little boy on a hobby horse,
hence the title.

In the mid-1780s Kiyonaga's figure style
reached the height of its elegance. Here the
four women are grouped into a cascade of
suave, relaxed poses; fluid, tapering lines
describe the impossibly long sleeves of their
kimonos.

The present autumnal colours of the print
are somewhat deceptive, for the kimono of
the tallest woman has faded from its original
bright purple to a delicate tan.

FURTHER READING Hirano, Chie, *Kiyonaga: A Study
of his life and works*, Cambridge, Mass., 1939

KUBO SHUMMAN (1757–1820)

212 A party in Shikian ('Four
Seasons') restaurant at Nakazu

c. 1786
Signature: Kubo Shumman ga ('painted by Kubo
 Shumman'); *seals*: Shumman (right) and
 Shumman ga (left)
Publisher: Shūeidō, Edo
Colour woodblock prints (diptych);
 each *c.* 360 × 250 mm
Provenance: R. N. Shaw Collection
Published: *Ukiyo-e shūka* 11 (1979), nos 56, 57; Ueno
 1985, no. 110; Smith 1988, no. 110
1924.3-27.09 (1, 2)

Shikian ('Four Seasons') restaurant was
among the most fashionable and exclusive
in Edo, doubtless due to its prime riverside
location on the corner of the Nakazu
entertainment district, a small area of
reclaimed land projecting from the banks of

the Sumida River. Every evening in summer
the river off Nakazu would be clogged with
a flotilla of pleasure boats and barges
assembled to enjoy the firework displays,
vaudeville theatre, fine restaurants and
unlicensed brothels there.

Here Shumman takes an unusual oblique
view across the corner of the Shikian so that
he can take in both the lively party scene
and the river behind, with views of
Fukagawa on the far bank. The poses of the
figures all suggest relaxed intimacy: a
couple holding hands as he leans on the
pillar; the other seated couple playing a
hand game; the pair of geisha tuning up
their *shamisen*; the waitress bringing in
another tray laden with raw fish. The
colours of the print are still wonderfully
vivid, with only the pale blue used for the
water having faded.

213

214

KITAGAWA UTAMARO (1754–1806)

2 | 3 Half-length portrait of Ohisa of the Takashimaya tea-shop

c. 1792–3
Signature: Utamaro hitsu ('the brush of Utamaro')
Published: Tsutaya Jūsaburō, Edo
Colour woodblock print with mica background;
 376 × 247 mm
Provenance: R. N. Shaw Collection
Published: Hillier 1961, pl. IX; Ueno 1985, no. 89;
 Smith 1988, no. 89
1927.6-13.6

Ohisa was the beautiful daughter of the proprietor of a chain of cake shops and tea-houses, the Takashimaya. She acted as a draw-girl in the teà-houses, where she was discovered and taken up as the subject of colour prints by several Ukiyo-e artists during the 1790s.

In the early 1790s Utamaro and his publisher Tsutaya introduced the innovation of half-length portraits of beautiful women set against a background of silvery-white ground mica. Ohisa is shown in a turning pose, her fan held as if her intelligent gaze has just fixed on someone outside the picture. She wears a thin black gauze kimono decorated with yellow and white resist-dyed flashes, over a pink under-kimono, the collar pulled back to show off her neck. The first line of the comic poem by Karabana Tadaaya printed above may be translated: 'Though love and tea are overflowing, neither grows cold.'

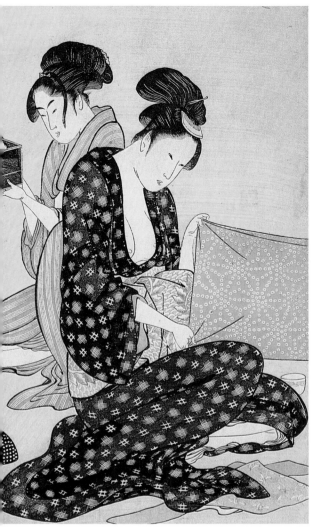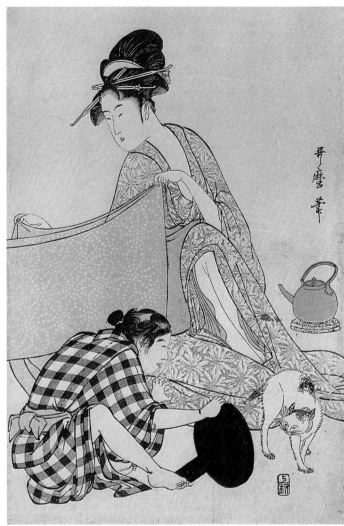

KITAGAWA UTAMARO

214 Women sewing

c. 1795–6
Signature: Utamaro hitsu ('the brush of Utamaro')
Publisher: Uemura Yohei, Edo
Colour woodblock prints (triptych);
 each *c.* 370 × 245 mm
Provenance: W. B. Paterson Collection
Published: Binyon 1916, p. 212; Hillier 1961, no. 51;
 Ukiyo-e shūka 11 (1979), nos 45–7
1912.4-16.220

Utamaro depicted more types of women, in
more varied activities, than any other
Ukiyo-e artist. He took a delight, too, in
capturing the special intimacy between
mothers and children. In this triptych
ordinary housewives are shown busying
themselves with the wide sashes (*obi*) that

formed such an important part of a
woman's costume: two are stretching and
folding a red *obi* with white 'starfish'
pattern, while another holds up a
transparent silk gauze sash – presumably to
check a mend she has just stitched. At their
feet a young boy teases a cat with its
reflection in a mirror, while the baby lolling
in his mother's lap plays with her fan. The
young woman seated at the rear is admiring
an insect, perhaps a firefly, in its tiny cage.

Though these are respectable middle-
class women, Utamaro conveys his usual
eroticism by depicting breasts and legs
casually revealed on a hot summer's day.

FURTHER READING Hillier, Jack, *Utamaro*, London,
1961, reprinted 1979

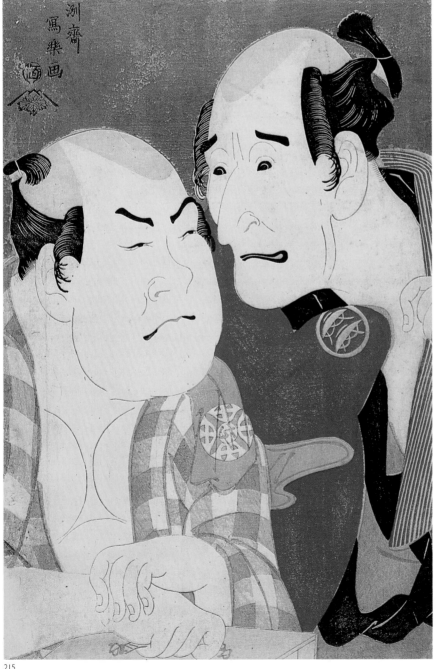

215

TŌSHŪSAI SHARAKU (worked 1794–5)

215 The actors Nakamura Wadaemon and Nakamura Konozō

5th month, 1794
Signature: Tōshūsai Sharaku ga ('painted by
 Tōshūsai Sharaku')
Publisher: Tsutaya Jūsaburō
Colour woodblock print with dark grey mica
 background; 350 × 242 mm
Provenance: Sir Ernest Satow Collection
Published: Binyon 1916, p. 155; Hillier 1966, no. 33;
 Ukiyo-e shūka 11 (1979), no. 6; Ueno 1985, no.
 140; Smith 1988, no. 142
1909.6-18.53

Wadaemon (right) plays the role of Bodara
no Chōzaemon, a customer visiting a house
of pleasure, and Konozō (left) that of
Kanagawaya Gon, the boatman who will
ferry him there. Both were minor roles in
the play *Katakiuchi noriai-banashi* ('A Medley
of Tales of Revenge'), performed at the Kiri
theatre in the 5th month of 1794.

The recently developed genre of the
half-length portrait meant that artists could
concentrate as never before on capturing the
distinctive facial features of each actor.
Sharaku went further than any of his
contemporaries, however, in his
penetrating analyses of each face,
exaggerating the peculiarities to brilliantly
expressive effect. Here the sharp, angular
features of the testy customer contrast
comically with the chubby, snub-nosed face
of the stolid boatman.

FURTHER READING Henderson, Harold G., and
Ledoux, Louis V., *The Surviving Works of Sharaku*,
New York, 1939, reprinted 1984

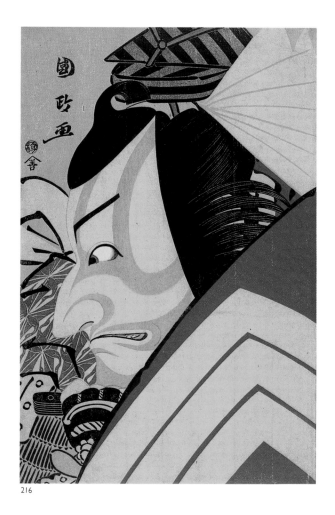

216

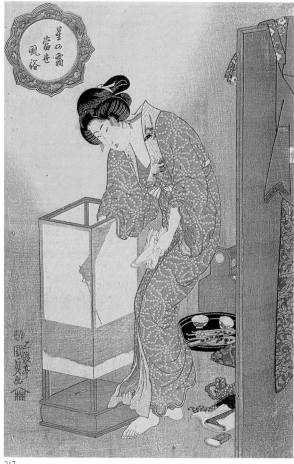

217

UTAGAWA KUNIMASA (1773–1810)

216 The actor Ichikawa Ebizō in a *shibaraku* role

11th month, 1796
Signature: Kunimasa ga ('painted by Kunimasa')
Publisher: Sanzen, Edo
Colour woodblock print; 385 × 250 mm
Provenance: Arthur Morrison Collection
Published: Binyon 1916, p. 277; Hillier 1966, no. 37;
 Ukiyo-e shūka 11 (1979), no. 169
1906.2-20.462

The *shibaraku* scene is perhaps the most famous in all Kabuki drama – a heavily stylised show-piece in which, with cries of '*shibaraku!*' ('wait a moment!') from the back of the theatre, a hero enters down the raised walkway (*hanamichi*) to rescue hapless victims about to be done to death.

For this 'large head' (*ōkubi-e*) portrait of the great Ebizō (formerly Ichikawa Danjūrō v) in his retirement performance of the *shibaraku* role, the artist Kunimasa has chosen an unusual, highly striking profile view. Many elements of the fantastic *shibaraku* costume and make-up are nevertheless visible: the 'five-spoke wheel' wig with white paper 'strength' decorations under the black lacquer court hat; the fierce

red make-up; a green jacket with white stylised crane pattern; and dominating the composition a sleeve of the persimmon-coloured over-costume decorated with the three white interlocking squares of the Ichikawa family emblem. Possibly Kunimasa is depicting the very moment when, gripping the handle of his fan in barely controlled fury, Ebizō will shout '*shibaraku!*'.

UTAGAWA KUNISADA (1786–1864)

217 Beauty beside a standing lantern

c. 1818–20
Series: *Hoshi no shimo tōsei fūzoku* ('Starfrost
 Contemporary Manners')
Signature: Gototei Kunisada ga ('painted by
 Gototei Kunisada')
Publisher: Iseya Rihei
Colour woodblock print; 380 × 251 mm
Provenance: J. J. O'Brien Sexton Collection
Published: Binyon and Sexton 1960, no. 43; *Ukiyo-e
 taikan* 3 (1988), no. 16
1942.1-24.015

It is deep in the night and a courtesan in her long red silk under-kimono decorated with

a white tie-dyed starfish pattern is shown beside a standing lantern. The shadow of her arm shows through the paper shade as she dresses the wick. The corner of the bedding, scattered hair ornaments and other personal accoutrements are just visible behind the edge of a folding screen, over which is thrown her kimono and *obi*, and the two cups on the black lacquer tray hint at the presence of the customer, discreetly hidden by the screen. The white satin collar of the woman's robe has been hand-painted with a design of a cuckoo, signed Gototei (one of Kunisada's art-names), so perhaps the artist intends us to think that it is he who enjoys her special favour.

The placing of the screen in the foreground so as to open up a sense of deeper space, as well as the use of complex effects of internal lighting, are relatively new departures for an Ukiyo-e artist. By retreating from the idealised poses and impossibly neat falls of drapery so common in late eighteenth-century figure prints, Kunisada is able to make startling gains in the immediacy and eroticism of the image.

FURTHER READING Suzuki, Jūzō, and Oka, Isaburō, *The Decadents*, Tokyo, 1969

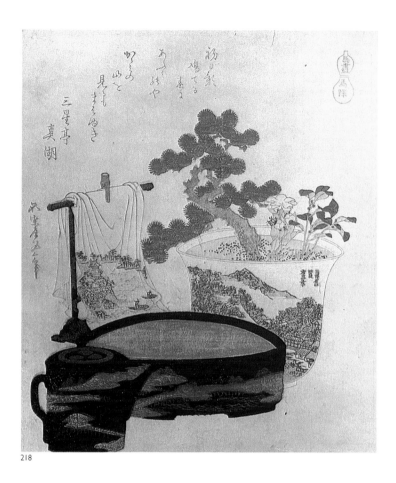

218

with equivalent graphic power. And through the hollow of the wave – as if seen through a telescope – sits Mount Fuji, the unperturbable, its graceful curves echoed by boats and waves alike.

In the late 1820s the chemical pigment Prussian Blue became available to Japanese publishers at a much reduced price from China. Here at last was a strong blue pigment for sky and water which would not fade, and one of the first large-scale publishing ventures that exploited its new potential was Hokusai's monumental 'Thirty-six Views of Mount Fuji'. Encouraged by the commercial success of the project, the publisher Nishimuraya Eijudō extended the series by a further ten designs, printed this time with black, not blue, outlines.

FURTHER READING Hillier, Jack, *Hokusai: Paintings, Drawings and Woodcuts*, London, 1955, reprinted 1978

UTAGAWA HIROSHIGE (1797–1858)

220 *Mii banshō* ('Evening Bell at Mii Temple')

c. 1834
Series title: Ōmi hakkei no uchi ('From the Eight Views of Lake Biwa')
Signature: Hiroshige ga ('painted by Hiroshige')
Publisher: Takenouchi Magohachi, Edo
Colour woodblock print; 252 × 382 mm
Provenance: Samuel Tuke Collection
Published: Binyon 1916, pp. 406–7
1907.5-31.591

Following on from the phenomenal success of his first large-scale landscape series, 'Fifty-three Stations along the Tōkaidō Highway' (*Tōkaidō gojūsan-tsugi no uchi*, *c.* 1833–4), Hiroshige designed a series of 'Eight Views of Lake Biwa' for the Edo publishers Takenouchi Magohachi (who had issued the 'Fifty-three Stations') and Yamamoto Heikichi. Doubtless influenced by the long tradition of painting these scenes in classical ink styles, Hiroshige devised grand, even austere designs with none of the human interest that had been such a feature of the Tōkaidō series.

The classical poem selected in 1500 by Prince Konoe Masaie and his son Naomichi to match the scene is written in the square cartouche at top right:

Omou mono	Lovers think
Akatsuki chigiru	'So begin our
Hajime zo to	dawn vows'
Mazu kiku Mii no	When first they hear
Iri-ai no kane	The evening bell of Mii Temple

KATSUSHIKA HOKUSAI (1760–1849)

218 Porcelain plant pot, towel rack, water pitcher and lacquer basin

1822
Picture title: Mayoke ('The Talisman')
Series: Uma-zukushi ('A Set of Horses')
Signature: Fusenkyo Iitsu hitsu ('the brush of Fusenkyo Iitsu')
Surimono colour woodblock print; 201 × 176 mm
Provenance: Charles Shannon Collection
Published: Gray 1948, no. 25
1937.7-10.0212

In the year of the horse (1822) Hokusai designed a series of elegant *surimono* still-life compositions relating very obliquely to the general theme of horses.

The poem by Sanseitei Marumi which appears on the print has been translated by Roger Keyes (*The Art of Surimono*, no. 200) as follows:

Hatsuhikage	In the rays
Nioteru haru ni	Of the Spring sun
Ōmi no ya	On Lake Biwa,
Kagami no yama o	Mirror Mountain
Miru mo mabayuki	Also glitters

The 'Eight Views' of Lake Biwa, near Kyoto, were a subject for classical ink-paintings, and Hokusai has hidden references to these famous views throughout the design: Mii Temple, Ishiyama Temple and Mount Hira

painted on the porcelain plant pot; the Ukimidō 'Floating' Temple at Katada and the Long Bridge of Seta decorating the lacquer pitcher and basin; Awazu Castle and the returning boats at Yabase on the towel (which itself represents the sail of one of the boats); the miniature pine tree standing in place of the ancient pine at Karasaki.

FURTHER READING Keyes, Roger, *The Art of Surimono*, London, 1985

KATSUSHIKA HOKUSAI

219 *Kanagawa oki nami-ura* ('Hollow of the Wave off the coast of Kanagawa')

c. 1829–33
Series: Fugaku sanjūrokkei ('Thirty-six Views of Mount Fuji')
Signature: Hokusai aratame Iitsu hitsu ('painted by Hokusai changing name to Iitsu')
Publisher: Nishimuraya Eijudō, Edo
Colour woodblock print; 259 × 372 mm
Provenance: Charles Shannon Collection
Published: Gray 1948, no. 62; Smith 1981, no. 2
1937.7-10.0147

Hokusai has produced an image in which the awesome forces of nature are conveyed

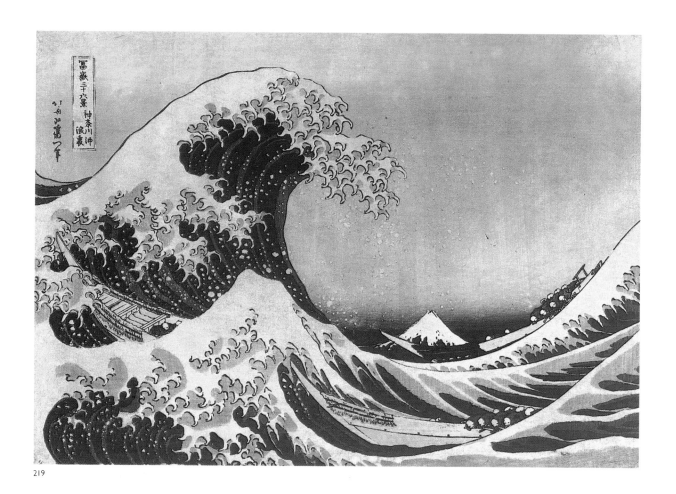

219

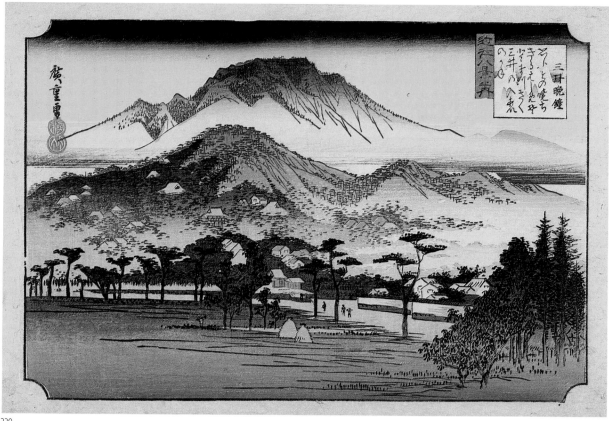

220

221

UTAGAWA KUNIYOSHI (1797–1861)

221 Princess Takiyasha summoning a skeleton spectre to frighten Mitsukuni

c. 1844
Signature: Ichiyūsai Kuniyoshi ga ('painted by Ichiyūsai Kuniyoshi')
Publisher: (?) Hachi
Colour woodblock prints (triptych);
 each *c.* 370 × 250 mm
1915.8-23.0915, 0916

Kuniyoshi's sweeping panoramic compositions use the wide format of the triptych print in a revolutionary way.

Until his defeat and destruction in AD 939, the provincial warlord Taira no Masakado had established himself as the head of a rival 'Eastern Court' in Shimōsa Province, in open rebellion against the legitimate court in Kyoto. The scene here is Masakado's ruined palace of Sōma, inhabited after his death by his daughter Princess Takiyasha (left), a sorceress. She is reading an incantation to summon up a terrifying monster skeleton to drive away the warrior Ōya no Tarō Mitsukuni (kneeling, centre left), who has been sent by the court to investigate any surviving conspirators.

Kuniyoshi is said to have possessed a reference collection of imported Western prints and he has doubtless copied some Western medical illustration to produce this

harrowingly accurate depiction of the skeleton, as it rips away the tattered court blinds with its bony fingers to menace Mitsukuni.

The story of Mitsukuni and Princess Takiyasha was made into a Kabuki play in 1836, performed again in another version in 1844. It has been suggested that Kuniyoshi produced this essentially 'historical' treatment of the episode to cater to public interest caused by the Kabuki performance of 1844, for the Tempō Reforms had made it for the time being illegal for artists to depict actors or theatrical scenes directly in colour woodblock prints.

FURTHER READING Robinson, B. W., *Kuniyoshi: The Warrior Prints*, Oxford, Phaidon, 1982

UTAGAWA KUNIYOSHI

222 A farewell *surimono* for Ichikawa Danjūrō VIII

1849
Signature (on banner): Ichiyūsai Kuniyoshi e ('picture by Ichiyūsai Kuniyoshi');
 seal: Kuniyoshi
Extra large colour woodblock print; 272 × 555 mm
Provenance: Arthur Morrison Collection
Published: Ukiyo-e taikan 3 (1988), no. 55
1906.12-20.1342

In the 5th month of 1849 Ichikawa Danjūrō VIII, the twenty-seven-year-old star

of the Kabuki theatre, left the Edo stage to travel to Osaka for a reunion with his father Ebizō (Danjūrō VII), who had been banished from Edo during the repressive Tempō Reforms some seven years earlier. As a parting salute to their idol, members of two clubs of amateur *haiku* poets – the Shimba and Uogashi clubs located in the fish market districts of Edo – sponsored this large, *de-luxe*-edition print. To match the time of year, Kuniyoshi chose the subject of decorations for the Boys' Festival on the 5th day of the 5th month: a monster paper carp kite flying over a cloth banner painted with the bristling scarlet figure of Shōki, ancient Chinese queller of demons. As a tribute to the Danjūrō actor family, Shōki's face is transformed into a portrait of the exiled Danjūrō VII; perhaps the leaping carp – a symbol of manly perseverance – is intended to represent his son. Danjūrō VII's acting emblem was a curled lobster, and Taiwa, one of the poets, represents in his verse the wishes of all the fishmongers in the Nihombashi area that their idol will return from exile:

Nibune no	Nihombashi
Ebi o machikeri	Waiting for the lobster boat
Nihombashi	To come into port

Danjūrō VII was indeed pardoned later that same year and allowed to return to his adoring public in Edo.

222

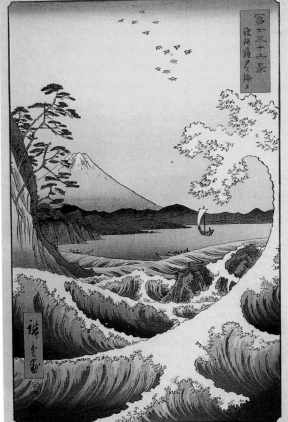

223

UTAGAWA HIROSHIGE (1797–1858)

223 *Suruga Satta no kaijō* ('Fuji from the Sea at Satta, Suruga Province')

4th month, 1858 (published 1859)
Series: *Fuji sanjūrokkei* ('Thirty-six Views of Mount Fuji')
Signature: Hiroshige ga ('Painted by Hiroshige')
Publisher: Tsutaya Kichizō, Edo
Colour woodblock print; 354 × 243 mm
Provenance: Ernest Hart Collection
Published: Binyon 1916, p. 468
1902.2-12.396 (25)

Hiroshige died on the 6th day of the 9th month 1858, possibly a victim of the cholera epidemic that had swept through Edo during that summer and autumn. The 'Thirty-six Views of Mount Fuji' was his last major series, in the upright format typical of his later landscape prints. All the series is dated 4th month 1858, and so not too much credence should be given to the posthumous eulogy by Santei Shumba (which was added on a later title page to the series) when he wrote that Hiroshige had delivered the drawings to the publisher at the beginning of the autumn just before he died, saying that it was a 'summation of his lifelong skills as an artist' (*issei no hitsui*). This title page is dated 6th month 1859, when the series may have been reissued as a complete set.

The pass at Satta on the old Tōkaidō highway had been the site of several famous battles. Hiroshige shows Mount Fuji through the hollow of a seething wave, frozen as it is about to come crashing down on the rocky coastline below. A flock of startled plovers has been thrown up like spray into the sky. This design must be something of a tribute to Hokusai's 'Hollow of the Wave off the coast of Kanagawa' (commonly known as 'The Great Wave', *c.* 1829–32, no. 219).

224

225

OKUMURA MASANOBU (?1686–1764)

224 'Courtesans as the three saké drinkers'

From the album *Yūkun sennin* ('Courtesans – Immortals')
c. 1710
Signature: Okumura Masanobu zu ('picture by Okumura Masanobu'); *seal*: Masanobu
Publisher: unknown
Woodblock-printed album; 275 × 190 mm
Provenance: Ōta Nampo (1749–1823); original British Museum stamp of 13 February 1894
Published: Anderson 1886a, fig. 64; Douglas 1904, p. 38
1915.8-23.012 (JA/JIB 44)

A classical painting subject showed the founders of the three great creeds of Buddhism, Confucianism and Taoism supping vinegar and forced into uncharacteristic agreement that it tastes awful. In Masanobu's breezy parody three types of prostitute – a *bikuni* entertainer, a high-ranking courtesan and an apprentice Kabuki actor (right to left) – are serving themselves from a tub of saké.

The British Museum album contains eleven black and white woodblock prints from what must have been a set of twelve. The handwritten title reads 'Courtesans Imitating Taoist Immortals' (*Yūkun sennin*), and in each illustration the women are humorously drawn with the attributes and in the iconographic settings of ancient Chinese hermits and holy men. This may be the most complete set to have survived. The British Museum also has one of the original wooden blocks used to print two of the designs in this album, carved back-to-back on a single board of cherry wood.

FURTHER READING Shibui, Kiyoshi, 'Masanobu no sumi-e', *Ukiyo-e kenkyū*, vol. VI, no. 3 (March 1929). Shibui knew of only this one illustration from the series.

NISHIKAWA SUKENOBU (1671–1751)

225 *Ehon Asakayama* ('Mount Asaka, a Picture-book')

New Year 1739
Signature: Karaku Bunkadō Nishikawa Sukenobu; *seal*: Sukenobu
Publisher: Kikuya Kihei, Kyoto
Woodblock-printed book; 269 × 181 mm
Provenance: Jack Hillier Collection
Published: Hillier and Smith 1980, no. 23; Ueno 1985, book no. 8; Hillier 1987, nos 121, 122; Smith 1988, book no. 8
1979.3-5.80 (JA/JH 80)

Sukenobu was the most accomplished and influential Ukiyo-e painter in Kyoto during the first half of the eighteenth century, and is recorded as having been in the service of the aristocratic Saionji family. The more than one hundred illustrated books he designed spread his fame to Edo as well, providing a source of inspiration for later artists such as Suzuki Harunobu (1724–70, no. 209), and subject-matter for decorative craftsmen.

Beginning with *Hyakunin jorō shina-sadame* ('One Hundred Women Classified According to their Rank') published in 1723, Sukenobu's book illustrations took on their classic form: black and white illustrations of groups of beautiful women of various professions and classes shown in interior and exterior settings around Kyoto – always with the same sweet, rounded faces and refined attitudes and poses.

Ehon Asakayama is unusual in that all background details have been swept away from the designs, giving heightened emphasis to the elegant silhouettes of the figures in the manner of single-sheet prints or paintings. The right-hand illustration of a courtesan walking in the classic *mikaeri* ('looking back over the shoulder') pose is reminiscent of many of Sukenobu's

hanging-scroll paintings of similar composition; the right hand holding up the skirts in front, the left sleeve hanging loose to show off the all-over wisteria pattern of the kimono, and a heavy brocade *obi* tied in front.

FURTHER READING Hillier, Jack, 'Nishikawa Sukenobu', in *The Art of the Japanese Book*, London, 1987, pp. 158–73.

KITAO MASANOBU (1761–1816)

226 The courtesans Hinazuru and Chōzan of the Chōjiya House

From *Yoshiwara keisei shin bijin-awase jihitsu kagami* ('A Mirror of New Yoshiwara Courtesans with Samples of their Calligraphy')
1784
Signature: Kitao Sensai Masanobu; *seals*: (unread), Masanobu no in
Publisher: Tsutaya Jūsaburō, Edo
Colour woodblock-printed album; 275 × 190 mm
Provenance: Jack Hillier Collection
Published: Hillier 1966, no. 25; Hillier and Smith 1980, no. 53; Ueno 1985, book no. 19; Hillier 1987, pl. 50, no. 257; Smith 1988, book no. 19
1979.3-5.146 (JA/JH 146)

During the 1770s and 80s a succession of evermore lavish tributes to the high-ranking courtesans of the Yoshiwara pleasure quarter appeared in the form of colour woodblock prints, illustrated books and albums by artists such as Harunobu, Koryūsai, Shigemasa and Kiyonaga. This grand album of 1784, showing scenes in the courtesans' private apartments at the New Year, was an attempt by Kitao Masanobu, an ambitious young artist, and Tsutaya Jūsaburō, a publisher keen to conquer the luxury market, to produce an unsurpassable

work of this kind. The large format is twice the size of normal single-sheet prints, and the colour printing is of unprecedented richness and complexity, with the additional novelty that each design includes courtly poems (*waka*) in the actual handwriting of the woman depicted. In his novels written under the pen-name Santō Kyōden and in colour prints such as these Masanobu established himself as the ultimate arbiter and guide to the exclusive world of the high-ranking courtesans, suggesting parallels with the great women poets and writers of the courtly Heian period (794–1185).

Here Hinazuru stands modelling her sumptuous New Year kimono, while Chōzan is seated at an elegant Chinese-style writing table, checking her calligraphy primer and an edition of the classic *Eiga Monogatari* ('Tales of Glory') before inscribing New Year verses on the decorated poem slips before her.

FURTHER READING Ōta Memorial Art Museum, *Tsutaya Jūsaburō to Temmei, Kansei no Ukiyo-eshitachi*, Tokyo, 1985

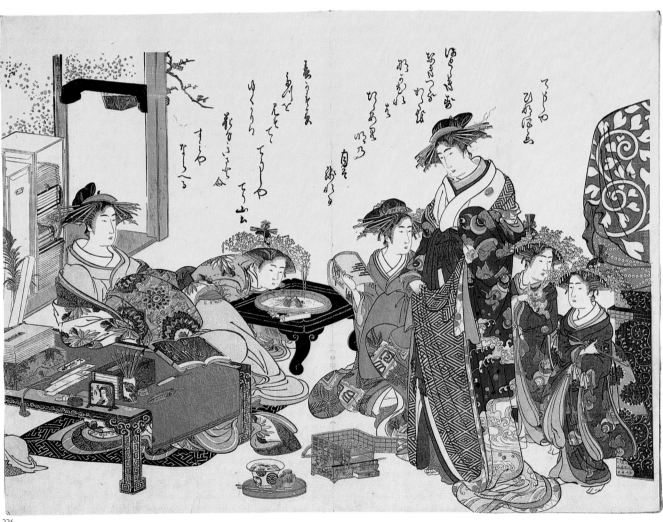

226

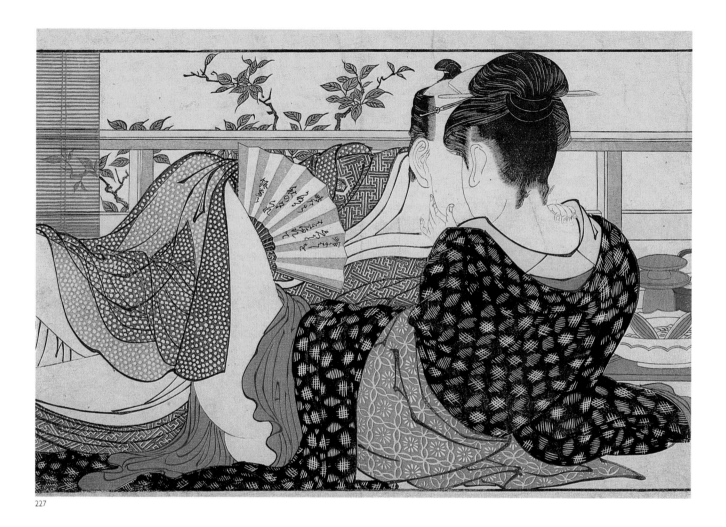

227

KITAGAWA UTAMARO (1754–1806)

227 *Uta makura* ('Poem of the Pillow')

1788
Publisher: probably Tsutaya Jūsaburō, Edo
Colour woodblock-printed album-leaf;
 255 × 369 mm
Published: Hillier 1987, pl. 61, nos 241, 278–9
OA+133 (06)

A couple are lying in close embrace in the
upstairs room of a restaurant, their legs
entwined beneath the transparent gauze of
his jacket, and her bare buttocks a shock
of white against the bright scarlet
under-kimono. They hold each other with
tender gestures, the man gazing intently
into his lover's eyes. The fan he holds
between them has been turned towards us

to display the suggestive verse by the
celebrated comic poet Yadoya no
Meshimori:

Hamaguri ni	Its beak caught firmly
Hashi o shikka to	In the clam shell,
Hasamarete	The snipe cannot
Shigi tachikanuru	Fly away
Aki no yūgure	Of an autumn evening

The album 'Poem of the Pillow' is a
masterpiece among erotic works by
Utamaro and among the entire erotic *oeuvre*
of the Ukiyo-e school. It transcends the
existing conventions of a genre which all too
easily resorted to stereotypical scenes of
lovemaking. The size of the figures is
unusually large and they are brought close
to the picture plane and viewed from low
angles. Stylistically and technically, too,

there is much innovation: a fine pale brown
outline to the bodies in place of the normal
black, and a variety of 'painterly' brush
strokes used to depict the drapery. 'Poem of
the Pillow' comes at the start of a sequence
of *de-luxe* colour-printed books and albums
designed by Utamaro and published by
Tsutaya – on the themes of birds, shells,
snow, moon and flowers – which widened
considerably the range of subject-matter
and styles in Ukiyo-e.

FURTHER READING Higashiōji, Taku (ed.), *Utamaro no Utamakura higa-chō*, Tokyo, 1980

鷓
鴣

228

KITAO MASAYOSHI (1764–1824)

228 Partridges

From *Raikin zui* ('Pictures of Imported Birds')
c. 1790
Signature: Keisai Kitao Masayoshi kōsha ('redrawn
by Keisai Kitao Masayoshi')
Publisher: Gungyokudō Matsumoto Zembei, Edo
Colour woodblock-printed album; 251 × 187 mm
Provenance: The British Museum stamp is dated
22 July 1868
Published: Ueno 1985, book no. 31; Hillier 1987,
pl. 77, no. 311; Smith 1988, book no. 31; *Ukiyo-e
taikan* 3 (1988), nos 210–19
JA/JIB 90

The printed foreword to the album explains
how a government official named Seki
Mitsubumi who was visiting Nagasaki in
1789 commissioned a Chinese artist resident

in the city to execute a set of five handscrolls
depicting exotic imported birds. On his
return to Edo Seki showed these to the
publisher Matsumoto Zembei, who decided
to publish a selection as a *de-luxe*
colour-printed album at the end of 1790. The
Ukiyo-e artist Kitao Masayoshi was
employed to copy the Chinese artist's
paintings and prepare designs which could
be used by the woodblock engravers and
printers. In the autumn of 1793 Seki and the
publisher issued a second volume of
explanatory text to go with the illustrations,
Kaihaku raikin zui setsu, which included the
information that the birds had originally
been imported on a boat called *Hachiban*
('Boat No. 8') in 1762.

The normal convention for Ukiyo-e prints

was to have a thin black outline
surrounding every area of colour, but here
elaborate techniques of texturing the surface
of the printing block or wiping the edges of
inked areas have been employed to suggest
the soft colour transitions of the original
Chinese painting.

The only known complete copy of the rare
first edition of this album – including a
preface missing from the British Museum's
copy – has recently been discovered in the
collection of the Kōbe City Museum.

SAITŌ SHŪHO (1769–1859)

229 *Kishi empu*
('Mr Aoi's Chronicle of Charm')

6th month, 1803
Publisher: Ueda Uhei and Nurakami Sakichi, Osaka
Colour woodblock-printed book; 3 vols;
 257 × 182 mm
Provenance: Collections of Hayashi Tadamasa and
 Felix Tikotin
Published: Royal Academy of Arts 1981, no. 142
1952.11-8.011 (1-3) (JA/JIB 515A)

According to Yamanouchi Chōzō's
commentary on *Kishi Empu*, it was the
custom at New Year in Osaka for courtesans
of the Shimmachi pleasure quarter to dress
in the fine new kimonos given them by their
patrons to pay a first visit to the local temple
of the deity Aizen Myō-Ō. The more new
kimonos a woman wore during the three
days of the New Year holiday, the greater
the number of her clients.

This is the auspicious opening illustration
to a three-volume work showing the annual
customs and human foibles of those
working in and around the Osaka
entertainment districts. The startling
composition, diagonally constructed and
punctuated by umbrellas sporting the mallet
emblem of one of the houses of pleasure, is
typical of the bold design sense of artists in
western Japan trained in the Shijō style.

In 1982 *Kishi Empu* was proven to be the
work of Saitō Shūho, who after 1805 is
known to have painted unadventurous
works in the academic Kanō style.

FURTHER READING Yamanouchi, Chōzō (ed.), *Kishi
Empu*, Tokyo, 1985

229

KATSUSHIKA HOKUSAI (1760–1849)

230 Dragon ascending Mount Fuji

From vol. 2 of *Fugaku hyakkei* ('One Hundred
 Views of Fuji')
1834 (vol. 1); 1835 (vol. 2); *c.* 1849 (vol. 3)
Signature: Zen Hokusai Iitsu aratame Gakyō Rōjin
 Manji hitsu ('formerly Hokusai Iitsu changing
 signature to Old Man Mad with Painting,
 Manji'); *seal*: (Fuji)
Publisher: Seirindō, Edo (and others)
Woodblock-printed book; 3 vols; 227 × 157 mm
Provenance: Jack Hillier Collection
Published: Hillier and Smith 1980, no. 110; Ueno
 1985, no. 51; Hillier 1987, nos 580–5
1979.3-5.454 (1-3) (JA/JH 454)

Following the tremendous success of his
series of colour prints 'Thirty-six Views of
Mount Fuji' (*Fugaku sanjūrokkei, c.* 1829–32)
– which was actually extended by a further
ten designs – Hokusai went on to design 102

230

more views of the sacred peak. These were
issued as a book in three volumes published
in 1834, 1835 and finally completed in
c. 1849. The illustrations in fine black line
and several shades of grey were printed
from blocks cut by the workshop of the
master carver Egawa Tomekichi. Though
the link with the 'Thirty-six Views of Mount

Fuji' (no. 219) is clear, the 'One Hundred
Views' have a much less well-defined sense
of topography and a much wider range of
cleverly contrived compositions.

FURTHER READING Smith, Henry (ed.), *Hokusai: One
Hundred Views of Mount Fuji*, London, 1988

12

TWENTIETH-CENTURY PRINTS

(nos 231–50)

The arts of the post-Meiji period have flourished with a vigour which might not at one time have been expected, considering the apparently relentless flood of Westernisation which was still in full spate at the death of the Meiji emperor in 1912, and has in fact rarely abated since. Yet contemporary Japan is now noted for the continuing excellence of its traditionally based arts and crafts – pottery and porcelain, dyed textiles, laquerware, handmade papers are only a few of them – and the production of prints in a wide variety of styles and techniques has to be included among those successes. The British Museum's comprehensive collection of prints is used here to illustrate the excellence of Japanese graphic art in the twentieth century. The history of printmaking also reflects other tendencies during this period which apply in some respects to other arts.

Although the traditionally produced popular woodblock print must have seemed almost defunct by 1912, the vigorous seeds of a new sort of graphic art had already been sown by the artist, reformer and educator Yamamoto Kanae (1882–1946) who in 1904 made Japan's first 'creative print' (*sōsaku hanga*), designed, cut and printed by himself. He used a curved chisel, leaving irregular, nervy edges to the areas of colour to be printed; he gouged depressions in the woodblocks which would leave the paper white, the reverse of the Ukiyo-e process, but a natural result of his early journalistic training in Western-style wood engraving; and he used less than perfectly smooth woodblocks which left a lively grain on the printed colours. All of these were to become standard features of the movement. His style is strongly derived from French art of the period, but his consequent preference for pale pastel colours became another permanent legacy to Japanese graphic art. It cannot be claimed that he was himself a great print-artist, but his influence found rapid fulfilment in the works of Onchi

Kōshirō (1891–1955, no. 240), Hiratsuka Un'ichi (1895–, no. 235), Hirakawa Seizō (1897–1964, no. 238) and a number of other talented printmakers such as Fukuzawa Sakuichi (1896–1946).

Because of Yamamoto's early leadership Sōsaku Hanga artists tended until after 1945 to be politically left of centre, but this did not reflect to any great extent in their subject-matter, except for some early attempts at 'Proletarian' art by Hiratsuka and Ono Tadashige (b. 1909). On the whole the Japanese preference to avoid the harrowing detail of contemporary suffering continued in the art of the print. Hiratsuka alone of all print-artists felt able to face and express the unprecedented horrors of the 1923 earthquake. Nevertheless, the movement produced much excellent work in townscape, which did not avoid the ugliness of industrial cities, and evolved a grittier landscape style (no. 240), together with biting comments on contemporary manners which are in a sense a revival of Ukiyo-e (see Chapter 11). There was also much work in European abstract styles, authoritatively led by Onchi, but this side of Sōsaku Hanga was not to develop strongly until after 1945. With a few exceptions, such as the charming landscape and townscape lithographs of Oda Kazuma (1882–1956), prints were produced in the woodblock medium and remained quite small in scale.

In a sense they were, therefore, still in the Ukiyo-e tradition, in subject-matter as well as technique and scale, but with the very big difference that they addressed a minority audience, mostly each other, and made little money from their art. It is also a piquant paradox that for all their modernity the Sōsaku Hanga artists were at the same time cultivating a deliberate roughness of texture which was an unconscious reversion to the ancient ideal of the amateur Chinese scholar-painter. This rather enclosed artistic world was to change abruptly after 1945.

At almost the same moment a last, unexpected flowering of the Ukiyo-e print proper was taking place. The traditional print publishers, who had controlled artists, woodblock cutters and printers, had virtually gone out of serious business by the end of the Meiji period. Some, like Unsōdō of Kyoto, had moved into de-luxe editions of connoisseurs' and designer-books, while others, like the cutter and printer Igami Bonkotsu, had partly gone over to the emerging Sōsaku Hanga artists, helping the less technically skilful, such as Ishii Hakutei, to realise their designs as prints.

The Tokyo publisher Watanabe Shōsaburō at this point came to the conclusion that the centuries-old methods of producing Ukiyo-e prints should not be allowed to vanish and that they still had much to offer if suitable artists could only be found. This he set about doing, and it is due to him that Itō Shinsui (1898–1972) and Kawase Hasui (1883–1957) were brought into the field of print-designing in their preferred subjects of bijinga ('pictures of beautiful women') and fūkeiga ('landscape pictures'). These had been two of the three great subjects of Ukiyo-e, and it was not long before Watanabe reintroduced the third – portraits of Kabuki actors – with the designs of Natori Shunsen (1886–1960) and Yamamura Kōka (Toyonari, 1885–1942).

These were all young artists, and indeed Shinsui was only sixteen when Watanabe in 1915 persuaded him to design his first print. Nevertheless, he was able to contribute that essential element of passion which had been missing noticeably during the previous generation; and passion returned as well in the expressively emotional use of vibrant colours and strong line (no. 231), which had been the forte of Ukiyo-e since the time of Harunobu's first colour prints in the 1760s (no. 209). The early landscapes and townscapes of the young Hasui shared the same excitement, hardly surprising as both artists had been youthful pupils of the neo-Ukiyoe painter Kaburagi Kiyokata (1878–1972). Similar excellence returned to the actor print by the early 1920s, with increasing numbers of talented designers joining Watanabe's stable. Watanabe must have thought then that his Shin Hanga ('New' or, better, 'Revival' prints) would be a major new force for the forseeable future, the more so since his example had also inspired older and more independent-minded artists to join the revival. The most eminent were Hashimoto Goyō (1880–1921, no. 232) and Yoshida Hiroshi (1876–1950, no. 237), who capitalised on his training as an artist in oils and watercolours to produce occasionally distinguished landscape prints in the woodblock medium, which in the 1930s had a great vogue in the USA.

History, and its own inherent weakness as a fundamentally exotic art-form out of its time, led to the virtual extinction of Shin Hanga as an influential force by about 1940. When the great Kantō earthquake of 1923 destroyed premises, woodblocks and stocks of paper, there was afterwards inevitably a drop in quality as publishers tried quickly to rebuild their livelihood. Shinsui, Hasui and Yoshida all over-produced as a result,

and their designs began to lose their earlier intensity. The movement itself seemed to turn further and further away in its subject-matter from the political and social realities of post-earthquake Japan: as the global war widened, the foreign interest and support which had been a vital part of Shin Hanga's success all but vanished. By 1940 all artistic production was declining in Japan and internal censorship had become crippling. Although the firms of Watanabe and Yoshida still continued, they now did so in a spirit close to antiquarianism, which after 1945 naturally turned back to a new foreign market for the exotically pretty. The old energy was never regained.

Japan's greatest twentieth-century print-artist, Munakata Shikō (1903–1975) emerged in the 1930s from a quite unexpected direction. After unsuccessful early attempts at becoming a painter in the international style, he found a medium and a technique in the rough, apparently spontaneous black and white prints of Hiratsuka; a style that is a fusion of contemporary French with ancient folk-Buddhist and Shintō; and an idealistic background in the aspirations of the mingei ('folk crafts') movement led by Yanagi Sōetsu (1889–1961). Already by the mid-1930s this extraordinary individualist was designing, cutting and printing works with a unique energy and movement, drama and humour (no. 239), which in spite of their uncompromising and sometimes obscure native subject-matter soon began to appeal to international connoisseurs. When eventually Munakata won the first prize at the São Paulo Biennale in 1955, it not only established him internationally as Japan's most celebrated print-artist but brought the modern Japanese print itself to the notice of the rest of the world. Since then Japanese artists have rarely been absent from notice on the international circuit. Munakata's vigorous style has been an inspiration to many artists, including Mori Yoshitoshi (b. 1898) who works, however, in the stencilled medium which is another aspect of the folk-art movement, Jihei Sasajima (b. 1906), the younger artists Yasuhiko Kida (b. 1944), Naoko Matsubara (b. 1937) and a host of lesser followers.

While Munakata was bursting with some force on the post-war international scene, the Sōsaku Hanga artists came more quietly into their birthright. With the American occupation, and the imposition of a democratic political system, they were suddenly in favour. Onchi's Ichimokukai ('First Thursday Society') became the centre for disciples of the artist now recognised as a national leader. In the last ten years of his life, in a now truly

international milieu, he was able to realise his full potential as an abstract colourist, and he was followed in this by very talented pupils, including Gen Yamaguchi (1903–76, no. 244) and Yoshida Masaji (1917–71, no. 242), who continued his vein of muted but noble abstraction. Onchi's innovative spirit has been carried on by another master of the woodblock medium, Hideo Hagiwara (b. 1913, no. 243). Others of his circle flourished in the post-war period, notably Azechi Umetaro (b. 1902), Maekawa Sempan (1888–1960), Maki Haku (1924–), Hiratsuka and Ono, Takahashi Rikio (b. 1917) and Iwami Reika (b. 1927). A feature of all this post-war work has been a gradual increase in the size of their prints, now often commissioned by dealer-galleries and made to frame and hang on the walls of modern houses and apartments, and a slow but sure decline in their sense of cohesion. Sōsaku Hanga now no longer exists as a self-conscious grouping.

While the Sōsaku Hanga artists, using almost exclusively woodblock, reached their apogee in the 1950s and 60s, they were already under threat from two new trends. One was the much increased ability to travel, which brought younger artists from the mid-1950s onwards more and more into contact with the international art world. The other was the setting up of an American-style system of education, with many universities and schools of art. Professors of printmaking, like the highly influential etcher Komai Tetsurō (1920–76), began to set up their own specialist traditions, and foreign techniques began to challenge the use of woodblock – intaglio, lithograph, silkscreen, mixed media. With new techniques came new international styles which woodblock was less well equipped to express. These tendencies have produced at least three great print-artists who might otherwise have remained as painters – Hamada Chimei (no. 246), Onogi Gaku (no. 245) and Noda Tetsuya (no. 248).

But woodblock remains at the heart of Japanese printmaking, and even as international trends were threatening to overwhelm production in the 1960s and 70s so new artists began to emerge who used woodblock in a greater spirit of individuality to express a wider range of subject-matter. They include Kurosaki Akira (b. 1937), a brilliant Japaniser of psychedelic art, the enigmatic Jōichi Hoshi (no. 247), the vigorous young interpreter of urban tension, Kawachi Seikō (no. 249), and the extraordinary recent revivals of the old Kabuki tradition by Tsuruya Kōkei (no. 250).

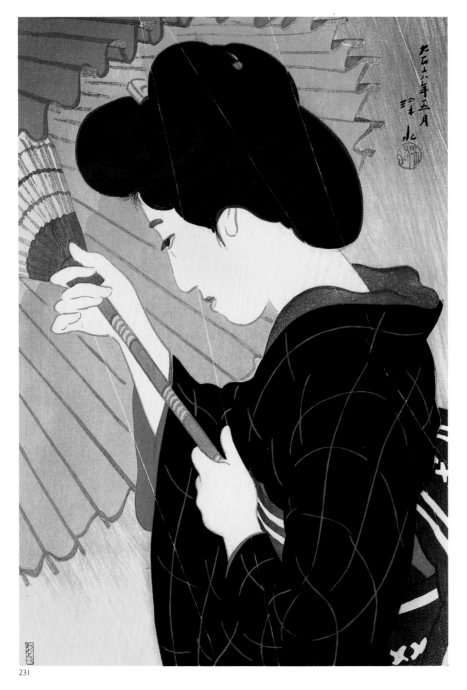

231

some of the artist's youthful fire had faded, and thereafter an increasing number of his prints were adaptations from his brush-paintings.

FURTHER READING Hosono, Masanobu, *Itō Shinsui*, *Gendai Nihon bijinga zenshū*, Tokyo, 1979

HASHIGUCHI GOYŌ (1880–1921)

232 *Kamisuki* ('Combing the hair')

March 1920
Signature: Goyō ga ('painted by Goyō'); *seal*:
 Hashiguchi Goyō
Colour woodblock print, with mica background;
 448 × 348 mm
Published: Smith 1983, no. 29
1930.9-10.01

The title is given by many Japanese publications but is not on the print itself. Goyō's late call to the woodblock print after a career of illustration in other media was inspired by a love of the old technique and an intense admiration for the great portraits of *bijin* ('beautiful women') by Utamaro (see nos 213–14). His perfectionism led to his publishing only a handful of prints, each one technically flawless and suggestive of a wistful passion which is characteristic of the art of the Taishō period. The fine cutting of the black blocks to represent the intricacies of women's hair was an Ukiyo-e tradition which Goyō has enthusiastically revived, and to ensure its greater impact he has restricted the rest of his palette to little more than pale blue and the cool silver grey of the mica ground.

ITŌ SHINSUI (1898–1972)

231 **Sudden shower**

May 1917
Signature: Shinsui; *seal*: Shinsui
Publisher: Watanabe Shōsaburō
Colour woodblock print, no. 91 in an edition of
 100; 443 × 301 mm
Published: Smith 1983, no. 31
1981.8-1.03

Shinsui was in the direct line of Ukiyo-e art, having been the pupil of Kaburagi Kiyokata, one of the greatest artists in the Nihonga (native painting) style of the twentieth century, and a specialist in *bijinga* (portraits of beautiful women). Shinsui followed the same course and soon excelled his master in technique, if not always in inspiration. The publisher Watanabe commissioned his first print design from him in 1915, thus beginning the Shin Hanga movement (pp. 234–5), and a series of superb graphic works resulted, of which this is one of the best. Until the Kantō earthquake of 1923, the artist, encouraged by Watanabe, produced many of his finest designs, and as with the prints of Hasui (no. 233) there is a finer, more tactile quality to the paper and printing. After the disaster, Shinsui and Watanabe increased their production, but

KAWASE HASUI (1883–1957)

233 *Yuki no Shirahige* ('Shirahige in the Snow')

Winter 1920
Series: Tōkyō jūnidai ('Twelve Tokyo Subjects')
Signature: Hasui; *seal*: Sui
Publisher: Watanabe Shōsaburō
Colour woodblock print; 271 × 389 mm
Provenance: Arthur Morrison Collection
Published: Smith 1983, no. 42
1946.2-9.069. Bequeathed by Arthur Morrison

The designs of Hasui were the beginning of the short but fruitful Renaissance of landscape prints, and especially in his early

years the poetic qualities of his landscapes and townscapes mark him as the true successor of Hiroshige (see nos 220, 223). Those published before the great Kantō earthquake of 1 September 1923, which destroyed the stock of woodblocks of so many publishers as well as of prints themselves, have a fresh grace and intensity of mood which the artist never quite recaptured. The printing, too, and especially the ultra-thick paper were of a sensuous quality which did not reappear after the devastation. The 'Twelve Tokyo Subjects' is in the old Ukiyo-e tradition of townscape sets and remains one of the finest. It was issued in an edition of only 200, and it is not thought that subsequent pulls were taken from the blocks.

The district is known for the Shirahige shrine and is in Higashi Mukōjima in Sumida Ward (on the Sumida River).

FURTHER READING Pachter, Irwin J., and Takushi, Kaneko, *Kawase Hasui and his Contemporaries*, Everson Museum of Art, Syracuse, NY, 1986

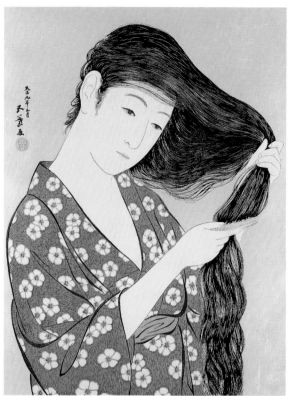

232

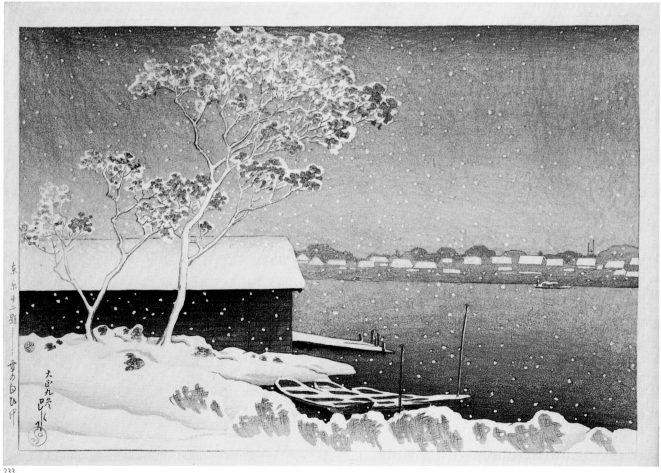

233

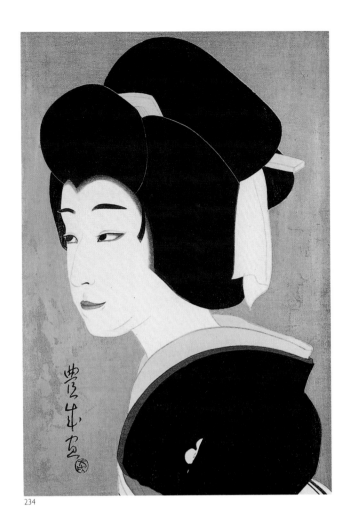

234

236

YAMAMURA KŌKA (TOYONARI) (1885–1942)

234 The Kabuki actor Sawamura Sōnosuke I as Umegawa

1922
Signature: Toyonari ga ('painted by Toyonari');
 seal: Toyonari
Publisher: Watanabe Jūsaburō
Colour woodblock print with mica background,
 from a limited edition of 150; 428 × 290 mm
Published: Smith 1983, no. 56
1973.7-23.010

The character played is Umegawa, the
courtesan who formed a tragic liaison with
the townsman Chūbei which ended in their
suicide. The play *Umegawa-Chūbei*, still a
Kabuki favourite, was based on a Bunraku
puppet drama written in 1706 by
Chikamatsu Monzaemon, Japan's greatest
dramatist. The portrayal in prints of
Kabuki's *onnagata* (female impersonators)
has always been haunted by the example of
Sharaku (worked 1794–5), and this is no
exception, deriving almost tangible
electricity from the tension of male within
apparent female. The starkness of colour
owes something to the Creative Print
Movement already dominated by Kōshirō
Onchi.

235

HIRATSUKA UN'ICHI (1895–)

235 *Shiba Daimon*
('The Main Gate at Shiba')

April 1925 (certificate)
Series: Tōkyō shinsai-seki fūkei ('Tokyo after the Earthquake')
Signature: 'Un-ichi' (in Roman letters); *seal*: Un'ichi (certificate)
Publisher: Yamaguchi Hisayoshi, *Hanga no ie* ('House of Prints') (certificate)
Colour woodblock print, no. 23 in an edition of 50; 265 × 350 mm
1987.10-14.02

Hiratsuka, already one of the activists of the Creative Print Movement, produced in the eighteen months following the Kantō earthquake of September 1923 what has proved to be the greatest artistic tribute to Japan's biggest peacetime disaster. Where his contemporaries tended to react to the event either obliquely or through nostalgia for what had been lost, Un'ichi faced it squarely and recorded its results harrowingly. The rough, angular style of cutting the woodblocks was favoured by artists of the Sōsaku Hanga movement to produce a more 'sincere' effect, and it has proved here better able to express the bleakness of the devastation in Tokyo. The roughness is, however, an illusion. The artist has in fact loaded his colour blocks with precision and finesse to produce a pink blush in the smoky sky, reflected with great subtlety in the foreground. Whether this is the sun seen through the smoke or the great fire itself is left for the viewer to guess.

KITANO TSUNETOMI (1880–1947)

236 **Woman adjusting her comb in the mirror**

c. 1930
Signature: Tsunetomi hitsu ('the brush of Tsunetomi')
Published by the artist
Colour woodblock print with mica background; 397 × 269 mm
1983.7-7.02

In the 1920s and 30s Tsunetomi produced a number of prints on the traditional subject of *bijin* ('beautiful women'), of which this

237

and the better-known *Sagimusume* ('Heron Princess') are his masterpieces. Originally apprenticed in the woodblock-print trade as a maker of *hanshita-e* (final sketches for cutting on the block), he turned to painting and to designing his own prints. In his house in Osaka he set up his own printing business and had many pupils. Although close to Ukiyo-e by training, Tsunetomi in this print shows the strong influence of Kōshirō Onchi in his colour sense, bold concept and construction, and slightly dark mood.

YOSHIDA HIROSHI (1876–1950)

237 'Hayase'

1933
Signatures: Yoshida (in ink), Hiroshi Yoshida (in pencil); *seal*: Hiroshi
Printed by the artist's studio
Colour woodblock print; 278 × 400 mm
Provenance: Robert Vergez Collection
1984.5-17.03

Yoshida had made a name for himself in Japan as a Western-style landscapist in oils

or watercolour. On meeting Watanabe Shōsaburō in 1920, he began to design prints for this publisher but after a few years began to produce his own, setting up his own studio. Yoshida's biggest achievement was to devise a woodblock-printed style which would effectively express the light and shade effects of Western-style painting and its wide ranges of colour, while retaining the traditional format of the Japanese landscape print, its use of black outline and its warmth of texture. Much of his work was directed at the American market, where his reputation once stood very high and is now recovering from eclipse. His reputation has also risen within Japan now that he is no longer seen as a 'foreign' artist. The sumptuous romanticism of his style is seen in this waterside scene in cherry-blossom time and comes from his most mature period.

FURTHER READING Ogura, Tadao, *et al.* (eds), *Yoshida Hiroshi zen mokuhanga shū*, Tokyo, 1987

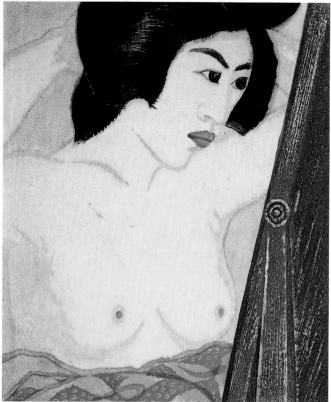

238

HIRAKAWA SEIZŌ (1897–1964)

238 *Aku no Hana* ('Flower of Evil')

c. 1935
Signature: S. Hirakawa (in pencil); *seal*: Sei
Colour woodblock print; 395 × 305 mm
Provenance: Robert Vergez Collection
1987.3-16.496

The artist became a member of the 'Japanese
Creative Print Society' in 1920 and worked
with Kōshirō Onchi and his circle,
appearing in the same art magazines.
After about the time of this print the
circumstances of his life are not known. This
moody, somewhat embittered-looking
woman is very much influenced by Onchi's
own prints on the perennially interesting
artistic subject of the woman looking in a
mirror. She is clearly in the entertainment
business. The arresting and surprising use
of colour is another sign of Onchi's
influence. The print, nevertheless, has a
concentrated passion which makes it one of
the masterpieces of the Sōsaku Hanga
movement.

239

MUNAKATA SHIKŌ (1903–75)

239 The Buddhist deity Fudō Myō-Ō (Acala)

1937
Series: *Kegon-fu* ('The Aratamsaka-*sūtra*')
Printed by the artist
Woodblock print; 530 × 725 mm
Provenance: Bernard Leach Collection; Philip W.
 Leach Collection
1983.7-2.08

Munakata lost most of his stock of prints
and his woodblocks in an air-raid on Tokyo
in 1945. The prints made before that period
are therefore rare. This almost gleeful
version of Fudō among flames (see no. 22) is
from a series of twenty-four prints on the
subject of the Buddhist *Kegon-sūtra*, very
imaginatively interpreted. One complete set
was given by Munakata to the potter
Bernard Leach, who was a colleague of the
artist in the folk crafts (*mingei*) movement,
and thus survived in this country, though
five of the sheets had been dispersed before
they reached the British Museum. The set is
one of his masterpieces in the black and
white style, which was inspired partly by
Japanese folk Buddhist imagery. The sense
of turbulent movement and of a restless
surface, which are among Munakata's most
obvious characteristics, are very evident in
this print.

FURTHER READING Tokyo National Museum of
Modern Art, *Shikō Munakata*, Tokyo, 1985

ONCHI KŌSHIRŌ (1891–1955)

240 *Unzen ikkei*
('A View of Mount Unzen')

1938
Series: *Shin Nihon hyakkei* ('100 New Views of
Japan')
Seal: Kō
Colour woodblock print; 256 × 334 mm
Provenance: Robert Vergez Collection
Published: Tokyo National Museum of Modern Art
1976, no. 115; *Onchi Kōshirō hanga shū* 1977,
no. 193
1988.3-15.67

Following the successful completion of the
series 'One Hundred New Views of Tokyo',
to which Onchi was the most important
contributor, this even more ambitious series
was begun in 1938 as an act of confidence by
the Creative Print Movement under Onchi's
by now generally admitted leadership, but
had reached only no. 39 by 1941 when it had
to be discontinued because of the expansion
of war. It is chosen here as the new type of
landscape style hesitatingly begun by Kanae
Yamamoto on clear enough French models,
and matured into a manner entirely suited
both to the Japanese scene itself and to the
expressive possibilities of the woodblock
medium as practised by the movement. Of
Onchi's many achievements perhaps the
greatest is his unerring colour sense, well
demonstrated in this subtle view of a
Kyūshū spa resort.

FURTHER READING Sabato Swinton, Elizabeth de,
*The Graphic Art of Onchi Kōshirō: Innovation and
Tradition*, New York and London, 1986

240

KŌSAKA GAJIN (1877–1953)

241 **Shrine among trees**

c. 1950
Seal: Gajin
Woodblock print; 390 × 527 mm
Provenance: Robert Vergez Collection
1987.3-16.411

Kōsaka is known today for a small group of
black and white prints designed, cut and
printed by the artist himself in the last few
years of his life. They are characterised by a
vivid confrontation of black and white
which excels in dynamic energy even the
work in a similar vein by Hiratsuka Un'ichi
in the 1940s and 50s. It does so because of
his unique technique of cutting the blocks so
that they print like very wet strokes of brush
and ink on absorbent paper. Yet they are
unlike any ink-painting because of the
massiveness of the blocks of black and the
sense of incandescent light drawn from the
white paper. Kosaka until then had an

241

undistinguished career as a painter in both
Japanese and international styles and as a
minor printmaker. He was not the first or
the last Japanese artist to emerge from
conventionality in his late years to produce
at the last something remarkable (see also
no. 247 by Hoshi Jōichi).

242

YOSHIDA MASAJI (1917–71)

242 *Shizuka (nagare)*
('Silence No. 74')

1958
Signature: Masaji Yoshida (in pencil)
Colour woodblock print, no. 3 in an edition of 50;
831 × 551 mm
Provenance: Robert Vergez Collection
1985.10-23.024

Masaji (often so-called to distinguish him
from a number of other print-artists with the
surname Yoshida) had a relatively short life
filled with much sadness and difficulty. It
was his special achievement to express
these emotions in works of great beauty
which speak also of peace and hope.
Though a Western-style painter by training,
he found his true medium in the abstract
woodblock print which Kōshirō Onchi had
brought to its high point in the ten years
after 1945. One of Onchi's last pupils, he is
said to have been considered his best by the
old master; history has already begun to
confirm that view. Masaji is a supreme
colourist in the muted palette which often
recalls the moss, rocks and gravel of a Zen
garden, and his technique of printing his
blocks on very wet paper produces a sense
of natural mist and damp. In this print there
are certainly such Zen echoes. The sense of
space and silence behind the apparent
surface is remarkable.

HAGIWARA HIDEO (b. 1913)

243 *Yoroeru hito 18*
('A man in armour 18')

1963
Signature: Hideo Hagiwara (in pencil)
Colour woodblock print, no. 5 in an edition of 30;
 885 × 668 mm
Provenance: Gaston Petit Collection
1986.3-21.0217

Hagiwara has some claims to be Japan's
greatest living artist in the woodblock
medium. His long career, punctuated by
periods of painting in which he has seemed
to gather new energy, has been one of
energetic creativity and constant innovation
in the possibilities of woodblock printing.
His refusal to stand still and his openness to
influence from the international art world
have sometimes led him up blind alleys, but
he has always been able to abandon
mistakes and return to ever-maturer
explorations of the dense, abstract manner
which is his glory. This large, virtuoso print
is a remarkable example of the passionate
intensity of Hagiwara's colours and textures
at their best. The depth of colour results
from first printing the back of the paper
with dense, dark colour which seeps
through to the front to provide a strong
base.

FURTHER READING Hagiwara, Hideo, *Hagiwara
Hideo hanga shū*, Tokyo, 1982

243

YAMAGUCHI GEN (1903–76)

244 'A Fedrifuge'

1964
Signature: Gen Yamaguchi (in pencil)
Colour woodblock print, no. 9 in an edition of 50;
 834 × 630 mm
Provenance: Gaston Petit Collection
1986.3-21.0848

Yamaguchi was an entirely self-taught artist
who early in his life fell in with the Creative
Print Movement. After the war, he was a
regular associate of Kōshirō Onchi, who
was the most dominant influence on his
work and steered him in the direction of
large-scale woodblock abstracts printed in
restrained colours. Intellectually more
restless and less secure than Onchi, he
developed a greater dynamism of structure
suitable to the rather nervy psychological
interests which lie at the heart of his work.
This compelling composition is mistakenly
titled – it should read 'A Febrifuge', an
obscure word meaning 'a cure for fever'.

FURTHER READING Yamaguchi Gen Society,
Yamaguchi Gen hanga shū, Numazu, 1983

244

245

ONOGI GAKU (1924–76)

245 'Landscape – T.L.W.'

1974
Signature: G. Onogi (in pencil)
Silkscreen print with embossing, no. 8 in an
 edition of 13; 680 × 640 mm
1984.10-22.01

Moving from early figurative works through
a more derivative abstract expressionism,
Onogi had by 1968 developed his mature
style of mesmerically strange shapes
painted or screen-printed in shades of blue.
In these the dark always dominates over the
light which appears to be struggling to
emerge. Perhaps the eerie power of his work
can only be explained in terms of the images
it uses from the unconscious mind, the
more disturbing because painted or printed
with extreme precision (a lesson learned
from the European surrealists). All of these
works are called *fūkei*, meaning in Onogi's
sense 'internal landscapes'. The letters and
numbers which identify them refer to their
year of composition.

FURTHER READING Sugawara, Takeshi (ed.), *Gaku
Onogi fūkei*, Tokyo, 1980

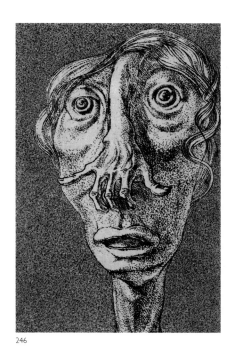

246

HAMADA CHIMEI (b. 1917)

246 *Kao* ('Face')

1976
Series: *Kumori nochi hare* ('Cloudy then Fair'), pub.
 16 November 1977
Signature: 'Chimei H.' (in pencil)
Publisher: Gallery Hiro, Tokyo; *printers*: Yamamura
 Motoo and Yamamura Tsuneo
Etching and aquatint, no. 13 in an edition of 50;
 430 × 335 mm
1985.6-14.046 (2)

This portfolio of ten prints explores
Hamada's sense of horror in terms of a
comic futility. Other titles include 'Slightly
Neurotic', 'I don't Care! I don't Care!' and
'Somehow I'll Manage'. The overwhelming
emotion, as in all his work, is of pathetic
loneliness. This is found too in his strange,
small-scale bronze sculptures. Hamada's
apparently simple, surrealist images,
painted in this portfolio in reticent pale
browns, have proved to have the quality of
lingering in the mind. It is this that has
made his work, produced in small quantity
and limited editions, so sought after by
connoisseurs of the contemporary print.

FURTHER READING Hamada, Chimei, *Hamada
Chimei sakuhin shū*, Tokyo, 1982

247

HOSHI JŌICHI (1913–79)

247 *Takai kozue (B)*
('High Treetops (B)')

1976
Signature: Jōichi Hoshi (in pencil), inscribed
 'Especially made for John and Sandy
 [Milne-Henderson]'; *seal*: Hoshi
Colour woodblock print with gold leaf;
 741 × 479 mm
Provenance: John and Sandy Milne-Henderson
 Collection
1987.5-30.01

Hoshi's intricate woodblock prints were
usually made in editions of between seventy
and 100, but he was known to make a few

extra unnumbered proofs for his friends.
They included the Milne-Hendersons, who
got to know him in his last years and made
his work known in England. Hoshi had
produced not especially interesting
abstracts in the 1950s, and considerably
more exciting works on the theme of stars
and constellations in the 1960s; but in his
last ten years he found his inspiration in his
love of trees, developing his considerable
skills in woodblock cutting and printing in
the direction of ever greater complexity and
finesse. He also moved towards formats and
compositions which were closer to
traditional painting.

248

has managed to add to a photograph of his daughter the monumental dignity which this great portrait so powerfully expresses.

FURTHER READING Fuji Television Gallery, *Noda Tetsuya zen sakuhin 1964–1978*, Tokyo, 1978

KAWACHI SEIKŌ (b. 1948)

249 'Double Image'

1982
Signature: S. Kawachi (in pencil)
Woodblock print, no. 21 in an edition of 30;
 978 × 686 mm
1985.6-14.031

Kawachi's editions have never been large, since he does all his carving and printing himself in the pure Sōsaku Hanga tradition. Naturally this has become more demanding as the scale of the prints has increased and, for the largest, editions may be only five or ten copies. Some of the strength and energy needed to force the images into these large sheets from behind, using the quite small traditional *baren* pad, can be felt in this typically troubled and nervous image. Many serious Japanese printmakers have avoided direct or even indirect reference to the undeniable stresses imposed on human beings by contemporary life, nowhere more obvious than in the huge megalopolises of Japan. Kawachi has consistently faced them and converted them into images of intolerable tension which draw their life from the excited surfaces he is able to produce with a wide range of cutting, gouging and scratching of the blocks, and careful choice of lively grains.

FURTHER READING Okada, Takahito, *et al.* (eds), *Kawachi Seikō zen hanga 1968–1987*, Tokyo, 1987

NODA TETSUYA (b. 1940)

248 'Diary: June 24th '78'

June 1978
Signature: T. Noda (in pencil), with his finger print
Mimeograph and silkscreen with woodblock, no. 2
 in an edition of 25; 978 × 628 mm
1983.10-3.011

All Noda's prints are simply titled with a diary date, and almost all are based on the artist's own photographs as their starting-point. In this sense they are exceptionally personal. In spite of this Noda's reputation is higher in the international circuit of art-printmakers than that of any other Japanese, even of Akira Kurosaki. He mimeographs versions of his photographs, increasingly, as he gets older, altered by hand on the plate, and prints this version through a silkscreen. Backgrounds are filled in with white in woodblock, though he is careful to leave a margin of the beige paper, which adds a sense of age and distance. It is perhaps futile to ask how he

249

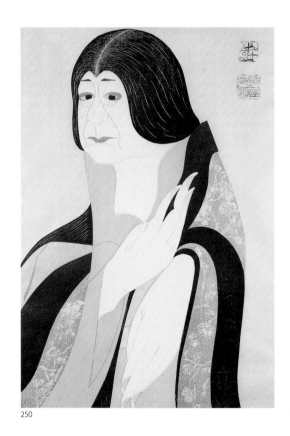

250

TSURUYA KŌKEI (b. 1946)

250 **The actor Onoe Baikō VII as Mokuzume in** *Tamamo no Mae Kumoi no Hareginu*

October 1984
Seal: Tsuruya Kōkei
Colour woodblock print, no. 11 in an edition of 45;
 398 × 275 mm
1986.7-7.05

In recent years no Japanese print-artist has achieved such sudden celebrity as Kōkei, who began in 1978 to record contemporary Kabuki theatre actors in performance in very small editions of prints, the blocks for which he then destroyed. With increasing fame and demand, the editions have grown bigger but are still by no means large. His refinement of technique (he does all his own cutting and printing) and the delicacy of the thin, almost transparent paper he uses contrast strangely with the grotesque exaggerations of his portraits, dominated by oversized and disturbingly expressive hands. Kōkei has found, by an infusion of racy, cartoon-like style, a way to revive the old tradition of popular Kabuki portraiture and has placed himself firmly in it.

The Baikō line of actors has always specialised in *onnagata* (female impersonator) parts. *Onnagata* have traditionally offered a special challenge to the artist.

FURTHER READING Pacific Asia Museum, Pasadena, *The Woodblock Prints of Tsuruya Kōkei*, Pasadena, 1989

247

CHRONOLOGY

Japanese art periods as used in different sources have many confusing variants. The system used here is based on that found in the *Kodansha Encyclopaedia of Japan*. The word 'period' (Japanese *jidai*) means an arbitrarily chosen length of time corresponding to recognisable cultural tendencies (for example, Edo period). The word 'era' (Japanese *nengō*) means a relatively short length of time with a specific name in the Japanese historical calendar (for example, Kambun era). In this table only particularly significant or often-quoted eras are mentioned.

Jōmon period
c. 10,000 BC–*c.* 300 BC
Variously divided by different archaeologists

Yayoi period
c. 300 BC–*c.* AD 300

Kofun ('great tombs') period
c. AD 300–mid-6th century AD

Asuka period
mid-6th century–AD 710

Nara period
AD 710–794

Heian period
AD 794–1185
Sometimes called Fujiwara

Kamakura period
1185–1333

Muromachi period
1333–1568
Sometimes called Ashikaga

NB The period 1333–92 is sometimes separately listed as **Nambokuchō** – 'The Northern and Southern Courts'

Momoyama period
1568–1600
Sometimes called Azuchi-Momoyama. For variants see Introduction, p. 9.

Edo period 1600–1868	Kambun era 1661–1673
	Genroku era 1688–1704
Modern period 1868–	Meiji era 1868–1912
	Taishō era 1912–1926
	Shōwa era 1926–1989
	Heisei era 1989–

GLOSSARY

Ainu A Japanese ethnic group now inhabiting the northern island, Hokkaidō, once spread throughout Japan.

aragoto 'Rough stuff' – the bombastic acting style of Kabuki theatre in Edo.

aware Melancholy sense of transience, typical of courtly culture.

ayasugi 'Cryptomeria twill' – a sinusoidal grain in sword blades.

baren A coil of hard rope in a shallow lacquered *papier-mâché* dish, covered with a bamboo leaf, used to take an impression of a woodblock print by hand pressure.

beni Pale crimson colour derived from safflower petals used in woodblock prints.

beni-e Prints hand-coloured with *beni*.

benizuri-e Prints printed in green and *beni*.

bijinga Pictures of beautiful women.

bikuni A female entertainer dressed as a travelling nun.

bokashi Wiping of woodblocks to produce gradated tones on a print.

bokutō A wooden sword, either talismanic or simply in imitation of a sword, or for *kendō* practice.

Bugaku A masked dance-drama associated with Shintō shrines.

bunjin Literati of China, Korea and Japan who practised painting, poetry, music and other accomplishments.

Bunraku Puppet theatre.

bussho Temple workshop, especially for sculpture.

byōbu A folding screen.

byōbu-e A painted folding screen.

Chadō (or Sadō) 'The Way of Tea'.

chagama Iron kettle for the Tea Ceremony.

chaire Tea-caddy.

chaji The most complete form of Tea Ceremony including a light meal.

Cha-no-yu The usual Japanese term for the Tea Ceremony.

chashaku Bamboo scoop for powdered tea.

chashitsu Tea-room for the Tea Ceremony.

chawan Bowl for drinking tea.

chinkinbori Lacquerware with decoration in finely carved outlines filled with gold.

daimyō The samurai governor of a province.

dan Chapter in classic literature.

dōhoko Ritual bronze spear of the Yayoi period.

dōtaku Bronze ritual bells of the Yayoi period.

Edokoro The Imperial Painting Office in Kyoto.

ema Painted wooden panels, usually of horses, offered to Shintō shrines.

e-maki (mono) Handscroll with pictures.

fuchi Sword-hilt fitting.

fūkeiga Landscape pictures.

fukigaeshi Two swept-back flaps either side of the front of a helmet.

Fukkō Yamato-e Revivalist Yamato-e school of painting which began in the late eighteenth century.

funamanjū Boat prostitute.

furosaki-byōbu Low folding screen used in the Tea Ceremony.

fusuma-e Sliding door made of paper over a wooden lattice, decorated with paintings.

fūtai Traditional hanging tabs at the top of a hanging scroll.

fūzokuga Genre painting (particularly of the Momoyama and Edo periods).

geisha A professional entertainer, usually female, particularly at parties in the pleasure quarters.

Gigaku A masked processional dance-drama popular during the Nara period.

gofun White pigment made from powdered shell.

gomabashi Chopsticks used in Buddhist ritual.

gosaide Five-coloured enamelled Kutani porcelain.

goyō eshi Title of an official painter to the shogun.

gunome An abruptly undulating *hamon* on a sword blade.

guri Layered lacquer or metalwork surface with repeated carved arabesques revealing the separate layers.

habaki Metal fitting which retains a blade firmly in its scabbard.

Haji ware Low-fired red household pottery of the Kofun period and later, sometimes found in tombs together with Sue ware.

hakubyō Monochrome painting in small formats, done in very detailed brushwork in black on white paper.

hamon The crystalline edge pattern on a sword blade.

hanaire Flower-vase.

haniwa Pottery models set in the ground at the sites of burial mounds of the Kofun period.

Hannya The Nō character of a woman transformed into a demon.

hanshita-e Sketches to guide the cutting of woodblocks for prints.

harimise A room facing the street in which courtesans could be viewed.

heidatsu Nara period technique of inlaying metal level with the surface of lacquerware.

hiragana Cursive phonetic writing style originally developed in the early Heian period.

hiramakie *Makie* lacquer applied level with the surface.

Hōin 'Seal of the Law' – a Buddhist title sometimes granted to artists and craftsmen.

hōkyū The 'Treasure Jewel' – a Buddhist symbol.

Hōraizan The Island of Immortality described originally in Chinese legend, often found as a motif on mirrors.

hosoban Small, narrow-format woodblock print.

hyōgo-mage A hair-style with the hair turned back in loops.

hyōgu The mounting of silk or paper paintings.

ichiboku zukuri Sculpture from a single block of wood.

iki Lively stylishness, a concept particularly used in the Edo period.

Imari Traditional name of porcelain shipped via the port of Imari in Kyūshū.

in Yin, the female principle in Chinese Daoist philosophy.

inrō Multi-compartmented medicine or seal container carried suspended from the sash of the kimono, and usually of lacquered wood.

ishimeji A hammered metal surface effect simulating stone.

itame 'Wood plank' grain on a sword blade.

jimbaori An armour surcoat.

jinie *Nie* on the *ji*, or ground, of a sword blade.

ji-tsubushi Techniques of printing the background of a woodblock print in a single colour.

Kabuki Popular urban theatre beginning in the seventeenth century.

kagami hada 'Mirror skin' – a grain on sword blades which is so fine as to be virtually invisible.

kagamibuta 'Mirror lid' – type of netsuke with a metal disc set in a surround of wood or ivory.

kagura Ancient ritual Shintō drama, performed mostly in rural areas.

kakemono Painting in hanging-scroll format.

kamaboko-bako 'Fish-sausage box' – a round-lidded chest in European shape.

kamadogami 'Hearth god' – often represented by a very large mask.

Kamakurabori Technique of carving wood in sunken relief and then lacquering it red and/or black, named from the town of Kamakura.

Kambun (1) Name of the era 1661–73, used to characterise a style of swordmaking and also a fashion of female beauty.

kambun (2) Japanese literature written entirely in Chinese characters and with a Chinese sentence structure.

Kanga Chinese-style landscape paintings of the Muromachi and Momoyama periods.

kanshitsu Hollow sculpture formed of moulded layers of textile soaked in lacquer.

Kanze school One of the schools of Nō, based in Kyoto.

Kara-e Painting from China, or in Chinese style – a term used mainly in the Heian period.

kara-zuri *Gaufrage* (embossed) printing technique.

kashihon'ya Itinerant book lender in the Edo period.

kashira Sword-hilt pommel.

katana A long sword worn thrust through the *obi*.

kendō The 'way of the sword' – the theory and practice of fencing.

kentō A technique of colour registration for prints using notches cut into the blocks.

kimmade Inlaid lacquer tradition derived from Burma and Thailand.

Kimpira-bon Seventeenth-century illustrated books of adventure stories, printed simply in black and white.

kinchaku Purse.

kira-zuri Ground mica used to fill in the backgrounds of colour prints.

kirin Mythical quadruped with a lion's tail, cloven hooves and the scales of a dragon.

kissaki The point section of a sword blade.

Kōdaiji *makie* Momoyama period style of *makie* decoration on lacquerware typified by the collection in the Kōdaiji Temple in Kyoto.

kofun Burial mounds of the Kofun period (fourth to sixth centuries).

kōgai A form of bodkin kept in a slot in a sword scabbard.

kokatana Utility knife kept in a slot in a sword scabbard.

Ko-Kutani Old (seventeenth century) Kutani porcelain ware.

komade 'Spinning top' – a design technique of lacquerware decorated in rings of different colours, derived from southern China.

kongōtai A technical term in esoteric Buddhism, meaning ultimate reality.

konuka hada 'Rice flower skin' – a close-packed form of *mokume* grain on sword blades.

kotō 'Old swords' – those made before the Momoyama period.

kyōka 'Crazy verse' – a thirty-one-syllable comic poetic form, flourishing in the Edo period.

magatama Comma-shaped ritual beads, usually of stone, often found in *kofun*, though of greater antiquity on the continent of East Asia.

makie Literally 'sprinkled pictures' – lacquer coloured with gold or other dust or filings.

makkinrō Method of decoration by scattering gold filings over a design painted in lacquer.

mandara *Mandala* – a schematic painting in esoteric Buddhism.

manjū A type of netsuke in the shape of the *manjū*, a round bun filled with sweet bean paste.

masame A straight longitudinal grain found on sword blades.

mattcha Powdered tea used in the formal Tea Ceremony.

midareba A 'wild', or undefined *hamon*.

mikaeri The pose of a person looking back over the shoulder.

mingei 'Folk crafts' – a term first used by Yanagi Sōetsu in 1926.

mitate-e 'Parody picture' – traditional subjects reworked in an up-to-date, often humorous style.

mitsuda-e Method of painting on a lacquered surface with oil-based pigments.

mizusashi Water jar for the Tea Ceremony.

mokkō A four-lobed shape.

mokume A pattern on sword blades with concentric whorls resembling a complex wood grain.

mon The badge of an aristocratic or samurai family, or of a business.

moriage Technique of building a painting surface up in relief with *gofun*.

mukade 'Centipede' – a Momoyama period style of *tsuba* decoration.

namban 'Southern barbarian' – a Momoyama period term describing non-Japanese, and particularly Europeans.

nanako 'Fish roe' – a metalwork surface texture done with a hollow punch.

Nanga 'Southern painting' – a Chinese Song Dynasty ink-painting style affected by *bunjin*.

nashiji The pearskin effect in lacquerware, created by sunken scattered metal filings.

Negoro A technique of lacquering wood vessels and furniture with red over a black ground.

nehanzu Painting of the death of the historical Buddha.

Nenjū Gyōji The annual events of the Imperial court.

netsuke Decorative toggle to fix *sagemono* in the *obi*.

nie Metallic crystals on a sword blade, individually distinguishable.

nigoshide An opaque white porcelain glaze.

Nihonga Late nineteenth- and twentieth-century school of painting in Japanese style using traditional techniques.

nioi 'Fragrance' – a white structure in the *hamon* of a sword blade in which the crystals of steel are not individually distinguishable.

nishiki-e 'Brocade pictures' – a term for woodblock prints using many colours.

Nō A classical drama characterised by very slow movements with chanted accompaniment.

noborigama Type of kiln with linked chambers rising on a hillside.

noren The short dividing curtain over the door, especially of a shop or business.

notare A gently undulating *hamon*.

nuno-zuri Prints embossed with the texture of textile weave.

obi The sash of the kimono.

ojime A drawbead used to tighten the cords of *sagemono*.

okabasho Unlicensed pleasure quarter.

okimono An ornamental sculpture with no practical use, mainly made in the Meiji period.

ōkubi-e A half-length or head-and-shoulders portrait in the woodblock print.

onagadori A long-tailed bird.

onnagata Female roles acted by male actors in Kabuki theatre.

otogi-zōshi 'Servant's tales' – fairy stories, often illustrated in album or handscroll form.

ōyoroi Style of armour developed in the Heian period.

raden The technique of inlaying pieces of shell in lacquer.

rakan A legendary disciple of the historical Buddha.

renka Linked verses, usually improvised by a group of poets.

Rimpa 'The School of Kōrin' – eighteenth- to nineteenth-century school of painting named after Ogata Kōrin (1658–1716).

roji Path leading from the waiting-room of a tea-house across its garden.

sabi 'Rust' – the patina on objects caused by the passing of time – especially used in Tea Ceremony aesthetics.

Sadō (or Chadō) 'The Way of Tea'.

sagemono 'Suspended things' – items such as *inrō* carried suspended from the *obi*.

sahari Alloy of copper with tin and lead.

sakoku National policy of isolation from the rest of the world, effective between 1639 and 1854.

sambasō Comic street or theatre dance at New Year.

samurai The hereditary military class.

sankōshō Three-pronged *vajra* (ritual thunderbolt, a Buddhist symbol).

satori 'Enlightenment' (Buddhist).

sekkyō jōruri A type of popular ballad singing.

sennin Chinese Daoist immortals, often represented in netsuke.

senryū Seventeen-syllable comic verse, popular in the Edo period.

sentoku A form of brass.

seppa Metal spacers fitted either side of the *tsuba*.

shakudō An alloy of copper with a small percentage of gold, patinated to a lustrous blue-black.

shakuhachi A form of flute.

shamisen A three-stringed musical instrument associated with the popular theatre and entertainment in general.

shibai-jaya Theatre tea-house.

shibui 'Astringent' – the Japanese concept of austere good taste.

shibuichi Alloy of copper with about one-quarter silver, especially used in sword-fittings.

Shijō School of painting of Matsumura Goshun (1752–1811) and his followers.

shiki fūzoku-e Paintings of pleasures and pastimes illustrating the four seasons.

shikoro Neck-guard around the sides and back of a helmet.

Shin Hanga Revivalist woodblock printing style begun by the publisher Watanabe in 1915.

Shinden An architectural style of noble houses and palaces developed in the early Heian period.

Shingon An esoteric Buddhist sect.

shinogi The ridge on a sword blade.

Shintō (1) 'The Way of the Gods' – the native religion of Japan.

shintō (2) 'New swords' – those made after the Muromachi period.

shirazaya Plain wood mounting for storing sword blades.

shishi A mythical form of lion-dog associated with precipices and peonies. Figures of a pair of *shishi* often guard the approaches to Buddhist temples and Shintō shrines.

shitamachi A 'downtown' area (particularly in Edo).

shoin-zukuri Classic domestic architectural style originating in the late fifteenth century.

Shugendō Religious sects combining Buddhist and native ideas, and centred on worship in mountains.

Somada Family name, and their technique of lacquerware using fine shell inlay.

sometsuke A type of porcelain decorated with underglaze blue.

Sōsaku Hanga 'Creative Print' – a twentieth-century movement of artists following European practices of printmaking.

Sue ware High-fired grey burial pottery of the Kofun period.

sui 'Chic' – a term especially used in the Edo period.

suebako Tray for Buddhist paraphernalia or scriptures.

sumie-makie Lacquer technique producing designs in imitation of ink-painting.

sumizuri-e Black and white woodblock print.

suzuribako A box containing writing-equipment.

tachi A long sword carried suspended by cords or chains.

takamakie Gold lacquer work in high relief.

tan Orange lead pigment, used especially on early Ukiyo-e prints and books.

tanroku-bon Printed books hand-coloured in green and orange (seventeenth century).

tantō Dagger.

tarashikomi Technique of 'puddling' the wet ink or colours, used by painters of the Rimpa school.

tatami The standard flooring mats in traditional Japanese architecture.

Tendai An esoteric Buddhist sect.

tengai A canopy suspended over Buddhist images.

Tenka-Ichi 'First under Heaven' – a title sometimes conferred on craftsmen, especially metalworkers.

Three Friends, the The decorative motif of pine, plum and bamboo.

togidashi Technique of highly polished gold lacquer decoration.

tokonoma Alcove for the display of a hanging scroll, flower arrangement or ornament.

tōramba *Hamon* resembling the waves of the sea.

torii The gateway on the approach to a Shintō shrine.

tsuba Sword guard.

tsuikoku Carved black lacquer.

tsuishū Carved red lacquer.

tsukinami fūzoku-e Paintings of events associated with the twelve months.

tsuya-zuri Burnishing to obtain a texture on prints.

uchigatana A long sword.

ukiyo 'Floating world' – the world of urban pleasures in the Edo period.

Ukiyo-e Paintings and prints of the 'floating world' of urban pleasures (seventeenth to nineteenth centuries).

urushi-e 'Lacquer pictures' – woodblock prints with glue added by hand over black areas to imitate the shiny surface of lacquer.

usagi Rabbit or hare.

usucha Weak tea.

utsuri A white shadow-like structure on the ground of a sword blade.

wabi Restrained good taste, the central aesthetic concept of the Tea Ceremony.

waka The classical thirty-one-syllable verse form.

wakashū A young urban dandy, especially in the early Edo period.

wakizashi The shorter of the samurai's two swords.

Wanli Chinese period (1573–1619), and name of the style of porcelain made during it.

Yamato-e The native Japanese painting tradition characterised by bright, clear colour.

yatate A writing-brush holder.

yō Yang, the male principle in Chinese Daoist philosophy.

Yōga Western-style painting.

yosegi zukuri Hollow wood sculpture technique using many separate components.

Yoshiwara The government licensed pleasure quarter in the city of Edo.

yotaka 'Nighthawk' – a street prostitute.

zushi Portable shrine with doors, used to hold religious images or texts.

BIBLIOGRAPHY
RELATING TO THE JAPANESE COLLECTIONS
IN THE BRITISH MUSEUM

ABBREVIATIONS

BMQ *British Museum Quarterly*

TPJSL *Transactions and Proceedings of the Japan Society, London*

ANDERSON, William, 1886. *Catalogue of the Japanese and Chinese Paintings in the British Museum*, 2 vols, London

–1886a. *The Pictorial Arts of Japan*, London

–1895. *Japanese Wood Engravings: Their History, Techniques and Characteristics*, London

ANON. 1965. 'A Fourteenth-century Japanese Cult Portrait of the Buddhist Priest Jion Daishi', *BMQ*, vol. XXIX (nos 3–4), 120

BARKER, Richard, and SMITH, Lawrence, 1976. *Netsuke: The Miniature Sculpture of Japan*, British Museum, London

BARRETT, Douglas, 1973. *Chinese and Associated Lacquer from the Garner Collection*, British Museum, London

BINYON, Laurence, 1916. *A Catalogue of Japanese and Chinese Woodcuts Preserved in the British Museum*, London

–1916a. 'The Art of Asia', *TPJSL*, vol. XIV, 2–23

–1927. 'Exhibitions III: Japanese Colour-Prints', *BMQ*, vol. I (no. 4), 111–12

–1927. 'Japanese Colour-Prints', *BMQ*, vol. II (no. 1), 27–8

–1927. 'Japanese Prints: Mr R. N. Shaw's Gift', *BMQ*, vol. II (no. 2), 53–4, pl. XXXIII

–1927. 'Japanese Screens', 'Japanese Paintings and Prints', *BMQ*, vol. II (no. 3), 65–6

–1928. 'Japanese Paintings and Prints: Recent Accessions', *BMQ*, vol. III (no. 2), 53–4

–1930. 'Japanese Prints: Persian Miniatures', *BMQ*, vol. V (no. 2), 65, pl. XXXII

–1931. 'Tiger by Ganku', *BMQ*, vol. VI (no. 1), 13–14, pl. IX

–1931a. 'Japanese Prints: R. N. Shaw Gift', *BMQ*, vol. VI (no. 2), 44–5

–1932. 'Japanese Prints and Paintings', *BMQ*, vol. VII (no. 1), 10–11

–1933. 'A Woodcut by Okumura Masanobu', *BMQ*, vol. VIII (no. 2), 72

–1934. *Painting in the Far East*, London

BINYON, Laurence, and SEXTON, J. J. O'Brien, 1923. *Japanese Colour Prints*, London, reprinted edn 1960

BOWES, James L., 1890. *Handbook to the Bowes Museum of Japanese Art Work, Liverpool*, Liverpool

BRANDT, Klaus J. 1977. *Hosoda Eishi, 1756–1829*, Stuttgart

BRITISH MUSEUM, 1887. *A Guide to the Chinese and Japanese Illustrated Books, etc.*, London

–1964. *Netsuke – List of Exhibits*, London

–1977. *Japanese Paintings and Prints – Schools of Ganku and Bunchō*, exhibition handlist by Lawrence Smith, London

–1981. *Edo Art of Japan 17th–19th Century*, exhibition handlist, London

–n.d. *Japanese Paintings 17th–19th Century, from the Harari Collection*, exhibition handlist, London

CHIBBETT, David, 1977. *The History of Japanese Printing and Book Illustration*, Tokyo

CLARK, John, 1989. 'Japanese Etchings in the British Museum: Brief Checklist of Japanese Titles', unpublished typescript in the Department of Japanese Antiquities

CONDER, Josiah, 1911. *Paintings and Studies by Kawanabe Kyōsai*, Tokyo

CRIBB, Joe, 1983. 'Some Japanese Forgeries', *IBSCC/IAPN Bulletin on Counterfeits*, vol. 8 (no. 1)

–1987. 'Nezumikin – A Group of Japanese Coin Imitations', *Swiss Numismatic Revue*, vol. 66, 205–19

CRIGHTON, Robin A., 1973. *The Floating World: Japanese Popular Prints 1700–1900*, London

DARRACOTT, Joseph, 1979. *Art for All: The Ricketts and Shannon Collection*, Cambridge

DOUGLAS, Robert Kennaway, 1898. *Catalogue of the Japanese Printed Books and Manuscripts in the Library of the British Museum*, London

–1904. *Catalogue of Japanese Printed Books and Manuscripts in the British Museum acquired during the years 1899–1903*, London

EVANS, Tom and Mary Anne, 1975. *Shunga: The Art of Love in Japan*, London

FLEMING, Lore E., 1983–4. 'The Migration of the Art of Papermaking from the Far East', *IPH Yearbook of Paper History*, vol. 4, 353–71

–1984. 'The Japanese Print and its Conservation', *Orientations* (March), 14–29

–1988. 'Managing the Repair of a Collection of Japanese Printed Books', *IIC Preprints of the Contributions to the Kyoto Congress 'The Conservation of Far Eastern Art'*, 25–9

FORRER, Matthi (ed.), 1982. *Essays on Japanese Art Presented to Jack Hillier*, London

–1988. *Hokusai*, New York

FRANKS, Augustus W., 1876. *Catalogue of a Collection of Oriental Porcelain and Pottery Lent for Exhibition*, Bethnal Green Branch Museum, London

FUKUDA, Kazuhiko, 1989. *Ukiyo-e yōroppa korekushon*, Tokyo

GARNER, Harry, 1979. *Chinese Lacquer*, London

GITTER, Kurt A., and FISTER, Pat, 1985. *Japanese Fan Painting from Western Collections*, Museum of Art, New Orleans

GOWLAND, William, 1899. *The Dolmens of Japan and their Builders*, London

–1914. 'Metals and Metalworking in Old Japan', *TPJSL*, vol. XIII, 19–99

–n.d. *Dolmen Collection: Objects from Japanese Burial Mounds and Dolmen*, London

GRAY, Basil, 1932. 'A Sixteenth Century Tosa Roll', *BMQ*, vol. VI (no. 4), 100–1, pl. XLI

–1934. 'A Dragon Painting by Tani Bunchō', *BMQ*, vol. IX (no. 1), 2–3, pl. II

–1935. 'Japanese Prints', *BMQ*, vol. IX (no. 3), 91

–1936. 'A Gift of Japanese Prints', *BMQ*, vol. X (no. 3), 93–4, pl. XXIX

–1938. 'Recent Acquisitions of Japanese Paintings', *BMQ*, vol. XII (no. 2), 47–8, pls XVI–XVII

–1938a. 'Japanese Prints from the Tuke Collection: The Kō Signature', *BMQ*, vol. XII (no. 3), 96–9, pls XXXIV, XXXV

–1939. 'The Tuke Collection', *BMQ*, vol. XIII (no. 2), 47–8

–1948. *The Work of Hokusai – Woodcuts, Illustrated Books, Drawings and Paintings: A Catalogue of an Exhibition held on the Occasion of the Centenary of his Death*, British Museum, London

–1952. 'The Raphael Bequest II: Oriental Antiquities and Japanese Colour Prints', *BMQ*, vol. XV, 91–2, pl. XXXVIII

–1953. 'Sloane and the Kaempfer Collection', *BMQ*, vol. XVIII (no. 1), 20–3

–1955. *Japanese Screen Painting*, Faber Gallery of Oriental Art Series, London

–1957. 'Western Influence in Japan', from *Britain and Holland*, vol. 9 (no. 2), Anglo-Netherlands Society, London

–1961. 'Fudō', *BMQ*, vol. XXIV (nos 1–2), 46–50

–1962–3. 'A New Portrait of Shōtoku Taishi', *BMQ*, vol. XXVI (nos 1–2), 47–9, pl. XXVII

–1963. 'An Utamaro Painting', *BMQ*, vol. XXVI (nos 3–4), 110–11, pl. LX

–1968. 'A Medieval Japanese Painting of the Twelfth Century', *BMQ*, vol. XXXII (nos 3–4), 123–5, pls XLI–XLIV

GROOT, G. T., 1952. *The Shell Mounds of Ubayama*, Archaeologia Nipponica, vol. II

HARRIS, Victor, 1986. 'Japanese Swords and the Bizen Tradition', *Arts of Asia*, vol. 16 (no. 3, May/June), 125–9. (Special issue on the Department of Oriental Antiquities, British Museum)

–1986. 'Gigaku Mask', *Orientations* (September), 26–8

–1987. *Netsuke: The Hull Grundy Collection in the British Museum*, London

–1989. 'Japanese swords', in *Swords and Hilt Weapons*, London, 148–71

HAYASHI, T., NAKAMURA, M., and HAYASHIYA, S. 1974. *Japanese Art and the Tea Ceremony*, Heibonsha Survey of Japanese Art 15, Tokyo

HILLIER, Jack, 1955. *Hokusai: Paintings, Drawings and Woodcuts*, London, reprinted 1978

–1960. *The Japanese Print: A New Approach*, London

–1961. *Utamaro*, London

–1966. *Japanese Colour Prints*, London, reprinted 1975

–1966a. *Japanese Drawings: From the 17th to the end of the 19th century*, London

–1970 and 1973. *The Harari Collection of Japanese Paintings and Drawings*, 3 vols: 1 *Genre and Ukiyo-e School*, 2 *Hokusai and his school and Hiroshige*, 3 *Kanō/Decorative/Nanga/Maruyama/ Shijō/Independents/Fans*, London

–1974. *The Uninhibited Brush: Japanese Art in the Shijō style*, London

–1979. 'Source-books for Japanese Craftsmen' (Lecture given at the London Netsuke Convention, 1978), London

–1980. *The Art of Hokusai in Book Illustration*, London

–1987. *The Art of the Japanese Book*, 2 vols, London

HILLIER, Jack, and SMITH, Lawrence, 1980. *Japanese Prints: 300 Years of Albums and Books*, British Museum, London

HOBSON, R. L., 1927. 'A Series of Japanese Mirrors', *BMQ*, vol. II (no. 3), 64–5, pls XLI, XLII

–1930–1. 'Notes on Japanese Potters', *TPJSL*, vol. XXVIII, 97–109

–1948. *Handbook of the Pottery and Porcelain of the Far East in the Department of Oriental Antiquities, The British Museum*, London, 3rd edn

HOLLOWAY, Owen E., 1957. *Graphic Art of Japan: The Classical School*, London

HULTON, Paul, and SMITH, Lawrence, 1979. *Flowers in Art from East and West*, British Museum, London

JENYNS, Soame, 1939. 'The Todd Collection', *BMQ*, vol. XIII (no. 3), 70–1, pl. XXX

–1940. 'The Kington Baker Bequest', *BMQ*, vol. XIV (no. 3), 53–4, pl. XXI

–1952. 'The Raphael Bequest II: Oriental Antiquities b. Two Japanese Masks', *BMQ*, vol. XV, 88–90, pl. XXXVII

–1953. 'Oriental Antiquities from the Sloane Collection in the British Museum', *BMQ*, vol. XVIII (no. 1), 18–20

–1953. 'The Franks Collection of Oriental Antiquities', *BMQ*, vol. XVIII (no. 4), 103–6

–1955. 'A Japanese Gigaku Mask from the Tenpyō Period (AD 710–94)', *BMQ*, vol. XX (no. 2), 50–3, pl. XVII

–1956. *Loan Exhibition of Japanese Porcelain*, The Arts Council Gallery, London

–1957. 'Japanese Lacquered Casket of the late Sixteenth Century', *BMQ*, vol. XXI (no. 2), 56–7, pl. XVII

–1959. 'A Seto Vase of the Kamakura Period (1185–1333)', *BMQ*, vol. XXI (no. 4), 104–6, pl. XXXVII

–1965. *Japanese Porcelain*, London

–1966–7. 'Japanese Lacquered Document Box of the Late 12th or early 13th Century', *BMQ*, vol. XXXI, 38–40, pls XIV, XV

–1967. 'Feather Jacket (Jimbaori) of the Momoyama Period (1573–1638) supposed to have belonged to Hideyoshi (1536–98)', *BMQ*, vol. XXXII (nos 1–2), 48–52, pls XX, XXI

–1971. *Japanese Pottery*, London

JOHNES, Raymond, 1961. *Japaniche Kunst*, London

JOLY, Henri L., 1913. *Catalogue of the H. Seymour Trower Collection of Japanese Art*, London

JOLY, Henri L., and TOMITA, Kumasaku, 1916. *Japanese Art and Handicraft*, 2 vols, London

JONES, Yolande, *et al.*, 1974. *Chinese and Japanese Maps*, British Museum, London

KŌFUKUJI (Temple) and YAKUSHIJI (Temple), 1982. *Jion Daishi mi-kage shūei*, Kyoto

KŌNO, Motoaki, 1987. *Tani Bunchō (Nihon no bijutsu no. 257)*, Tokyo

LANE, Richard, 1976. 'A Gallery of Ukiyo-e Paintings (XIV)', *Ukiyo-e* 64 (January), 81–108

–1989. *Hokusai: Life and Work*, London

Le Japonisme 1988 (Japonisumu Ten 1988). Grand Palais, Paris, and National Museum of Western Art, Tokyo

MAYUYAMA, Junkichi, 1966. *Japanese Art in the West*, Tokyo

MITCHELL, Charles H., 1972. *The Illustrated Books of the Nanga, Maruyama, Shijō and other related schools of Japan*, Los Angeles

MORRISON, Arthur, 1909. *Exhibition of Japanese Prints*, Fine Art Society, London

–1910. *Exhibition of Japanese Prints*, Fine Art Society, London

–1911. *The Painters of Japan*, 2 vols, London

Muromachi monogatari shū 1989. Vol. 1, ed. Sawai Taizō *et al.*, Tokyo

NARAZAKI, Muneshige, 1951. 'Nichigetsu shiki-zu', *Kokka* 709 (April), 154, 161, pls 4, 5

–1975. 'Hishikawa Moronobu hitsu hokurō oyobi engeki zukan ni tsuite', *Kokka* 980 (June), 9–12

–1983. 'Ganku hitsu bashō-ka byōho shōkin zu', *Kokka* 1066 (September), 2–3

Nihon byōbu-e shūsei 1979. Vol. 5 *Jimbutsuga – Yamato-e kei jimbutsu*, ed. Yamane Yūzō, Tokyo

Onchi Kōshirō hanga shū 1977. Ed. Iwabe Sadao, Tokyo

PEER GROVES, W., 1936–7. 'Some little-known Japanese Wares: Part 2', *TPJSL*, vol. XXXIV, 1–24

ROBINSON, Basil W., 1961. *The Arts of the Japanese Sword*, London

–1961. *Kuniyoshi*, London

ROYAL ACADEMY OF ARTS 1981. *The Great Japan Exhibition: Art of the Edo Period 1600–1868*, ed. William Watson, London

RUCH, Barbara (ed.), 1981. *Zaigai Nara ehon*, Tokyo

SEXTON, J. J. O'Brien, 1922. *Catalogue of Ukiyo-e selected from the O'Brien Sexton Collection*, London

SMITH, Lawrence, 1971–3. 'Japanese Porcelain in the First Half of the 19th Century', *Transactions of the Oriental Ceramic Society*, vol. 39, 43–82

–1977. 'The Early Influence of Maruyama Ōkyo's New Style: A Handscroll by Komai Genki in the British Museum', in *Artistic Personality and Decorative Style in Japanese Art*, ed. William Watson, London, 86–100

–1981. *Hokusai: Twelve Views of Mount Fuji*, British Museum, London

–1982. 'Japanese Prints and their Relationship with Painting', *Apollo*, vol. XCV (no. 239, January), 40–8

–1983. *The Japanese Print Since 1900: Old Dreams and New Visions*, British Museum, London

–1984. 'Netsuke and their Social Implications', *Orientations* (October), 20–7

–1985. *Contemporary Japanese Prints: Symbols of a Society in Transition*, British Museum, London

–1988. *Ukiyo-e: Images of Unknown Japan*, British Museum, London

–1988a. 'Kyūtōryū o taiji suru Susano'o no Mikoto', *Kyōsai* 36 (September), 2

–1988b. 'Daiei hakubutsukan-zō Kyōsai sakuhin (1)', *Kyōsai* 36 (September), 3–11

SMITH, Lawrence, and HARRIS, Victor, 1982. *Japanese Decorative Arts from the 17th to the 19th Centuries*, British Museum, London

SMITH, Lawrence, and MYERS, Emma, 1984. *Flowers and Birds from Imao Keinen's Album*, British Museum, London

STRANGE, Edward F., 1909–11. 'The Art of Kyōsai', *TPJSL*, vol. IX, 264–78

TAJIMA, Shiichi (ed.), 1909. *Masterpieces Selected from the Maruyama School*, 2 vols, Tokyo

TOCHIGI PREFECTURAL ART MUSEUM (Tochigi Kenritsu Bijutsukan) 1979. *Shazanrō Tani Bunchō*, Utsunomiya

TOKYO NATIONAL MUSEUM 1987. *Daiei Hakubutsukan shozō Nihon-Chūgoku bijutsu meihin ten*, Tokyo

TOKYO NATIONAL MUSEUM OF MODERN ART 1976. *Onchi Kōshirō to 'Tsukuhae'*, Tokyo

TOYAMA ART MUSEUM (Toyama Bijutsukan) 1987. *Botsugo 150-nen tokubetsuten: Ganku*, Toyama

Tōyō bijutsu taikan, 1909. Vol. 1, ed. Tajima Shiichi, Tokyo

UENO ROYAL MUSEUM (Ueno no Mori Bijutsukan) 1985. *Daiei Hakubutsukan shozō ukiyo-e meisakuten*, ed. Narazaki Muneshige, Tokyo

Ukiyo-e shūka 11 (1979). Daiei Hakubutsukan . . ., ed. Narazaki Muneshige, Tokyo

Ukiyo-e taikan 1 (1987). Daiei Hakubutsukan I, ed. Narazaki Muneshige, Tokyo

–2 (1987). *Daiei Hakubutsukan II*, Tokyo

–3 (1988). *Daiei Hakubutsukan III*, Tokyo, 1988

URASENKE TEA FOUNDATION 1985. *Rikyū to Sono Dōtō*, Kyoto

Waley, Arthur, n.d. *Catalogue of Japanese Illustrated Books* [in the Department of Japanese Antiquities, British Museum], unpublished typescript

Washizuka, Yasumitsu, 1987. 'Daiei Hakubutsukan Shozō: Nihon/Chūgoku Bijutsu Meihin Ten', *Kobijutsu* 83 (July), 8

Waterhouse, David B., 1962. 'Twelve Japanese Prints', *BMQ*, vol. xxv (nos 3–4), 95–101, pls xxxviii, xxxix

–1963–4. 'Fire-arms in Japanese History: With Notes on a Japanese Wall Gun', *BMQ*, vol. xxvii (nos 3–4), 94–7, pl. xlviii

–1964. *Harunobu and his Age: The Development of Colour Printing in Japan*, British Museum, London, 1964

Watson, William, 1959. *Sculpture of Japan*, London

Zaigai Nihon no shihō 1979. Vol. 5 *Rimpa*, ed. Yamane Yūzō, Tokyo

–1980. Vol. 1 *Bukkyō kaiga*, ed. Yanagisawa Taka, Tokyo

–1980. Vol. 2 *Emakimono*, ed. Akiyama Terukazu, Tokyo

–1980. Vol. 4 *Shōhekiga*, ed. Takeda Tsuneo, Tokyo

–1980. Vol. 7 *Ukiyo-e*, ed. Narazaki Muneshige, Tokyo

–1981. Vol. 10 *Kōgei*, ed. Kitamura Tesurō, Tokyo

Zwalf, W., 1985. *Buddhism: Art and Faith*, London

INDEX

Numbers in italic type refer to catalogue entries; other references are to pages.